RUSSIAN REALISMS

RUSSIAN

REALISMS

LITERATURE AND PAINTING, 1840–1890

Molly Brunson

NIU PRESS / DEKALB

Northern Illinois University Press, DeKalb 60115
Printed in the United States of America
25 24 23 22 21 20 19 18 17 16 1 2 3 4 5
978-0-87580-738-6 (paper)
978-1-60909-199-6 (ebook)

Book and cover design by Yuni Dorr

Library of Congress Cataloging-in-Publication Data
Names: Brunson, Molly, author.
Title: Russian realisms : literature and painting, 1840–1890 / Molly Brunson.
Description: DeKalb : Northern Illinois University Press, 2016.
Identifiers: LCCN 2016007600 (print) | LCCN 2016008451 (ebook) | ISBN
 9780875807386 (paperback) | ISBN 9781609091996 (ebook) | ISBN
 9781609091996 (Ebook)
Subjects: LCSH: Aesthetics, Russian—19th century. | Realism in art—Russia.
 | Realism in literature. | Painting, Russian—19th century—Themes,
 motives. | Russian literature—19th century—History and criticism. |
 BISAC: HISTORY / Europe / Russia & the Former Soviet Union. | ART /
 Russian & Former Soviet Union. | LITERARY CRITICISM / Russian & Former
 Soviet Union.
Classification: LCC BH221.R93 B78 2016 (print) | LCC BH221.R93 (ebook) | DDC
 700/.4120947—dc23
LC record available at http://lccn.loc.gov/2016007600

Publication of this book was made possible, in part, by a grant from the First Book Subvention Program of the Association for Slavic, East European, and Eurasian Studies.

Illustrations in this book were funded in whole or in part by a grant from the Meiss/Mellon Author's Book Award of the College Art Association.

college **art association**

For my parents

Contents

List of Illustrations

Acknowledgments

Over the years it has taken to bring this book into being, I have accrued many debts of gratitude. First and foremost, I am grateful to Irina Paperno, who advised the dissertation upon which this book is based. Although I did not know it at the time, it was her seminar on *Anna Karenina* in my first semester of graduate school that guided me to the nineteenth-century classics and eventually to this project. Since then, she has been a constant source of intellectual inspiration and professional guidance. I am similarly grateful to Olga Matich, who has been unwavering in her thoughtful and encouraging reception of my work. These two women, in their high expectations and dedication to their students and to the field, serve as my models for what it means to be a mentor and a colleague. I am also thankful to T. J. Clark, who encouraged this project from the start, taught me how to *really* look at paintings, and motivated me to thoughtfully and creatively translate that looking into words on the page.

I have been fortunate to find two nurturing and stimulating academic homes, first at the University of California, Berkeley, and then at Yale University. It has been through conversations with mentors, colleagues, and students, in and out of the classroom, that I have learned both what I wanted to write and how to write it. I am especially grateful to my colleagues in Yale's Slavic Department—Vladimir Alexandrov, Marijeta Bozovic, Katerina Clark, Harvey Goldblatt, Bella Grigoryan, and John MacKay—all of whom have read and commented on portions of the manuscript, and have been steadfast in their support at every step of the way. Rosalind Blakesley, Marijeta Bozovic, Michael Kunichika, Allison Leigh, and John MacKay, as well as the anonymous readers at Northern Illinois University Press, deserve special mention for reading and offering vital feedback on the entire manuscript at critical moments in the revision process. I owe extra debts to Bella Grigoryan and Michael Kunichika for serving, each in her or his own way, as invaluable interlocutor, unforgiving taskmaster, and valued friend. For pushing me to clarify and advance my ideas, I am thankful to the brilliant students who have taken my graduate seminars on Russian realist literature and painting and the Russian novel, and my undergraduate courses on nineteenth-century Russian literature and art. I

must also acknowledge the many other colleagues who have made their mark, in ways big and small, on this book: Tim Barringer, Polina Barskova, Paul Bushkovitch, Anne Dwyer, Laura Engelstein, Jefferson Gatrall, Aglaya Glebova, Luba Golburt, Maria Gough, Anthony Grudin, Kate Holland, Margaret Homans, Maija Jansson, Anastasia Kayiatos, Christina Kiaer, Galina Mardilovich, Stiliana Milkova, Eric Naiman, Anne Nesbet, Donna Orwin, Serguei Oushakine, Jillian Porter, Harsha Ram, Lindsay Riordan, Kristin Romberg, Wendy Salmond, Margaret Samu, Jane Sharp, Victoria Somoff, Jonathan Stone, Alyson Tapp, Maria Taroutina, Victoria Thorstensson, Roman Utkin, Elizabeth Valkenier, Boris Wolfson, and the late Viktor Zhivov. Given that this is my first book, it also seems appropriate to thank my very first teacher of Russian, Kelli McSweeny.

While at the University of California, Berkeley, my research and writing were supported by the Dean's Normative Time Fellowship and the Chancellor's Dissertation Year Fellowship, as well as travel grants from the Institute for Slavic, East European, and Eurasian Studies. At Yale University, I was able to revise the manuscript with the help of a Morse Junior Faculty Fellowship. Additional publication support has been generously provided by Yale's Frederick W. Hilles Fund, the College Art Association's Meiss/Mellon Author's Book Award, and the Association for Slavic, East European, and Eurasian Studies' First Book Subvention. I would also like to acknowledge the staffs of the State Tretyakov Gallery (Moscow), the State Russian Museum (St. Petersburg), the State Tolstoy Museum (Moscow), the Russian State Archive of Art and Literature (Moscow), and Yasnaya Polyana (Tula) for their assistance with primary and secondary sources, their hospitality during my research, and their permission to reproduce materials in this book. As I completed the manuscript, I was lucky to have the careful and competent research assistance of Megan Race and Vadim Shneyder. In the final stages, the ever efficient and savvy Daria Ezerova stepped in to obtain all images and permissions from Russia. Finally, I am grateful to everyone at Northern Illinois University Press, especially Amy Farranto, whose enthusiasm has been matched only by her expertise and efficiency.

Portions of chapter 4 appeared as "Painting History, Realistically: Murder at the Tretiakov," in *From Realism to the Silver Age: New Studies in Russian Artistic Culture*, ed. Rosalind P. Blakesley and Margaret Samu (DeKalb: Northern Illinois University Press, 2014), 94–110; and as "Wandering Greeks: How Repin Discovers the People," *Ab Imperio: Studies of New Imperial History and Nationalism in the Post-Soviet Space* 2 (2012): 83–111.

While I was working on this project, many friends sustained me in ways well beyond the intellectual. My winter in Moscow was made much warmer by the friendship of Ani Mukherji, Keeli Nelson, Bill Quillen, Kristin Romberg, Erik Scott, and Victoria Smolkin. My final years in the Bay Area would not have been the same without Katya Balter, Mikayla Cuyler and Oliver Marquis, Aglaya Glebova, Anthony Grudin, J. C. Rafferty and Blake Manship, Brian Shih, Brian Sullivan, and Chris Wimer. After moving to New Haven, I was lucky to

find yet another family in Bella Grigoryan, Katie Lofton, Paige McGinley and Pannill Camp, and Sam See. In a category of her own, Sara Cardace has shown up for all things, good and bad, for which I could never thank her enough.

Lastly, but most importantly, there is little I can say to properly thank my parents, my mother, Jodell, and late father, Geofrey, for their unconditional love and support. I have been defined by a lifetime of watching them sacrifice for and rejoice over my successes, both personal and professional. Without them, none of this would have been possible. And so, I dedicate this book to them.

Note on Transliteration and Translation

When transliterating from Russian to English, I have used the Library of Congress system with occasional modifications in the interest of familiarity and readability. For example, Tolstoi has become Tolstoy, Il'ia has become Ilya, and Moskva has become Moscow. In parenthetical notations of Russian words or phrases, and throughout the notes and bibliography, I have adhered precisely to the Library of Congress transliteration standards.

Unless specifically noted, all translations are mine. When quoting existing translations, I have sometimes made slight changes for the sake of clarity.

Introduction

ON THE SEVENTH OF October 1880 the painter Ilya Repin, already hav-
ing finished dinner, heard a knock at the door. The evening visitor was an
older man, stocky, and with a graying beard. It took Repin a moment, but then
he recognized the man standing before him. In a letter the following day to
the critic Vladimir Stasov, the mastermind of this meeting, Repin exclaimed:
"Just imagine now my astonishment when I saw with my own eyes Lev Tolstoy
himself! [Ivan] Kramskoy's portrait of him is a tremendous likeness."[1] Tolstoy
stayed for a couple of hours, and the two men—Russia's great realists—talked.
Or rather, to quote Repin, "he talked, and I listened, and pondered, tried to
understand."[2] Tolstoy was, at this point in his career, beginning the assault on
aestheticism that would ultimately lead him to condemn on moral grounds
even his own masterpieces, *War and Peace* and *Anna Karenina*. It was this
intensely critical eye that the writer turned to the sketches strewn about
Repin's studio, among them a study of a group of Cossacks penning a letter.
Never one to mince words, Tolstoy proclaimed the study lacking in the "higher
meaning" or "serious, fundamental idea" that would render it suitable for a
larger, morally sound painting.[3] Cowed by the judgment of such a towering
figure, Repin informed Tolstoy a week later that he had decided to abandon
the Cossack picture altogether. But in the same letter, Repin also admitted that
the visit had had another unexpected effect; it had brought into greater focus
for him the "actual path of the artist."[4] Repin explained that their conversation
had prompted him to "define more clearly the notions of study and painting,"
and to conclude that these terms might obtain entirely different "technical"
meanings for artists than for writers.[5] What Repin suggests in this otherwise
timid response to Tolstoy's dismissive critique is that the meaning of a painting
might not lend itself to the terms of a writer, that the path to truth is deter-
mined by the mode and the medium of representation.

 The chapters that follow are about these many, varied paths that converge
to form the tradition of nineteenth-century Russian realism, a tradition that
spans close to half a century, from the youthful projects of the Natural School

in the 1840s to the mature masterpieces of Tolstoy, Fyodor Dostoevsky, and the painters of the Wanderers (*Peredvizhniki*), chief among them, Repin. In an age that saw the rise of the Russian novel, the professionalization and canonization of a school of national painting, and the continued development of an ever more robust community of critics, collectors, and publishers, it is realism that predominates. Although realism was certainly not alone in the second half of the nineteenth century—indeed, it developed very much in dialogue with alternative aesthetic practices, from the conventional dictates of academicism and politically conservative literary ideologies to painterly forms related to Impressionism—it nevertheless secured its central position in part through the privileging of all things realist in Soviet literary and art historiography, and in part through the celebration of the Russian realist prose canon, and especially its classic novel, in broader studies of literature. And yet, this monolithic presence of realism more often than not splinters into equivocation or endless qualification. It is little wonder, given the dizzying array of objects that must crowd beneath this singular term. In Russia, as elsewhere, realism can be photographic or artistic, tendentious or picturesque. It can be naked and vulgar or, to quote Dostoevsky, of a "higher sense," capable of depicting the "depths of the human soul."[6] The literary and painterly works of realism regularly profess rigorous objectivity and also propose epic expanses and religious transcendence. They judge society in one breath, and eschew judgment entirely in the next. They balance (or not) commitments to grand ideas, and to form and style.

It is the intent of this book *not* to force an agreement among these varied forms of realism, or to redefine them as aberrant, hybrid, or protomodernist. Rather, I offer an overarching model for understanding realism that retains difference. By closely reading and looking at the classics of Russian realism, I explore the emergence of multiple realisms from the gaps and disruptions, the struggles and doubts, accompanying the self-conscious transformation of reality into representation. These many manifestations of realism are united not by how they look or what they describe but by their shared awareness of the fraught yet critical task of representation. This task, reflected in an ongoing preoccupation with medium and artistic convention, is motivated by epistemological concerns, to be sure, but also by social status, political ideology, and even the hope for spiritual transfiguration.

Throughout this book, I maintain a double focus on realism as both historical and transhistorical. In the first sense, realism is understood as a pan-European and American movement that compels all the arts—literary, visual, musical, and dramatic—to forgo the fantasies and phantasms of romanticism for more sober and democratic subjects with positivist pretensions. This historical delimiting of realism is guided by what René Wellek calls a "period concept," a collection of characteristics that respond, in one way or another, to an age that turned away from the imagination, trumpeted a scientistic approach to the study of humanity, and sought to apply that approach to its cultural production.[7] Throughout the West, this empirical and historicist orientation is

inspired and driven by the now familiar mechanisms of modernity: the spirit of revolution and reform, urbanization and its social effects, the growth of an educated professional class, and significant advancements in science and technology, of which photography is just one. Although realism emerged in literary and painterly culture throughout Europe and the United States, it enjoyed perhaps its greatest prominence in France during the decades after the July Revolution, culminating in the masterworks of Gustave Courbet and Gustave Flaubert from the 1850s.[8]

While Russian writers and artists turn to realism somewhat later (as is so often the case), it will be in Russia that realism reaches its ultimate potential in the novels of Tolstoy and Dostoevsky, universally considered to be the preeminent examples of the genre and, at the same time, the places where realism expends itself. In many ways exhilaratingly divergent and transgressive, Russian realism also remains relatively commensurate with its European and American counterparts; it is at once exemplary and extraordinary. The aims of this book, however, are not comparative in nature; as I discuss in this introduction, they focus instead on the interart relations within Russian realism proper. That said, my analyses are nevertheless informed by a wide range of criticism on nineteenth-century realism well beyond the Russian Empire, and in this sense, *Russian Realisms* can and should be considered a case study of a much broader phenomenon.

Beyond its historical aspect, realism is also understood in this book as a transhistorical mode, with its origins in Platonic and Aristotelian conceptions of mimesis and a genealogy that encompasses everything from classical poetry and Italian Renaissance painting to the abstraction of the early Russian avant-garde. Realism in this aesthetic sense is inextricable from its philosophical roots in theories of epistemology.[9] This philosophical preoccupation with truth in the world, an inviolable truth that can be accessed through sensory experience, has been expressed throughout the history of art as a declaration of the most truthful methods and modes of representation. Therefore, when Horace unites the sister arts in his phrase *ut pictura poesis* (as is painting, so is poetry), he is commenting upon the arts' parallel capacities for verisimilitude. When Leonardo da Vinci asserts that "painting is mute poetry, and poetry is blind painting," he is making a claim for the objective veracity, and thus superiority, of the painter's illusion. And when Gotthold Ephraim Lessing writes on the limits of painting and poetry, he does so to delineate which categories of experience are more accurately rendered by which art. When coupled with the positivist and historicist conceits of the epoch, this commitment to discovering the aesthetic limits of mimesis across the arts (which in turn motivates the history of interart theory discussed later in the introduction) ultimately produces the profound veridical imperative of the nineteenth century's varied realist movements.

In this book, I argue that this persistent comparison between the sister arts inherent in realism as a transhistorical mode is the conceptual key to unlocking not only the aesthetic conventions of realism in its nineteenth-century

Russian expression, but also the particular ideological and metaphysical aims to which Tolstoy, Dostoevsky, Repin, and others aspire in their novels and paintings. As a guiding principle, I maintain that the clearest elaborations of this aesthetic thought are to be found within the works of art themselves, in moments of interart encounter that function as emblems of realist representation. In literary texts such emblems might appear as extended ekphrases of artworks, or subtle spatiotemporal shifts between narration and description, or suggestively picturesque language. In paintings they might be suggested by the arrangement of figures in a composition, or gestures toward allegorical readings, or the tension between brushstrokes and signification. In these instances of interart encounter, I do not parse essential or absolute definitions of the visual and the verbal; rather, I follow how the work *imagines* its artistic "other," and how the work either polemicizes with the notion of that foreign medium, or attempts to absorb it into itself.

By seeking to bridge the divide between the sister arts, or in some cases drawing greater attention to that very divide, these interart emblems enact the larger struggle of realism to eliminate the distance between art and reality. For example, when a novel halts narration for the sake of an extended description, attempting to place a virtual "picture" before the reader, it reveals its ambition to escape the borders of the verbal realm but also its suspicion that this goal is ultimately futile. After all, a picture in a novel will always be a "picture," just as the narrative of a painting will necessarily always be a "narrative." This inevitability, however daunting, does not stop the prose and painting of realism from negotiating and manipulating such artistic borders. On the contrary, in their ubiquity, such interart encounters capture the audacity of realism itself, its desire to transcend the very borders of art and life. For if one art can achieve the impossible—a novel becoming a painting, a painting becoming a story— then who or what is to say that art cannot become the very reality it represents?

A Letter and a Map

To illustrate the hermeneutic power of these interart encounters, allow me to present two pieces of paper. We find the first in Repin's painting *The Zaporozhian Cossacks Writing a Letter to the Turkish Sultan*, which Tolstoy had condemned on that October 1880 evening, although, it would seem, not convincingly enough, for Repin returned to the subject and developed it into one of his most enduring canvases (1880–1891, figure 1). More specifically, look at the center of Repin's picture, at the barely visible glimmer of white, which represents the rude letter (purportedly composed in 1676 to the Ottoman sultan Mehmed IV) that served as inspiration for the depicted subject. The second interart encounter is located roughly halfway through *War and Peace*, in a map of troop positions that introduces Tolstoy's description of the Battle of Borodino (1865–1869, figure 2).[10] These two images—Repin's letter, Tolstoy's map—will figure prominently in the second half of this book. For

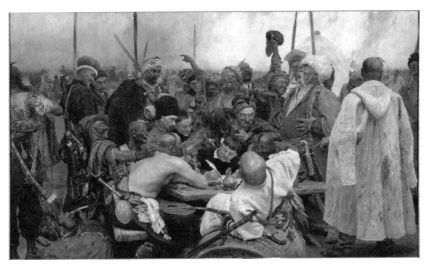

FIGURE 1. Ilya Repin, *The Zaporozhian Cossacks Writing a Letter to the Turkish Sultan,* 1880–1891. Oil on canvas, 203 x 358 cm. State Russian Museum, St. Petersburg.

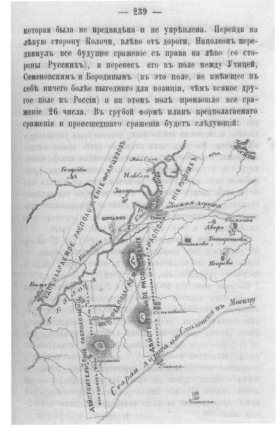

FIGURE 2. Lev Tolstoy, Map of the Battle of Borodino. From six-volume edition of *War and Peace* (Moscow: Tip. Ris, 1868–1869): 4:239. Photo Credit: New York Public Library, New York.

now, however, I want to emphasize their status as artistic intruders. As such, they produce pockets of aesthetic self-consciousness that invite reflection on the mechanisms of representation in the painting and the novel, respectively.

For a painting that depicts the very process of writing, it is perhaps surprising that Repin seems to have taken great pains to obscure the letter itself. Although it is positioned roughly in the center of the canvas, the letter is fragmented into three small, irregular shapes, blocked from view by the scribe's hands, the rollicking bald figure leaning back toward the viewer, and a jug of what is likely the elixir fueling this riotous occasion. Where visible, the letter is pristine, still awaiting text. And even more, the spot where the tip of the pen would meet the surface of the paper, the precise origin of verbal expression in this picture, is hidden somewhere behind the jug, which in turn taunts the viewer with a subtle patch of white on its upper half, either a filtered view of the letter or a reflection of light on the surface of the glass.

In early studies, including the one Tolstoy may have seen, the letter is given pride of place. An 1878 sketch places the table parallel to the picture plane, its left leg and surface entirely exposed, providing a clear view of the letter being written (figure 3). A study from two years later zooms in closer to the table, adds our familiar leaning figure, but leaves the letter open to view (figure 4). There is no jug, or any other object blocking our sight line. And although the scribe's left hand is placed over the paper, it does not prevent us from spotting several squiggly black lines of text. So why, then, does Repin choose to minimize the presumably verbal subject of *Zaporozhian Cossacks* in the final version? Still another preparatory work suggests one possible answer to this question. In this small sketch the scribe hunches over the letter in the center of the page, oblivious to a pair of floating hands behind him holding up a sheet of paper (figure 5). It is in this moment that we discern a shift in Repin's focus, away from the depiction of a legendary event, already mediated by historiographic representation, and toward the depiction of a supposedly unmediated experience. Populating his canvas with breathing, laughing, smoking bodies, Repin takes the origin of his subject, a two-dimensional sheet of paper, lifts it up into the grizzled, meaty hands of a Cossack, and spins it into three-dimensional space. By obscuring the writing on the letter with the robust bodies of the men, Repin displaces the burden of representation from a verbal to a plastic realm. The words on the document, he seems to say, may be a starting point in accessing the past, but they will nonetheless always remain flat. It is the thickly applied paint on the surface of the canvas and the illusion of space in which figures can hunch and point and lean that more faithfully approximate the reality of historical experience.

Borrowing a term from Renaissance aesthetic theory, I call this phenomenon, the sometimes antagonistic, sometimes conciliatory comparison between modes of artistic representation, the realist *paragone*. In broad terms, *paragone* is understood rather benignly as a comparison between different art forms; although with its roots in ancient athletic and artistic contests (*agones*), the *paragoni* made famous through Renaissance debates on the relative status of

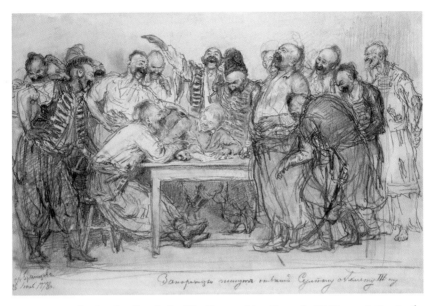

FIGURE 3. Ilya Repin, Sketch for *The Zaporozhian Cossacks Writing a Letter to the Turkish Sultan*, 1878. Graphite pencil on paper, 20.2 x 29.8 cm. State Tretyakov Gallery, Moscow.

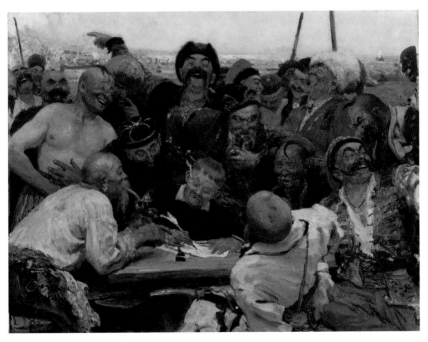

FIGURE 4. Ilya Repin, Study for *The Zaporozhian Cossacks Writing a Letter to the Turkish Sultan*, 1880. Oil on canvas, 69.8 x 89.6 cm. State Tretyakov Gallery, Moscow.

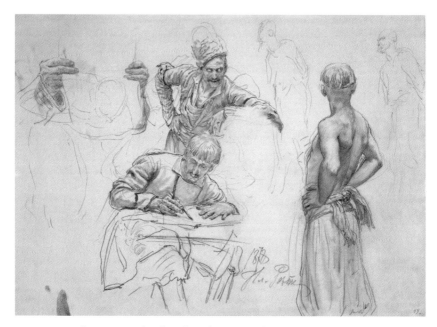

FIGURE 5. Ilya Repin, Sketches for *The Zaporozhian Cossacks Writing a Letter to the Turkish Sultan* (Zaporozhian Cossack in hat; scribe; Zaporozhian Cossack with bared chest; male figure in profile), late 1880s (misdated on sketch). Graphite pencil on paper, 25 x 34.8 cm. State Tretyakov Gallery, Moscow.

the arts take on a more competitive orientation. In his well-known *paragone*, for example, Leonardo argues for the superiority of painting over poetry on the grounds of the eye's more immediate and scientific access to nature.[11] "The imagination is to reality as the shadow to the body that casts it and as poetry is to painting," claims Leonardo, "because poetry puts down her subjects in imaginary written characters, while painting puts down the identical reflections that the eye receives, as if they were real."[12]

In Repin's painting, and perhaps most poignantly in the gray shadow cast upon the white paper by the scribe's hand, the viewer hears an echo of this *paragone* from years past. Leonardo's analogy stands; on paper, in words, the vibrant details of this historical drama become mere shadows, filtered, mediated, and refracted. In fact, even in the painting's insistence on materializing the hand's shadow and the letter's reflection on the glass jug, we see a display of one-upmanship. The picture announces its ability to make present and lasting the most elusive phenomena of reality, turning shadows and glints of light into tactile, solid painterly forms. Or to quote Leonardo once again, "your tongue will be parched with thirst and your body overcome by sleep and hunger before you can describe with words what a painter is able to show you in an instant."[13]

For Tolstoy's realist *paragone*, let us turn to the second piece of paper. It is here, with the one visual aid in all of *War and Peace*, that we begin to

understand the fundamental distance between the two artists. The map of the Battle of Borodino is in and of itself nothing special, a fairly schematic outline of major topographical landmarks with two sets of rectangular boxes that mark the "proposed" and "actual" positions of the French and Russian armies. Inserted as it is after a harsh critique of the historiography of the battle, the map manifests all the inadequacies of certain kinds of representation, since the map, abstracted as it is by space and time, tells us very little about what *actually* happened during that fateful August. Any continuous narrative or "higher meaning" dissolves into a series of lines and dots.

As with Repin, though, Tolstoy's preparatory work tells us even more. In a sketch that the author himself made during an 1867 trip to Borodino, the ground swells into a semicircular hill, traced over with a meandering line and patches of rapid pencil scratches (figure 6). Although text labels the major landmarks, the overall impression of this sketch is one of space, of the volume of the round hill and the orientation of the viewer in relation to that hill. From letters and reminiscences, it is clear that Tolstoy traveled to Borodino to see how the space looked and felt at different moments of the day and from different perspectives. And so, in the two suns, one rising in the lower left quadrant and the other setting in the upper right, we see condensed the many hours, minutes, and seconds of that historic day. What is most striking about this sketch is that despite its diminutive size and lack of finish, it presents a relatively dynamic version of the historical site, one that collapses space, time, and movement into one image. So what does it mean that Tolstoy would minimize these dynamic visual elements in the final version of the map? A partial answer is offered by the narrator in a juxtaposition of the "real" experiences of a military campaign with those mediated by a graphic representation: "The activity of a commander does not have the slightest resemblance to the activity we imagine to ourselves, sitting at ease in our study, analyzing some campaign on a map" (11:269; 825). The commander, he continues, is never so removed from the battle; he "always finds himself in the middle of a shifting series of events" (11:269; 825). This "shifting series of events" is, for Tolstoy, what a novel, and more specifically, his *particular* brand of realist novel, is able to produce that a picture is not. And it is this dynamic expression that he seeks to highlight by contrasting narrative to a static visual image. Even the two suns of Tolstoy's initial sketch, however appealing, simply do not offer the "slightest resemblance" to the temporal movement, causality, and lived perspectives of a novelistic narrative.

The development of Russian realism, I argue, can be discerned precisely in such moments of aesthetic self-awareness. By mobilizing the grand shifts in the history of the sister arts—from the liberal coupling of painting and poetry proposed by *ut pictura poesis* to a more combative vying for supremacy in Leonardo's *paragone* and finally to Lessing's drawing of prescriptive and protective boundaries—these moments of interart encounter make impassioned arguments for their respective realisms, while also expressing the relative optimism or discord of their sociohistorical context. In the coming pages, we will see how the writers of the Natural School and the painter Pavel

FIGURE 6. Lev Tolstoy, Field notes from trip to Borodino (detail) (text and drawing by L. N. Tolstoy, text in unreproduced part of the manuscript page by S. A. Bers), September 25–27, 1867. Manuscript 23, f. 1, no. 9194/21. State Tolstoy Museum, Moscow.

Fedotov, propelled by a spirit of democratic inclusion, take a similarly inclusive approach in their joining together of words and images for the sake of a shared mimetic mission. But as the social fabric begins to fracture during the era of reform, this Horatian equivalence yields to differentiation. Not so much openly antagonistic, but certainly aware of their distinct representational capacities, the early novels of Ivan Turgenev and the paintings of Vasily Perov manipulate the borders between visual and verbal modes of representation for maximal illusionistic and social effect. For Tolstoy and Repin, and also for Dostoevsky, these interart borders provide the fodder for more intensive aesthetic debate, and the opportunity for nuanced examinations of history, society, and faith. Indeed, as we will see, all three engage the border between the sister arts—sometimes polemically, at other times opportunistically, never benignly—in order to produce realisms that aspire to move beyond the objectivity of the Natural School and the ideology of critical realism, and into far more profound epistemological planes.

The Audacity of Realism

Mainly because of its perceived status as a harbinger of socialist realism, nineteenth-century realism received continuous and, for the most part, unabashedly positive scholarly and popular attention in the Soviet Union throughout the twentieth century.[14] And perhaps because of the robust industry in novel studies, not to mention the effusive evaluations of such modernists as Virginia Woolf—"if the Russians are mentioned one runs the risk of feeling that to write of any fiction save theirs is a waste of time," she writes in 1919—Russian realist literature has found a lasting place in the Western literary canon as well.[15] By contrast, other than in the work of Western specialists of Russian art, the painting of Russian realism has not enjoyed the same fate.[16] This makes it all the more curious, and somewhat shocking, that Repin makes an appearance in art critic and theorist Clement Greenberg's famous essay "Avant-Garde and Kitsch," published in the *Partisan Review* in 1939. What is more, the reference is not even made in passing but as part of a relatively extended comparison with, of all artists, Picasso. This would seem to be a fortuitous bit of exposure for the otherwise little-known tradition of nineteenth-century Russian painting, and so it is with great relish that we read on: "Let us see for example what happens when an ignorant Russian peasant [. . .] stands with hypothetical freedom of choice before two paintings, one by Picasso, the other by Repin."[17] At this point, our excitement wanes; we begin to worry that the exposure might not be so positive. And sure enough, as we follow Greenberg's thought experiment, we are told that the Russian peasant likes the Picasso well enough, even appreciates in it something like the stylistic minimalism of religious iconography, but standing in front of Repin's battle scene, the peasant is enthralled. He "recognizes and sees things in the way in which he recognizes and sees things outside of pictures—there is no discontinuity between

art and life, no need to accept a convention."[18] Summarizing the results of his hypothetical exhibition, Greenberg writes that "Repin pre-digests art for the spectator and spares him effort, provides him with a short cut to the pleasure of art that detours what is necessarily difficult in genuine art. Repin, or kitsch, is synthetic art."[19]

Repin, or kitsch. Although this equivalence effectively interrupts any significant inclusion of Repin into Greenberg's modernist canon, it is also clear that the critic was invested neither in Repin nor in Russian realist painting as anything other than a polemical device. For him, Repin is a convenient stand-in for socialist realism and other forms of totalitarian or capitalist art, the mere antihero to an avant-garde that resists aesthetically manipulating the masses. However, what Greenberg's Picasso-Repin opposition highlights quite well is how exactly realism was dumbed down by modernism. Followed as it was by the aggressive formal experimentation and self-reflexivity of the avant-garde, realism was recast by Greenberg and many others as an earnest yet dangerously simpleminded ancestor, and its central philosophy interpreted (incorrectly, I argue) as the gullible belief that art could and should perfectly reflect reality.

Therefore, it is perhaps with a feeling of redemption (maybe even a little schadenfreude) that we read Greenberg's postscript, appended to the 1972 reprint of his essay:

> P. S. To my dismay I learned years after this [essay] saw print that Repin never painted a battle scene; he wasn't that kind of painter. I had attributed someone else's picture to him. That showed my provincialism with regard to Russian art in the nineteenth century.[20]

Even with this admission, even with the subsequent challenges to Greenbergian modernism, realism continues to suffer from the presumption of its naïveté.[21] In this book, then, I seek to correct what I see as the dual "provincialism" of Greenberg's virtual exhibition. First, I recover some of the difficulty and discontinuity that modernism evacuated from both literary and painterly realism, in order to redefine realism not as a supposed transparent reflection of reality but as a conventional, self-conscious, and bold aesthetic project. And second, I address the undeniable fact that Russian realist painting, even without Greenberg's unfortunate intervention, had and still has a status that is considered secondary to its coincident literary tradition. As I have mentioned, this imbalance is reflected in the divergent historiographies of Russian literary and painterly realism—the first, having successfully integrated Russian writers into a larger transnational and transhistorical narrative; and the second, with a few important exceptions, never having quite managed to put Russian painters in sustained dialogue with their more famous European counterparts.[22] Rather than deny this unevenness, which is as much historical as it is historiographic, I embrace it as a productive lens through which to view the aesthetic awareness of paintings that were, more often than not, read as

uncomplicated, even pedantic narratives. By doing so, by providing a model for *really looking* at the works of Repin and others, I hope to secure for them a place in the study of nineteenth-century realisms—literary and painterly; Russian, European, and American.

What makes the modernist critique of realism possible is a certain murkiness that has affixed to the term itself, so that "realism" can come to mean almost anything. This terminological slipperiness has even produced one of the necessary tropes of scholarship on the subject: that realism is, in a word, elusive.[23] Realism's supposed elusiveness originates mainly from the long and twisted history of the "real" in Western civilization, from the classical embrace of mimesis to Renaissance innovations in representation and German romantic philosophy. As a result, concludes Lydia Ginzburg, "realism has become an infinitely elastic concept," carrying with it the baggage of a transhistorical mode, the disparate ways in which art has sought to position itself vis-à-vis reality throughout the history of the modern world.[24]

In Russia the elasticity of realism can be detected in the tendency to, in Wellek's words, "hunt for realism even in the past."[25] Aleksandr Pushkin and Nikolai Gogol; the painters Aleksandr Ivanov and Karl Briullov; they all, however formally and ideologically distinct, are said to have laid the groundwork for the achievements of realism proper.[26] It is the twentieth century, however, that provides the most vivid examples of this terminological mutability. Writers as different as Ivan Bunin, Vyacheslav Ivanov, and Maksim Gorky can be deemed realist. And in an even more daring redefinition of the foundations of realism, in 1915 Kazimir Malevich calls his abstract Suprematist canvases "the new painterly realism," a first-order realism based on the ontology of the art form rather than its relation to any external phenomena.[27] In still another jarring aesthetic reversal, less than two decades later, state bureaucrats reject this avant-garde formalism altogether for yet a newer version, socialist realism, an aesthetic grounded in the idiom of nineteenth-century realism but with a reformed ideological viewpoint.

Tracing this phenomenon, what he calls the "extreme relativity" of realism—that is, how various approaches to mimetic representation change from one historical moment to the next—Roman Jakobson highlights realism's flexibility, while also grounding its indeterminacy within a structure of historically contingent artistic conventions.[28] Neither meaninglessly vague nor naïvely transparent, realism is, in Jakobson's estimation, a complex system of representation. In other words, it is not to be taken as a passive reflection of reality—à la Stendhal's definition of a novel as a "mirror, taking a walk down a big road"—but as a calculated attempt at approximating that reflection through a set of conventions.[29] The study of this conventionality takes different forms, of course. Art historian E. H. Gombrich posits the copying and reimagining of artistic conventions as the basis for illusionistic representation.[30] The Russian Formalists consider how Tolstoy and others "estranged" reality into an aesthetic object, or "deformed" source materials to produce a literary narrative.[31] Discussing literary description, Roland Barthes asserts

that "realism (badly named, at any rate often badly interpreted) consists not in copying the real but in copying a (depicted) copy of the real"; realism is, for him, "code upon code."[32] What these approaches emphasize, above all, is that realism is conventional and contingent, that its art is considered in its construction, even if it mostly pretends not to be.

Erich Auerbach responds to the problem of realism's instability rather differently, by identifying a shared interest in the democratic and the vernacular among the varied representations of reality in Western literature. Charting a path from the Bible to Dante Alighieri and Miguel de Cervantes, culminating famously in the insistently historicist realism of Honoré de Balzac and Stendhal, Auerbach focuses on the lower realms of human experience, representations of the everyday lives of common people. This democratic impulse is also evident in the early moments of Russian realism, heard in the call to depict subjects from the poor and merchant classes that motivated the Natural School. And although the waters of realism muddy during and after the age of reform, artists otherwise in ideological opposition remain bound by the Auerbachian humanist project of describing the lives of individuals "embedded in a total reality, political, social, and economic, which is concrete and constantly evolving."[33] The clashing generations in Turgenev's novels, Tolstoy's Pierre Bezukhov at the Battle of Borodino, the peasants and Cossacks and laborers of the Wanderers: these subjects mark Russia's realism as one more chapter in Auerbach's broader history. Although he only discusses the Russians briefly, Auerbach sees in them, and mostly in Dostoevsky, "a revelation of how the mixture of realism and tragedy might at last attain its true fulfillment."[34] This, for Auerbach, is the pinnacle of modern realism, its ability to elevate its vernacular origins to something far more profound, to fuse the comic and the tragic into a transcendent representation of human experience.

What Auerbach captures in his brief mention of the Russians is that realism at its best, and maybe in its Russian expression most of all, always attempts to move beyond itself, to aim for something more. For those we call critical realists, this something more is the literary judgment of reality in the hope of inspiring widespread reform or even revolution in real life.[35] For others, such as Turgenev and Tolstoy, this something more is felt in the narrative swerve toward generalization apparent in the character type, or in moments of epic commentary or lyrical digression. For Dostoevsky, this surplus, that which is in excess of "reality," is the promise of Christian revelation. The point that is worth emphasizing is that realism does not *equal* mimesis. In representing reality, realism must always grapple with the distance between art and life. It is within this distance that the most astounding solutions are to be found, ones that may in fact seem quite unrealistic but that are nonetheless realist. More importantly, when works of artistic realism *do* cross into subjective or spiritual or imaginary realms, they are not violating their own aesthetic commitments. In these instances, they do not become hybrid, romantic, or protomodernist, but rather exploit the inherent paradoxicality of realism itself.[36]

Realism is, in a word, aspirational. And this aspiration to collapse art into life presupposes both a show of magnificent bravura and an awareness of ultimate failure. In describing the novel's early steps toward its mimetic goal, Vissarion Belinsky, the first and perhaps most passionate proponent of Russian literary realism, expresses this aspiration in slightly different terms, writing that the novel "strove toward the approximation of reality" (*stremilsia k sblizheniiu s deistvitel'nostiiu*).[37] It might be said, therefore, that realism is more an orientation toward a grand and obviously impossible end, rather than that end itself. In moments of heightened self-consciousness, when realist art interrupts its striving for reality to reflect upon itself, it reveals these aesthetic strategies, strategies that are at times confident and at times anxious. This is because despite being motivated by a desire to achieve mimetic proximity, realism is forever aware of the impossibility of this project. It is in its willingness to persevere in the face of this most certain failure, and not in a willed ignorance of medium and convention, that realism distinguishes itself from modernism.[38]

Late and Second-Rate

In Russia, realism was aspirational in more than just this aesthetic sense, and no one knew this better than Belinsky himself. As early as 1834, the upstart young critic opens "Literary Reveries," a lengthy review of Russian literary history, with the following provocation: "We have no literature!"[39] This would seem an odd statement to make before such an extended multipart survey of decades of literary history, until we realize that Belinsky's aim is as much to rally the young generation of cultural leaders, as it is to highlight the extraordinary achievements of Mikhail Lomonosov, Gavrila Derzhavin, Nikolai Karamzin, and others. A healthy literary tradition cannot be sustained by a handful of talented writers alone; rather, what is needed is a community of writers who have the professional security and artistic freedom to live and breathe their craft, as well as an educational system that can produce an enlightened public capable of supporting such a community.

If Belinsky had had any interest in the visual arts when he wrote his "Literary Reveries," he might have followed his opening salvo with a second exclamation: "We have no painting!"[40] And yet, despite Belinsky's despair at the "lack" of a Russian literature, the fact is that the institutions of a diverse and relatively independent literary tradition developed at a far more rapid rate than those of the visual arts. In contrast to the majority of writers, and certainly the likes of Tolstoy and Turgenev, painters were mainly of humble origin, coming to the art profession from merchant, military, or peasant classes, and therefore occupied not only with creative pursuits but also with more pressing concerns of professionalization, economic security, and social status.[41] Moreover, while writers by midcentury could rely upon a growing number of critics and journals to support their work, painters remained largely dependent upon the

Imperial Academy of Arts and systems of state patronage well into the 1850s and even, it has been argued, long after the formation of the Society of Traveling Art Exhibitions, or Wanderers, in 1870.[42]

Indeed, writing during the heyday of the Wanderers, the most prominent supporter of Russian realist art and music, the critic Vladimir Stasov, remarks that "our literature has a significant advance on art."[43] Wondering whether this advance was a result of discrepancies in education or natural talent, Stasov concludes that Russian painting has nothing even close to the "best scenes from *Boris Godunov, Taras Bulba*, and *War and Peace*."[44] At the beginning of the next century, the art historian Alexandre Benois considers little changed, remarking that "the arts of the image, of plastic form, meanwhile trudge along, scrape by, always remaining far behind literature and music, as some sort of faint echo of them."[45] With Fedotov and Repin as his two examples—the artists that frame this book's consideration of realist painting in Russia—Benois recalls that "we looked upon them as a fleeting amusement, as some kind of barely necessary illustration to those books on the shelf, which so absorbed us and completely filled our entire intellectual life, and not as the most important, necessary, indispensable adornment of our existence and edification of our spirit."[46] In the shadow of the masterpieces of Russian literature and their preoccupation with profound intellectual questions, the pictures of Repin and his fellow realists become, for Benois, nothing more than frivolous objects of amusement. "Repin," Greenberg would say, "or kitsch."

Despite this substantial disparity in the relative development and status of literature and painting, Belinsky and Benois nonetheless participate in the same overarching narrative about the belatedness and derivativeness of Russian history and culture, most memorably expressed in Pyotr Chaadaev's philosophical letters, the first of which was written in 1829 and already well known by the time of its Russian publication in 1836. In these letters, Chaadaev describes a Russia that has failed to successfully integrate herself into a broader global community, and therefore lacks any genuine history, set of shared humanistic values, or original culture: "We do not belong to any of the great families of the human race; we are neither of the West nor of the East, and we have not the traditions of either. Placed, as it were, outside of time, we have not been touched by the universal education of the human race."[47] All surface and no substance, with no sense of a unique past or a culture that is not "imported and imitative," Russia becomes in Chaadaev's imagination a specter, a perpetually stunted child, a rootless wanderer.[48]

As if answering Chaadaev's grim diagnosis, Belinsky concludes his 1834 article in an optimistic key, writing that in time "we will have *our own* literature, we will become not imitators, but rivals of the Europeans."[49] Along with the other members of the Natural School, Belinsky would dedicate the next decade to building just such an artistic tradition seemingly from the ground up. This project, the self-conscious development of Russia's own literature, might seem incommensurate with the fact that the early literary sketches of the Natural School, as I discuss in the next chapter, were modeled closely on

popular French almanacs and Balzac's "sociological" realism. Early realism in Russia, then, *was* to a certain extent both belated and derivative. In fact, it would seem that realism suffered doubly from the anxiety over imitation expressed so clearly by Chaadaev. An imitation of a necessarily imitative aesthetic, mimesis of mimesis, a copy of a copy of reality, Russian realism was always aware of the need to master and move on, to match the achievements of Western Europe and then offer its own original contribution, all the while constructing a clearly native lineage for its literary realism.[50]

Given the widespread perception of its "secondariness" (*vtorichnost'*), realist painting in Russia would have even greater hurdles to overcome. These obstacles were compounded by what was long perceived to be the persistent logocentrism of Russian culture, a privileging of the word over the image that can be traced back to religious iconography.[51] In order to boost the status of realist painting, therefore, Stasov would turn not to European painterly models for legitimation but would highlight what he saw as the innate connection of Russian painting to the literary arts. For Stasov, this literary association not only supported the legitimacy of Russian painting, putting the arts on a seemingly equal footing, it also supplied painting with the narrative and ideological content that the critic considered its defining characteristic.

On the margins and a decade late, Russian realism was inevitably colored by its historical insecurity and its peripheral status.[52] For the writers and artists considered here, the mastery of realism represented the key to cultural and professional legitimacy, social and political potency, and national, perhaps even global, rejuvenation. We might say, therefore, that the audacity and doubt prevalent in realism, as a broader mode and a movement, is mirrored in Russia's nineteenth-century variants by an audacity and a doubt that emanates from much deeper cultural mechanisms. To adopt realism becomes about catching up with the centers of European culture, but also very much about overcoming these centers. Seeing themselves as late and second-rate, Russian literature and painting approach the epistemological task of realism with a pronounced urgency, and a desire to reach and transcend the limits of the "real."

Sisters, Cousins, Neighbors

Hours before he is to meet his co-protagonist in *Anna Karenina* (1875–1877) for the first and only time, Konstantin Levin goes to a concert, where he listens to *King Lear on the Heath*, a musical fantasia based on William Shakespeare's tragedy. He is taken aback and confused, and so, during intermission seeks out the opinion of a music connoisseur by the name of Pestsov. "'Amazing!'" exclaims Pestsov, praising the performance as "graphic," "sculptural," and "rich in color" (19:261; 685).[53] What Levin discovers is that he had not noticed these visual aspects of the fantasia because he had not read the notes in the playbill, and therefore missed the cues to the supposed "entrance" of Cordelia in all her sculpturesque and lush beauty. Transforming his confusion into the outlines

of an aesthetic objection, Levin remarks that "the mistake of Wagner and of all his followers lay in their music wishing to cross over to the sphere of another art, just as poetry is mistaken when it describes facial features, something that should be done by painting" (19:262; 686). To the student of classical aesthetics, Levin's ornery critique can have its source in only one text, published over a century earlier in 1766, Lessing's *Laocoön, or On the Limits of Painting and Poetry.*[54]

Lessing opens his treatise with a description of the famous Greek statue of Laocoön and his two sons, twisted in the vise of Poseidon's snakes, writhing in unimaginable pain. Why, Lessing asks, does the sculptor transform the father's agonizing scream, so vividly captured by Virgil, into a subtle, perhaps even peaceful, peep?

> The scream had to be softened to a sigh not because screaming betrays an ignoble soul, but because it distorts the features in a disgusting manner. [...] The wide-open mouth, aside from the fact that the rest of the face is thereby twisted and distorted in an unnatural and loathsome manner, becomes in painting a mere spot and in sculpture a cavity, with most repulsive effect.[55]

For Lessing, repulsiveness itself is not the problem; rather, it is the medium used to represent that repulsiveness. To explain this, he constructs a rudimentary formulation of painting and poetry as spatial and temporal sign systems. As a consecutive form, poetry is better equipped to describe action and can even represent ugly subject matter, since it allows for the reversal or dispersal of that ugliness over time. Painting, on the other hand, is better suited to the depiction of bodies and images in space, and subjects that will not offend their viewer when perceived all at once in a single moment. For a painter to depict a scream would not only result in an unpleasant image, an unsettling "spot" or "cavity," it would subject the viewer to that unpleasantness for eternity.

In a move that redefines the relationship between painting and poetry, making sisters into neighbors, Lessing voices a plea for good fences:

> But as two equitable and friendly neighbors do not permit the one to take unbecoming liberties in the heart of the other's domain, yet on their extreme frontiers practice a mutual forbearance by which both sides make peaceful compensation for those slight aggressions which, in haste and from force of circumstance, the one finds himself compelled to make on the other's privilege: so also with painting and poetry.[56]

In Lessing's aesthetics, there is no room for the kind of fast and loose interart commingling to which Levin objects in the Shakespearian fantasia. Poetry and painting; music and sculpture—they all are to stay within their own distinct spheres. Even when it comes to ekphrasis, which as a verbal description of a visual work of art would seem to be inherently liberal in its artistic relations, Lessing sees fit to reinforce artistic borders. Referencing Homer's ekphrasis of the shield of Achilles, Lessing responds that "we do not see the shield, but the

divine master as he is making it," an observation that turns a material object into a consecutive action for the sake, we can assume, of artistic propriety.[57]

Although portions of Lessing's treatise had been translated into Russian as early as 1806, the first complete translation was published in 1859, and was preceded two years earlier by a series of biographical articles on Lessing by none other than Nikolai Chernyshevsky, the progressive critic who effectively sets the aesthetic *program* for the "real criticism" (*real'naia kritika*) of the reform era.[58] Writing not long after the defense of his dissertation, "The Aesthetic Relations of Art to Reality" (1855), Chernyshevsky comes down hard on the violation of interart borders.[59] The result, Chernyshevsky says, is a poetry that is immobile, lifeless, and desperately in need of the theory that Lessing provides with his *Laocoön*. "Do not describe beauty for me in verses—the description will be pale and bleary—but show the effect of beauty on people, and it will be traced in my imagination vividly, maybe more vividly than in a picture."[60] The critic Nikolai Dobroliubov, in a review published in the *Contemporary*, goes a step further and proclaims that Lessing's theory will even be useful "for the literary education of our public," effectively pulling the aesthetics of *Laocoön* into contemporary relevance, and making it available for Tolstoy, Levin, and others to cite in their declarations of artistic philosophy.[61]

What Lessing (and Chernyshevsky) take issue with is the doctrine of the sister arts, which posits an intrinsic and mutually beneficial relationship between the verbal and visual arts. If we follow this doctrine back to its origins, we discover that the sisterhood of the arts is as inextricable from theories of realism as the sister arts themselves are from one another. Despite their different conclusions regarding the value of mimesis, both Plato and Aristotle identified imitation as one of the primary tasks of poetry and of painting. For Plato, deceitfully illusionistic painting became a rhetorical weapon to wield against similarly mimetic poetry. To quote Jean Hagstrum, "the lie of the poet was compared to the image of the painter; the analogy between the arts was designed to humiliate poetry."[62] For Aristotle, who rejected Plato's negative assessment of mimesis, the two arts were again equally up to the task, although in a moment that subtly gestures toward what we might now call medium specificity, he conceded that they achieve this imitation in distinct ways. They were, Hagstrum writes, "not sisters but cousins."[63]

Be they sisters or cousins, the verbal and the visual arts have largely been defined throughout the history of aesthetics around two phrases, more invitations than fully formed propositions—"painting is mute poetry, poetry a speaking picture" and "*ut pictura poesis*" (as is painting, so is poetry). The first belongs to Simonides of Ceos, as quoted by Plutarch; the second to Horace. Horace's *ut pictura poesis*, taken in context, offers little more than a rough analogy between how one is to encounter a poem and how a painting. In this simplest of similes, Horace suggests that some works of poetic art, as with painting, are best experienced up close and others from afar; some hold up to detailed analysis, others do not. While Hagstrum sees "no warrant whatever in Horace's text for the later interpretation: 'Let a poem be like a painting,'"

Leonard Barkan reads the maxim as "unmistakably unidirectional," positing a *pictura* that is "'simpler,' more natural, more immediate, while *poesis* is constituted as more complex, more sophisticated, and (often) nobler."[64] Plutarch's citation of Simonides is similarly shifty. In the passage in question, Plutarch does not speak of the sister arts at all, but rather praises Thucydides's extraordinary descriptions, the way in which the historian is able to summon forth and make visible—like a speaking picture—stories from the past. On the surface, then, it would seem that Simonides offers merely a mirrored definition; however, the implication in Plutarch's phrase is of painterly lack as opposed to poetic potential. Poetry can aspire to the pictorial, but painting must remain forever mute. This will be how Leonardo interprets Plutarch in his famous *paragone* nearly fourteen centuries later, offering instead an alternative platitude: "Painting is mute poetry, and poetry is blind painting."[65]

"Each of them," writes Barkan of these most famous of interart mottos, "purports to be a whole poetics in a nutshell," and this is "where the whole problem begins, because these famous phrases are not very *good* definitions of poetry. In place of a clear description, we are left with tropes and tautologies."[66] So why has *ut pictura poesis* had such a lasting impact on aesthetic thought? Why does Leonardo return to Plutarch to make his impassioned case for painting as a legitimate liberal art? And why does Lessing feel the need to counter an aesthetic doctrine that is centuries old? It seems to me that these classical tropes, in some sense certainly dusty and overused, nonetheless retain great stores of epistemological and hermeneutic potential for writers and artists, as well as for scholars. In the first instance, the relation between word and image offers writers and artists a means to think through their own processes of creative expression, their relative capacities for mimetic representation, and their place within a larger professional and cultural context. In the second, the sister arts provide the scholar with a structure for analogy and comparison, one that shifts and takes on varied tones, that teeters back and forth like a seesaw or a faulty scale. In and of itself, the formula means little, but understood within historical context, the status of sibling relations can tell us a great deal. And so, when we hear Levin ventriloquize Lessing, we hear not only a statement about the formal particularities of the various arts, we also hear the novel assume a defensive posture against the intrusion of foreign modes of representation, and we hear the novelist assert a kind of dominance in the cultural sphere. We hear, in other words, a *paragone*.[67]

The Realist *Paragone*

As part of its inheritance from classical aesthetics, nineteenth-century European realism is marked by an undeniable preoccupation with artistic "others"; its novels are intensely visual, its paintings mostly narrative.[68] In *Realist Vision*, Peter Brooks posits that it is sight, privileged by classical philosophy and held up as empirical by John Locke, that rules the realist mode. What we see, in

realist literature, becomes a conduit for what we know, what we understand. And according to Brooks, under the surest of hands this sight can even lead to "visionary visions, ones that attempt to give us not only the world viewed but as well the world comprehended."[69] In its investment in the visual as a means to knowledge and truth, the realist novel participates not only in classical, Enlightenment, and theological conversations, it also engages with nineteenth-century discourses on vision brought about by the rapid advancement of optical technologies, most notably the invention of photography.[70] This is, to be sure, a historical moment that is very much obsessed with the scientific and social applications of visual technology, and yet, we need think only of the birds swooping down to peck at Zeuxis's grapes, or of the flickering projections of a magic lantern show, to know that with greater illusion comes greater awareness of limits and of deception. The realist novel, as I discuss especially in relation to Tolstoy and Dostoevsky, deftly navigates the precarious status of vision in modernity and uses it to interrogate the very nature of representation. If the visuality of the realist novel often functions in the mode of empiricism or verification, voicing something like "to see is to believe," it just as frequently serves as a reminder of the untrustworthiness of our eyes. When this visuality is introduced by reference to a work of art, as it so often is, it sometimes confirms the reliability of art as a copy of nature, and at other times chooses to explore what haunts the mimetic project, the inadequacy or impossibility of truthful representation, be it visual or verbal.[71]

We can chart a related, if not exactly parallel, mechanism in realist painting by considering its presumed orientation toward verbal structures of signification. In his influential work on painterly realism, Michael Fried identifies a pervasive tendency toward *reading* rather than *looking* at realist painting. Realist pictures are, Fried asserts, "looked at less intensively than other kinds of pictures, precisely because their imagined causal dependence on reality—a sort of ontological illusion—has made close scrutiny of what they offer appear to be beside the point."[72] In Russia, this narrative orientation of realist painting is exaggerated by what I have already suggested is the distinct logocentrism of Russian culture. While Stasov and others saw in this "literariness" (*literaturnost'*) an advantage, certain factions within the Wanderers, as well as artists and thinkers who would come to form the core of the early modernist movement in Russia, condemned, or at the very least challenged, this focus on content at the expense of aesthetic concerns. What these struggles reveal is that realist painting interacts with its "other" in a manner that resembles the realist novel's preoccupation with vision and visual modes of representation. In both cases, this turn to an artistic sibling is also a turn inward, revealing the work's historically specific aesthetic thought, as well as its philosophical and ideological orientation.

In my focus on the internal relations of the "verbal" and "visual," understood as concepts constructed by a given medium and not as essential categories, I am guided by what W. J. T. Mitchell has theorized as a method of interart study "beyond comparison."[73] In his wide-ranging work on word-image relations,

Mitchell proposes a critical shift away from comparisons between the visual and verbal arts—between, for example, a text and its illustration, a novel and its cinematic adaptation—and toward a consideration of the "image/text problem" within specific works. "In short," writes Mitchell, "all arts are 'composite arts' (both text and image); all media are mixed media, combining different codes, discursive conventions, channels, sensory and cognitive modes."[74] It follows, then, that all arts lend themselves to this kind of mining of the word-image divide.

> Something like the Renaissance notion of *ut pictura poesis* and the sisterhood of the arts is always with us. The dialectic of word and image seems to be a constant in the fabric of signs that a culture weaves around itself. What varies is the precise nature of the weave, the relation of warp and woof. The history of culture is in part the story of a protracted struggle for dominance between pictorial and linguistic signs, each claiming for itself certain proprietary rights on a "nature" to which only it has access. At some moments this struggle seems to settle into a relationship of free exchange along open borders; at other times (as in Lessing's *Laocoön*) the borders are closed and a separate peace is declared.[75]

For Mitchell, tracing this dialectic of word and image leads, of course, to formal insights about how diverse media go about their projects of representation. But it also contains the possibility for much grander conclusions. In power struggles and moments of cooperation, in assertions of difference and of affinity, the sister arts—as an interpretive tool—reveal all manner of historical and social relations within a given cultural system. In other words, within the word-image divide we glimpse far more profound divisions, geopolitical, gender, racial, and otherwise.

In tempering the role of comparison in the study of word-image relations, Mitchell seeks to lift the field of interart study out of the impasse in which it had found itself by the end of the twentieth century.[76] Just as the pendulum has swung back and forth between a Horatian equivalence and a Lessingian assertion of borders in the history of aesthetics, so too have debates formed in scholarship between those who desire a system of analogies or correspondences that can bind together literary and art history, and those who fear or outright reject the erasure of critical and disciplinary boundaries.[77] While an excessively permissive interpretive model threatens to dilute formal description—everything becomes picturesque, sculpturesque, novelistic—there is also a danger in overreacting to such territorial disputes by closing off the possibility of productive cross-disciplinary communication. In my approach to the literature and painting of Russian realism, I walk a careful line between the Horatian and Lessingian critical factions, and practice a methodology predicated less on interdisciplinary comparisons than on multidisciplinary juxtapositions, ever grounded in close reading and careful looking. This is not to say that implicit or explicit connections will not be made. They will, and they must. But they will be made with care given to the hermeneutic potential of

artistic parallels, the way in which such parallels make visible formerly invisible points of confluence, as well as to the advantages of retaining formal and disciplinary distinctions.

At this juncture, it is also worth mentioning a particularly well-known vein of interart studies—the study of the biographical relationships between artists and writers. There are many such famous pairings in the history of Russian culture. Tolstoy, for example, was well acquainted not only with Repin, as I describe in the opening pages of this book, but also with Ivan Kramskoy and Nikolai Ge. And in chapter 4, I briefly discuss the importance of Repin's friendship with the writer Vsevolod Garshin for his history painting.[78] One of the closest of such relationships, however, was that of Anton Chekhov and the renowned landscape painter Isaak Levitan, whose connection some have argued to be as much stylistic and aesthetic as biographical.[79] Although curious, these kinds of biographical links, especially as the foundation for aesthetic comparison, are not the focus of this book. I maintain, instead, that the interart orientation and realist aesthetic of my writers and painters is best found within their respective works rather than in their personal or professional relations with one another.[80]

The structure of *Russian Realisms* reflects this methodological philosophy, alternating between discrete sections on literature and on painting, yet in a way that amplifies resonances. In the first half of the book, I take up the two most important emblems of realism—the window and the road. In chapter 1, I explore the window, bequeathed to realism by Leon Battista Alberti, as one of the dominant organizing mechanisms of the Natural School, and especially in the urban sketches of *The Physiology of Petersburg* (1845) and the genre paintings of Fedotov. Peeking through windows provides these artists with content for their democratic project, with access to the previously invisible, poor, and intimate corners of the city. These primarily visual phenomena are supplemented by the sounds and stories of the urban environment, with visual and verbal united by the figure of the strolling narrator or artist. In this way, the picture windows of the Natural School depend upon cooperation between the sister arts, in order to attain the illusion of a complete, objective, and multisensory imitation. And yet, we know that the Albertian window, while offering a transparent view of the world, also mediates, frames, and synthesizes that view. The window thus becomes an emblem of the paradox, present even in such an early and optimistic moment, of realism's simultaneous promise and denial of mimetic transparency.

In chapter 2, inspired by Stendhal's description of the realist novel as a "mirror on the road," I consider the road as one of the more prominent tropes of Russian realism in the era of reform, focusing on the early prose of Turgenev, including his novel *Fathers and Children* (1862), and the more critically oriented paintings of Perov. The road, in its ability to crystallize multiple conceptions of time and space, becomes a productive image for the novel and the painting, allowing both to explore their particular capacities for narration and description, for representing movement, life, and progress, on the one hand,

and space, depth, and materiality, on the other. Both Turgenev and Perov draw on this complexity of the road, so that they may push their respective media beyond the circumscribed windows of the Natural School and into an illusion of the world that has dimension and scope, that aspires to be more aesthetically and ideologically dynamic than any one framed view, and that might even elicit an ethical response from its audience.

In the second half of the book, I employ the interart categories developed from the window and the road—visual and verbal, time and space, narration and description—in analyses of a selection of canonical works from the Russian realist tradition. In chapter 3, I follow the many references to visual culture—in the form of paintings, panoramas, telescopes, and magic lantern shows—in the representation of the Battle of Borodino in Tolstoy's *War and Peace*. Engaging the competitive impulse of the *paragone*, Tolstoy moves his hero (and ultimately his reader) through a series of false visual impressions. In place of these aestheticized and deceptive descriptions, Tolstoy offers a novelistic illusion, a representation of history that depends upon narrative movement to transport the reader between multiple perspectives, across space and time, and through states of consciousness. This is a realism that embraces a polemical stance toward the sister arts, in an effort to achieve a more convincing illusion of human experience.

History and human experience also, to some extent, figure in chapter 4, which turns to a trio of paintings by Ilya Repin—*Barge Haulers on the Volga* (1870–1873); *Ivan the Terrible and His Son Ivan, November 16, 1581* (1885); and *The Zaporozhian Cossacks Writing a Letter to the Turkish Sultan*. Taking seriously Stasov's demand for "tendentiousness" (*tendentsioznost'*) in Russian realist art, I imagine this ideological tension as emanating not solely from the critical content of Repin's paintings, but also from the friction between their political convictions and their investment in aesthetic expression. For Repin, I argue, to involve the viewer in lively narratives, whether contemporary or historical, is also to absorb that viewer phenomenologically into the space of the picture. It is in the pushing and pulling of these opposed experiences, one conceived as "literary" and the other as "painterly," that we find Repin's realism, a realism that relies on an engaged and embodied viewer for the activation of its progressive message.

The fifth and final chapter considers the very different kind of realism proposed by Dostoevsky in his novel *The Idiot* (1868–1869). Like Tolstoy with his optical illusions, Dostoevsky discerns in certain moments of visuality—a photographic snapshot, Nastasya Filippovna's Medusan gaze, Hans Holbein's painting of the dead Christ—a threat to the continuation of his narrative. Mobilizing the double potential of ekphrasis, to still a narrative in the contemplation of a visual image while also giving voice to an otherwise mute visual object, Dostoevsky attempts a fusion of the sister arts in the final pages of his novel. In this fusion of word and image, we find the essence of Dostoevsky's fantastic realism, which desires to move beyond the mimetic divide, to

transfigure reality into a perfect artistic form, and thus to transcend the very border between death and life.

It is here—in the metaphysical, in the transfigurative, in that which the Russians do so well—that realism runs out of road. There is nowhere left to go. For to abolish the distinction between art and life is to upset the balance on which realism relies. It is to tip the scale a little too far in the direction of art, approaching something like a modernist self-reflexivity. Or, if the scale is weighted more toward the other side, it leads to the total forsaking of art. It makes realism real. This is a lofty goal, indeed, and one to which all the artists in my study aspire, but it is a goal that when reached, dissolves altogether. After all, we cannot forget that in the moment Pygmalion kisses Galatea into life, the sculpture he had so loved is no more. For realism, then, to be success-ful is to fail. Better to desire, to hold out hope in the certainty of despair.

When one art attempts the impossible, to fully translate or embody another, to cross over into the realm of life, we are afforded momentary glimpses into the operations of realism as it has been practiced since ancient Greece, and insights into how this mode remained significant in a time and place as differ-ent as imperial Russia. In the second half of the nineteenth century, Tolstoy and Dostoevsky, Repin and the Wanderers, turned to realism for reasons epistemological, ideological, psychological, and spiritual. They would create a national tradition of painting. And a novel like nothing anyone had yet seen. What made this possible was the self-consciousness of realism and its wild optimism in the face of failure, a presence constantly stalked by absence—the audacity of realism.

1

The Natural School's Picture Windows

Here an officer with a captured drunk,
Like Fedotov had drawn him.

<div align="right">NIKOLAI NEKRASOV[1]</div>

LIKE MOST YOUNG, AMBITIOUS newcomers to a big city, the eponymous hero of Nikolai Nekrasov's unfinished novel *The Life and Adventures of Tikhon Trostnikov* (1843–1848) lives in a modest apartment. Located in the basement, it is the architectural opposite of, although just as shoddy as, the coffin-like attic room that Dostoevsky's Raskolnikov would occupy two decades later. An aspiring poet, Trostnikov writes day and night largely uninterrupted, but for one rather annoying distraction.

> One needs to know that my apartment was on a lower floor with windows onto the street. The first three days, when the shutters were open, passersby would stop and, with wild curiosity and for a prolonged period of time, would examine my completely empty room, in which a person was lying in the middle of the floor. Once I even noticed that some person, apparently an observer of mores [*nabliudatel' nravov*], in a brown overcoat and sky-blue pants, stood for a very long time at the small window, staring at my apartment, and every so often jotted something down.[2]

Who might this "observer of mores" be, peeking into Trostnikov's window and scribbling something into a pad of paper? Nekrasov suggests one possible culprit in an 1843 feuilleton called "An Unusual Breakfast." The host of this rather "unusual breakfast," himself a newspaper feuilletonist, shares with his guests one of his more curious professional practices.

> I have, gentlemen, the habit, when I have no money, which happens twenty-nine times a month, of strolling along the outlying Petersburg streets and looking into the small windows of the lower floors: this really entertains me and often supplies

material for my feuilletons. You cannot imagine what kind of wonders one some-
times happens to see: sometimes, walking past some small window, in one min-
ute, in one passing glance, you will see the plot of an entire drama, sometimes a
wonderful vaudeville scene. [...] Imagine a panorama, in which views are con-
stantly changing.[3]

As a chronicler of the ordinary and extraordinary happenings of urban life, the
writer of the popular feuilleton seems an obvious candidate for Trostnikov's
Peeping Tom. How better to gain access to the truly salacious scenes of St.
Petersburg life than by treating the city streets like a moving sidewalk, passing
by the images of a never-ending peep show?

If we continue to look for suspects, however, we realize that there seems to
have been a downright epidemic of spying in the imperial capital during the
1840s. In his contribution to Nekrasov's illustrated almanac *The Physiology of
Petersburg* (1845), Evgeny Grebenka instructs his reader: "Walk along the not
very even and somewhat rickety sidewalk made of wooden boards, and you
will see in the basement floors, almost at your feet, various touching family
pictures."[4] A young Dostoevsky, introduced to Nekrasov by another contribu-
tor to *Physiology*, his friend and former roommate Dmitry Grigorovich, writes
in 1847 that such a "family picture in the window of a poor little wooden
house" could inspire a "whole history, novella, novel."[5] Perhaps such a scene
even sparked the idea for his first novel, *Poor Folk* (1846), the tale of an ill-
fated romance conducted through letters, but also through glances exchanged
between the windows of neighboring buildings. According to the writer and
editor Aleksandr Druzhinin, the painter Pavel Fedotov, who would become a
sensation in the Petersburg art scene around this time, also liked to peer into
windows; he would roam about the "outlying parts of the city [...] finding
himself beneath the illuminated windows of unfamiliar houses and observing
by the hour some kind of a family scene."[6] Thus, while any number of offenders
could have been peeking into Trostnikov's window, furiously sketching away,
these examples focus attention on a circle of interconnected individuals who
would come to be known as the Natural School (*natural'naia shkola*). Its mem-
bers—writers, critics, editors, and artists—would devote the better part of a
decade to looking through windows, literally or metaphorically, in order to see
anew their city and its inhabitants, and to represent them in art—supposedly,
as they really are—for the first time.

This outbreak of window-gazing exemplifies one of the defining character-
istics of an early aesthetic of realism in Russia. Most apparently, the window
lends itself well to a perception of the city as a picture gallery, as a labyrinth
of streets that contains a countless number of framed everyday scenes. These
scenes, neatly sectioned out of a larger and more chaotic urban environment,
provide the raw material for the prose and paintings that Nekrasov, Fedotov,
and others produced during the 1840s. These windows do far more than frame
a visual experience, however; they also serve as creative triggers, supplying a
visual foundation for subsequent verbal descriptions, plots, and stories. As such,

they function as openings within which dynamic scenes can unfold, in a manner that is more akin to that of a living spectacle than of a stilled and silent image.

This interrelation of the visual and the verbal is explored in this chapter by focusing on representative works of the Natural School: the literary sketches of *The Physiology of Petersburg* and the genre painting of Fedotov and, in particular, *The Courtship of the Major* (1848, figure 7). In both cases, these works turn on their pronounced incorporation of visual *and* verbal modes of representation. Not only is the *Physiology* illustrated, its articles and verbal sketches depend upon a visual poetics for their construction of a mimetic illusion. In a parallel vein, Fedotov's paintings rely in almost equal measure on their modal opposite, that is, on semantic and narrative structures, so much so that Fedotov, at his first major exhibition in 1848, stood in front of the *Courtship* and recited a poem that he himself had written to accompany the picture. What these examples show is that the prose and the painting of the Natural School, while distinct in so many ways, nonetheless share a realist aesthetic based on collaboration between the sister arts, a collaboration with its roots in the Horatian axiom of *ut pictura poesis*. For the Natural School, this reciprocal relationship is mutually beneficial to the verbal and visual arts, in an aesthetic as well as professional sense. This interart cooperation bolsters the realist illusion, representing more fully the living impressions of reality; even more, it enhances the reputations of both literature and painting, creating the

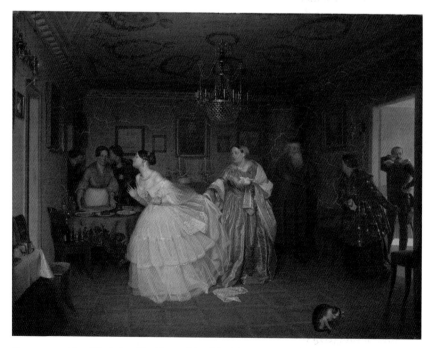

FIGURE 7. Pavel Fedotov, *The Courtship of the Major*, 1848. Oil on canvas, 58.3 x 75.4 cm. State Tretyakov Gallery, Moscow.

illusion—and ultimately, the reality—of a robust, native, and multidimensional Russian culture.

From the beginning, the members of the Natural School were motivated precisely by this larger goal of nurturing national culture, driven especially by a belief that they represented a new generation of Russian literature. Aleksandr Pushkin had died in 1837, Mikhail Lermontov in 1841. Against the backdrop of these cultural transitions, a circle of young men would become acquainted in the university lecture halls and on the sidewalks of Petersburg, their circle bound as much by shared urban spaces and a condensed period of time as by a common artistic aesthetic. The year 1838 saw both Nekrasov and Dostoevsky move to the city to attend school, where they met fellow student Grigorovich. Having graduated that same year, Ivan Turgenev left for further study in Germany, but would return in 1841. In 1839 Belinsky, somewhat older but like-minded, arrived from Moscow and took a job at the journal *Notes of the Fatherland*. After a brief stint in military service, Dostoevsky in 1844 quit to become a writer. Fedotov, after a considerably longer military career, quit that same year to devote himself to painting.[7]

With all the pieces in place, in 1845 Nekrasov and Belinsky published the first, and, as it would happen, the only two volumes of what was intended to be a serial almanac, *The Physiology of Petersburg*.[8] The first volume is composed of an introduction and article by Belinsky, and literary sketches by Nekrasov, Grigorovich, Grebenka, and Vladimir Dal (also known as Lugansky). The second volume is more diverse in its contents, including two essays by Belinsky, a poem by Nekrasov, a short play by Aleksandr Kulchitsky (also known as Govorilin), and two literary sketches, one by Grigorovich and the other by Ivan Panaev. Both volumes include illustrations by the leading graphic artists of the time, Vasily Timm, Yegor Kovrigin, Rudolf Zhukovsky, and the engraver Evstafy Bernardsky. Virtually from the start, the *Physiology* was identified as a foundational text, and Belinsky's introduction has since been read as a kind of manifesto of the Natural School, declaring that literature ought to be a "reflection of society" in all of its strengths and weaknesses (10; 10).[9] The almanac even inspired the very coining of the movement's name. In a characteristically disdainful review, the conservative critic Faddey Bulgarin remarks that the almanac "belongs to a new, that is natural, literary school, which posits that one should represent nature without a veil. We, on the other hand, maintain the rule […] 'nature is only good, when it is washed and coiffed.'"[10] Belinsky, ever the opportunist, adopted Bulgarin's characterization for his own purposes, turning the almanac's supposed lack of polish and artistry into positive and unifying attributes of the emergent realism. In the past, he explains, writers had "adorned nature, idealized reality, that is, they represented the nonexistent, they told stories about the unheard-of, but now they reproduce life and reality in their truth."[11] Belinsky's words, and in particular their parsing of then and now, emphasize what he saw as the essential aesthetic and philosophical shift from romanticism's privileging of the imagination to a new dependence on concrete observation and visualization.

The most important native influence for this kind of realism was, of course, Nikolai Gogol, so much so that critics frequently noted, in terms both laudatory and less so, the "Gogolian tendency" (*gogolevskoe napravlenie*) in the prose of Nekrasov and his colleagues, as well as in the painting of Fedotov.[12] By the middle of the 1840s, the eccentric writer had already moved abroad, begun his descent into madness, and seemingly abandoned what was considered by Belinsky to be his socially oriented artistic project. Consequently, the critic called upon his colleagues to pick up where Gogol so unceremoniously left off.[13] By doing so, he hoped to grow a literature that was "wholly national, Russian, original, and authentic, [...] to make it the expression and mirror of Russian society, to animate it with the living national interest."[14] This was, for Belinsky, not just about the truthful reflection of society; it was also about society's engagement with this reflection in the interest of greater self-consciousness (*samosoznanie*).[15] In his articles and reviews, Belinsky repeatedly makes the point that a literary tradition capable of shouldering such a social function must be actively nurtured, by encouraging a school rather than a smattering of isolated geniuses, supporting that school through a robust critical and publishing apparatus, and appealing consistently to the readerly public. What he ultimately aspired to was a post-Gogolian literature, a literature that would reflect society but also reflect itself. And this infinite reflection would hold the key to a self-aware and self-sustaining culture and society.

Although Belinsky celebrated the unique Russianness of the *Physiology*, he was well aware that it was not without precedent. Beginning in the 1830s, illustrated compendia of *physiologies*—short verbal sketches informed by the journalistic genre of the feuilleton and related to the pseudosociological literature of, among others, Honoré de Balzac (in, for example, his *La Comédie humaine*)—had become enormously popular in France and indeed throughout Europe. Confident in the powers of observation, the *physiologies* took as their subjects various social types—for example, a specific person, profession, place, or institution—and strove to deduce unifying characteristics of this type through the systematic chronicling of sensory phenomena. In other words, the *physiologies* represented what could be seen, heard, even smelled and touched, in an effort to abstract from these perceptions more general conclusions about the modern city, its inhabitants and their mores. Significantly, these *physiologies* were often collected as part of encyclopedic multivolume or serial publications, intended to offer readers a panoramic view of contemporary society.[16]

While Russians had long been drawn to Western European literature informed by moral or social concerns, from Joseph Addison's *The Spectator* to the more contemporary works of Charles Dickens, Victor Hugo, Eugène Sue, and Balzac, the particular popularity of the *physiologie* as a genre began to be noted in the press in 1840, although it was most certainly apparent even earlier.[17] It did not take long for Russian editors and publishers to clamor for their own native *physiologies*. To offer just one example of this transnational influence, Léon Curmer's nine-volume *Les Français peints par eux-mêmes* (The French Painted by Themselves), published in 422 installments in 1840–1842,

inspired Aleksandr Bashutsky to release his own Russified version, *Russians Painted from Nature by Themselves* (1841–1842). Although Bashutsky's edition was far more modest in size, scope, and impact, it nevertheless retained a similar format: short *physiologies*, mainly of social types, with corresponding illustrations.[18] The response to the French *physiologies* and their Russian variants fell, unsurprisingly, along more or less firm ideological lines, with Bulgarin and his like bemoaning their vulgarity and Belinsky praising their veracity in representing society. Indeed, Belinsky remarked repeatedly on the superiority of the French *physiologies*, noting their broad social themes and technical proficiency, most evident, he thought, in their seamless and mutually beneficial integration of text and illustration.[19]

Building on this tradition, Nekrasov's almanac included a number of Balzacian *physiologies*, called in Russian "physiological sketches" (*fiziologicheskie ocherki*). Beyond the shift from French to Russian subjects, there are few dramatic stylistic or aesthetic differences between the *physiologies* and the Russian physiological sketches. It would be wrong, however, to dismiss works like Nekrasov's *Physiology* as mindlessly derivative. Rather, the resemblance between the physiological sketches and their French precursors gestures toward the participation of Russian culture in the broader project of pan-European literary realism. And moreover, this kind of imitation, as Belinsky makes clear in his praise of the French works on which the *Physiology* would be based, carries the promise of Russian literary and national advancement: French *physiologies* supplied Russian writers with models for sophisticated artistic examination of their world, thereby giving Russian readers access to the social benefits of such literature, and ultimately to greater self-realization.

The physiological sketch, considered by some to be not only the quintessential genre of the Natural School but also the very foundation of the realist prose of the classic Russian novel, was motivated by a dual didactic and ideological purpose.[20] Like its French cousins, it is intended to expose its readers to previously unnoticed places and peoples, to (quoting one of Belinsky's two reviews of the *Physiology*) "acquaint provincial readers, and, perhaps even more so, Petersburg readers, with Petersburg."[21] Toward this goal of exposing their readers to the unvarnished reality of the city, the sketches of Nekrasov's almanac provide exhaustive physical descriptions, coupled with historical and sociological commentary. While not overtly critical, this didactic intent cannot help but be ideologically motivated. After all, more often than not, these sketches' subjects are the poor, the suffering, the forgotten; and their theme, the jarring confrontation of the reader with a less fortunate "other."

Although Belinsky wrote very little about the visual arts, often only resorting to them for critical analogies and metaphors, given the realist emphasis on exposing and making *visible* the previously overlooked, it would seem self-evident that there would be a substantial number of visual artists among the ranks of the Natural School.[22] Indeed, a number of noted graphic artists worked alongside Nekrasov and Belinsky on their projects. Fedotov himself would contribute illustrations to one of Dostoevsky's sketches for Nekrasov's

Illustrated Almanac (1848).[23] Nonetheless, there are very few painters, other than Fedotov, who might be considered an equivalent to the Natural School's writers. And there was certainly nothing like a school of Russian realist painting in the 1840s. While it is certainly true that by this time Russia had enjoyed a decades-long history of genre painting, most famously reflected in the work of Aleksei Venetsianov and his students, for the most part Russian painters were still largely dependent upon the classical education of the Academy of Arts and its firm policing of traditional subjects and methods.[24] As a result, in scholarship on the period, Fedotov has emerged as one of the only suitable parallels to the physiologists in the artistic sphere, despite his seeming sometimes too sentimental, or too burlesque, or too castigatory, to be comfortably aligned with certain aspects of the Natural School's objective and didactic social realism.[25]

What is ultimately at issue here is a definition of the Natural School. Is it, first and foremost, a social circle? Or is it a commitment to a set of themes and types? Is there stylistic continuity, or a shared dedication to a particular genre or medium? Yury Mann argues that while the works of the Natural School may embody similar motives, there is no generic or stylistic consensus that encompasses the novels of Aleksandr Herzen and Ivan Goncharov, the early works of Dostoevsky, and the physiological sketches and feuilletons. Mann suggests, instead, that what lies at the root of the Natural School is a common artistic philosophy, a desire to address the question of man's relation to, even dependence on, his environment.[26] This chapter offers an alternative, yet complementary, perspective from which to view the diverse works of the Natural School. On the face of it, these works often look and sound very different: Fedotov's melodramatic future bride in the *Courtship* is miles away from Grigorovich's somber street musician in the *Physiology*. But they are both defined by a markedly inclusive approach to the realist project, an approach that unites the spatial and temporal dimensions of reality into a total representation. To achieve this multimodal mimesis, they break down interart borders, as well as social ones, moving between the visual and the verbal, just as they move between the neighborhoods of Petersburg. Therefore, while the physiological sketches and Fedotov's paintings are not analogies of one another (given their different media, the usefulness of such an identification would be limited at best, distorting at worst), the contours of an early realist aesthetic can be derived by tracing the formal, structural, and thematic echoes across the works. At its core, this will be an aesthetic that calls upon the artist to throw open the windows of the city, to look into its previously hidden corners, and represent the banal and neglected. And to do so, it will demand that the artist gather the varied modes at his disposal—visual and verbal—to create a tightly bound tautological circle of *pictura* and *poesis*, and, also, of reality and representation.

If we return to poor Trostnikov and his Peeping Tom, we find that they reveal another element of the Natural School aesthetic that is central to this chapter's argument. Recall that the mysterious "observer of mores" looks into

the window and writes about the young poet, while the young poet writes and looks out the window. It is a moment of aesthetic self-consciousness, not to mention interart reciprocity, with which, as it turns out, Nekrasov himself was all too familiar. Looking back much later on his living conditions when he had first moved to Petersburg, Nekrasov explains:

> I lived then on Vasilyevsky Island in a half-basement room with a window onto the street. I wrote lying on the floor; passersby on the sidewalk would often stop before the window and look at me. This angered me, and I started to close the inner shutters, in such a way that there was still light for writing.[27]

When Nekrasov gives this memory to his loosely autobiographical hero, he engages in a moment of self-examination.[28] This is also what we are asked to do when we read the *Physiology* and look at the *Courtship*, to see in their multimodal representations not only the demands of mimesis, but also records of their creative history. This extreme self-consciousness, more subtle forms of which are fundamental to realism as such, is often perceived as the clunky trace of a not quite mature artistic tradition. And to an extent, this is true. But the overwrought quality of these early works is also a reminder that these are the products of a school. In ways both explicit and implicit, they train their writers and readers, their painters and viewers, for much greater pursuits in the future. Perhaps, then, the "observer of mores" is not a seasoned feuilletonist. Perhaps it is us, looking in on Nekrasov's creative process and taking notes, becoming readers and writers equipped for this new age of Russian culture.

Before Our Very Eyes

Grigorovich opens "Petersburg Organ Grinders," his sole contribution to the first volume of *The Physiology of Petersburg*, with an appeal to the reader.[29] "Look at this person, moving slowly along the pavement; examine his figure attentively" (51; 71). The narrator urges the reader to look ever more closely at this peculiar character, following the imperative of a verb that connotes a more casual act of looking (*vzglianite*) with one that requires more focused examination (*vsmotrites'*). The narrator then provides a visual accounting, which directs the reader's virtual gaze from the tip of the figure's pointed hat all the way down to his boots.

> A torn cap, from under which long black hair, as black as pitch, sticks out in disarray, overshadowing a thin, sunburned face; a jacket without color or buttons; a worsted scarf, carelessly wound about a swarthy neck; canvas trousers, tattered boots; and finally, a huge musical organ, bending this figure with its weight—all of this constitutes the property of one of Petersburg's most unfortunate artisans: the organ grinder. (51; 71)

By presenting the visual impression of the organ grinder in consecutive fragments, Grigorovich simulates the process of analysis, perhaps his own artistic process, moving from the observation of a vaguely defined figure, to closer inspection, and, ultimately, to the typological classification of a Petersburg organ grinder. While the narrator eventually settles on this verbal signification, which not only fixes the figure with a professional title but also associates him metonymically with a much larger social group, the distinctly observational mode of the preceding description suggests that this closing linguistic move would have been impossible without visual analysis.

In this, Grigorovich captures what Belinsky considered the essence of the age; "the spirit of analysis and investigation," he writes, "is the spirit of our time."[30] In his 1842 "Speech on Criticism," Belinsky describes the procedures of this analysis largely through metaphors of visuality, drawing on well-worn associations of sight with empirical knowledge that were advanced perhaps most famously by John Locke in *An Essay Concerning Human Understanding* (1690).[31] "The world has matured," proclaims Belinsky. "It needs not a motley kaleidoscope of the imagination, but a microscope and telescope of reason, which brings it closer to that which is distant, which makes the invisible visible."[32] Belinsky develops further this metaphor of scopic realism in his introduction to the *Physiology*, writing that he hopes the sketches will offer "a more or less accurate observation [*nabliudatel'nost'*] and a more or less truthful view [*vzgliad*]" of their subjects (13; 14). In his subsequent reviews of the *Physiology*, he calls Nekrasov's sketch a "living picture," and Grigorovich's "a charming and elegant little picture, drawn by the pencil of a talented artist."[33] Taken in isolation, these examples of visual language read as little more than flourishes of critical rhetoric. And yet, this rhetoric is so pervasive that it suggests a connection between the Natural School's realism and modes of visual experience that goes beyond Enlightenment clichés of seeing and believing.

In fact, while the visual imperative of the physiological sketches certainly fulfills a positivist function, turning narrators and readers into scientists of a sort, it also reaches back to classical and Renaissance discussions of mimesis, and to tropes of presence, in particular. Aristotle speaks first of the power of the word to produce the illusion of presence (*energeia*), but it will be the Renaissance theorists who enact a strange, and lasting, conflation between this rhetorical device, *energeia*, and a term with much stronger visual, even fantastic, connotations, *enargeia*. This results in a conception of *enargeia* that highlights the ability of language to summon objects into virtual presence through the visualizing capacities of the reader or listener.[34] The physiologists drew on precisely this characteristic of language, hoping to activate the visual imagination of their readers, and to make that which is absent virtually present. With reference to Vladimir Dal's physiological sketches, Turgenev suggests this very point, remarking that when "the author writes from nature, he places before you [*stavit pered vami*] a pot-bellied merchant, or a Russian peasant on a mound of earth, a street cleaner, an officer's servant," and so on.[35]

For Turgenev, Dal does not merely represent or describe; he places his subjects before you, before the reader.

In his sketch for the *Physiology*, Grigorovich enhances the effect of this *enargeia* by imploring the reader to become a mobile and embodied viewer. Turning his attention to the habitat of the organ grinder and his compatriots, the narrator directs the reader's gaze from the outer façade of the tenement building, up the stairs, and to the apartment door. He then makes the following suggestion:

> If you wish to have a precise understanding of it [the apartment], then take the trouble to stoop down and enter the first room. The first object, on which your eyes will stop, blurred by tears (the effect of the alcoholic content of the staircase), will be a Russian stove of incredible size, covered with soot and surrounded by rags. (56; 78)

It turns out that the only way to *really* understand anything about the apartment is to actually go into it and look around. However, in the absence of such a possibility, Grigorovich does the next best thing. He couples a presumably universal experience, the burning of eyes and blurring of vision, with a marked insistence on second-person narration, to suggest a connection with the reader and enhance the illusion of proximity to his subjects. And, as if to remedy this blurring of vision for the sake of effect, with just a flip of the page, the lines of the room are restored in one of Kovrigin's detailed illustrations for the sketch (figure 8).

The illustrations in *Physiology* benefited a great deal from advances in printing technology during the nineteenth century and, more specifically, from the increased use of wood engraving in concert with movable type. This polytype method made possible the integration of illustrations into the surrounding text, rather than (as in the case of a lithograph, for example) images being tipped into an already typeset volume.[36] According to one scholar, "illustration ceases to be in the 1840s just the text's elegant companion, its fine adornment, and transforms into the writer's genuine colleague, called on to vividly, truthfully, and accurately explain the literary text to the reader."[37] For Nekrasov and his colleagues, therefore, illustration offered yet another opportunity to support the visual illusion of the physiological sketches, while also serving an explanatory purpose for less sophisticated readers.[38] Indeed, in an 1843 review of two French *physiologies* in Russian translation, Belinsky makes special note of the interconnectedness of word and image, writing that one of the strengths of the Parisian works is that "the text and pictures join their abilities, mutually helping each other."[39] In the *Physiology*, illustrations mostly follow suit, confirming and completing the descriptions of the physiological sketches, rounding out the descriptive illusion into a "living picture." In this way, the commingling of visual and verbal modes of representation in the literary aesthetic of the *Physiology* is supported on the level of medium by the integrated engraving and typesetting technology used to produce the almanacs themselves.

FIGURE 8. Yegor Kovrigin, Illustration for Dmitry Grigorovich's
"Petersburg Organ Grinders" (etched by Evstafy Bernadsky). From
The Physiology of Petersburg (St. Petersburg: Izdanie knigoprodavt-
sa A. Ivanova, 1845): 1:152. Photo: Beinecke Rare Book and Manu-
script Library, Yale University, New Haven, Connecticut.

This supplementary function is most apparent in the illustration that fol-
lows the initial introduction to the organ grinder (figure 9). While the narrator
had described the musician's appearance by means of discrete details, leav-
ing the reader's imagination to summon his entire image, Kovrigin fills in the
gaps between the hat and the scarf and the coat with outlined shapes, parallel
lines, and cross-hatching.[40] Overall, the illustration gives the impression of

FIGURE 9. Yegor Kovrigin, Illustration for Dmitry Grigorovich's "Petersburg Organ Grinders" (etched by Evstafy Bernardsky). From *The Physiology of Petersburg* (St. Petersburg: Izdanie knigoprodavtsa A. Ivanova, 1845): 1:136–37. Photo: Beinecke Rare Book and Manuscript Library, Yale University, New Haven, Connecticut.

completion, of connecting all the dots. And yet, as convincing as the illustration is in its confirmation of Grigorovich's description, it also sounds a discordant note in the sketch's purportedly complete realism. Perhaps misreading, perhaps taking creative liberty, Kovrigin adds three round buttons to Grigorovich's buttonless coat. In a way, he *over*-completes the description of the organ grinder, filling in buttonholes that were not meant to be filled. Kovrigin's impulse to fill in the gaps represents a fundamental aspect of the Natural School aesthetic. As with classical *energeia*, these buttons make present what is absent, visible what is invisible. They do so by attempting a productive collaboration between the sister arts, with the image filling in the absences of the word.

Of course, once we notice the buttons, it is hard to forget them. One reason for this is that they make apparent the slippages between text and image, and, ultimately, between realism and its referent. In an essay on George Cruikshank's illustrations for Charles Dickens's novels, themselves an important parallel with and source for Russia's illustrated urban sketches, J. Hillis Miller explains this troubled interart relationship and its connection to realism.

The relation between text and illustration is clearly reciprocal. Each refers to the other. Each illustrates the other, in a continual back and forth movement which is

incarnated in the experience of the reader as his eyes move from words to picture and back again, juxtaposing the two in a mutual establishment of meaning. Illustrations in a work of fiction displace the sign-referent relationship assumed in a mimetic reading and replace it by a complex and problematic reference between two radically different kinds of sign, the linguistic and the graphic. Illustrations establish a relation between elements within the work which shortcircuits the apparent reference of the literary text to some real world outside.[41]

Miller finds in this relation a "reciprocally sustaining, reciprocally destroying vacillation" between an acceptance of the mimetic illusion and a recognition that both text and image are fictions, equally removed from the source they seek to represent.[42] For Miller, this self-consciousness is somehow inherent to realism, even when it strives for a straightforwardly mimetic effect.

Nekrasov exposes this aesthetic self-consciousness, wrested into the open by a similar collision of image and text, in his contribution to the *Physiology*, a sketch titled "Petersburg Corners," which was excerpted from his Tikhon Trostnikov novel. The narrator, Trostnikov himself, walks into the courtyard of the ramshackle building that will become his new home. Once the shock over the horrid smell subsides, he notices a riot of signs attached to the façade, describing in semiliterate and partial phrases who or what can be found inside.

> Each sign had a hand which pointed to the entrance of a shop or an apartment, along with something that explained the sign itself: a boot, scissors, a sausage, ham surrounded by bay leaves, a red sofa, a samovar with a broken handle, and a uniform. The ability to explain a text with pictures was thought up much earlier than we think; it entered literature directly from the signs posted on streets. Finally, a rouged (one could say reddened) figure of a woman, about thirty years old, poked out of a corner window on the fourth floor. At first, I took her also for a sign; and maybe I was not mistaken. (93; 131)

"The ability to explain a text with pictures." Could there be a better summation of the mimetic promise, of the possibility of a one-to-one correlation between signifier and signified? The painted icons flaunt their fusion of word and image, and in doing so, they also imply that there is little or no distance between reality and representation. In other words, just as the icons adequately explain the somewhat illegible text on the signs, so too do they reflect, almost equal, that which lies behind them, behind the walls of the building. But what happens when the reader, following Trostnikov's lead, glimpses the figure of a woman? Is she framed in a window, or drawn on a sign? Is she rouged, or painted red? In her oscillation between sign—in both its senses—and reality, she is a reminder of the division between art and life that realism has asked the reader to forget.

The Natural School's realism desires just such a fusion of text and illustration, one in which the gaps between signifier and signified are filled and the

reader is presented with a sketch that is like an open window. Anticipating later critiques of realism and interart studies of illustration, Nekrasov's digression on signs hints that the promise of complete, unmediated access to reality is itself an illusion. While the illustrations might explain and assist, they also impede and sometimes contradict. But these impediments do not undo, or even challenge in any sustained way, the realism of the sketch. Herein lies the difference between the Natural School and the realisms that will be discussed in subsequent chapters. In this case, the interart encounters are not part of an overarching polemical orientation toward other artistic media. Although the illustrations certainly belie some greater worry concerning the visualizing capacities of language, neither text nor image coheres into a full-blown *paragone*, that is, neither privileges one mode of representation or artistic medium over another. Rather, they are presented in harmony, both contributing to the same project. When they do expose the fissures between word and image, they do so not to undermine trust in the illusion, but as self-conscious reminders of the processes of representation. In this way, they contribute to the mimetic mode, while also reinforcing the transparency necessary for the creation of a movement.

The Art of Walking

After introducing the organ grinder, Grigorovich's narrator instructs the reader to "observe this individual as he works the street" (51; 71). Turning the crank of his instrument, flooding the street with sound, the musician fixes his gaze upon the windows of the houses. The narrator commands the reader, "Look!" And he then answers the command with a description of what exactly the musician would see: a young woman leaning out of an open window to drop a single coin. Kovrigin steps in again at this moment, supplying an illustration of the woman to supplement Grigorovich's text (figure 9). While this woman would seem to be our readerly double—she is, after all, the audience to an artistic performance—she is actually a rather poor role model for the reader of the physiological sketch. Having tossed her money to the organ grinder, she will close the curtains and think of him no more. The reader, by contrast, will follow the musician through the city streets, watch him perform in rain and shine, and find out more about his life. In order to do this, the sketch demands more than simply a spectator; it demands a mobile spectator. Devoid of anything resembling a plot, the sketch propels itself forward by focalizing the narrative in the figure of a strolling physiologist. And it does so for reasons both aesthetic and social. By moving the reader forward, the narrator is able to supplement the visual images with narrative development, resulting in a more complete illusion. At the same time, by complicating what would be an otherwise voyeuristic spectacle with information about the musician's background and living conditions, this narrative movement fulfills a didactic and social purpose.

Grebenka's sketch "The Petersburg Side," which follows Grigorovich's in the *Physiology*, even goes so far as to claim that getting out and exploring the other side of town on foot might just cure the malaise of the upper classes.

> If you have a lot of money, and if you live in the center of town, [...] if your eyes have grown accustomed to the bright gaslights and the brilliance of luxurious stores and you (as is natural of a person of means) start to sometimes complain about your fate, [...] then I advise you to take a stroll to the Petersburg side, this poorest section of our capital. Look at the long rows of narrow streets, many of them unpaved, lined with wooden houses. [...] Remember that in them live tens of thousands of poor but honest workers, often cheerful and happy in their own way, and, believe me, you will become ashamed of your grumblings about fate. [...] After the sight of a paltry shop with broken glass panes, your eyes will gratefully relax at the sight of the mirrored windows of stores, stocked with sought-after luxury goods. (72; 103–4)

Grebenka concludes that "sometimes it is very useful [*polezno*] to stroll through the Petersburg side" (72; 103). This usefulness is not the result of merely gawking at the occasional street musician or even peeking through the occasional window. Rather, what renders these visual impressions useful is the process of walking from the wealthy city center to the outskirts and back again, experiencing the incremental changes that add up to a dramatic socio-economic contrast. It is, therefore, the combination of striking visual imagery and unceasing narrative movement that produces the realist aesthetic *and* the realist ethic of the physiological sketch.

One cannot help but think here of the flâneur, that quintessential urban character of the modern age, who rose to prominence in Paris during the 1830s. Of bourgeois origin, and therefore with the time and means to spend his days strolling in leisure, the flâneur takes in the impressions of the modernizing city, at once a part of and apart from the environment that surrounds him. Although Charles Baudelaire and Flaubert would transform the flâneur into a disaffected and disillusioned figure, the pre-1848 flâneur, so important for the prose of Balzac, is still motivated largely by wide-eyed curiosity and a thirst for experience. To walk through the city is to see and understand it; the movement of the Balzacian artist-flâneur is, to quote Priscilla Parkhurst Ferguson, "a mode of comprehension, a moving perspective that tallies with the complexity of a situation that defies stasis."[43] With the adoption of French illustrated almanacs, many of which featured the flâneur either as the subject or the implied narrator, the Natural School also absorbed, to an extent, the representational strategies of flânerie, albeit with one key difference. Despite Grebenka's address to a wealthy reader, the Natural School's physiologist is most definitely *not* of bourgeois origin. He is a working man, mostly a struggling writer or journalist. While he may contribute feuilletons to weekly publications, in his physiological sketches he does not assume the chatty, gossipy, even frivolous tone of the feuilletonist. Instead, the physiologist describes the sights of Petersburg with a blend of objectivity and pathos.[44]

Describing a more contemporary historical moment, Michel de Certeau writes that walking frees the city dweller from the totalizing forces of urbanism and capitalism. In contrast to the panoptic view from a skyscraper, "the ordinary practitioners of the city live 'down below,' below the thresholds at which visibility begins."[45] It is here, at street level, de Certeau argues, that the ordinary person asserts autonomy in the creation of individual and invisible "cellars and garrets" for the storage of "rich silences and wordless stories."[46] By constantly walking, and not only on Nevsky Prospect but also along dingy alleys and crooked side streets, the physiologist explores the everyday life that remains invisible to the power centers of the imperial city. Grigorovich's narrator observes the organ grinder, and then follows him into his one-room apartment. Nekrasov's Trostnikov walks up to a building plastered with signs, and then walks into the living space of the city's poorest individuals. In this continual movement *into* the spaces of the sketch's subjects, the Natural School's writer-narrators transform Petersburg's overlooked "cellars and garrets" into subjects worthy of artistic representation.

And yet, de Certeau's words introduce an element of unease into the Natural School's project. For even though the physiologist is not as much of an "other" as the flâneur, and even though he does not merely gape through windows but seeks a more intimate connection, he nonetheless usurps his subjects' agency. He does not allow their spaces to remain "rich silences and wordless stories"; rather, he describes them, and from every angle. This narrative intrusion most certainly challenges the democratic ethos of the Natural School. Because it has a different set of priorities, the physiological sketch does not foreground this ethical dimension, even though it is certainly present. Unlike the more critically minded realism of the 1860s, that of the Natural School is concerned less with how to condemn and reform reality than it is with how to represent reality in as truthful a manner as possible, to shine a light rather than cast judgment. This is not to say that the Natural School did not have a social imperative, only that this imperative manifested primarily in the introduction of subject matter that had been previously excluded from the realm of artistic representation.

To understand this interconnection of the Natural School's aesthetic and social projects, let us return to Grigorovich and his organ grinders. Toward the end of the sketch, Grigorovich describes a performance that takes place on a humid autumn evening. The performers set up in a courtyard and an audience begins to gather, at which point the narrator asks the reader, "Why don't we stop in, too?" (65; 91). The performance is enjoyed immensely by all, but as it comes to an end, the crowd begins to disperse, only a few coins tumbling from the open windows. The musicians scramble, all the while being heckled by the remaining audience members. If Grigorovich had closed his sketch with this vignette, the singular aim of the work might seem to be a critique of society's disregard for the lower classes. However, in a final turn to the reader, Grigorovich asks: "Have you ever happened to walk along Petersburg's far-flung streets late at night in the fall?" (69; 98). He describes the dark walls

of the buildings that loom on either side of the street, the windows that sparkle "like moving stars," the dark narrow alleys. And then:

> Suddenly, amidst the silence and stillness, a street organ is heard. The sounds of *Luchinushka* reach your ear, and, very shortly, the figure of the organ grinder passes by.
>
> It is as if you have come to life. Your heart has begun to beat strongly. Your melancholy momentarily disappears, and you set out cheerfully for home. The mournful sounds of *Luchinushka*, though, continue to hover over you. For a long time there flashes before you the pitiful figure of the organ grinder whom you have met in the dark alleyway late at night, and involuntarily you think: perhaps, at this very minute, he is tired, shivering from the cold, exhausted from hunger, and alone in a lifeless world. Perhaps, also, he is recalling his native hills, his aging mother, the olive and grape trees, and his black-eyed mistress. And again involuntarily you ask: why and by what wind has the organ grinder been carried to God-knows-where, to a foreign land where he meets neither a kind word nor a friendly smile and where, as he rises in the morning, he does not know how the day will end, and whether he will end up wretched and cold . . . (70; 98–99)

Like the audience members in the previous scenario, the addressee of this sketch returns home, full of joy after his chance encounter with the organ grinder. What is different, though, is that the reader is haunted by the sounds of the lone musician. The memory of the bleak notes and flickering figure triggers a series of thoughts about this sad Italian performer, far away from his native land. And the reader wonders, and maybe we wonder too, what brought him here. The question is left unanswered, with an ellipsis.

Flash forward fifty-odd years to another memory of a Petersburg stroll. "Walking one rainy autumn day along Obukhovsky Prospect, I saw an old organ grinder, who had hoisted with difficulty his instrument onto his back. Up until this point, these people had never captured my attention."[47] This is how Grigorovich, in his *Literary Reminiscences*, recalls choosing his subject for the physiological sketch that Nekrasov had asked him to contribute to the first volume of the *Physiology*. Grigorovich remembers the rainy evening of the sketch as a rainy day, but the echoes between the two works, one literary and one memoiristic, are nevertheless striking, down to a parallel between the sketch's closing ellipsis and the memoir's "and so on":

> Following them with my eyes, I often asked myself, by what paths were they able to get here from Italy, how many hardships did they have to overcome in their wanderings, how had they settled in our country, where and how do they live, whether they remember their abandoned homeland with happiness or bitterness and so on.[48]

What this passage makes clear is that when the narrator of "Petersburg Organ Grinders" writes "and again involuntarily you ask," the addressee is not only the reader, but also the writer, Grigorovich himself. It is the writer who wanders out on a rainy fall evening and it is the writer who spots a musician out of

the corner of his eye. And finally, it is the writer who goes home and remembers this figure, asking himself question after question, and then answering those questions with the sketch itself. Grigorovich's concluding statements are actually the beginning of the story. Memories of a chance encounter and lingering unanswered questions drive him (and the reader) to look, to scrutinize, and to delve deeper into the history and home of this mysterious figure. "Look at this person, moving slowly along the pavement." "Take the trouble to stoop down and enter the first room." It might have seemed that the narrator-writer was speaking directly to the reader the whole time, but it turns out that he was also addressing himself, remembering and reliving his own creative journey.

Suddenly, the whole sketch becomes not so much a record of lived experiences on the streets of Petersburg, as a series of memories of the artistic process, a process that Grigorovich describes as follows:

> First of all, I busied myself with the gathering of material. For approximately two weeks, I spent entire days wandering along the three Podyachesky Streets, where the organ grinders primarily settled then, engaged them in conversation, stopped by impossible slums, took notes on each detail that I saw and about which I heard. Having conceived the plan of the article and divided it into chapters, I sat down, although with a timid and unsure feeling, to the writing.[49]

In order to "represent reality just as it actually presents itself," which Grigorovich identifies in his *Reminiscences* as the central task of his realism, he must remember, and thus relive, the sights and stories he collected on the city streets.[50] He sits at his desk and summons certain lasting visual images—a musician's pointed hat, a sooty Russian stove—which yield verbal information that he then puts to paper. By linking the verbal and visual impressions, referring them constantly to one another, the physiological sketch actualizes the tautological loop of *ut pictura poesis*. As is painting, so is poetry. Or in this case, to recall the many "family pictures" glimpsed through Petersburg windows with which this chapter opened: as is a picture, so is the physiological sketch, and vice versa. Each affirms the other's realism. Each reveals the other's artistry. But as long as the circle remains closed, the sister arts remain mutually beneficial to the overall mimetic illusion.

For this reason, the sketches can often seem like a directionless string of impression after impression, interspersed with miniature anecdotes about city life. What gives the sketch shape is the figure of the writer, sitting at home, recalling a journey. We have, in a certain sense, been standing outside Grigorovich's window all along. And what better way to rear a new generation of writers (and readers) than to let them look in on the creative process, showing them how to transform observations into texts? In this way, the physiological sketch is just that, a sketch. By borrowing terminology associated with its sister art, the physiological sketch invokes the spontaneous and unmediated, the preparatory and pedagogical, the very processes of artistic

representation.[51] Above all, the sketch is an artistic work that displays the traces of its production on its surface, allowing us to follow the thought process of the artist, see the digressions in the corners of the page, the half-erased lines and partially formed figures. And when we hold the book at arm's length, when we look at Nekrasov's *Physiology* as we would a sketch, what we see is a persistent linear movement, lines and lines of city prospects, punctuated by rectangles of visual representation, little picture windows.

Like a Speaking Picture

In his biographical reminiscences of his good friend Fedotov, Druzhinin describes the painter rising early every morning and, regardless of the weather, throwing open his window to breathe in the fresh air. He would then go out for his daily stroll around the city, searching out places with many people, places bustling with activity. He would observe and sketch, and sometimes engage a particularly fascinating stranger in conversation. Druzhinin recalls Fedotov saying, "I study life, I work hard, looking with both eyes for my plots that are scattered throughout the city."[52] Druzhinin loved to catch his friend after these daily excursions, for the artist had a special knack for transforming his observations into entertaining stories.

> He had peeked into a window and had seen a poor husband, cowering in the corner, while his live-in mistress screamed throughout the whole house and passersby stopped. And everything was narrated as few can; moreover, the speech was accompanied by a joke, by some joyful laughter, by an apt witticism, by some sort of detail that just hovered before your eyes.[53]

A passion for walking and window-gazing, and a talent for storytelling. Fedotov's creative process exhibits the hallmark of the Natural School: visual observation and verbal description bound together by the physical movement of a narrator. Although it operates within the unique constraints and possibilities of its own medium, Fedotov's painting, like the *Physiology*, nevertheless attempts an optimistic fusion of verbal and visual impressions into a multisensory realist representation. His paintings pulse with visual detail; in the array of discrete objects, textures, and surfaces stuffed into his interior scenes, one senses the insatiable gaze of an artist. Yet, it is impossible to deny that one of Fedotov's greatest gifts was, as Druzhinin recalls, his gift for storytelling. As much as his pictures resonate with optical experience, they also spin elaborate tales.

For proponents of nineteenth-century realism, such as the critic Vladimir Stasov, Fedotov's penchant for storytelling aligned him with the later painting of the critical realists and the Wanderers, often regarded as predisposed toward literary, narrative, even openly ideological content.[54] Writing in 1915, at the peak of the Russian avant-garde movement, Nikolai Punin cites just

such a narrative tendency in his assessment of Fedotov as an amateurish artist who was overly concerned with "anecdote" at the expense of painterly form.[55] During the heyday of Russian realism, however, this "anecdotalism" (*anekdotichnost'*), what Punin and his fellow modernists deemed the impure reliance of painting on semantic and narrative structures, was precisely what secured Fedotov's position among the much larger and more venerated pantheon of Russian realist writers, leading many to dub Fedotov the "Gogol of painters." For Fedotov and for Russian painting more generally, this literary association performed an important and pragmatic professional service. In 1840s Russia, before the great painters and art critics of the reform era, painting was still very much considered the lesser of the sister arts. Because of this, the analogy of the largely self-taught Fedotov with established writers not only boosted his own social and professional status, it legitimized an emerging tradition of Russian painting. Thus, while it is true that, like the physiological sketches, Fedotov's painting embraces the sister arts for the sake of a mimetic illusion, it is also true that this Horatian collaboration carries much different stakes for Fedotov. To be sure, the verbal, or literary, sphere enhances the overall visual illusion, but it also affirms the cultural legitimacy of painting and the painter.

So how exactly does this verbal sphere manifest in Fedotov's painting? A good look around the merchant's dining room in *The Courtship of the Major* reveals that the narrative, or story, of this picture is inextricable from the composition of the interior (figure 7). The back wall runs parallel to the picture plane, producing a "theatrical" cube or box.[56] The potential bridegroom stands in a doorway, bathed in a green glow that is electrified by natural light. This doorway is mirrored on the opposite wall by two other doorways. An old woman peeks her head through one, inquiring about the excitement, and is answered with a whisper and a finger pointing in the other direction. These doorways are both an architectural necessity and a suggestion of temporality. Mimicking the process of reading a text, the viewer's gaze moves from right to left to right, so as to unravel the path of this marriage plot.[57] The rooms that are glimpsed to the left and the right suggest a prologue and an epilogue to the dramatic scene at hand. It should come as little surprise, then, that Fedotov had planned two additional works, sketched but never completed, depicting the aftermath of the wedding and the return of the newlyweds to the merchant's home.[58]

It is worth emphasizing that Fedotov's picture does not just *suggest* a narrative; the *Courtship* was, in fact, both preceded and succeeded by accompanying literary texts.[59] The kernel for the painting resides in Fedotov's long poem, "The Improvement of Circumstances, or the Marriage of the Major," which tells the story of an officer who marries into a well-to-do merchant's family to solve his financial woes.[60] Although this poem, due to its satirical content, was never published during the artist's lifetime, it circulated widely in oral and handwritten versions. One might therefore speculate that the painting picks up where the poem leaves off, representing as an image that which could

not, for political reasons, be published as a literary text.[61] However, Fedotov's penning of a second, much shorter poem, which he would later read while standing in front of the painting as both an invitation to viewers to gather around and an explanation of the painting's most salient moments, suggests a more complex relation between word and image in his painterly production.[62] Neither poem nor painting is the illustration of the other; neither word nor image takes precedence in Fedotov's picture. Rather, they refer to one another in an infinite loop, creating the impression of a holistic mimetic illusion.

Even without Fedotov's poem, the *Courtship*, with its many open mouths and lively gestures, resounds with the potential for uttered words, phrases, even whole sentences. The matchmaker whispers to the merchant, perhaps saying, "The major is waiting." And the mother purses her lips in the *oo* of the word *dura*, "silly girl."[63] In a supplementary prose description of the painting, Fedotov explains that the old woman in the doorway is asking, "What are all of these preparations for?"[64] For good measure, he repeats her open mouth in a sketch, as if to perfect the physical gesture of speech (figure 10). Indeed, in this same prose description, Fedotov goes so far as to attribute an utterance to the cat sitting on the floor, quoting the Russian proverb that equates a grooming cat with the impending arrival of guests—"the cat summons the guests" (*koshka zazyvaet gostei*).[65] An explanation for the hunched feline is certainly welcome, for she is one of the stranger details in the painting; somehow disconnected from the ground plane, she threatens to slide right off the canvas and onto the gallery floor. This precariousness is even more apparent in relation to an earlier version of the cat, far more convincing with little tufts of fur lining her back (figure 11). Somewhere between study and painting, somewhere between proverb and picture, the cat loses her texture, her materiality, her substance, and becomes instead a little verbal icon trapped in pictorial space. In the cat's refusal to cohere to her surroundings, the viewer is reminded of the inevitable impossibility of representing visually a verbal communication, and by extension, the impossibility of ever bridging completely the divide between life and art.

All the same, Fedotov attempts this interart realist project with gusto, uniting the sister arts in a bold representation of reality. And so, like the organ grinder's reappearing buttons, this moment of tension invites us to consider the processes of representation that underwrite the realist promise. Consider, for example, the combination of text and image in a drawing of a woman inviting two men to be seated (figure 12). The inscription—"Please take a seat!"—is not located in the traditional position of a caption (although Fedotov often captioned his drawings in such a manner). Rather, it is scribbled at the top of the page, begging the question of which came first, text or image? Seemingly codependent, there is no evidence that one mode of representation generated the other. This codependence certainly contributes to the fullness of the drawing's mimetic illusion; visual and verbal complete each other, filling the empty spaces of representation. But this interart reciprocity also, as it does in the

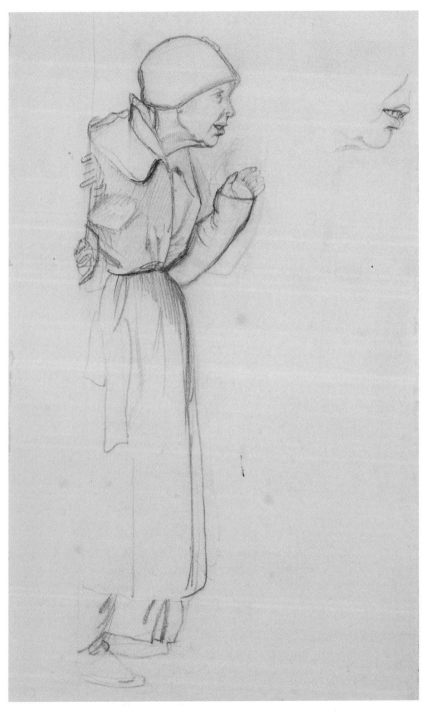

FIGURE 10. Pavel Fedotov, Sketch for *The Courtship of the Major* (old woman), 1848. Graphite pencil on paper, 21.7 x 11.4 cm. State Russian Museum, St. Petersburg.

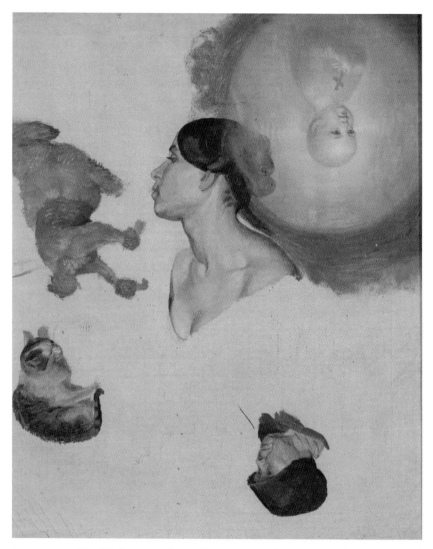

FIGURE 11. Pavel Fedotov, Study for *The Courtship of the Major* and *The Aristocrat's Breakfast* (head of the bride; head of the old woman; cat), 1848–1849. Oil on canvas, 34.5 x 29 cm. State Russian Museum, St. Petersburg.

physiological sketches, gestures toward Fedotov's creative process, determined as it was by the simultaneity of sights and sounds.

In his search for painterly material, Fedotov relies equally on his powers of visual observation and verbal communication. Again, Druzhinin offers some insight, writing that once, "at the Tolkuchy and Andreevsky markets, our painter spotted a few old women and servants, invited these people to his home, treated them to tea, hired them for an appropriate fee and, while working, chatted with them in a way that only he was able to chat."[66] His models must not only

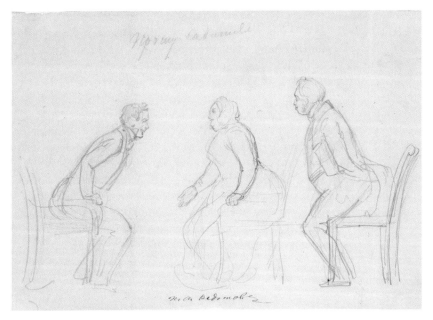

FIGURE 12. Pavel Fedotov, *Please Take a Seat!*, 1846–1847. Graphite pencil on paper, 20.8 x 29.8 cm. State Tretyakov Gallery, Moscow.

look the part, they must also sound the part. An anecdote repeated by the critic Ivan Mozhaisky shows the extraordinary lengths to which Fedotov would go to acquire such a deep and multidimensional understanding of his subjects.

> When the merchant type was needed for my *Major*, I often walked around Gostiny Dvor and Apraksin Dvor, peering into the faces of merchants, listening in on their conversations and studying their mannerisms. [...] By Anichkin Bridge [Mozhaisky quotes Fedotov as using the occasional nickname of Anichkov Bridge], I met the embodiment of my ideal; no happy man who had planned the most delightful rendezvous on Nevsky could have rejoiced more at seeing his beauty than I rejoiced at seeing my red beard and plump belly. I followed my discovery to his house, then found the chance to meet him, courted him for an entire year, studied his character, received permission to paint my honorable old man (although he considered it a sin and a bad omen), and only then introduced him into my painting.[67]

Maybe the theme of the painting influenced the manner in which Fedotov gathered his subjects, or colored his language in the telling of this story. Either way, he has cast himself in the role of suitor, rendezvousing with a paunch-bellied merchant on one of Petersburg's famed bridges. Fedotov gets to know the merchant, studies him, makes small talk. The painter, in other words, *courts* his subject, and he is left not with a marital union between man and woman, but with a pictorial marriage between visual and verbal impressions.

The gregariousness of the *Courtship* is, in sum, both referential and self-referential. In the first instance, Fedotov mimics the sounds of the everyday by manipulating compositional structure and gesture, and drafting supplementary texts, all in an effort to assist the visual and present a more complete reflection of reality. In the second instance, this painterly record of the city's sights and sounds, much like the literary record provided by Grigorovich's physiological sketch, does not refer to a reality outside of the picture, but to the very processes of the picture's construction. This is a realism, therefore, that despite its manifest dedication to the representation of reality, is also consistently occupied with the matter and method of that representation. When considered through this second lens, the servant does not ask about the food and the fuss in the merchant's home. Rather, she sits at a table, drinking tea while Fedotov sketches her. A glassy glimmer catches her eye, a bit of luxury clearly out of place in this humble apartment. Pointing to the bottle of unopened Veuve Clicquot, she asks, "What are all of these preparations for?"[68]

Everyday Things, Everyday Space

The Courtship of the Major is not very large, only about sixty by seventy-five centimeters. Given its diminutive size, the painting is crammed with a surprising number of objects, many begging for interpretation. And indeed, these objects say quite a lot, the champagne and the décor and the clothing all speaking to the optimistic expectations of the meeting and the merchant's flaunting of a particular cultural or social currency.[69] But Fedotov's attention to detail also reflects a more technical interest in the observation of everyday life, and the methods necessary for transferring those observations onto canvas. In fact, Fedotov was known to obsess over such matters. In an oft-repeated anecdote, Druzhinin recalls entering Fedotov's studio and finding the artist staring at a blank canvas. "I will not start doing anything until I learn to paint mahogany," Fedotov explains.[70] This worry over surfaces is evident in the bottle of Clicquot and the champagne flutes, the way in which they glint in open rebellion of the darkness of the room. As if in response, the rich brocades and embroidered fabrics shimmer and ruffle and fold. These objects do something more than communicate information. With vertical strokes of white, the champagne bottle attracts the eye of the viewer. And this sparkle then winks at the most enticing object in the room, the chandelier. Having initially spotted this chandelier through the window of a tavern somewhere near Gostiny Dvor, Fedotov conjures its transparent crystal baubles with the help of thick, opaque oil paint.[71] It is a wonderful illusion, turning glass into paint into glass. Even though the *Courtship* certainly relies on objects to signify social and economic status, urging the chandelier to tell its story, it also makes the most of such optical moments, moments that silence the narrative and revel in the pure materiality of the object world and of painting itself.

In his analysis of the *Courtship*, art historian Dmitry Sarabianov argues that the tension between this beauty of the object world and social content highlights the very message of Fedotov's picture, that is, its exposure of society's distasteful hypocrisy.[72] Mikhail Allenov makes a related point, asserting that the *Courtship* balances the tone of a "mocking author," who pokes fun at his sorry subjects, and the response of an admiring audience, who appreciates the sumptuous visual details of the work. He writes that the *Courtship* "treats equally the narrative and the painterly plasticity of the painting."[73] There is, however, still another way to understand the painterliness of the *Courtship*: not so much as a mocking contrast to the picture's critical content, but as a means to enhance the overall mimetic effect. In the appeal of its luscious materiality and the pull of its spatial illusion, the painting posits a radical reevaluation of the border between life and art, a reevaluation that forms the core of Fedotov's realism.

In its size, subject, and love of the material world, the *Courtship* owes a debt to Dutch genre painting of the seventeenth century, a realist tradition invested above all in the depiction of everyday life.[74] In Russia, as in Western Europe, the specter of Dutch painting loomed large in the development of a philosophy and critical language for the new realist aesthetic, functioning as a polemical concept against which to define the characteristics and direction of nineteenth-century realism.[75] An elastic term, Dutch painting—often called Teniersism (*ten'erstvo*) in Russian, after the artist David Teniers the Younger—was held up by some as a prototype for the objective depiction of everyday materiality and democratic subjects, while despised by others as a slavish copy of reality, mired in the low and vulgar. In its pejorative sense, the Dutch analogy tended toward a conflation with what was perceived as the naked realism of the daguerreotype (*dagerrotipizm*), and the two together became a common weapon wielded against the realist aesthetic of the Natural School.[76]

Dutch painting exerted an enormous influence on Fedotov, and not just in his choice of merchant subjects and objective mode. In the absence of conventional academic training, Fedotov learned a great deal about painterly finish and space from the considerable Dutch collection housed in the Hermitage Museum. While this Dutch influence is certainly apparent in the everyday subjects of the *Courtship*, merchants rather than nobles or heroes, there is still another curious echo that is worth mentioning. More specifically, by aligning the picture plane more or less with an invisible fourth wall, Fedotov posits a viewer who is looking into the dining room from somewhere outside. And given Fedotov's own propensity for peeking into windows to find his subjects, not to mention the small size of the canvas, which encourages the viewer to peer into rather than be absorbed by the picture, it follows that the *Courtship* borrows not only Dutch painting's scale and subject but also its not infrequent use of the window frame as an implicit or explicit compositional trope. Look, for example, at Gerard Dou's *Old Woman Unreeling Threads* (figure 13). The window, for Dou, is visible, and the woman is posed within its frame. It remains unclear, however, if part of her hand or even a single thread penetrates

this imagined border between inside (the space of the picture) and outside (the supposed space of reality). Thus, the painting argues for its realism by blurring the lines between the worlds inside and outside the picture. In Druzhinin's recollection of a trip to the Hermitage, Fedotov seems particularly attuned to this reality-bending potential when looking at a Dutch painting of a folk dance, exclaiming:

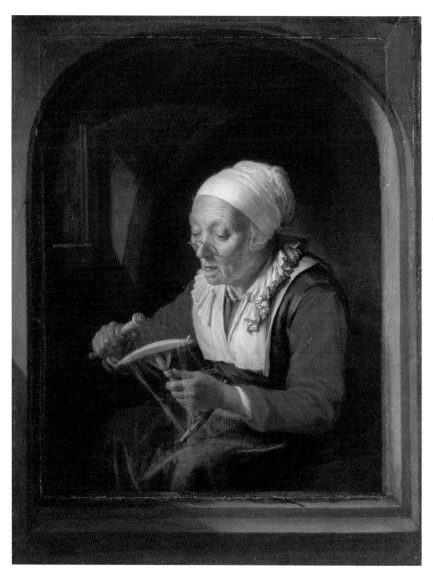

FIGURE 13. Gerard Dou, *Old Woman Unreeling Threads*, c. 1660–1665. Oil on panel, 32 x 23 cm. The State Hermitage Museum, St. Petersburg. Photo: Leonard Kheifets.

Look here, at how the dancer has raised his fat lady and flung her up into the air! How joyful they all are, and what satisfied mugs! One becomes joyful oneself! Recall these pictures in the morning: it will seem to you that you yourself were dancing with these pretty fat ladies! Always check the impression that a painting makes on you when you awake in the morning! It is necessary that your recollection of it, so to speak, merges with your actual life.[77]

The Dutch masters provide Fedotov not only lessons in the construction of a painting, but also models for a painting that achieves an illusion so real that it "merges with your actual life," or at least seems to. By eliminating the window frame, the *Courtship* complicates the Dutch compositional trick. Nonetheless, Fedotov retains the window's fluid movement between inside and outside, between life and a picture of life, by drawing on other aspects of painting's spatiality.

It is to another time and place altogether that the classic formulation of the window as a tool for realism belongs. In his fifteenth-century treatise *De pictura*, Leon Battista Alberti suggests the open window as an analogy for the space inside the picture frame. As many have pointed out, Alberti and his Renaissance colleagues did not intend the window as an actual mechanism for painterly construction, but rather as a useful trope for comprehending the spatial and linear precision of naturalistic representation.[78] Nevertheless, in debates about painterly representation over the centuries, from Alberti to the present, the window has crystallized into a trope both material and metaphorical; to quote Anne Friedberg, "it has functioned both as a practical device (a material opening in the wall) and an epistemological metaphor (a figure for the framed view of the viewing subject)."[79] Rendered explicitly in the famous woodcut by Albrecht Dürer, this picture window is at once a clear view onto the real world, and a mechanism to systematize that world (figure 14). For Fedotov, this perspectival "window" also offers the promise of realist transparency, all while reasserting its presence, as a pane of glass or a frame or a gridded line. Replace Dürer's German odalisque with a Russian cook carrying an empty tray and you get one of Fedotov's preparatory drawings for the *Courtship* (figure 15). The grid of lightly sketched horizontal and vertical lines, mimicking the master square of the windowpane (and that of the picture plane), organizes the three-dimensional figure and supplies the spatial system within which perspective can operate.

A quick glance through Fedotov's sketches reveals the artist's determination to master linear perspective, leaves of paper covered with straight lines, likely drawn with a ruler, meeting here and there to form little miniature cubes (figure 16). Perhaps the most evocative perspectival drawing is the sketch that Fedotov made for one of his sepia paintings, *The Store* (1844–1846, figures 17 and 18). The floor in this shop, like that beneath the coy bride-to-be, relies on a gridded pattern to create an illusion of spatial depth, a necessity emphasized by the sheets of grid paper cascading from the counter onto the floor. As in the preparatory sketch, the lines, much neater than those in the *Courtship*, are

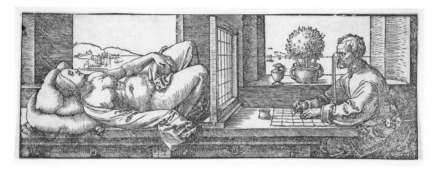

FIGURE 14. Albrecht Dürer, *Draftsman Making a Perspective Drawing of a Reclining Woman*, 1525. Woodcut, 7.7 x 21.4 cm. The Metropolitan Museum of Art, New York. Gift of Henry Walters, 1917. www.metmuseum.org.

FIGURE 15. Pavel Fedotov, Sketch for *The Courtship of the Major* (cook holding a dish), 1848. Graphite pencil on paper, 28.7 x 16.2 cm. State Russian Museum, St. Petersburg.

complemented by orthogonals that run the length of the countertops, converging at a single point just above the head of the man in the center of the room. In the sketch, Fedotov has rid the store of all of its goods. There are no bolts of fabric, or ballerinas, or even countertops. And so, the young child, standing on tiptoes, points not to an object of consumer desire, but to the vanishing point itself.

Of course, classical perspective consists not of one, but of *two* points: a vanishing point, residing in a distant place somewhere in infinity, and a viewing point, originating with the eye of the beholder. Hubert Damisch describes the viewing subject's experience of traversing the imaginary line between these two points as one of "becoming lost" inside the perspectival construction. For Damisch, this system "traps the subject," absorbing him or her inside the space of the picture, to roam around as if in a labyrinth.[80] Although any perspectivally constructed painting allows for this extraordinary virtual movement through and between real and painterly space, what is special about Fedotov's painting is its pronounced emphasis on the device, an emphasis that invites

FIGURE 16. Pavel Fedotov, Five compositional drawings for *The Officer's Anteroom*, n.d. Graphite pencil on paper, 35.3 x 21.7 cm. State Tretyakov Gallery, Moscow.

FIGURE 17. Pavel Fedotov, *Store*, 1844–1846. Sepia and pen on paper, 32.3 x 50.9 cm. State Tretyakov Gallery, Moscow.

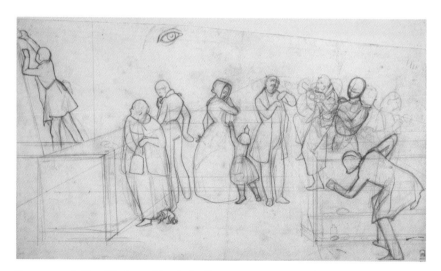

FIGURE 18. Pavel Fedotov, Sketch for *Store*, 1844–1846. Graphite pencil on paper on cardboard, 27.5 x 48.2 cm. State Russian Museum, St. Petersburg.

the viewer both to window shop and to browse in the store itself. By allowing for this fluidity between outside and inside, the viewer is also able to make partial sense of the eye floating above the shoppers. While clearly the kind of incongruous detail common in a sketch, it also carries meaning as an emblem of the picture's spatial system. It is the viewing point, either reflected in the

glass of the windowpane, or taking a fanciful trip inside the store. Delightfully, Fedotov himself takes up this fantastic offer and steps inside the space. There he is on the right side of the sepia painting, standing with his head bowed into the light of the window.

In the architectural insistence of the walls and the parquet floor, the *Courtship* participates in a similar perspectival illusion. While the diagonal lines of the floor tiles and the ceiling joints invite the viewer into the interior space and toward an unseen vanishing point, the union of the crown molding with the top corners of the frame reasserts that the picture plane is, in fact, a boundary. The viewer is pulled into the world of the illusion, and then positioned firmly outside the space of the picture. In this flipping back and forth, the Natural School projects its dual task, the simultaneous summoning of reality and of the process of representing that reality. The visual elements, much like the bits of conversation floating in the air, contribute to the believability of the illusion, producing something like a pictorial *enargeia*. We feel as if we can touch the glass, taste the champagne; we imagine that we are present at this momentous occasion. But then we register the painterly materiality and the clunky perspectival orthogonals, and we watch not this little courtship drama, but the struggles and victories of Fedotov as he creates his painting. As if to highlight that this is, in some important if not primary sense, a picture about picturing, Fedotov lines the back wall with five rectangles, at once windows into other worlds and echoes of the picture plane.

Picture Windows

Not long after his successful 1848 exhibition, this delicate balance between reality and illusion would begin to tip in troubling ways for Fedotov. Some have suggested that increased political scrutiny made the painter paranoid and anxious. His friends would say that he worked too hard for too long, and paid the price with his physical and mental health. But even before Fedotov was sent to a mental hospital for the final years of his short and tragic life, the world that he had created *inside* the picture frame began to infiltrate his life *outside* the frame, culminating in a rather surprising visitor to the artist's home.

> In walks some kind of retired major, already gray, in a uniform jacket, a stranger to Pavel Andreevich, and throws himself at the artist. Our artist was extremely astonished by such tenderness on the part of the stranger. Finally, after the initial outbursts of joy, the stranger explained to Fedotov that he had come to his house only to express his delight and surprise that the artist, not knowing him, had so masterfully and truthfully painted his history, that the story of the *Major* was his own story, that he had also married a wealthy merchant woman to sort out his circumstances and now is very content and happy. Then behind the major, a huge basket with champagne and various hors d'oeuvres was dragged in, with which the major undoubtedly wanted to treat his famous biographer.[81]

It seems that the window that is supposed to reliably, or mostly, separate art from life has been left carelessly open. And through this open window steps the major himself, out of Fedotov's picture and into Fedotov's apartment. Not only that, he brings the bottle of Veuve Clicquot with him, and even supplies the picture with a rather unlikely happy ending.

Fedotov himself would take advantage of this open window, crawling through it into an imaginary world of love plots, engagements, and intrigue. This was a world that he had always denied himself; rather than courting young women, he wooed bearded old merchants. In fact, to Druzhinin he confirmed his intention to remain a bachelor: "I feel," Fedotov said, "that with the end of a solitary life my artistic career will also end. [...] I must remain a solitary onlooker until the end of my days."[82] But in his final days, he abandoned his studio for this fictive realm. His biographer Andrei Somov describes the painter roaming the city, talking to himself, and buying various trinkets for "some kind of imagined wedding."[83] Moreover, in one of his final drawings, Fedotov transports himself into a saucy love scene, depicting himself awkwardly trying to lift the hem of a woman's skirt (figure 19). Behind the couple can be seen the ghostly outline of a woman in profile. She wears the same hairstyle as the feisty future bride in the *Courtship*. One cannot but wonder if this drawing is the result of an artist who has entered his artwork, who has swapped real life for a more appealing illusion.

The people and things that Pavel Fedotov placed so neatly within *The Courtship of the Major* seem to haunt him up until his very death. While in the hospital, the artist scribbled obsessively in notebooks, a mangled leaf of

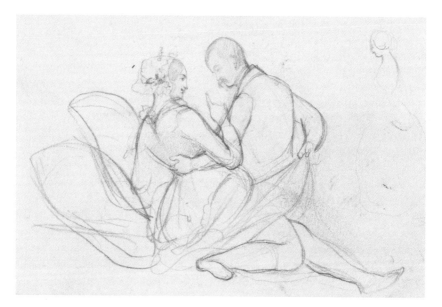

FIGURE 19. Pavel Fedotov, *Genre Scene (P. A. Fedotov with a Lady)*, 1849–1851. Graphite pencil on paper, 9.6 x 13.9 cm. State Russian Museum, St. Petersburg.

paper bearing witness to this graphomania (figure 20). Text and image crowd the paper to its very edges. It is difficult to make much out, but then we see them—the profile of the bride, the proverbial feline. In the *Courtship* these images participate in a swift and delicate dance between picturing and storytelling, word yielding to image yielding to word; but on this scrap of paper they offer nothing like the graceful movement between the verbal and the visual. Instead, the disconnected forms refuse anything but the barest of signification—woman, cat—and the graphic lines and shapes do not invite us into the image but rather present an insurmountable wall, shuttering us forever out of the world in which Fedotov has locked himself.

In one of the poems from his cycle *About the Weather: Street Impressions*, written between 1858 and 1865, Nekrasov conjures the atmosphere of the 1840s with a series of images glimpsed on a stroll through Petersburg. There is a crowd gathering: "more pedestrians, travelers, idle onlookers than one can count."

> Here an officer with a captured drunk,
> Like Fedotov had drawn him;
> Here an old woman with a pharmaceutical glass,
> Here a gray-haired gendarme general;
> And here a lady so very angry—
> Yield the path to her immediately![84]

"Like Fedotov had drawn him." In this one line Nekrasov captures not only the images of the 1840s, pictures of officers and merchants on the streets of the imperial city, he also captures the essence of the Natural School method discussed throughout this chapter. "As is painting, so is poetry," Horace tells us. As if in response, Nekrasov mobilizes the visual memory of his readers, urging them to pause and reflect upon Fedotov's drawings of everyday city scenes, sketching characters in the mind's eye. Here an officer and a drunk. Here an old general. And here an angry lady. These images are so real, so present, hovering before our eyes, that we are compelled to move out of the way. "Yield the path!" exclaims Nekrasov.

In this brief yet evocative mention of Fedotov is condensed the Natural School's commitment to *ut pictura poesis* as an aesthetic strategy for representing reality. For the writers of the physiological sketches and for Fedotov, the sister arts are locked in an embrace, fused by an assumed equity between visual and verbal modes of representation. This minimizing of the difference between word and image, the assertion that a poetic officer is just like that drawn by Fedotov and that a painted cat is just like a proverb, reflects the Natural School's more general democratic orientation. The cooperation of word and image, then, maps onto a broader set of social and cultural relations, bringing together writers and artists in collaborative projects meant to overcome strict social hierarchies. This is, despite the occasional anxiety that bubbles to the surface, a hopeful enterprise, the mobilization of art for the sake of social enlightenment. This spirit of equity is also apparent in the movement's

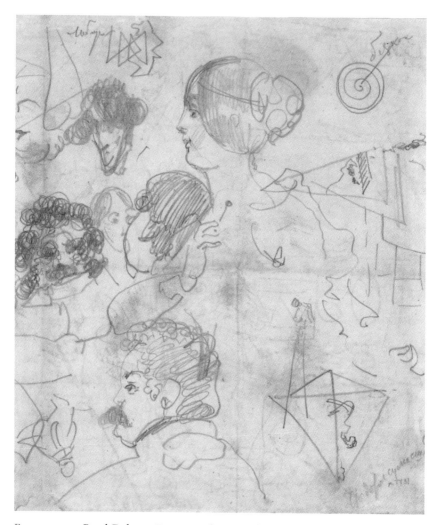

FIGURE 20. Pavel Fedotov, Drawings done in All Saints Hospital in St. Petersburg (details), 1852. Graphite pencil on paper, 43.9 x 35.2 cm. State Russian Museum, St. Petersburg.

marked aesthetic optimism. In calling on the image to resolve the absences of language, and the word to fill the silences of painting, the Natural School aspires to a realism that makes the representation real, or at least as real as possible. But, of course, herein lies one potential end for the Natural School. As in Fedotov's late sketches, the complete elision of the border between art and reality annihilates any possibility for the realist representation to function as an art object. In other words, some distance—even just the barest suggestion of a windowpane—must be retained. Otherwise, we move into the merchant interiors, into the tenement buildings, never to emerge again. And

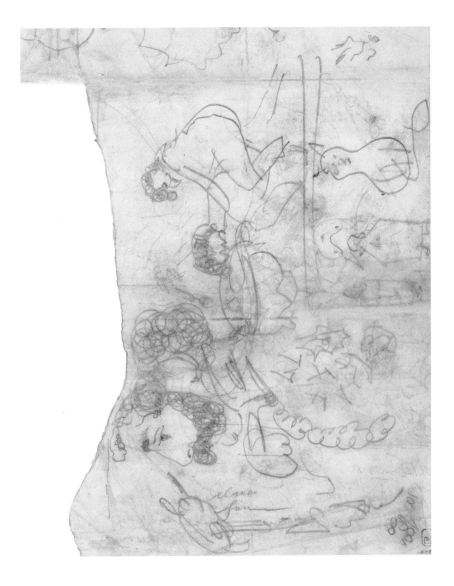

without this emergence, no aesthetic, social, or moral reflection is possible. We become the representation, and of what use to reality is that?

Ever more physically and mentally depleted, Fedotov died in late 1852, eight months after the death of Gogol. Belinsky was already gone, having succumbed to tuberculosis four years earlier, in the same year that revolutions swept through Europe. Although they were quickly suppressed and never reached Russia, the 1848 revolutions made an impact nonetheless, ushering in a seven-year period of reactionary policies and increased censorship. In 1849 Dostoevsky was arrested as part of the Petrashevsky Circle and exiled to

Siberia. Herzen had already emigrated, never to return. Turgenev would continue to publish, and Nekrasov would remain editor of the *Contemporary*. But for all intents and purposes, the Natural School came to a close with the end of the decade. It would not be until 1855, with the ascension of Alexander II to the throne, the winding down of the Crimean War, and the advent of an age of social and political reform, that a literary and painterly sphere would truly pick up where the Natural School left off, returning to a robust and relevant artistic realism capable of addressing the social and cultural needs of the day. Of course, by then, the climate would be much different from that of the 1840s; a new generation would seek to make themselves heard, more complicated ideological viewpoints would vie for dominance, and the visual arts would begin on a path toward greater prestige and autonomy.

And so, the decline of the Natural School can be understood both as a historical and an artistic necessity, its politics oppressed, its aesthetic at an epistemological dead end. Or maybe the answer is simpler. Maybe after revealing its creative processes, training readers and writers, artists and viewers, the Natural School graduated its last class. Equipped with strategies for encountering, describing, and depicting Russian reality, the members of the Natural School, and their descendants, could now move on to more sophisticated artistic pursuits. These pursuits, responding to an age defined not by liberal democratism alone but by an increasingly fractured ideological atmosphere, would themselves begin to operate less within reciprocal structures and more within systems of distinction and differentiation. Word and image, along with generations and social groups, would begin to pull away from one another, opening up rifts in the arts and society that would be mined for the maturation and reform of both.

2

Roads to Realism in the Age of Reform

> A crooked road, a road on which the foot feels the stones beneath it,
> a road that turns back on itself—this is the road of art.
>
> VIKTOR SHKLOVSKY[1]

"I'VE FALLEN UNDER THE wheel," concedes Evgeny Bazarov in the final pages of Ivan Turgenev's novel *Fathers and Children* ([1862]; 8:395; 288).[2] Just a few hours from death, he speaks with the woman he loves, Anna Odintsova, for the last time. Bazarov's is a profoundly moving and somewhat unexpected confession. After all, the upstart nihilist had moved through the novel, from estate to estate, through the fields and into the salons, with an aggressive swagger, unyielding in his progressive principles and positivist convictions. While it is certainly a shock to witness the rapid decline of such a robust figure, it is perhaps more unsettling to hear him resort in his final moments to such uncharacteristically poetic language.[3] Indeed, not long before this, after his falling out with Arkady, Bazarov expresses distaste for precisely this kind of pervasive road-as-life metaphor. "A romantic would say, 'I feel our paths are beginning to diverge,' but I will simply say that we are tired of each other" (8:371; 261). Might it be possible, then, to take Bazarov at his word when he states that he has "fallen under the wheel"? To see not a young doctor lying in bed, emaciated and shivering, vials of medicine strewn about, but Bazarov lying on a country road, the victim of a carriage accident? The road would stretch back to where Bazarov came from, the Kirsanovs' estate, Marino, and his parents' modest home, and continue forward to other places, a village graveyard and a different, future Marino. A trail of dust would be scarcely visible in the distance, kicked up by the perpetrator of the hit-and-run that brought Bazarov's path to an end.

Russian, as English, abounds in expressions relating to the road and the path, figurative constructions that are so common as to be practically beyond notice. Aligning itself with the trajectory of an individual or a story, the road becomes the road of life, or the path to success, or interrupted by forks that

allow for multiple choices. It is, therefore, of little surprise that the topos of the road makes its way quite regularly into the literary language of novels, functioning as metaphors of life, time, and history, as well as structural devices for the organization of plot and description. In this case, Turgenev's *Fathers and Children* is certainly no exception. In fact, the novel opens on the road, with Nikolai Kirsanov awaiting the arrival of his son Arkady at a coaching station. Happily reunited, father and son, along with Arkady's university friend Bazarov, travel down the road to the family's estate, glancing at picturesque scenes of rural life as they pass by. Just as it transports the young men into the varied spaces of the novel, so too does the road present them with difficult choices between mutually exclusive life paths. "The road to the right led to the town, and from there home to his father's; the road to the left led to Madame Odintsova's house" (8:334; 221). For Arkady and Bazarov, whether to turn right or left is anything but a benign question; on the contrary, it is a choice between the narrative potentialities of a love plot and of a domestic idyll. Therefore, when Bazarov concedes that he has fallen under the wheel, he not only expresses figuratively that the path of his life has come to an end, he also confesses to being done in by narrative, and by the novel itself, both having proceeded along a different route without him.[4]

With Turgenev's early prose and Vasily Perov's genre painting as central examples, this chapter takes up the road in a still broader sense, as a flexible figure that mobilizes the aesthetic and sociohistorical preoccupations of painterly realism during the age of reform. As such, the road continues the Natural School's project of describing the formerly unseen corners of everyday life, except it does so by moving through much wider swaths of Russian space, directing attention to a multitude of worlds visible through carriage windows, on the sides of dusty roads, and off the beaten path. Not only does the road offer a more expansive and diverse experience of space than, for example, the city street, it brings with it associations of development and progress. The dynamic mobility possible on a road, in contrast to the much slower plodding of the urban physiologist, is far better suited to the 1860s, an era overwhelmed with massive social and historical changes.

It is Stendhal who, in *The Red and the Black* (1830), makes the road an unavoidable part of the conversation about realism and the novel. "A novel is a mirror, taking a walk down a big road," professes his narrator. "Sometimes you'll see nothing but blue skies; sometimes you'll see the muck in the mud piles along the road."[5] Although it is more evocative than informative, Stendhal's metaphor supplies a compelling starting point for considering the significance of the road in realist art. By invoking the mirror, Stendhal highlights the supposedly unfiltered objectivity of the realist novel, its status as a reflector of all things, good and bad, propelled forward not by aesthetic intention or design but by an unforgiving and undifferentiating narrative movement. In this sense, the road becomes the backbone of realism's objective imperative, that which unites realism's subject and its method. It is at once the very matter that is reflected in the novel's unrelenting mirror as well as the vehicle for the

reflection of that imperfect matter. In this way, Stendhal's passing statement, which seems at first rather thin, in fact communicates well the unique capacity of the road to activate the social and aesthetic functions of realism.

After Stendhal, the road makes perhaps its next most memorable appearance in Mikhail Bakhtin's essay on the chronotope in the novel. "Time, as it were, fuses together with space and flows in it (forming the road)," writes Bakhtin in his concluding comments.[6] A linear form that charts the passage of time and that tunnels endlessly into space, the road becomes for Bakhtin the ultimate materialization of his otherwise abstract concept.

> In the literary artistic chronotope, spatial and temporal indicators are fused into one carefully thought-out, concrete whole. Time, as it were, thickens, takes on flesh, becomes artistically visible; likewise, space becomes charged and responsive to the movements of time, plot, and history. This intersection of axes and fusion of indicators characterizes the artistic chronotope.[7]

A place where time and space interact, the road is also a place where the varied concepts of verbal and visual—that is, narration and description, content and materiality, mobility and stasis—encounter one another. The specific nature of this encounter is determined largely by the medium through which the road winds. Turgenev explores the capacity of prose narrative, focalized in certain cases along the road, to produce temporal and spatial illusions, and to structure the relation between plot development and the landscape descriptions for which he is so well known. For Perov, the road functions primarily as a compositional element; pitched at an oblique or right angle to the picture plane, it creates the illusion of plasticity, dimension, and movement through pictorial space. Like Turgenev's roads, which encourage mobility but also static images, Perov's roads also become a locus for the viewer's engagement with seemingly distinct experiences of time and space, mapped roughly onto the categories of verbal and visual phenomena.

Because of its aesthetic and symbolic richness, the road is naturally a cherished image in literature and painting far beyond the borders of Russia and of the nineteenth century. However, the rate at which roads or paths or tracks appear in Russian realist painting suggests not only a preoccupation with the state of travel in the empire, but also a dependence on the road as a particularly powerful compositional and rhetorical device.[8] To get a sense of this, one need only take a cursory stroll through Pavel Tretyakov's famed collection of Russian painting from the second half of the nineteenth century. In addition to the works by Perov that will be discussed at length in the second half of this chapter, a few additional pictures, all firmly ensconced within the national canon, make the point well. In the lower right corner of Fyodor Vasilyev's *Thaw*, a set of tracks curves around and toward two figures making their way along the slushy, sloppy road (1871, figure 21). An invitation to the viewer, a mechanism for creating the illusion of spatial depth, and a nod not only to the hardships of rural life, but also to the hope that one might pass through into a better season,

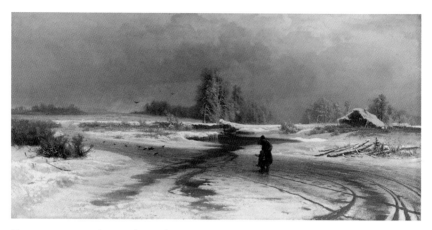

FIGURE 21. Fyodor Vasilyev, *Thaw*, 1871. Oil on canvas, 53.5 x 107 cm. State Tretyakov Gallery, Moscow.

Vasilyev's road condenses the structural and thematic functions of the figure. In Ivan Shishkin's *Rye*, a bird glides low along the winding path, which in turn guides the viewer's gaze in the other direction, toward a red-kerchiefed peasant working in the fields (1878, figure 22). The road here serves simultaneously as an indicator of space and motion, and a reminder of the very real labor taking place within the glowing fields of grain. Ten years later, Vasily Surikov uses the road to transport his viewer back to the seventeenth century to witness the arrest of the defiant Old Believer Feodosya Morozova (figure 23). In front of this enormous painting, the viewer stands at eye level with the snow in the foreground, invited to imagine the sensation of sliding along the slick packed-down tracks and sinking into the crisp piled-up mounds. What even these few examples show is that the ubiquity of the road is most likely a result of its flexibility as a figure, its ability to condense formal concerns of space and time, to activate phenomenological engagement, and to suggest broader national and universal narratives about history, progress, life, and death.

So omnipresent, the road is frequently overlooked, perhaps considered too obvious for commentary, or too simplistic a trope to contain any substantial depth of aesthetic thought. However, the road can be understood as a powerful emblem of the aesthetic, ideological, and professional stakes of realism in the 1850s and 1860s. Whereas the Natural School had invited us to peer through the windows of St. Petersburg, glimpsing framed visual images animated with verbal utterances, explication, and storytelling, the realism of Turgenev and Perov sweeps us along a network of roads, offering an interart representation that is subtly yet significantly different from that of Nekrasov and Fedotov. As we move along these roads and paths and streets, we are still treated to a mimetic plurality, verbal and visual multiplying into an impression of completeness; however, we also begin to notice a space opening up between word and image, a gap within which one mode distinguishes itself from the other.

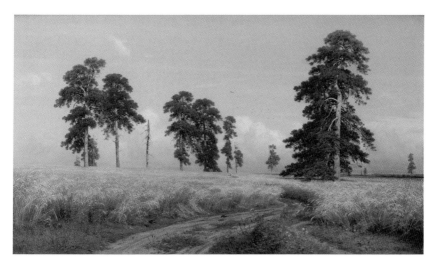

FIGURE 22. Ivan Shishkin, *Rye*, 1878. Oil on canvas, 107 x 187 cm. State Tretyakov Gallery, Moscow.

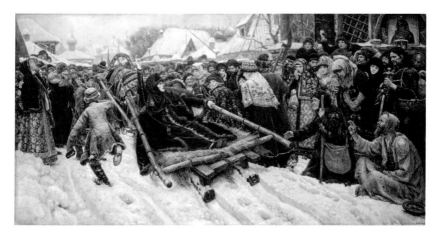

FIGURE 23. Vasily Surikov, *Boyarina Morozova*, 1887. Oil on canvas, 304 x 587.5 cm. State Tretyakov Gallery, Moscow.

To be sure, this is not yet an assertion of territorial borders, the likes of which Lessing had proposed, or of a discernedly modernist medium specificity; nor is it the more extreme polemical stance taken by Tolstoy, discussed in the next chapter. But neither is this a Horatian collaboration between the sister arts. When Turgenev injects temporality into a landscape description, or Perov moves away from a story and into pictorial depth, each is not rejecting one mode for another, but rather exploiting interart distinctions to impart a sense of vibrancy to his mimesis and to enhance the physical and ethical engagement of his audience. As it did with the Natural School, this interart strategy reflects its particular sociohistorical context, a context determined less by an

idealistic democratic equity than by a splintering of the social and political sphere. In other words, as society begins to pull apart, so too do word and image, and literature and painting.

With the rise of Alexander II to the throne in 1855 came the relaxation of artistic censorship and the introduction of a series of social and political reforms, including the emancipation of the serfs in 1861. Among the young men of the sixties and their fathers' generation was represented an unprecedented range of liberal, conservative, and radical ideological viewpoints, with certain factions of the "sons" tending toward more extreme anarchic and populist positions. Nowhere is this shift more apparent than in the staff of the journal the *Contemporary*. Still under the leadership of Nekrasov, it nonetheless came to be dominated not by the liberal idealism of which Belinsky had been such an impassioned proponent, but by the radical materialism of Nikolai Chernyshevsky and his fellow "real critic" Nikolai Dobroliubov.[9] In his 1855 dissertation, "The Aesthetic Relations of Art to Reality," Chernyshevsky outlines three main characteristics of a socially engaged realism that would be attuned to the historical moment. First and foremost, art must be a mimetic "reproduction of life" (*vosproizvedenie zhizni*), and frequently even an "explanation of life" (*ob"iasnenie zhizni*). In this sense, Chernyshevsky's aesthetic theory is virtually identical to that of the Natural School. However, he then adds a third ingredient, writing that works of artistic realism ought to "pronounce judgment on the phenomena of life."[10] It is this judgment, this condemnation, that makes for the distinctly *critical* realism of the 1860s.

Turgenev, a man of the forties, was categorically opposed to such radical views, severing his ties with the *Contemporary* and addressing the ramifications of such a fractured society in his novels, and, especially, in *Fathers and Children*.[11] Perov, whose works fit more comfortably within a Chernyshevskian critical mode, was, however, not particularly vocal with regard to politics, a position not uncommon among artists of the time. And yet, despite Turgenev's and Perov's respective political views, their prose and painting, albeit in different ways and to varying degrees, responded to the same call for realism to acquire a more assertive stance, to not only represent but to comment upon, critique even, the sociohistorical reality of Russia at mid-century. If the physiological sketches had been fairly passive, offering "objective" observation with relatively less moral guidance, Turgenev and Perov became ever more aware of the potential for their works to engage an audience in ethical realizations. They both pursued this dual project—to strive for a convincing mimetic illusion, while also injecting an element (or more) of social thought—within the confines of their respective media, exploring the unique abilities of prose and of painting to represent and shape reality.

By mobilizing these interart divisions, Turgenev and Perov also began to establish their ontological and professional identities, determining the aesthetic specificity of the novel and the painting, as well as more general distinctions between the arts. Along these lines, during the second half of the 1850s, Turgenev shifted from short literary sketches to longer forms, thus

participating in Russian realism's adoption of the novel as a privileged genre and ultimately its advance toward creative autonomy and international recognition. The stakes of this project were even more pressing for painters like Perov. Given the typically low social status of artists (Perov himself was disadvantaged because of his illegitimate birth) and the presumption that painting was the "lesser" of the sister arts, the mastery of painterly technique and the participation in a secure art market became especially important for establishing credentials as a professional painter. A series of events that took place in St. Petersburg during 1863 presaged broader changes in the Russian art world that would eventually create the conditions for this kind of professional and creative self-realization. In November 1863, protesting the compulsory themes for the gold medal competition in painting, Ivan Kramskoy and thirteen of his colleagues seceded from the Academy of Arts, establishing their own independent artistic organization, the St. Petersburg Artel of Artists (*Artel' khudozhnikov*). Born of the "liberationist mood of the 1860s," to quote Elizabeth Valkenier, the Artel, as a cooperative organization (along the lines of what Chernyshevsky had proposed in *What Is to Be Done?*), also functioned practically, allowing its members to work as artists independent from the Academy and to profit socially from a communal environment.[12] Although Perov was not a member of the Artel—not only was he somewhat senior to the Artel members, he also lived and worked in Moscow during the 1860s—he nevertheless contributed to and benefited from these broad institutional changes in the history of Russian art.

Importantly, it is also at this time that art criticism in Russia began to gain prominence in the cultural sphere, evident in the growing journal polemics of a community of ideologically diverse art critics, perhaps most vocal among them the pro-realist and anti-academic Vladimir Stasov.[13] And finally, it is also during these decades that Pavel Tretyakov launched his collection of national art, initiating a career as a patron that would prove essential to the development of Russian realist painting.[14] In this chapter, these changes in the perceived legitimacy of Russian painting, changes wrought by the founding and flourishing of new institutions, are tied to the interart encounters within Perov's canvases. And when considered in juxtaposition to Turgenev's experiments in prose, Perov's pictures become part of the larger project of establishing the place of Russian realism within the history of Russian and European culture. Therefore, in the interart distinctions of these works—in their growing awareness of the difference between the temporal and the spatial, the narrative and the painterly—one also sees emerge the distinct identities of Russian literature and Russian painting, as autonomous and self-conscious cultural spheres.

In his seminal *Theory of Prose*, Viktor Shklovsky invokes the image of the road for his definition of art. "A crooked road," he writes, "a road on which the foot feels the stones beneath it, a road that turns back on itself—this is the road of art."[15] Shklovsky's goal is to follow each word, to recognize it, to sense it, to make the "stone stony." By tracing this singular topos through the prose and painting of Turgenev and Perov, it is possible therefore to isolate the stones of

realism's crooked road, the stones that are particular to the realist novel and to the realist painting. What arises is an emblem particularly well suited for the physical, social, and sometimes ethical engagement sought by the literary and painterly realism of the 1860s. While the windows of the Natural School had allowed for intermittent violations of the border between art and reality, inviting us at times to flip in and out of the space of the sketch and the painting, the border always somehow held, relegating us to this side of the windowpane. In the roads of the sixties, we are asked as readers and viewers to interact with the represented subjects in far more complicated ways, to stride into pictures, crawl over embankments, pause to repair a carriage. And to make choices. Which road will we take? What or whom will we pass by? And what does this say about us? Turgenev and Perov navigate these difficult choices by mining the interart gap between the verbal and the visual that is so apparent within the figure of the road.

The Plotted Road

For obvious reasons, the figure of the road dominates the travel narratives of Aleksandr Radishchev, Nikolai Karamzin, and Mikhail Lermontov, but it is Nikolai Gogol's *Dead Souls* (1842) that represents the quintessential road narrative in the Russian tradition. Gogol's paean to the road begins with the image of a carriage rattling into the town of N and concludes with lengthy lyrical digressions on the topics of travel and the exceptionalism of Russian space. "What a strange, and alluring, and transporting, and wonderful feeling is in the word: road! and how wondrous is this road itself: the bright day, the autumn leaves, the chill air." Gogol's road produces frenetic, kaleidoscopic visions of the countryside. Movement is rapid. "You wake up: five stations have passed by." And (who knows how much) later: "You wake up—again there are fields and steppes before you, nothing anywhere—everywhere emptiness, all wide open. A milestone with a number flies into your eyes."[16] One is never quite sure if Chichikov's troika is going to plummet into a ditch or lift off into the heavens, and the reader is not particularly surprised when both occur. To say that the road is a theme of Gogol's novel is to downplay its true significance. The road is the novel's hero. It is what allows Gogol to "mirror," in Donald Fanger's analysis, the bizarre inhabitants of the provinces.[17] It is what reflects the muck underfoot and what guides the reader into the vast airy expanses of Russia. For Yury Lotman, the road is the "universal form of spatial organization" in *Dead Souls*, traversing and containing the infinite and the infinitesimal, and everything in between.[18]

While not so much invested in the reality-bending and myth-making aspects of the trope, Turgenev nevertheless takes up the road as a central thematic and structural device in his *Notes of a Hunter*, a collection of sketches written and published between the years 1847 and 1851, and released as a separate volume in 1852. The volume's twenty-five sketches are united by a single

narrator, a noble landowner who travels the Russian countryside on hunting expeditions. With the narrator's travel at the center of the collection, the crisscrossing of the country roads becomes a skeleton that binds the disparate pieces together, facilitating the movement of the narrator from one adventure to the next. In this way, the roads of *Notes of a Hunter* chart an imaginary geography and contribute, in the implication of their infinite continuation through and beyond the text, to a powerful illusion of space.

Turgenev's hunter-narrator opens the sketch "Lebedyan" with an address to the reader: "One of the principal advantages of hunting, my dear readers, is that it forces you to travel ceaselessly from place to place, which for someone without any occupation is very pleasant. True, sometimes (particularly in rainy weather), it's not too much fun to go about on country roads" (4:186; 192).[19] The narrator follows this comment with a laundry list of typical travel annoyances: difficult peasants, substandard accommodations, and poorly maintained bridges and highways. But, he concludes, "all these inconveniences and mishaps are compensated for by advantages and satisfactions of another kind" (4:186; 192). These advantages are, presumably, the happy accidents of travel, its unexpected meetings and enlightening revelations. In this desire to expose diverse corners of rural life, the notes of Turgenev's hunter certainly parallel the physiological sketches of the Natural School. In both cases, a central narrator moves through space, along a street or a road, and collects impressions—good and bad, verbal and visual—into a more or less unified representation of reality. Because of these echoes, and especially given the historical overlap, *Notes of a Hunter* can be understood as a transitional text, transporting the urban sketch to the country, and in the direction of a more expansive novelistic prose. What secures the sketches' distinct status is their subtle insistence on a differentiation between the sister arts—modeled as the relation between narration and description, temporal and spatial experience—that will gain in aesthetic and social significance in Turgenev's subsequent novels. More specifically, by following their hunter as he journeys, gets lost, stops for rest and repair, Turgenev's sketches employ the figure of the road as a mechanism for opening the gap between *pictura* and *poesis* ever so slightly, and exploring the distinct temporal and spatial capacities of prose narrative.[20]

Turgenev often relies on the road to invite the reader into the space of the text, highlighting the parallel functions of the literary and painterly road as a *repoussoir* (a detail in the foreground of a painting that guides the viewer's eye into the composition).[21] This fairly simple technique is rendered all the more explicit in Russian through the use of prefixed verbs of motion. Coupling such a verb with a direct address to the reader, Turgenev's sketch "Tatyana Borisovna and Her Nephew" begins: "Give me your hand, dear reader, and come on an outing" (4:199; 204). The reader is then driven along a "broad, level road" through a typical Russian landscape: rippling fields of rye; rooks perched on the road; a valley; a small hill. As he nears the destination, the house of Tatyana Borisovna, the coachman picks up the pace. In the last few sentences of the first paragraph, the verb "to go in," or "to enter" (*v'ezzhat'*),

is used three times in the present tense. The repetition of these and related verbs is, on the one hand, testament to the power of language to produce an almost intuitive sense of motion and spatial depth, yet on the other hand, it also gestures to the text's necessary dependence on language to produce a spatial illusion (4:199–200; 204–5).

As with any road (and any narrative), sometimes there are unforeseen detours. In the sketch "Loner," the hunter-narrator is on his way home when an unexpected thunderstorm rolls in.

> The road wound its way ahead of me. [...] I moved forward with difficulty. The droshky jumped about as the wheels struck the hard roots of centuries-old oaks and limes, which crisscrossed the deep ruts made by cartwheels, and my horse began to stumble. [...] Suddenly lit up by a lightning flash, I thought I saw a tall figure on the road. I began looking intently in that direction and saw that the figure had literally sprung from the earth just beside my droshky. (4:167; 173)

While a "broad, level road" had escorted the reader to Tatyana Borisovna's home, this road, gnarled with roots and ruts, has become impassable. But all is not lost; the hunter has simply been diverted. He spots the local forester, illuminated by lightning, who then escorts the narrator to his hut. Because of this travel mishap, the narrative swerves away from what might have become a pleasant dinner scene at the hunter's country estate, and toward an entirely different literary space. The failed droshky becomes, therefore, a sign of the fragility of narrative momentum, the ease with which it can be redirected.

But what if the droshky had been up to the task? What if the narrator had just driven by the forester without more than a passing glance? The narratological significance of such breakdowns or detours for Turgenev, of which there are many in *Notes of a Hunter*, is that they disclose the seemingly infinite story lines that exist beyond the central narrative. At the beginning of "Kasyan from the Beautiful Lands," the narrator spots one of these, to quote the cliché, roads not taken:

> I looked around. We were driving through a broad, flat area of plowed land into which low hills, also plowed up, ran down like unusually gentle, rolling undulations. My gaze encompassed in all about three miles of open, deserted country; all that broke the almost straight line of the horizon were distant, small groves of birch trees with their rounded, tooth-shaped tips. Narrow paths stretched through the fields, dipped into hollows and wound over knolls, and on one of these, which was due to intersect our road about five hundred yards from us, I could distinguish some kind of a procession. (4:114; 121)

It is a funeral procession. The hunter and his driver try to speed up to avoid meeting the procession, a bad omen, but the axle breaks, and the two men are stranded, hats in hand, as the procession drives by.

What is most curious about this episode is that it has little impact on the remainder of the sketch. The omen goes nowhere. It is simply a reminder that the road is a place where stories intersect, sometimes fleetingly as is the case with the procession, and at other times less so. As Bakhtin writes, "the road is a particularly good place for random encounters."

> On the road ("the high road"), the spatial and temporal paths of the most varied people—representatives of all social classes, estates, religions, nationalities, ages—intersect at one spatial and temporal point. People who are normally kept separate by social and spatial distance can accidentally meet; any contrast may crop up, the most varied fates may collide and interweave with one another.[22]

By engaging this potential of the road, Turgenev is able to craft a much richer and presumably more accurate representation of the countryside, allowing his narrator to encounter, if sometimes only for a moment, people and situations that would have no place near his estate.

In its possible access to a more expansive social totality, Bakhtin's road not only provides an opportunity for greater verisimilitude, it also engages the spatial and temporal dynamics of prose. In light of Bakhtin's assertion that "time, as it were, fuses together with space and flows in it (forming the road)," the landscape description that opens "Kasyan" becomes all the more remarkable.[23] As the hunter looks out over the expanses, space condenses into a straight horizon line dividing the massive emptiness into sky and earth, a few clusters of birch trees here and there. Narrow paths curve through the fields, crisscrossing at various intervals, forming hills and valleys as they flicker in and out of visibility. This is, in one sense, a verbal attempt to represent pure space. And as such, it is a site of the juncture between vantage point and narrative possibility. The plotlines dip and dive, intersect, part ways; plot recuperates the spatial dimensions of its etymology, uniting space and story into a singular image, while also reinforcing the difference between its spatial and temporal meanings.[24]

The ability of the road to highlight these distinct capacities of narrative is perhaps most apparent in the sketch that was intended as the epilogue to *Notes of a Hunter*, "Forest and Steppe." The most impressionistic of the collection, this sketch is structured as a persistent journey through the countryside, a journey that transforms the landscape through the movement of narrative. At the very start, the narrator places a sleepy reader into a carriage. Still early, quiet and stillness reign, but as the passage gains momentum, the reader and the surroundings seem to awaken simultaneously.

> You drive, drive past a church, downhill and to the right across a dam. [...] By the time you've traveled two miles or so the rim of the sky is beginning to crimson; in the birches jackdaws are awakening and clumsily fluttering from branch to branch; sparrows twitter about the dark hayricks. The air brightens, the road clears, the sky lightens, the clouds whiten, the fields green. (4:383; 384)

The repeated references to color and to spatial relations, coupled with the second-person address, reveal this passage to be primarily invested in a project of summoning forth a visual image through language. Borrowing the rhetorical devices of *enargeia*, so prominent in *The Physiology of Petersburg*, this sketch seeks to put the landscape before the eyes of the reader. However, this is not a fixed image, but rather an image, to borrow Stendhal's phrase, "taking a walk down a road." The series of imperfective verbs in the present tense impart the impression that this vision of nature is on the move, evolving.[25] The sky turns red, the air lightens, the sky clears; and this mutability of the landscape is as much due to the rhythms of the natural world as it is to narrative's, or the road's, temporal capacities.

Throughout the reader's journey, the dual aspect of the landscape—as visual and spatial, and textual and temporal—emerges as perhaps the sketch's most dominant theme.

> You can see for miles all around [*Daleko vidno krugom*]. There, a village beyond the woodland; there, farther away, is another village with a white church; and there, a hill with a birchwood; beyond it is the marsh to which you are driving . . . Step lively there, horses! Forward at a brisk trot! . . . No more than two miles to go now. The sun is rising quickly, the sky is clear. [. . .] Then you have ascended the hill . . . What a view! The river winds away for seven miles or more, becoming faintly blue through the fog; beyond it are the watery-green meadows; beyond them, low-lying hills; in the distance lapwings veer and cry above the marsh. (4:383; 384)

In this passage, the sketch attempts twice to still or frame a landscape view: "You can see for miles"; "What a view!" And each time the visual gesture is followed by spatially descriptive diction, plotting the locations and positions of various geographical markers. However, in both cases, this visually motivated description quickly transforms through the movement of the carriage along the road, the narrative drive to forever push forward. Horses gallop apace, birds soar through the sky, the reader carries on. Even when pausing at a scenic spot atop a hill, the reader's gaze continues to hurtle forward with the force of inertia, the river taking on the road's spatial role, winding its way into the distance.

In this way, Turgenev transforms the landscape description through the temporal dynamics of narrative, a narrative that is almost wholly condensed within the figure of the road. The reader is invited to watch this image of the country emerge ("What a view!"); however, this "picture" is anything but framed and immutable. On the contrary, this landscape brims with natural time and physical movement, a narrative approximation of living experience. What the narrative road makes possible, then, is movement through discrete spatial and temporal phenomena, in a manner that enhances the reader's sense of the illusion's overall fullness. Rather than folding the visual and the verbal into one another, as had the picture windows of the Natural School, Turgenev's

roads retain the suggestion of their difference, highlighting the shifts between representative modes and creating the impression that this "reality" is seemingly limitless in its scope and variety. While the joining of the spatial and the temporal within the sketch suggests a certain epistemological fullness, the inevitable futility of this project lurks within Turgenev's descriptions. The reader is invited to view the undeniably powerful spatial illusion of these landscapes, but the perpetual tension in literary description nevertheless makes itself known. After all, even when the view is approximated with, for example, the repetition of spatial prepositions, the effect is produced through the consecutive accumulation of text rather than anything resembling a visual gestalt. Description thus continually gives way to narration. This mobilization of the visual is exactly how Turgenev's sketch approximates a multidimensional experience, but it is also where the text comes up against its limits, admitting the difficulty of translating the visual into the verbal, and by extension, the difficulty of making reality a believable representation.

As discussed in the next section, in Turgenev's novels this aesthetic function is occasionally layered with broader social and even ethical implications. But curiously, this extra-aesthetic function is present even in the most impressionistic of Turgenev's sketches, "Forest and Steppe." Early in the sketch, the narrator describes a chance encounter while strolling through the forest: "A peasant drives by at a walking pace, leaving his horse in the shade before the sun gets hot. You greet him, pass on, and after a while the metallic rasping of a scythe can be heard behind you" (4:384; 385). There is undoubtedly something in this moment of the Natural School's optimistic democratic realism, its desire to put all levels of society on equal footing, or, at the very least, make them all equally visible. Traveling through the country, Turgenev's hunter-narrator and his reader-companions, who are mainly members of the privileged landowning class like the author himself, are afforded brief looks into these unfamiliar social spaces. Even though his hunter-narrator does not meet everyone and experience everything—this, after all, would be impossible—in the illusion of infinite space and a never-ending road, Turgenev suggests the illusion of a reality that is also never-ending, unframed and unedited, and, therefore, somehow complete. But we must also remember that Turgenev's narrator spends his days hunting—for sport—whereas the peasant he passes by on the road will spend his day engaged in unforgiving manual labor. All that remains of this harsh reality is the swooping sounds of the scythe. In other words, the perpetual movement of narrative eats away at description. A peasant in a landscape, seen one moment, becomes a mere swoosh and then disappears altogether, in the next. In the more expansive world of the novel, with more space and time and greater narrative diversity, Turgenev will seek ways to harness this fraught relation between narration and description, and by doing so, to develop the social and ethical implications of this narrative movement, what it means to enjoy a picturesque view, catch a glimpse of a peasant, and then simply drive by.

On the first of October 1883, the artist Aleksei Bogoliubov delivered a eulogy before the departure of Turgenev's funeral procession from Paris to St. Petersburg. In it, he employs what would become a common trope of Turgenev scholarship, likening the author to a great painter of landscapes.

> His golden quill, like the brush on the rich palette of an artist, represented clearly and faithfully in his works, with words, that elusive charm of nature accessible only to a master such as Turgenev. The background of his pictures (if I may call them such) was always faithful, never overworked, but finished just enough so that the reader could grasp the details, which went straight into the soul.[26]

While it is not terribly surprising that a painter would resort to such flourishes of interart analogy, Bogoliubov is far from the only one to use visual language in reference to Turgenev's prose. As early as 1848, Belinsky wrote that Turgenev "loves nature not as a dilettante but as an artist. [...] His pictures are always true, and you never fail to recognize our Russian landscapes in them."[27] Over a century later, Vladimir Nabokov declared that these descriptive moments "are Turgenev at his very best," telling his students that "it is these mellow-colored little paintings—rather watercolors than the Flemish glory of Gogol's art gallery—inserted here and there into his prose, that we still admire today."[28]

In isolation, such statements could be chalked up to nothing more than a rather understandable propensity for visual rhetoric in critical language. In Turgenev's case, however, this reliance on visual language has become part of his critical legacy, defining him within the canon of European literature as Russia's reluctant realist, an artist out of place within a literary tradition celebrated for its philosophical and ideological heft. Dmitry Mirsky, in his history of Russian literature, writes that Turgenev's "art answered the demands of everyone. It was civic but not 'tendentious.' It painted life as it was. [...] It was full of truth and, at the same time, of poetry and beauty."[29] And yet, Mirsky seems to discern a wrinkle in Turgenev's "middle style" when it comes to landscape descriptions. "His attitude to nature had always been lyrical, and he had always had a lurking desire to transcend the limits imposed on the Russian novelist by the dogma of realism."[30] Indeed, many critics see in Turgenev's artistry a discordant note, something that makes him more palatable to a Western audience, but also less of a realist than a romantic or an idealist.[31] Or a poet or a landscape painter. These kinds of disruptions are, however, part and parcel of any realist aesthetic. Whether in the universalism of the type, or the aestheticism of Repin's paint handling, realism does not betray itself when it exceeds an "objective" representation of reality; rather, it is in these moments that the precise nature of a given realism is best glimpsed. And so it is with Turgenev. When he pauses his narration for a landscape description, he does not interrupt the realist content of his novels.[32] On the contrary, the relation

between narration and a visually inflected description lends aesthetic, social, and, on occasion, critical, force to his realism.

There are also reasons beyond the critical corpus to consider the landscape "painting" of Turgenev's prose, for the writer throughout his life was not at all indifferent to the visual arts. Turgenev befriended many artists, most notably the Russian painters Aleksandr Ivanov and Vasily Vereshchagin, and was himself an avid amateur draftsman.[33] In the 1870s he began to amass a modest, yet impressive collection of canvases, including several works by the contemporary artists Jean-Baptiste-Camille Corot, Charles-François Daubigny, and other members of the Barbizon School.[34] Speaking privately with friends in 1874, Turgenev even went so far as to claim that if he were to have the chance to start over, he would have chosen the career of a landscape painter over a writer.[35]

Turgenev's love of landscape makes its way into an 1861 essay, which recounts an Italian outing with Ivanov and the writer Vasily Botkin. Cognizant of the potential for visual distraction, Turgenev promises not to veer off into lengthy descriptions, especially because, in his words, "after Claude Lorrain no landscape painter could do full justice to the Roman landscape; writers, too, found themselves incompetent" (14:85). A few pages into the essay, however, Turgenev can hold back no longer.

> The road climbed the mountain along a so-called "gallery," lined by a whole row of splendid evergreen oak trees. Each of these trees was several hundred years old, already Claude Lorrain and Poussin had admired their classic contours. [...] Circular Albano Lake showed blue and just barely steamed beneath us, and around us, along the slopes of the mountains and along the valleys, near and far, divine colors spread before our eyes into a magically transparent veil ... But I have promised not to indulge in descriptions [ne vdavat'sia v opisaniia]. Mounting higher and higher, riding through genial, bright, yes, bright woodlands, on emerald green, summery grass, we finally reached the little town called Rocca di Papa. (14:90–91)

The road, triggered by the double meaning of the word "gallery" (as both a passageway and an exhibition space for art), leads to, or perhaps morphs into, a gallery filled with Lorrains and Poussins. Turgenev stands mesmerized, and only after a particularly suggestive ellipsis, shakes himself out of this visual reverie, apologizing for his lapse into description and continuing along his way. In this case, it is the road, reinforcing the subtle narrative that is the day trip through the Italian countryside, that both enables this aesthetic experience and provides an exit from it.

In his promise not to "indulge in descriptions," Turgenev echoes an anxiety shared by his fellow member of the Natural School, Dmitry Grigorovich. It is also worth noting that both men hint at something akin to the injunction against the heedless crossing of artistic borders expressed by Lessing in his famous treatise Laocoön, or On the Limits of Painting and Poetry, which had been published in Russian in 1859 (and would come to underwrite the more profound novelistic paragoni of Tolstoy and Dostoevsky discussed in

subsequent chapters). Recalling the field research for his first novel, *The Village* (1847), Grigorovich writes: "In vain I wandered for whole days in the fields and the forests, feasted on the pictures of nature [*liubovalsia kartinami prirody*], [...] searching out an interesting plot [*siuzhet*]—the plot did not take shape."[36] While peering through picture windows had not posed a problem for the physiologists, when faced with a novel, feasting on pictures is not only inadequate, it is potentially disruptive. What Grigorovich needs and does not have is a clear path, a road, a narrative that provides momentum and propels the reader through a plot.[37] Turgenev clarifies this distinction between the needs of a series and those of a novel in an 1859 letter to Ivan Goncharov, in which he bemoans his inability to write anything more than a "series of sketches" (*riad eskizov*). He fears he will never be able to achieve a "novel in the epic sense of the word" (3:290).[38] While the road in *Notes of a Hunter* had provided Turgenev the opportunity to explore narrative potential, what he describes in this letter is the need for a much firmer hand. What he seeks is a road that can introduce narrative propulsion into these series of sketches—these rows of trees—transforming them from mimetic episodes, impressionistically linked, into ruminations on society, history, and the self.

One such novelistic landscape can be found at the beginning of *The Nest of the Gentry* (1859). Returning home after many years abroad, Fyodor Lavretsky gazes out the carriage window at a country scene familiar from his childhood.

> His tarantass bowled briskly along the soft surface of a country road. [...] A mass of slightly dark clouds with vaguely drawn edges crawled across the pale blue sky; a fairly strong breeze hurried in a dry, uninterrupted stream over the land, but did not disperse the heat. Laying his head back on a cushion and folding his arms, Lavretsky gazed at the rows of fields which slowly passed into and out of sight, at the stupid rooks and crows which looked out of the corners of their eyes in dull suspiciousness at the passing carriage, at the long boundaries between the fields overgrown with ragwort, wormwood, and field rowans; he gazed [...] and this fresh, lush nakedness and wilderness of the steppe; this greenery; these long, low hills; the ravines with their ground-hugging clumps of oak trees; the gray little villages; the flowing shapes of birches—this whole Russian picture, which he had not seen for so long, evoked in him sweet and simultaneously anguished feelings and oppressed his heart with a kind of pleasant sadness. (7:183; 81–82)[39]

As in his earlier landscapes, Turgenev directs our attention to the pleasures of the countryside, relying upon diction closely linked with the realm of the visual arts in his opening description of the clouds with their "vaguely drawn edges." But these clouds do not sit still on the landscape. Crawling across the sky, they seem to mimic Lavretsky's own movement. The breeze, too, hurries. And the visual impressions begin to pass more rapidly before Lavretsky's eyes—fields, birds, more fields—eventually settling into a "Russian picture."

Lavretsky's journey continues. And what had started out for a moment as a visual image, clouds sketched on a blue sky, turns into thought and memory. "His thoughts took a slow wandering course; their outlines [*ochertaniia*] were as vague and troubled as the outlines [*ochertaniia*] of those high and also seemingly wandering clouds" (7:183; 82). With this move from clouds to thoughts, a move from vision to memory connected via the word "outline," Lavretsky turns his gaze inward. Images of the past come one after another: his mother on her deathbed, his father at the dinner table, his estranged wife. Lavretsky's mind then wanders to thoughts of Robert Peel and the history of France, transforming memory into history. The carriage jolts him out of this thought process and he opens his eyes. "The same fields, the same views of the steppe" (7:184; 83). But they are not the "same views." What Turgenev has done in the course of Lavretsky's carriage ride is transform a traditional landscape view into a journey through the random associations of the mind, into the past and into the annals of history, to France and back.[40]

This transformation—from a view described to a view narrated—takes on a more immediate social function in *Fathers and Children*. In one of Turgenev's more notable landscapes, Arkady Kirsanov looks out at the countryside on the way to his family's estate.

> The places through which they were driving were not in the least picturesque [*zhivopisnymi*]. Field after field stretched away to the horizon, now sloping gently up, now dropping down again. Here and there was visible a copse, and winding ravines sparsely planted with low bushes, recalling to the eye their particular representation on old maps from the time of Catherine. There were little streams, too, with hollow banks and diminutive ponds with narrow dams, hamlets with squat little huts beneath blackened and often half-collapsing roofs, and crooked threshing barns with wattled walls and gaping doorways opening on to abandoned threshing floors, and churches, some brick-built with the stucco peeling off in patches, others of wood with crosses awry and churchyards that had gone to ruin. Arkady's heart constricted a little. As though on purpose, the peasants whom they met on the way were all in rags and mounted on the sorriest little nags. (8:205; 83)

The landscape, while not "picturesque" (literally, "painterly"), presents itself at first in a markedly visual manner. The spatial layout of the fields and the shrubbery in relation to the horizon is made explicit. In fact, the composition is rendered so schematically that it reminds the narrator of another visual medium, the two-dimensional representation of space on an old map. Rather than reinforcing the visuality of this scene, however, this map, by referring back to the time of Catherine II, introduces the temporal dimensions of history, and ultimately of the contemporary moment, into the landscape description. As the reader knows from the first page of the novel, the year is 1859, two short years before the emancipation of the serfs, and this tumultuous moment makes itself felt in the collapsing roofs, peeling stucco, and ruined churchyards. Moreover, Turgenev wreaks havoc upon *manmade* architectural structures; the small

huts and barns, like landscape paintings and maps, are the products of creative labor. By representing them as crumbling and dissolving, Turgenev in effect transforms the illusion of a fixed visual picture into a literary description of the countryside through time, through history, through narrative.[41]

In this intervention, Turgenev does not reject the landscape, or beauty as such, as immoral or inadequate. Turgenev's introduction of landscape, unlike what we will see with Tolstoy in the next chapter, is not motivated by a polemical impulse to bolster his verbal illusion at the expense of the visual. Rather, what he does is show the potential for narrative to transform representation through the invocation of time and space, and, in the process, he gestures toward the ontological specificity of the novel, without declaring its superiority outright. A contemporaneous, yet far more critical, landscape description offers an instructive contrast. In an 1863 feuilleton, Mikhail Saltykov-Shchedrin goes to great lengths to "paint a picture" of the countryside:

> The picture [*kartina*] of simple country folk, who have gathered together for the fulfillment of their duties, will always be especially attractive. [...] Picturesque [*zhivopisnye*] groups of women in long white shirts, harmonious swings of the sickle, golden ears of rye ... [...] Even when the local men stretch in a long procession toward the plowed field, carrying manure, even then it is possible to compose a very dear little picture [*skomponovat' ochen' milen'kuiu kartinku*], because, you see, in a little picture manure does not smell.

Even manure, distanced and thus aesthetically neutralized can make a beautiful picture. The absurdity of this statement is our first clue that Saltykov-Shchedrin does not intend to indulge in landscape. And so, it is not terribly surprising when he changes his tune considerably.

> But don't let the viewer become too absorbed in the charming picture. Let him once and for always confirm for himself that his eyes lie, that the artist who drew the picture is also doing something untrue, and that in rural life there are no delightful landscapes, no splendid *tableaux de genre*, but hard and unsightly [*nevzrachnyi*] labor.[42]

Pictures lie, if not outright, then certainly by omission, neglecting the difficult labor that is, quite literally, unavailable to sight (*nevzrachnyi*). In *Fathers and Children*, Turgenev suggests that Arkady likewise might recognize the lie of such pastoral visions; he might begin to smell the manure, so to speak. This is suggested by means of a subtle physiological response. After his encounter with the crumbling landscape that revealed so convincingly the harsh social realities of the historical moment, Arkady's heart, the reader is told, "constricted a little." But despite what seems like a realization of some kind, however subtle it may be, as soon as his heart relaxes, Arkady moves on. The carriage keeps going, the road pushes him forth, and his thoughts respond. He takes note of the arrival of spring; the landscape becomes lush again, reanimated with life.

As if to reinforce this shift away from the social and ethical and back to the aesthetic, Arkady's father quotes some Pushkin.

For Turgenev these distinct experiences—aesthetic and ethical, visual and verbal—are all made possible through the persistent movement of narrative, structured along actual or virtual roads, guiding the characters and readers through descriptions and impressions, from plot to plot. Arkady can see both the beauty and the harsh reality of the countryside. He can experience poetic exuberance and something like an ethical twinge. In its scope, its ability to hold together contrasts and contradictions, the novel allows for these diverse experiences, experiences that are as spatiotemporally dynamic as they are socially differentiated. As a famously problematic realist, Turgenev is perhaps the best example of this novelistic potential, for just as he provides his readers with precise social and historical commentary, he also cannot resist a splendid landscape. In this constant negotiation between plot and context, on the one hand, and description and aesthetics, on the other, the novel highlights its flexibility as a form, its ability to expand and contract according to the needs of the narrative. In *Fathers and Children*, the fates of the two "sons" reflect these varied narrative possibilities. Arkady, although his heart constricts at the sight of peasant suffering, chooses to step off the road and into the picturesque domestic idyll of Marino. Bazarov, on the other hand, suffers greatly for his choice to pay heed to the suffering of the poor. And as a result, he is trampled rather unceremoniously by the narrative, "fallen under the wheel." Of course, despite the impassioned arguments that surrounded the initial publication of the novel, neither of these paths seems particularly privileged by Turgenev. After all, even though the novel concludes with Bazarov's parents at his grave, it ends not with a final condemnation or affirmation, but with an ellipsis, a typographical "road" if ever there was one (8:402). In this, Turgenev ends the novel on the road, in the middle of a journey that can be read as spiritual, natural, or, aesthetic. This ambivalence is perhaps what Bogoliubov identified when, in his eulogy for the writer, he declared that "the background of his pictures [...] was always faithful, never reworked, but finished just enough so that the reader could grasp the details, which went straight to the soul." Or to rephrase Bogoliubov's sentiment in the terms of this chapter, Turgenev's landscapes were always finished just enough so that pictures hover before the reader's eye, and unfinished enough that they remain forever on the move.

The Painted Road

In the mythology of Vasily Perov, much is made of the artist's time spent abroad on an Academy of Arts traveling scholarship, awarded in recognition of his 1861 gold medal prize for *The Village Sermon*. Or rather, much is made of Perov's early return home. Having spent only two of the three allotted years in Paris, Perov writes to the Academy in 1864 asking permission to return to Russia. He explains that he has been unable to complete a single painting due

to his lack of native familiarity with the French people. "I find it less useful to dedicate myself to the study of a foreign country for several years," he writes, "than to study and cultivate as much as possible the limitless wealth of subjects of both urban and rural life in our own country."[43] This statement has been taken up by countless critics and scholars, ranging from the nineteenth-century ideologue Vladimir Stasov to Soviet art historians, as evidence of Perov's commitment to Russia and the development of a uniquely national painterly realism. However, Perov's time abroad had an impact of a non-ideological sort as well; exposed to the Western masters and to contemporary artists, and afforded ample time for professional practice, Perov returned to Moscow a much different and, according to most, technically superior artist.[44]

In Perov's pre-Paris canvases, such as the last major work he completed before his departure, *Tea-Drinking in Mytishchi*, one senses a kinship with the kind of closed spatial system explored by Fedotov a decade earlier (1862, figure 24). The greenery of the trees and clumps of grass hug the four sides of the painting, providing both a frame through which the viewer peers and a border that keeps the figures at a safe distance. On the whole, the picture presents itself

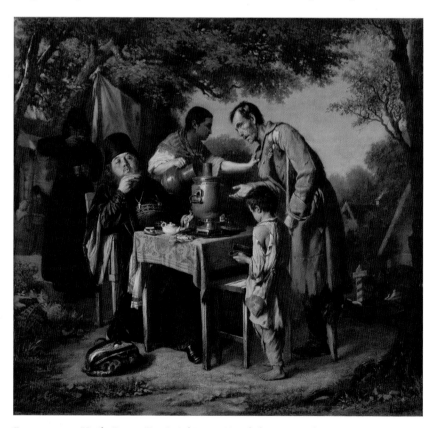

FIGURE 24. Vasily Perov, *Tea-Drinking at Mytishchi*, 1862. Oil on canvas, 43.5 x 47.3 cm. State Tretyakov Gallery, Moscow.

as a theatrical scene staged for the benefit of an audience. In relation to one of Perov's Parisian works, *Savoyard,* from 1863–1864, it becomes clear why so many scholars have identified his years abroad as a turning point (figure 25). Indeed, the comparison immediately makes clear the technical simplicity and even clumsiness of *Tea-Drinking,* the way in which Perov organizes disparate spaces as a series of planes parallel to the picture surface, stacked one in front of another like a relief. There is no amount of imaginative projection that could make the primary scene in the foreground cohere logically with the secondary scenes in the distant left and right middle ground. It is, to be honest, a spatially

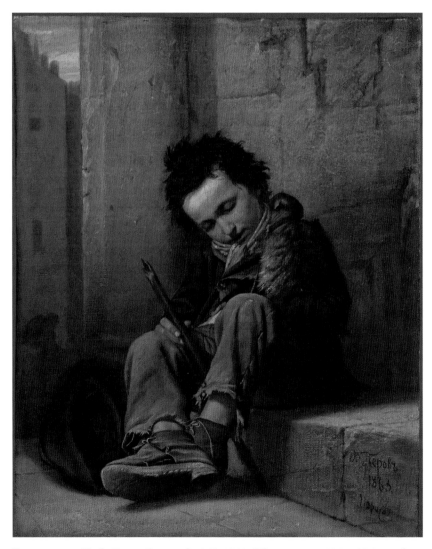

FIGURE 25. Vasily Perov, *Savoyard,* 1863–1864. Oil on canvas, 40.5 x 32.2 cm. State Tretyakov Gallery, Moscow.

flawed painting. In *Savoyard*, however, it becomes clear what a difference a year can make. With a more mature understanding of depth and perspective, Perov invites the viewer into a more nuanced engagement with the space of the picture. Perov must have squatted low on the street to examine the sleeping boy so closely. The right angle where the pavement meets the sidewalk does not rest parallel to the picture plane, but is tilted inward, creating pictorial space that sits at a diagonal, as if a door has been cracked open, allowing the space of the viewer to merge with that of the boy. The street—an urban transformation of the road—guides Perov to his subject and, as a compositional element, guides the viewer into the canvas. Moreover, while *Tea-Drinking* imagines itself as a discrete scene, Perov's later work creates the impression of a fuller reality, one that continues outside the four edges of the canvas and is coterminous with our own.[45]

Unlike Turgenev, Perov did not have entrée into the upper echelons of Parisian and Russian émigré society; his lower social class would have barred him from the finest of homes and their parties, dinners, and teas. It was therefore likely that the experience of roaming the streets of a foreign city provided Perov the most direct access to Parisian life and contributed to his development of the road motif and his new understanding of painterly space. A trace of Perov's presence in the city is evident in the artist's signature affixed to the side of the stone sidewalk in *Savoyard*, as if he is claiming the concrete space as somehow essential to his creative process. Even more compelling is the just

FIGURE 26. Vasily Perov, *Funeral in a Poor Parisian Neighborhood*, 1863. Graphite pencil on paper, 22.1 x 29.2 cm. State Tretyakov Gallery, Moscow.

barely visible shadowy figure on the left side of the painting, a reminder that the boy sits in plain view of any number of passersby, including, of course, Perov himself.

One discerns another dimension of Perov's indebtedness to the street in a sketch of a modest funeral procession in an equally modest Parisian neighborhood (figure 26). Although all of the figures have paused to watch the coffin move into the distance, it is the man on the left side of the street holding a walking stick with whom the composition, positing a viewing point left of center, invites the viewer to identify. A traveler with a pack on his back, he is possibly a double for Perov, an urban wanderer observing scenes from everyday life. The care that has been given to the tracing of individual rounded cobblestones emphasizes not only one's footing in navigating the bumpy streets, but also the importance of the "road" as a compositional element. Even though the buildings that line the right side of the street conform to a clear perspectival orthogonal, it is the street, by far more detailed in its rendering, that carries the weight of the spatial illusion, making the depth and slight incline almost palpable to the viewer. And here, along the uneven urban pavement, resound Shklovsky's words: "A crooked road, a road on which the foot feels the stones beneath it."

Perov borrowed from this sketch not only the subject matter, but also the composition for the first painting he completed upon his return to Russia, *Accompanying the Deceased* (1865, figure 27). Swapping stone for snow, Perov

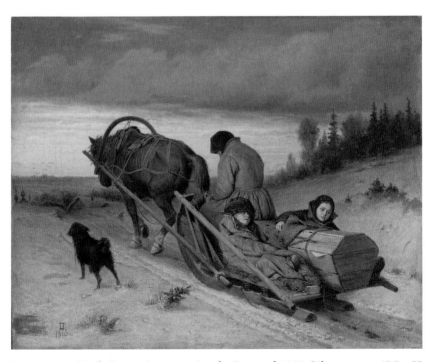

FIGURE 27. Vasily Perov, *Accompanying the Deceased*, 1865. Oil on canvas, 43.5 x 57 cm. State Tretyakov Gallery, Moscow.

nonetheless retains the strong compositional presence of a road, carved into the ground as a diagonal that is in turn echoed in the lines of the sleigh, the harness, and even the planks of the coffin. The mirrored orthogonals of the road and of the line of trees converge in a point marked by a house just over the hill.[46] Exploiting the perspectival potential of the vanishing point, Perov thus creates the illusion of space, and in this space depicts a sky that is beginning to clear in the distance, a flock of birds soaring just above the horizon. Pulled by perspectival depth and attracted by the intense brightness in an otherwise dark landscape, the viewer's gaze cannot help but be drawn into the distance, a space that offers momentary respite from the horse's labored movement and the unrelenting family tragedy.

While Perov's road certainly contributes to this illusion of spatial depth and, in doing so, provides visual relief from the harsh genre scene in the foreground, it also, paradoxically, plays what is now a rather familiar narrative role. In the most obvious sense, Perov's road evokes the kind of metaphor so loathed by Bazarov. It is the road of life, a path from the difficulties of earthly existence toward the bright expanses of eternity, a journey from childhood to adulthood to the afterlife. In fact, in this painting Perov employs a variety of rhetorical devices to communicate narrative content. The story becomes even more explicit in the juxtaposition of the sick sleeping child with the coffin, creating a connective link that tells us he is not long for this world, and in the doubling of the sloped backs of the mother and the horse, a simile uniting two beasts of burden. Because of these semantic and symbolic elements, not to mention the extraordinary suggestiveness of the road as a figure of time, it is not much of a leap to imagine the deathbed scene in a humble peasant home, or the quiet grief at a village graveyard. "Stripped of any kind of culminating moment," writes one scholar, "it appears the result and the continuation of a tragic event that has already happened—the death of the family's breadwinner."[47] Confirming the primacy of story in Perov's creative process, one of his former students even recalls that the artist would actively vet the clarity of his sketches and tear them up if the plot were not sufficiently accessible. "Is the sense of plot [*smysl siuzheta*] understandable in the composition of each sketch?" he would ask. "Is the idea suitably visible [*Dostatochno li vidna ideia*]?"[48]

At the turn of the next century, Alexandre Benois responded to the literariness of Perov's painting in typically modernist fashion. In a move that anticipated Nikolai Punin's dismissal of Fedotov's "anecdotalism," Benois cast Perov as the naïve victim of critical realism's attachment to content. "He just didn't know that the true realm of the plastic arts lies outside literary devices, that painterly *beauty* in and of itself is enough to make up the content of paintings, that a little tacked-on story [*pristegnutyi rasskazik*] only harms its truly artistic meaning."[49] While Perov's paintings undoubtedly rely on literary devices, their stories are anything but "tacked-on." They are integrated into the compositional structure and the color palette, worked into the very surface. It is undeniable that *Accompanying the Deceased* tells a "little story" about a poverty-stricken family who has fallen on great misfortune, a story that suggests the

plight of the lower classes and even bigger questions about the state of Russia. But it is also true that it communicates an entirely different experience in a distinctly painterly manner. The composition, with its vanishing point far left of center, posits us as viewers standing off to the side, somewhere behind the dog leading the way with his footprints in the fresh snow. This dog is meant to be *our* dog, waiting for us to catch up as we stand aside to let the sleigh pass by. This "story" of our encounter is not rendered through a literary device; rather, it is intended to be *felt* through the diagonal composition of the road, highlighting the capacity of painting to control space through the manipulation of perspective and to suggest a specific and meaningful place for the viewer within that space.

In his 1882 eulogy of Perov, Grigorovich speaks of the emotional weight of this canvas. "Before us is a sleigh with a woman and her children; visible is only the back of the woman. [...] Looking at this back alone, the heart constricts, one wants to cry."[50] Grigorovich is right; the woman's back, turned away from the viewer, communicates one of the more profound messages of this picture. On the one hand, it acts as a simile. Her back resembles the back of the horse. On the other, in its refusal to turn to the left, her back relegates the viewer to the position of bystander.[51] This denial of access seems to have not

FIGURE 28. Vasily Perov, Sketch for *Accompanying the Deceased*, n.d. Graphite pencil on paper, 16.9 x 20.3 cm. State Tretyakov Gallery, Moscow.

always been the plan for this painting. In a preparatory sketch, the experience is much different (figure 28). This family seems to have lost a child, for an adult man sits on the coffin and an old woman hobbles behind the cart. She leaves a trail of footprints behind her, one situated snuggly in the lower right corner, a little trail of pencil breadcrumbs for the viewer. No such point of entry is apparent in Perov's painting. Sleigh tracks and paw prints are visible in the snow, but there does not seem to be any plausibly solid footing. The viewer's approach is further complicated by the planked end of the coffin, which acts as a barricade of a sort, and the eerie facial expression of the little girl, off-putting in its directionless stare. Like Perov in Paris, the viewer is an outsider, a pitying yet ineffectual witness to social crimes.[52] Faced with such tragic futility, to recall Grigorovich's words, "the heart constricts, one wants to cry."

The heart constricts. It is not insignificant that Grigorovich uses the same turn of phrase that Turgenev had employed to describe Arkady's response to passing by struggling peasants on the side of the road. Responding to two painterly tearjerkers at the 1863 annual exhibition of the Academy of Arts, Vasily Pukirev's *An Unequal Marriage* and Valery Yakobi's *The Halt of the Convicts*, the progressive critic Ivan Dmitriev writes that the viewer is driven to great sympathy but that this sympathy alone is not enough (figure 63). "We cry, we bitterly cry. I propose, however, that this poor, old convict does not need our cheap tears; our fruitless commiseration brings no kind of benefit to him."[53] Much later, Repin recalls that "the pictures of this epoch forced the viewer to blush, shudder, and more sternly look inside oneself."[54] It is this third component that is so critical, the looking inside of oneself, the examination of one's conscience, for it is this examination that carries the potential for a real social and ethical response. For Perov, these tears, or constrictions of the heart, are not entirely without use. If successfully evoked, they jolt the viewer into a physical and emotional awareness.[55]

The ability to produce this kind of intense and involuntary physical and emotional response is at the core of the more critically oriented realism of the 1860s, even in Turgenev's more benign variant. Indeed, writing in opposition to an understanding of realism as purely objective in its aims, scholars from a variety of disciplines have identified an affective imperative to the realist aesthetic. Recently, for example, Fredric Jameson has argued that the realist novel turns on a persistent dialectic of narrative and affect.[56] Referring more specifically to the Russian context, historian Victoria Frede has claimed that both liberal and radical factions of the 1860s "regarded sensory experience and affective dispositions as essential sources of knowledge about nature, society, and the human individual."[57] The difference between the two groups, for Frede, resides not in the significance of affect, but in how it was conceptualized: the liberal fathers tended to sentimentalize or abstract emotions, while the radical sons considered them physiological impulses to be acted upon. There is still another way to understand the affect of realism, as a means to verify the authenticity of a representation through the physical and emotional

engagement of the reader or viewer.[58] In other words, the realism becomes more real through its affective impact.

In *Accompanying the Deceased*, it is the road that facilitates this physical, emotional, and ethical engagement of the viewer with the picture. It offers a heartrending story about the hardships of a family, but it also leads the viewer away from this verbal realm, into the distant horizon and an experience of soaring, weightless space and bright light. This distinction between the temporal and the spatial, between the "tacked-on little story" and the pictured view, mirrors the ambivalence we experience toward the subjects themselves. We waver between listening to the family's story and forgoing it for the beauty of the landscape, and so too do we feel, in one moment, as if we have been invited into the canvas and, in the next, relegated to the sidelines. We weep, we commiserate. But then we are condemned, or we condemn ourselves. We are, we suspect, complicit. In Perov's painting, the road makes possible this set of aesthetic and interart distinctions, while also reinforcing the social distinctions between the viewers and subjects of realist painting. The road serves as a vehicle for the movement between space and depth and color, on the one hand, and the social content, on the other; and, under ideal circumstances, this movement back and forth drives the viewer toward the recognition of difficult social truths. The awareness of such distinctions, made manifest with a shock to the heart or the burning of one's eyes, contains the power of Perov's realism, its desire to force awareness and spark pity in the viewer.

A Chipped Tooth, a Beaten Path, and a City Wall

While the mother's turned back and the pull toward the bright horizon offer momentary relief from the harsh realities depicted in *Accompanying the Deceased*, there is no similar source of respite to be found in *Troika* (1866, figure 29). No turned backs, no hidden faces, the social content of the picture assaults the viewer like a frigid wind. Stasov mused that these three children might just have been the children of *Accompanying the Deceased* a few years after the death of their father. "If these little children grow up, what sort of life will they then have?" asks Stasov. "Their entire story is told in their rags, poses, in the heavy tilt of their heads, in their tortured eyes, in their dear little mouths, half open from strain."[59] Filling in the gaps of what he sees as a clear narrative trajectory, Stasov charts a path from a tragic rural childhood through an urban transformation and to the present scene. And to be fair, it would be hard to call Perov's approach anything but heavy-handed. The narrative is apparent in the title itself, *Troika*, and the corresponding position of the three children. Its metaphor far less subtle than that of *Accompanying the Deceased*—these children are not *like* beasts of burden; they *are* beasts of burden. Their heads pitch forward, to the right and left, just like the heads of three horses pulling a sleigh through the snow.

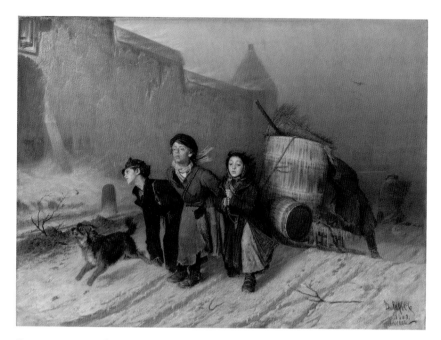

FIGURE 29. Vasily Perov, *Troika: Apprentices Carrying Water*, 1866. Oil on canvas, 123.5 x 167.5 cm. State Tretyakov Gallery, Moscow.

The details in the picture contribute both to a sense of story and a ground-edness in material reality. The boy on the left has two small scratches, one on his cheek and the other on his nose, traces of some previous accident or altercation. A touch of whimsy peeks out of the drab overcoat of the young girl, a pink skirt with fuchsia flowers. In a painting that is overwhelmingly uniform in color tone, this crisp bit of pastel is refreshing, suggesting the girl's past, perhaps even the memory of a doting mother who had chosen fabric in her daughter's favorite color. As for the boy in the middle, he has the most sig-nificant detail of all—a chipped tooth. Perov himself explains this small detail in a short story about the painting, "Auntie Marya," written and published in 1875. In the story, Perov recalls encountering a young boy and his mother while walking near Tverskaya Gate in Moscow one April afternoon. The artist immediately recognizes in the boy a perfect model for the central figure of *Troika*. Years later, the boy's mother, Auntie Marya, walks into Perov's studio, explains that her son has since died, and asks to be taken to the Tretyakov Gallery to view his likeness. Amid many canvases, she immediately picks out the right one and walks directly toward her son Vasya, crying out, "My Lord! My dear one, there is your little chipped tooth!"[60] It is the tooth that makes him recognizable, a tiny detail containing the real boy's personal history and the very essence of his pictorial realism. Overcome with emotion, Auntie Marya falls to her knees and prays to the painting, as if it were an icon.

There is no reason to doubt that the boy's chipped tooth is an indicator of the actual artist's model. And it is also, of course, a textbook example of Roland Barthes's "reality effect," the overwhelming impression of reality produced by a seemingly meaningless detail.[61] But the longer we look, the more we are able to extract this tooth both from an external reality and from an abstract Barthesian conception of "reality." Instead, we discern a distinctly nonverbal function to this detail, not a gapped tooth but a dab of deep crimson paint applied directly over smooth squares of white (figure 30). It seems that Perov had initially painted the boy with a full set of teeth. The chip—an absence turned presence—was applied afterward. This chip, this small dab of oil paint, works double duty. In its sweet sentimentality, it guides the viewer to sad stories of poverty and hardship, such stories as were written by Perov himself or imagined by Stasov. And yet, it also serves as a reminder of the paintedness of this representation. It is, after all, a visible mark of the artist's brush, a mark that pulls the viewer even further toward the surface of the canvas, to a materiality that slips free of signification. In this sense, the crimson dab becomes a moment of complicated referentiality within Perov's painting. It speaks clearly enough to convince Auntie Marya. But it also signifies nothing; it is a pre-figural or pre-semiotic form, not yet implicated in a set of linguistic structures.[62]

In this way, Perov's tooth corresponds to the duck-rabbit conundrum, the kind of optical puzzle that appears time and again in E. H. Gombrich's *Art and Illusion*.[63] Gombrich would say that it is impossible for us to hold both the tooth (with all of its associations) and the dab of paint in our imagination, to be simultaneously aware of the material and the illusion. More recently, art historian Richard Wollheim has countered that this coexistence of material and illusion, while not necessarily harmonious or symmetrical, is one of the defining paradoxes of figurative painting.[64] What the example of Perov's *Troika* highlights is that this coexistence also captures the paradox of realism, both as a mode and as a movement, and that it does so by activating an interart encounter between word and image. Bridging the divide between a painterly mark and Auntie Marya's "little chipped tooth," the form contains

FIGURE 30. Vasily Perov, *Troika: Apprentices Carrying Water* (detail), 1866. Oil on canvas, 123.5 x 167.5 cm. State Tretyakov Gallery, Moscow.

the promise of the realist mode, its promise to signify reality with coherence. But this crimson form, resisting any kind of second order of signification, resisting translation into a word or a story, and stubbornly remaining "just" a dab of paint, also contains potential for the critique of realism. Considered in its historical context, the form's oscillation between material and illusion reflects the vulnerability of nineteenth-century realism's social mission. As we see and then do not see the tooth, we notice and then ignore the content of the picture. We are drawn in, and then we pass by. It is this broadly conceived differentiation between visual and verbal—which was discerned between the landscape's spatiality and the family story in *Accompanying the Deceased*, and which can now also be imagined as a tension between painterly materiality and signification—that produces the fraught nature of Perov's realism. The little storytelling details attract us with their emotional resonance, but so too does the visceral quality of the paint.

This tension is even more apparent on the level of composition. The slow forward movement of the children is countered by the sled, which threatens to slide backward down the slope in the road.[65] The central trio, the cohesive figural group that carries the narrative of the picture, trudges toward an inevitable collision with the viewer; while, simultaneously, wind races toward their bare faces, sending strands of hair flying backward, an inward movement paralleled by the lines of the wall and of the road, meeting at a vanishing point in the distance. Barely visible in the distance is the vague outline of a fellow Muscovite who has presumably just crossed paths with this unfortunate collective. His back is turned. He reminds us of the shadowy figure in the background of *Savoyard*. Perhaps, then, he too is Perov, the artist who collects observations on the city streets. Or maybe he is a random urbanite, walking to or from work? Or might he be someone else entirely—you, me—the viewer, in this case, cast as passerby?[66]

Although the passerby was always a part of *Troika*'s composition, in a preparatory sketch this figure seems to have had a slightly different tone (figure 31). Far more visible and carrying some kind of bucket or shoulder bag, he or she is just another urban laborer, like the children and their master. Moreover, the overall brightness of the sketch lends a certain equivalence between the central figures and the passerby. In the final work, Perov has cloaked the passerby in darkness. Without relatively careful scrutiny, the viewer might not even notice him. The compositional clues, however, all lead to this figure; the deep tracks of the packed-down snow and the stepped levels of the monastery wall converge at the passerby and the very faint outlines of the ancient city.[67] Given the lack of identifying characteristics in his final painted version, the passerby remains unmarked, but also undeniably unoccupied, in opposition to the toiling children in the foreground. This contrast produces the internal social tension of the picture, a tension that is then communicated and possibly even transferred to the viewer. Because the passerby's ill-defined nature makes him a rather effective double for the viewer, he functions as a means to enter the painting and imagine the experience of engaging (or not engaging) with

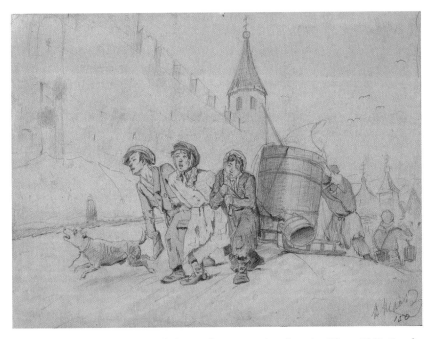

FIGURE 31. Vasily Perov, Sketch for *Troika: Apprentices Carrying Water*, 1865. Graphite pencil on paper, 15.7 x 21 cm. State Tretyakov Gallery, Moscow.

the children. His unburdened stroll becomes ours, and his troubled relation to the children becomes ours as well.

It is important to note that *Troika* is quite large for Perov's works of this time, and large for a genre painting, in general.[68] At about 120 by 170 centimeters, it is easily twice the size of *Accompanying the Deceased*. The effect of this scale cannot be underestimated. Standing in front of the painting, the viewer is enveloped by its coloring, which registers simultaneously as drab and gray, but also somehow warm. What is particularly eye-catching, however, is the blanket of snow that covers the lower quarter of the canvas. Unlike *Accompanying the Deceased*, the deep grooves in the snow intersect the bottom edge of the frame at several places, allowing the viewer multiple points of entry. It takes only a brief glance downward to be captivated by this beaten path, by the layering of textures and the tactile impasto of white, gray, and brown paint. This thickly applied field of warm gray tones finds its echo in the solid, impenetrable wall that provides the backdrop for the children's faces.

The wall also plays a role in the social message of this picture. As one of the imposing sides of the fortress of the Rozhdestvensky Monastery, it leads toward the distant and vague skyline of Moscow, representing the insurmountable barrier between the city, the realm of the clerical and privileged classes, and the gloomy outskirts, where our young heroes are doomed to spend their days. Despite this clear informative function, one scholar calls the wall a "mirage," somehow a more fitting, if somewhat elusive, description.[69]

As one of the more arresting elements of this picture, the wall does seem to work some magic. It appears to shimmer, catching bright pinks, oranges, and whites, at once immaterial and unforgiving in its brute materiality. Pitched at an angle, the wall seduces the viewer into the picture, but it also, in its facture and unbroken planarity, restores the blunt surface of the picture plane, becoming a border between real and pictorial space.[70]

As such, the wall, like the tooth, embodies the tension between reality and its representation inherent to realism, and expresses this tension as interart friction between the narrative and the pictorial. On the one hand, the wall acts as a sign of urban privilege, a literal barrier between social classes, and also serves as the backdrop for the children, transforming the viewer into the witness of an everyday urban drama. On the other, it insists upon a painterly materiality that is not inscribed into any narrative or signifying system. Importantly, the wall also houses a diagonal line that, paired with the road, pulls the viewer deep into the space of the picture. Like Turgenev's, Perov's road structures an imagined movement through space and time, into deep space and back to the surface, toward the narrative of the three children and toward spots that refuse to speak at all. In its constant mobility, the road ensures that the fissures between reality and representation in Perov's realism do not remain unbridgeable. In other words, we are never allowed to focus only on the "mirage" of the wall or only on the story of the children. Rather, like the passerby in the distance, we continually move along the road, seeing little scenes and then noticing their aesthetic construction. In our movement between these differentiated categories—between near and far, word and image, illusion and material—we also trace the social distances between ourselves and those around us, between a position of viewing privilege and subjects that are far from empowered. By exposing these subtle interart standoffs, not yet battles but certainly no longer embraces, Perov therefore draws our attention to the dual challenges of realist representation and Russian imperial reality, both troubled by fissures and fractures and divisions that seem to only grow with the passage of time.

Passing By

Last Tavern at the Gate is Perov's final serious consideration of the road motif (1868, figure 32). What is remarkable and quite new about *Last Tavern* is the relationship between foreground and background, the relative quiet of the genre component of this picture and the dominance of the distant landscape. This picturesque micro-landscape, a delicious riot of golds and yellows, acts as a magnet, both for the imagined traveler on the path beaten into the right side of the canvas and for the gaze of the viewer. Unlike the road in *Troika*, this road is unencumbered by hills or branches or rough patches. There is absolutely nothing to obstruct the path toward the city gates. Or almost nothing. However appealing the view in the distance, the glimmering of orange

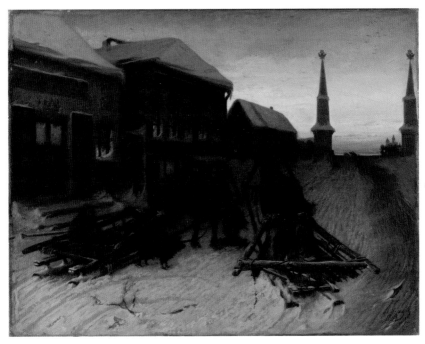

FIGURE 32. Vasily Perov, *Last Tavern at the Gate*, 1868. Oil on canvas, 51.1 x 65.8 cm. State Tretyakov Gallery, Moscow.

candlelight in the tavern's windows is bound to eventually catch the viewer's eye. The empty cart by the path is evidence that another traveler has been lured by the same sight, a promise of rest, good food, and a warm drink. This diversion away from the horizon and toward the left side of the road guides the viewer, perhaps for the first time, to what is otherwise quite difficult to see. A young girl, wrapped in a burgundy shawl, looks directly out, blowing on her fingers to keep them warm (figure 33). It is dark, very dark. It is easy to miss her—how could we have missed her?—but once she catches the viewer's eye, she can no longer be ignored. This is a powerful recognition. Given the social orientation of Perov's oeuvre, it is tempting to see the landscape as an aesthetic flourish, just a little something to brighten the picture, but otherwise disconnected from its true meaning.[71] But there is also a way to understand the meaning of the picture as emerging precisely from this tension between the girl in the foreground and the pretty scene in the background. Manipulating the contrast between genre and landscape, between dark and light, Perov confronts the viewer with an aesthetic and an ethical fork in the road. While he relegates the critical content to the dark shadows in the lower left corner, he opens up a purely visual realm in the distance, all light and color and depth. Pulled toward the picturesque yet haunted by the social content, the road is what brings together, but also what pulls apart, these two distinct modes. The viewer can drive into the sunset, or witness the suffering of a child. But neither

FIGURE 33. Vasily Perov, *Last Tavern at the Gate* (detail), 1868. Oil on canvas, 51.1 x 65.8 cm. State Tretyakov Gallery, Moscow.

option can be forgotten, for the road contains them both—stopping and passing by, narrative and pictorial—and forces the viewer to negotiate these distinct experiences, and confront his choice of looking at one over the other.

In his 1871 review of the first exhibition of the Wanderers, Saltykov-Shchedrin writes about yet another roadside spectacle, this one by Perov's friend and colleague Illarion Pryanishnikov (figure 34). His comments could easily have been applied to Perov's *Last Tavern*, and capture much of what makes the figure of the road so aesthetically and ethically productive for critical realism.

> Despite the uniformly bleak environs of *Empty Carts* (the highway in winter), it is difficult to tear oneself away from this painting. Everyone, of course, has a hundred times over happened to pass by a scene exactly like the one depicted in *Empty Carts*. And everyone, undoubtedly, has endured the well-known impressions of this spectacle; the impressions were so fleeting and hazy that the consciousness remained untouched. Mr. Pryanishnikov offers the opportunity to examine these impressions. You see before you shabby sleds, shaggy, undersized peasant horses on which a broken harness rattles and rumbles; you see a seminary student in an overcoat, not resembling at all warm clothing, who, having bunkered down in the sled, is clearly tormented by one question alone: will he arrive at his destination or freeze on the road? You see all of this, and thus the scene does not catch you unawares; it is fully possible for you to penetrate this innermost essence that has eluded you until

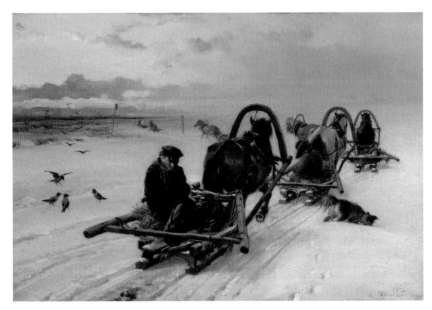

FIGURE 34. Illarion Pryanishnikov, *Empty Carts*, 1872. Oil on canvas, 48 x 71 cm. State Tretyakov Gallery, Moscow.

now. The whole force of this talent is contained in this ability to turn the viewer inside himself [*obratit' zritelia vnutr' samogo sebia*], and Mr. Pryanishnikov possesses this force in large amounts.[72]

According to Saltykov-Shchedrin, the success of Pryanishnikov's painting lies in its ability to force the viewer to contemplate a scene that he or she would normally have passed by. This is, in some basic sense, the crux of all realist representation, to make visible or knowable that which had been previously overlooked. In this case, however, and even with realists as different as Turgenev and Perov, there is still another dimension to realism in the age of reform. In addition to striving for mimetic representation, it must also push its audience to greater heights of self-understanding, and perhaps even inspire them to act or, at the very least, empathize.

Two final images of travelers on a road serve as a fitting conclusion to this chapter's consideration of Turgenev's and Perov's realisms. The first returns us to Turgenev. With a frank conversation between author and reader, Turgenev closes his novel *The Nest of the Gentry* in the following way:

"And is that the end?" the dissatisfied reader may ask. "What happened afterwards to Lavretsky? What happened to Liza?" But what can one say about people who may still be living but have passed from the walks of life, why not return to them? [...] What did the two of them think, what did they feel? Who can know? Who can say? There are such moments in life, such feelings ... One can but point to them—and pass by. (7:294; 203)

This is, on Turgenev's part, an admission of incompleteness, inadequacy, the shortcomings of representation. He concedes that, as a writer, he does not have access to a finite reality. He can merely take the reader by the hand, acting as a guide through the narrative of the novel and pointing out impressions otherwise too fleeting to notice. The lone figure in an 1873 sketch by Perov evokes this image of Turgenev as the writer-traveler (figure 35). Or, perhaps more likely, it is Perov himself, the painter-traveler, moving into the wind with the aid of a walking stick, passing by scene after scene, picture after picture, occasionally standing aside or whistling for his dog to wait up. One never knows what to expect on such journeys, except that there will be surprises, happy encounters and unsettling ones, views worth stopping over, and stories that make the skin prickle, the heart clench. What seems most important, for both

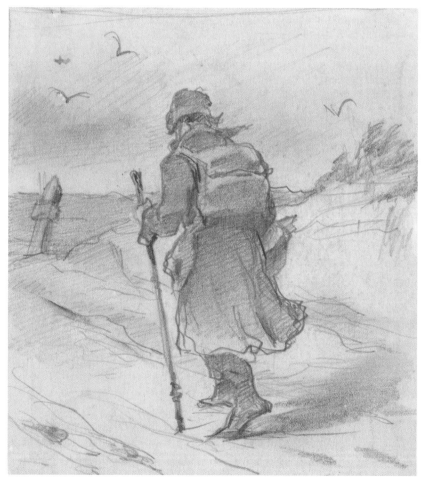

FIGURE 35. Vasily Perov, *Wanderer*, 1873. Graphite pencil on paper, 15.4 x 13.5 cm. State Tretyakov Gallery, Moscow.

Turgenev and Perov, is to keep moving along the road, accumulating impressions of life, and striving toward an ever more complete, more proximate, and more telling view of reality.

In the first decades of realism in Russia, the writers and artists of the Natural School and the sixties cover quite a bit of ground, figuring out how exactly to see and write about a distinctly national reality, how to convince and engage a reader or a viewer, how to produce art that is both aware of its own procedures and brash enough to pretend not to be. By the age of reform, what has come to be known as the classic Russian novel is beginning to emerge, painting is becoming more independent, and, as with any process of maturation, with greater sophistication comes greater self-awareness. The chapters to come will follow this process through a selection of works by Tolstoy, Repin, and Dostoevsky. More specifically, each of these creative giants will be shown to manipulate interart relations to his own end, transforming the Natural School's *ut pictura poesis* and the subtle aesthetic differentiation of Turgenev and Perov into a full-fledged contest between the sister arts. In ways subtle and less so, these artists will ask what best represents reality, literature or painting. And in their answers will be novels and pictures that aspire not only to mimesis, but to representation that is transgressive, transfigurative, and boldly self-conscious.

3

Tolstoy's Novelistic Illusion

> The spirit of the troops is beyond any description.
>
> LEV TOLSTOY[1]

ON THE EVENING OF August 24th, in that fateful year of 1812, Pierre Bezukhov leaves Moscow, riding west in the direction of Mozhaisk. He has heard that there has been a great battle, although no one seems to know whether the French or the Russians have emerged triumphant. Caught up in the excitement of such a monumental historical event unfolding on the very doorstep of the ancient capital, Pierre hastens to join the flood of troops migrating toward the action. Ever the impressionable sort, he is quickly overcome by "the need to undertake something and sacrifice something," to become part of something bigger than himself (11:182; 752). After informing us that this is "a new, joyful feeling for him," our narrator takes temporary leave of Pierre, so as to offer one of those historiographic interludes for which *War and Peace* (1865–1869) is so famous (11:182; 753). When next we meet Pierre, it will be the morning of the twenty-fifth, one day before the Battle of Borodino, arguably the turning point of the Napoleonic invasion, as well as the climax of Tolstoy's novel.

In the intervening chapter, the narrator dismantles the varied historical narratives that have since attempted to make sense of those two days spanning the fall of the Shevardino redoubt, the news of which sends Pierre on his way, and the battle outside Borodino. According to historians, it is explained, Napoleon Bonaparte and Mikhail Kutuzov carefully chose the location of the battle, positioning and repositioning their respective armies consciously and strategically. "So the historians say," retorts the narrator, "and it is all completely incorrect, as anyone who wishes to get the essence of the matter can easily satisfy himself" (11:184; 754). To reach said "essence," Tolstoy would travel to the historic site in September of 1867, declaring in a letter to his wife that he plans to write "a battle of Borodino, the likes of which there has never been" (83:152–53).[2] And so, when the narrator states that the inaccuracies

in the historical record, maintained to preserve the apparent "glory" of the revered generals, are "obvious to anyone who looks over the field of Borodino," it is not difficult to imagine Tolstoy himself surveying the geography, amending textbook accounts, and scribbling over the labels on military diagrams (11:185; 755). The narrator then proposes his own, markedly less heroic, summary of events, explaining that the final position of the Russian troops was certainly not planned, more the result of a hasty and haphazard response to shifting conditions than of Kutuzov's military genius.

To make clear this rift between what was planned and what actually happened, the narrator inserts a map (figure 2; 11:186; 757).[3] On this map, the *only* illustration in all of *War and Peace*, the "proposed" (*predpolagaemoe*) and "actual" (*deistvitel'noe*) positions of the French and Russian troops are marked by two sets of parallel rectangles, one formed by an appropriately patchy dotted line and the other by a more certain solid line. The proposed battle positions face off across the Kolocha River, cutting what-could-have-been into a diagonal across the page. And then, with a forty-five-degree turn counterclockwise, the narrator indicates the series of events that led to the actual battle: the advance of the French forward and around, the subsequent loss of Shevardino, the Russian flank swinging back uncontrollably as if on a broken hinge. And yet, beyond this initial assistance in visualizing the placement of the troops within the complicated geography of Borodino and its surroundings, the map offers little.[4] If we look closely, we see nothing of what *really* happened in that space between or indeed within the two sets of rectangles. Rather, the distinction between dotted, wavy, and straight lines that produces the meaning of the map, its potential to carry information, dissolves under the pressure of our gaze.

The narrator expands upon the inadequacy of such maps in the chapters that follow the battle. In a gesture that implicates us as readers in this historiographic farce, he writes that while we might think of war while "sitting at ease in our study, analyzing some campaign on a map," the *real* military commander is never so removed from the battle (11:269; 825).

> A commander in chief always finds himself in the middle of a shifting series of events [*v sredine dvizhushchegosia riada sobytii*], and in such a way that he is never able at any moment to ponder all the meaning of the ongoing event. Imperceptibly, moment by moment, an event is carved [*vyrezaetsia*] into its meaning, and at every moment of this consistent, ceaseless carving of the event [*v kazhdyi moment etogo posledovatel'nogo, nepreryvnogo vyrezyvaniia sobytiia*], a commander in chief finds himself in the center of a most complex play of intrigues, cares, dependency, power, projects, advice, threats, deceptions. (11:269; 825)

The narrator is obviously quibbling here with a kind of armchair warcraft, the presumption that anyone, historian or otherwise, could possibly glean the truth of an event from a position temporally and spatially removed, past the end and up above. This, of course, is a challenge not only for the historian or

the historical geographer, but also for the writer of historical novels. How will Tolstoy, poring over histories and memoirs at Yasnaya Polyana, describe in a fresh and insightful manner the Battle of Borodino, an event that has already been chiseled into the national memory? How will he move beyond history as a collection of shiny carved objects and toward a Borodino that is located within time, moment by moment by moment?

The answer is to be found precisely in this telling juxtaposition between a map and "a shifting series of events," between a static visual representation and the dynamic sequence of moments, perspectives, contradictions, and complications that makes up novelistic narrative. In his version of the most decisive battle of the Patriotic War, Tolstoy employs one of his favorite devices, the revelation of shortcomings, or even downright deception, in certain kinds of storytelling. Not even young Nikolai Rostov, flushed from his first experience of combat, is immune to this critique: "He told them about his Schöngraben action in just the way that those who take part in battles usually tell about them, that is, in the way they would like it to have been, the way they have heard others tell it, the way it could be told more beautifully, but not at all the way it had been" (9:295; 242). The realism of Tolstoy's novel is built on the disavowal of countless such false narratives, and the episodes that make up the Battle of Borodino are no exception.[5] What renders them unique, however, is that they activate still another level to this opposition. Just as they overturn aggrandizing and sensationalizing historical and personal accounts in favor of a more authentic war narrative, so too do they expose the limitations of, and in many cases dismiss altogether, visual modes of representation. Both the actual map inserted by the narrator and the imagined one "in our study" become emblems of this struggle for the most effective and persuasive account of history. In this interart encounter, the novel absorbs what the map (and on a more general level, the visual) offers: the ability to make images virtually present to a reader. In contrast to the illustrations and visual tropes of the Natural School, however, Tolstoy's novel also highlights the insufficiencies of the visual, especially its inability to incorporate temporality, before offering a distinctly narrative solution. This alternative—what is called in this chapter Tolstoy's novelistic illusion—arises out of a polemic against pictorial or optical illusions, and promises a representation of history, grounded in narrative, that best approximates the time, movement, and dimension of lived experience. So why must this supposedly more accurate version of the battle depend upon a polemic with the visual? Well, as our narrator says in response to Nikolai's tall tales, "to tell the truth [*rasskazat' pravdu*] is very difficult" (9:296; 242). Indeed, even though narrative itself is not infallible, it remains nevertheless the better illusion for Tolstoy's novel, strengthened at the expense of other (in this case, visual) modes of representation. This skirmish with visual modes of perception is, in a sense, a sleight of hand that enhances the perceived "truth" of the novelistic illusion.[6]

This sustained polemic with the visual sphere does not, however, render the Borodino chapters (or Tolstoy himself) aggressively anti-visual.[7] Much to the contrary, the Battle of Borodino presents history to the reader as something

that *can* and *must* be seen. Focalized almost entirely through the appropri-ately bespectacled Pierre, the narrative moves through panoramic vistas, over fields, and into trenches. Andrei will contemplate the projections of a magic lantern on the eve of the fatal event. There will be paintings and icons, binoc-ulars and telescopes. Pierre even gives voice to this visual imperative, telling a field doctor that he just "wanted to have a look" (*khotelos' posmotret'*). "Yes," the doctor answers, "there'll be plenty to look at" (11:189; 759). If inclined to imagine a doubling of hero and author, one might locate the origins of Pierre's insistence on seeing the battle in Tolstoy's own creative process, and in par-ticular, in his trip to Borodino. As one scholar has observed, Pierre "repeated the path of Tolstoy himself from Moscow to Borodino. Just like Tolstoy, Pierre departed Moscow after dinner and changed horses in Perkhushkovo."[8] And just like Tolstoy, he then moves on to Mozhaisk, stands atop a hill at Gorky, and ultimately descends from this elevated viewing point to see what the bat-tlefield was like for the soldiers on the ground. In fact, the Borodino chapters as a whole chart a trajectory similar to Tolstoy's, moving from the analysis of military maps to the field of battle itself, forever trying to find the right place to have a proper look.[9]

Realism's reliance on visual experience to access accuracy in representation originates in part, as was discussed especially in relation to the Natural School, in Enlightenment, and namely Lockean, associations of sight with truth. Peter Brooks has argued, however, that the works of high realism distinguish them-selves by pushing such first-order phenomenal observations into more expan-sive epistemological realizations.

> The visual is not necessarily the end of the story—hearing, smell, touch may ulti-mately be just as or more important—but it almost of necessity seems to be the beginning of the story. Realism tends to deal in "first impressions" of all sorts, and they are impressions on the retina first of all—the way things look. [. . .] It is on the basis of first impressions that the greatest realists will go on to far more encompass-ing and at times visionary visions, ones that attempt to give us not only the world viewed but as well the world comprehended.[10]

Although the notion of the visual "first impression" is a profound one for Tolstoy, the way in which Tolstoy mobilizes that impression introduces an important, if subtle, complication into what Brooks describes as a fundamen-tal connection, even causation, between visual observations and subsequent realizations. While it is certainly true, therefore, that Tolstoy often starts with the visual—showing the reader a map, placing Pierre before a panoramic view of the battlefield—he also just as quickly harnesses the temporality of nar-rative to move the reader and the hero beyond visual first impressions, sup-planting them with what the novel proposes is a fuller and more convincing representation.[11]

There have nevertheless been frequent and compelling attempts in literary scholarship to identify Tolstoy as a visual, and indeed visionary, writer. Perhaps

the most influential of such readings is that of Dmitry Merezhkovsky from the turn of the last century. Contrasting Tolstoy as a "seer of the flesh" (*tainovidets ploti*) with Dostoevsky as a "seer of the spirit" (*tainovidets dukha*), Merezhkovsky champions Tolstoy's ability to translate concrete visual phenomena into prose, thus summoning his subjects to life, and forging mystical bonds between his characters and his readers: "We enter into their inner world, we begin to live with them, live in them."[12] Such a vision is more than empirical; it is a second sight, capable of transcending the boundaries of the physical and metaphysical worlds.[13] A century later, in her study of *Anna Karenina*, Amy Mandelker makes a similar argument, claiming that Tolstoy counters a purely mimetic visuality, born of the Western Enlightenment, with an Eastern-inflected "iconic aesthetics," an approach to representation that seeks to move beyond verisimilitude and toward symbolic, lyric, and mythological images.[14]

Both Merezhkovsky and Mandelker maintain that Tolstoy's engagement with visual phenomena must yield to higher-level orders of vision, to something like the mystical, transforming the author into a "seer" of that which is unavailable to plain sight alone. And indeed, in a basic sense, Tolstoy *does* seek something beyond vision. However, unlike Dostoevsky who, as is discussed in chapter 5, reaches for transcendent visual images beyond the purely mimetic, Tolstoy seeks this something else not in pictures, but in words. Tolstoy does not, therefore, move his heroes (and readers) from the visual into a Brooksian "visionary vision," but rather *through* the visual toward a supposedly more truthful narrative representation of life in all its dimensions. This is not to say that words and narrative are infallible for Tolstoy. As the example of Nikolai's war stories proves, they are not. But time and again, Tolstoy posits novelistic narrative as the better, if still necessarily imperfect (as any representation must be), illusion.

This mistrust of vision is motivated in part by the novel's suspicion of foreign modes of representation, but it is also rooted in the particular historical conditions of visuality at the time. While the Enlightenment had celebrated sight as the "noblest of the senses," the invention of photography and the popularity of devices of optical illusion in the nineteenth century initiate vision's fall from grace, a fall that would conclude with, to quote Martin Jay, a "full-fledged critique of ocularcentrism in the twentieth century."[15] Jay writes: "But if photography and its improvements, like the three-dimensional stereoscope which came into prominence in the 1860s, could be praised for providing ever more faithful reproductions of the seen world, a subcurrent of skepticism also began to emerge. The most prominent inventor of the camera had, after all, been known as the master of illusion."[16] Jay's "master of illusion" is none other than Louis Daguerre, inventor of both the diorama, a device of optical trickery, and the daguerreotype, a presumably "truthful" reflector of reality.[17] In a slightly different spin, art historian Jonathan Crary attributes this revolution more specifically to the (binocular) stereoscope, as opposed to the (monocular) camera, and its creation of a wholly subjective and embodied observer, one that "becomes the active producer of optical experience."[18] Wherever

the emphasis is placed, what remains clear is that at precisely the moment when Tolstoy is writing his account of Borodino, the sense of sight, while still accepted as the primary means for acquiring epistemological truth, was also increasingly associated with amusement and deception. In short, the visual had never been so real and yet so illusory.

On the hills and fields around Borodino, there is plenty for Pierre to look at, and the narrator affords him this vision through a series of optical illusions meant to simulate reality. The novel lingers on picturesque descriptions of a landscape marred by battle, taking advantage of the potential for prose to harness what the ancients called *enargeia*, the rhetorical device of making present, making *visible*, verbal images.[19] In this, Tolstoy's novel reveals its debt to the Natural School, and more specifically, to the way in which the authors of physiological sketches had made visible previously unknown corners of urban space. Although he maximizes this power of visual language, Tolstoy ultimately rejects visual experience and pictorial representation as aesthetically and morally inferior, assuming a position that reflects a Lessingian insistence on artistic borders far more uncompromising than Turgenev's moderate differentiation. This is not, to be clear, a wholesale attack on vision; rather, Tolstoy engages the word-image divide as a polemical device, to reflect on the mechanisms of representation and posit a narrative of history that gains in credibility through opposition to an artistic "other." In its interart encounters, the novel asserts its ontological specificity as a genre, resisting and shedding visual modes of representation, and celebrating the fact that it is literary narrative alone (or so it boldly maintains) that allows Pierre to "take a look," to walk down and around, to experience history from afar and up close. In writing the Battle of Borodino, then, Tolstoy also writes a realist *paragone*, a statement of the novel's superiority to other media in the representation of reality.

Pierre's Panorama

After the narrator's lengthy excursus on the shortcomings of historiography and its maps, the next chapter rejoins Pierre as he drives out of Mozhaisk and ascends a small hill to get a clearer view of the battlefield.

> It was eleven o'clock in the morning. The sun was a little to the left and behind Pierre and, through the clear, rarefied air, shone brightly on the vast panorama that opened out before him like an amphitheater over the rising terrain.
> Cutting through [*razrezyvaia*] the upper left of this amphitheater, the Smolensk high road wound its way through a village with a white church that lay five hundred paces from the barrow and below it (this was Borodino). The road passed under the village, across a bridge and, ascending and descending, wound higher and higher up to the village of Valuevo (where Napoleon was now staying), visible some four miles away. [...] All over this blue distance, to right and left of the forest and the road, in various places, were visible [*vidnelis'*] smoking campfires and indefinite

masses of troops, ours and the enemy's. To the right, along the courses of the Kolo-cha and Moskva rivers, the terrain was all hills and gullies. Between their gullies, in the distance, the villages of Bezzubovo and Zakharyino were visible [*vidnelis'*]. To the left the terrain was more level, there were grain fields, and one smoking, burned-down village—Semyonovskoe—was visible [*vidnelas'*]. (11:191–92; 761)

Repetition of the reflexive verb "to be visible" (*vidnet'sia*) emphasizes that Pierre stands before a landscape that has been positioned especially for visual consumption, a view that is static, independent of its viewer, available to all who pass by. With the sun illuminating the view, the narrator deciphers this topography, translating visual evidence into approximate distances and even offering parenthetical remarks, identifying the barrow as Borodino and the location of Napoleon. This is the historiographic voice whispering to Pierre from the previous chapter, labeling the landscape as it had labeled the dia-gram.[20] This schematic diction is enhanced by the typographic appearance of the words on the page. Capitalized, the proper names of villages and riv-ers stand out like signposts, making the description strikingly legible. And this almost unmediated legibility, independent of syntax, intensifies the association of Pierre's first impression with the reader's initial impression of Borodino on the map. Activating a narrative mobility similar to that of Turgenev's roads from the previous chapter, the Smolensk high road, "cut-ting through" (*razrezyvaia*) the scene, indicates a force that might counter such topographic stasis. In their shared root (*-rez*), the Smolensk road pre-figures the "shifting series of events," forever in the process of being carved (*vyrezyvaniia*), that the narrator opposes to a military map as a more genu-ine experience of history.

Despite the historiographic atmosphere of this first description, a narrative voice more appropriate to fiction nevertheless makes itself heard. The smoking campfires of the troops, although not entirely visible, remind Pierre and the reader that there is another sphere within which to understand these events, one outside of the visual map, down from the raised viewing point, and with the soldiers themselves.

> Everything Pierre saw to the right and the left was so indefinite that neither the left nor the right side of the field fully satisfied his notions. Everywhere there were fields, clearings, troops, woods, smoking campfires, villages, barrows, streams, but not the battlefield he had expected to see; and as much as he tried to make it out, on this living terrain he could not find a position and could not even distinguish our troops from the enemy's. (11:192; 761)

Just as there was little of substance, of the *essence* of history, that was visible on the map of troop positions, there is little that can be discerned in this ele-vated view of the battlefield. The problem here seems to arise from a confu-sion of perspectives. While the elevated view is legible to the historian as an abstraction of events, Pierre resides in a different generic space altogether, in

On the next day, having overcome this initial disappointment, Pierre makes
a second attempt to "see" the battle. He reascends the hill at Gorky, this time
accompanied by General Kutuzov and other military officers, and stands
transfixed before a view that has shed its map-like associations for language
reminiscent of the colors, chiaroscuro, and materials of the fine arts.

> Going up the steps to the barrow, Pierre looked ahead of him and froze in delight at
> the beauty of the spectacle [*zamer ot voskhishchen'ia pered krasotoiu zrelishcha*]. It
> was the same panorama he had admired from the barrow the day before; but now
> the whole terrain was covered with troops and the smoke of gunfire, and the slant-
> ing rays of the bright sun, rising behind and to the left of Pierre, cast over it, in the
> clear morning air, a piercing light of a pink and golden hue, and long, dark shadows
> [*s zolotym i rozovym ottenkom svet i temnye, dlinnye teni*]. The distant woods, end-
> ing the panorama, as if carved from some precious yellow-green stone, were visible
> [*vidnelis'*] with their curved line of treetops on the horizon, and between them,
> beyond Valuevo, cut the Smolensk high road, all covered with troops. Golden fields
> and copses glistened closer by. Everywhere—ahead, to the right, to the left—troops
> were visible [*vidnelis'*]. It was all lively, majestic, and unexpected. (11:225–26; 789)

Although the landscape is described as "lively," again the repetition of the verb
"to be visible" acts as a frame that freezes this view as the object of our gaze.
Stopping Pierre in his tracks, the visual asserts its potential to still movement,
to stop the flow of narrative and allow for a leisurely contemplation of space
and form. And what this contemplation reveals is a landscape that is pictur-
esque, shot through with brightly colored hues and alternating patches of light
and shadow, marked off with a horizon of trees. To recall this chapter's open-
ing example, these trees, already carved into glistening green gems, represent
anything but the "consistent, ceaseless carving" of a "real" event. Nothing here
is evolving or changing. Nothing is difficult, or painful, or complex. Rather,
Pierre is stricken with the delightful beauty of the spectacle. His is an anesthe-
tized picture of war, lovely and safe, yet morally dangerous.[21]

At this point, the narrator ushers in the fog, and with this flirtation of sun-
light and mist, transforms the static image into an optical illusion:

> Above the Kolocha, in Borodino and on both sides of it, especially the left, where
> the Voyna, between its swampy banks, flows into the Kolocha, hung that mist which
> melts, dissolves, and turns translucent in the bright sun, and magically colors and
> outlines [*volshebno okrashivaet i prosvechivaet*] everything that shows through it. [. . .]
> And all this was moving, or seemed to be moving [*dvigalos' ili kazalos' dvizhushchim-
> sia*], because of the mist and smoke spreading over the entire expanse. (11:226; 790)

The fog becomes an artistic force and "magically colors and outlines," stirring
the landscape to life. Pierre stands frozen in front of the spectacle, absorbing

the visual information before him and locked in that epistemological limbo of the optical magic trick. As engrossing as this picture is, as entertaining the diversion, the seeds of doubt have been sown. Was it all moving, or did it only seem to be? Was it *real*, or simply an illusion?

By twice calling this view a "panorama," the narrator hints at the source of its instability as an image. It is possible (and perhaps even likely) that Tolstoy borrowed his "panoramic" terminology from war veteran and poet Fyodor Glinka's 1839 reminiscences of the Battle of Borodino.[22] Purporting to offer his reader a "fleeting panoramic view" (*beglyi panoramicheskii vid*) of the battle, Glinka writes: "Let us assume that one of the French artists made sketches for compilations of panoramic paintings of the Battle of Borodino." Glinka then invites us to imagine ourselves as artists, standing fixed at a "central point" and looking at scene after scene after scene.[23] At the conclusion of his panoramic description, Glinka tasks us, his readers, with transferring our observations "from paper to canvas," so that we have a "series of paintings, corresponding to the series of moments of the Borodino battle."[24] This compilation of discrete images is precisely what Pierre initially hopes to collect from his wartime experience, a survey of the space that approximates the supposed *look* of a battle, a look that synthesizes and aestheticizes an otherwise messy reality.

When Glinka writes of panoramic paintings, he seems to have in mind something like a collection of wide-angle views of the battlefield. However, the figurative and literal meanings of "panorama"—on the one hand, as a broad, sweeping, all-encompassing view or survey, and on the other, as a 360-degree painting on a cylindrical surface—remained closely linked throughout the nineteenth century.[25] It then seems appropriate, and indeed necessary, to restore the technical meaning of "panorama" to our far more general understanding of the word in its contemporary usage. What results is a peculiarly modern, in the nineteenth-century sense, vision of Borodino. Pierre, it turns out, is not just looking at a picturesque landscape; he is immersed in the spectacle of a panorama.[26]

Invented in 1787 by Robert Barker, a portrait painter from Edinburgh, the panorama was one of many forms of leisure entertainment that enjoyed enormous popularity in the nineteenth century.[27] The cultural obsession with the panorama, diorama, and other "-ramas" even reaches the dinner table of the Maison Vauquer in Honoré de Balzac's *Le Père Goriot* (1834–1835): "That new invention, the Diorama, which carries optical illusion to an even higher level than did the Panorama, has led a number of painters' studios to coin the jesting word 'rama,' the introduction of which term into the Maison Vauquer was effected by a young painter who often visited and had, as it were, inoculated the pension with it."[28] "Are we ever going to have *dinnerama*?" asks Bianchon. "Here comes a wonderful *souparama*," remarks Poiret. And likening the thick fog that had enveloped Paris that morning to the sickly and dejected aura of the old man Goriot, yet another dinner guest delivers the final punchline, "A *Goriorama*, because no one could see a thing."[29]

Meant to simulate a 360-degree view of the landscape, the panorama strives to eliminate all evidence of its artifice by controlling the interior environment of its circular home. The overhead lighting is coordinated with the temporally specific shadows in the painting. The outer edges of the canvas are obscured in darkness, directing the observer's eyes only to the illusionistically painted image. "False terrain," sculptural elements attached to the flat surface of the canvas, help to ease the transition between reality and illusion. And, most importantly, the path of the observer is restricted to the dark corridor leading up to the viewing platform and to the platform itself. If allowed to stray from the raised platform, the results could be disastrous, revealing the distorted perspectives, plywood props, and stretched canvas of the optical illusion. "The panorama," to quote one scholar of the device, "took charge of its spectators."[30]

In his history of the panorama, Stephan Oetterman calls this curious form of visual culture a paradox. "While seeming to offer an unconfined view of a genuine landscape," he writes, "it in fact surrounds observers completely and hems them in far more than all previous artistic attempts to reproduce land-scapes."[31] A phenomenon that dramatizes the collision between reality and illusion, two- and three-dimensionality, free movement and aesthetic entrap-ment, the panorama as a visual emblem captures the dangerous shortcomings of Pierre's early views of the battlefield. Restricted to an elevated vantage point, he sees only abstractions of reality, pictures that are at first too schematic and then too aesthetically deceptive. Rather than leaving Pierre to marvel at these sights, Tolstoy demands that his hero recognize the illusions, beautiful if ulti-mately false, for what they are—artful lies. By baring the devices of these opti-cal illusions, be they maps or panoramas, the novel posits a visual sphere that is inauthentic, inadequate, and morally inferior. And in doing so, the novel asserts its own capacity to move characters through space and time, a move-ment that almost always allows for corresponding shifts in understanding and consciousness. Made possible by narrative, this movement is what ultimately disabuses Pierre of his faulty notions of historical spectacle, and pushes him toward a more nuanced understanding of battle. He discovers that he must descend the barrow to get a different view. "Pierre wanted to be there," explains the narrator, "where those puffs of smoke, those gleaming bayonets and can-nons, those movements, those sounds were" (11:227; 790). And so he gallops off, his eyeglasses sliding off his nose, a not-so-subtle gesture to the removal of a falsely tinted lens. When we next meet Pierre, he will have joined the soldiers on the field of battle and will be confronted with a view of war that is entirely different yet no less disorienting.

Magic Lanterns, Revealed!

Throughout the Borodino chapters, there are still other characters who are no less haunted by visions. On the evening of August 25th, having already

received his orders for the following day, Andrei Bolkonsky sits alone in his quarters, thinking about the very real possibility of death. In opposition to this vivid metaphysical certainty, the trifling concerns of earthly existence fade and flicker like the projections of a magic lantern.

> And from this elevated vantage point [*s vysoty etogo predstavleniia*], all that used to torment and preoccupy him was suddenly lit up by a cold, white light, without shadows, without perspective, without clear-cut outlines. The whole of life presented itself [*predstavilas'*] to him as a magic lantern, into which he had long been looking through a glass and in artificial light. Now he suddenly saw these badly daubed pictures [*durno namalevannye kartiny*] without a glass, in bright daylight. "Yes, yes, there they are, those false images [*lozhnye obrazy*] that excited and delighted and tormented me," he said to himself, turning over in his imagination the main pictures of his magic lantern of life, looking at them now in that cold, white daylight— the clear notion of death. "There they are, those crudely daubed figures, which had presented themselves as something beautiful and mysterious. Glory, the general good, the love of a woman, the fatherland itself—how grand these pictures seemed to me, how filled with deep meaning they seemed!" (11:201–2; 769)

At this moment, shaken into consciousness by the existential demands of war, Andrei is no longer taken in by the magic lantern's convincing spectral images; instead, he sees the pictures stripped of their artificial devices, devoid of a glaring "artificial light" and a correct viewing perspective. As he does with Pierre and the panorama, the narrator guides Andrei away from the illusory images flickering on a screen and into the "cold, white daylight."[32] Or, rather, he guides them, and us, into another illusion of the "cold, white daylight," for we are not entering battle itself but rather a version of the battle narrated to us fifty years after the fact, and in a work of fiction. What Tolstoy achieves in these interart standoffs is an effect of realism by self-conscious negation. Step away from the entrancing images, the novel seems to say. Walk with Pierre, with Andrei, into an experience that simply *must* be more authentic than these "badly daubed pictures."

Invented as early as the seventeenth century, the magic lantern, like the panorama, continued to be popular throughout the nineteenth century. Indeed, it was at this time that the word "phantasmagoria" was coined to capture the viewer's uncertainty before the first magic lantern shows in London. With the lantern's clunky apparatus obscured behind curtains, the audience would sit transfixed before the projected images, wavering between self-satisfied recognition of the technological trick and uneasiness over the presence of specters. Terry Castle explains that this pastime quickly became an emblematic trope of romantic literature, casting shadows on reality and turning reverie into something shockingly tangible. In reference to Edgar Allan Poe, the master of such fantastic effects, Castle writes that he "sensed an epistemological abyss at the heart of the metaphor," that he "used the phantasmagoria figure precisely as a way of destabilizing the ordinary boundaries between inside and

outside, mind and world, illusion and reality."[33] According to René Wellek's definition of realism, "as a polemical weapon against romanticism," as a concept that "rejects the fantastic, the fairy-tale like, the allegorical and the symbolic," Tolstoy's allusions to visual spectacle (his examples of which all came into prominence during the late eighteenth and early nineteenth centuries, in other words, during the peak of romanticism) function, in part, as an assertion of realism in the face of romantic tropes.[34]

Maurice Samuels, in his study of nineteenth-century French culture, connects these forms of popular entertainment to the literary representation of history. He argues that phantasmagoria shows, panoramas, and wax museums, which all promised stable visions of national history, gained in popularity as a response to the disorienting effects of the French Revolution. It is the charge of the realist novel, Samuels proposes, to expose and overturn these romantic illusions, to show them to be false and, more importantly, dangerous in their usurpation and control of individual subjectivity. Identifying the novels of Stendhal as the culmination of this anti-romantic impulse, Samuels writes that the realist novel "brings us backstage—the *échafaudage* [scaffolding] visible, the illusion never taking hold. Rather than re-creating the past as a play, *Le rouge et le noir* offers us insight into the mechanics of such a production, its motivation, and its devastating effect on both actors and viewers."[35]

Tolstoy walks a thin line, however, exposing the deceptive capacities of the visual, while also exploiting the potential of these illusions (albeit in their disavowal) to initiate moments of genuine psychological and metaphysical clarity. One such example occurs toward the end of *Anna Karenina*. Anna is in a paranoid frenzy, having already set herself on a path to suicide, when she experiences a momentary "return of life" (19:331; 752). This brief respite from her intense psychic pain comes as the result of a series of lights and shadows that cohere into a virtual magic lantern show:

> She lay in bed with her eyes wide open, looking at the molded cornice of the ceiling and the shadow of a screen extending over part of it in the light of one burnt-down candle, and she vividly pictured to herself [*zhivo predstavliala sebe*] what he would feel when she was no more. [...] Suddenly, the shadow of the screen wavered, spread over the whole cornice, over the whole ceiling; other shadows from the other side rushed to meet it; for a moment the shadows left, but then with renewed swiftness came over again, wavered, merged, and everything became dark. (19:331; 751–52)

Terrified by the contemplation of her own death, Anna gets up to light another candle. Light enters the room, shadows dissipate, and Anna is jolted out of her opium-induced shadow show into a more grounded recognition of the love Vronsky still has for her and she for him.

Of course, this return to reality is only temporary. And even Andrei's supposed insight neither endures nor offers anything like lasting comfort; on the contrary, with the revelation of relative truth in the face of death

comes a terror akin to Anna's. Andrei gazes out of a crack in the wall onto a spectral picture of his imagination superimposed onto a shifting panoramic landscape:

> He looked at the line of birches with their motionless yellow and green leaves and white bark gleaming in the sun. [...] He pictured vividly to himself [*zhivo pred-stavil sebe*] his absence from life. And the birches with their light and shade, and the fleecy clouds, and the smoke of the campfires—everything around was transfigured for him and appeared as something dreadful and menacing. (11:202; 770)

For both Anna and Andrei, the disenchantment of the optical illusion makes possible certain profound metaphysical insights. Faced with the finality and inevitability of death, both Anna and Andrei are able to attain some kind of higher perspective, and this glimpse of a higher truth is figured as the rejection of a visual deception.[36] However, for both Anna and Andrei, this realization of death comes as the very kind of image it seeks to overturn, summoned before their minds' eye as a picture; in each case, Tolstoy resorts to the same construction, "to vividly picture to oneself" (*zhivo predstavliat' sebe*). What remains is something like a *mise en abyme*, a series of nesting illusions, which can only be neutralized by verbal narrative. If unchallenged by time and movement, Anna would still be gazing at the shadows on a screen and Andrei would still be entranced by a framed view of a landscape no better than a magic lantern. But instead, Anna runs out of her bedroom into the study, and Andrei bounds out of the shed, both propelled with urgency by the narrative. They are pushed forward, like Pierre, into their respective battles, because the "real" is not to be found in one place or one image but in perpetually evolving circumstances and states of consciousness.

Tolstoy's account of Borodino is, to borrow the rhetoric of the day, "Borodino *revealed*." Capitalizing on its ability to represent change over time, the novel strips away layer upon layer of visual artifice. By doing so, it produces the sense that Pierre, Andrei, and the reader are moving ever closer to a *true* experience of reality. Inevitably, this aesthetically self-conscious engagement with artistic representation, which undergirds the novel's interart polemics, threatens to expose the novel itself as its own kind of phantasmagoria, for to shed light on the limitations of others is always, somehow, to shed light on the limitations of one's own. This project is quite audacious; the novel does not show or tell the truth, but creates the illusion of truth by employing narrative to move through false visions, thus approximating the experience of disillusionment and realization.[37] In this way, truth is something of a moving target, represented as an experience to be narrated rather than a concrete entity to be described. This tension between the demands of description and the potential of narration is not unique to *War and Peace*, however; it haunts even the young writer, and seems to emerge frequently in relation to the visual arts and the unique challenges of realist description that they reveal.

Although perhaps the most famous condemnation of the visual arts in Tolstoy's oeuvre can be found in *Anna Karenina* in the figure of the painter Mikhailov, whose portrait of the eponymous heroine is discussed in chapter 5, the fine (and performing) arts do not fare much better in *War and Peace*. Through the eyes of Natasha Rostova, as Viktor Shklovsky famously argues, the conventions of opera are defamiliarized, and earlier in the novel Pierre is seduced by Hélène Kuragina with a sensual beauty that is described as sculpturesque.[38] But it is in the Borodino chapters that the reader is treated to one of the more humorous exposés of visual representation. On the evening of the twenty-fifth, after Pierre has seen his first panorama and Andrei his magic lantern show, Napoleon is presented with a very special gift, a portrait by François Gérard of his infant son as "*le roi de Rome*," wielding a scepter and a globe. Our narrator wastes no time: "It was not entirely clear precisely what the painter meant to express by presenting the so-called king of Rome skewering the terrestrial globe with a stick, but the allegory, to all those who had seen the picture in Paris, and to Napoleon himself, obviously seemed clear and pleasing" (11:213; 779). Inspired by this grand vision of world dominance, Napoleon assumes a solemn yet tender expression; "he felt that what he said and did now—was history" (11:213; 779). But this, as becomes more than clear from the skewering the narrator delivers to the little emperor's skewering, is absolutely nothing like genuine history. It is as affected, as false, as the elegant gestures of Napoleon himself.[39]

The potential for portraits to fall short, whether because of their allegorical status or overblown mannerisms, is apparent even in Tolstoy's stance toward literary portraiture, the description of individuals in prose. In an 1865 letter, Tolstoy explains this tension between portraiture and literary development: "Andrei Bolkonsky is no one, just as any character of a novelist is, unlike the [characters] of a writer of individual sketches [*lichnostei*] or memoirs. I would be ashamed to be published if all my work consisted of was copying a portrait" (61:80).[40] Just a year and a half later, in a second letter, this time to his illustrator Mikhail Bashilov, Tolstoy seems to double back on this statement, or, at the very least, to have gotten over any feelings of shame. Referring to three images (a daguerreotype, a postcard, and a large portrait, all at different ages) of Tanya Bers, his sister-in-law and model for Natasha, Tolstoy directs Bashilov to "make use of this type and its stages [*perekhodami*]" (61:153).[41] What has changed in this second letter is the recognition that a *series* of images, rather than only one, comes closer to embodying the particular demands of literary portraiture. Bashilov, then, is asked to approximate, to the best of his abilities, the narrative and fictional transformation of a living referent into a novelistic character.

Citing evidence from the young Tolstoy's diaries, in this case from July of 1851, Boris Eikhenbaum identifies in the budding writer an early uncertainty about the possibility of achieving such descriptive potency: "I thought: I will

go, I will describe what I see. But how to write it? One needs to go and sit at a desk spotted in ink, take a sheet of gray paper and ink, blacken one's fingers and draw letters on the page. Letters comprise words, words phrases, but is it possible to communicate the feeling? Might it be possible to somehow convey to another one's own perspective at the sight of nature? Description is inadequate [*Opisanie nedostatochno*]" (46:65).[42] For Tolstoy, the gap between seeing an object and describing the object threatens to be an insurmountable one, cluttered by the papers and letters of the writerly apparatus. In another diary entry from two days later, also quoted by Eikhenbaum, Tolstoy expresses particular concern about the description of people. "It seems to me that *to describe* a person is actually impossible [opisat' *cheloveka sobstvenno nel'zia*; emphasis in the original]. He may be an original person, or kind, or stupid, or consistent, and so on—but these words provide no real sense of a person; rather, they claim to outline a person when in fact they often only confuse" (46:67).[43] To counteract this kind of superficial description, Tolstoy, according to Eikhenbaum, develops a method that consists of several phases, moving from the description of others' perceptions of an individual, to the individual's perception of others, and, finally, to the individual's physical appearance. In such a way, Tolstoy avoids a lone potted portrait, and instead stretches the description of an individual throughout the narrative itself.

In the manuscripts for *War and Peace*, one finds another approach to this descriptive challenge. On the page that describes the driver Balaga, who makes a habit of carousing with Anatole and Dolokhov and has arrived to escort Anatole and Natasha to their elopement, Tolstoy includes a small sketch in the margins (figure 36). Seen in profile, Balaga is recognizable by his beard, snub nose, and kaftan. In the final draft of the novel, the sketch has yielded to text, and what remains, in the form of a physical description, takes up only two sentences. The record of Balaga's famed exploits that precedes this description, however, spans a substantial paragraph (10:353–55; 583). In absorbing the visual portrait into a more dynamic and sequential narrative, the description of Balaga is certainly different from what Eikhenbaum relates as a process of layering multiple perspectives; however, both methods are part of a repertoire of characterization that distinguishes between visual and verbal modes of representation. And given that description in a general sense posed a problem for Tolstoy, it follows that the protracted and varied views of the Borodino battlefield, although not literary portraits, are a similar attempt to counter any one fixed image with narrative expansion.[44]

Not long after Tolstoy wrote in his diary of his frustration with description, Turgenev, while spending time at the Viardots' Château de Courtavenel, invented a parlor game that, curiously enough, touches on related issues. Turgenev, Pauline Viardot, and their guests would play the portrait game (*igra v portrety*) with relish during October of 1856, and off and on throughout the 1860s and 1870s.[45] One of the surviving playing cards illustrates the rules of the game (figure 37). Turgenev would sketch a human profile on the top of a slip of paper, and then he and his guests would take turns writing a

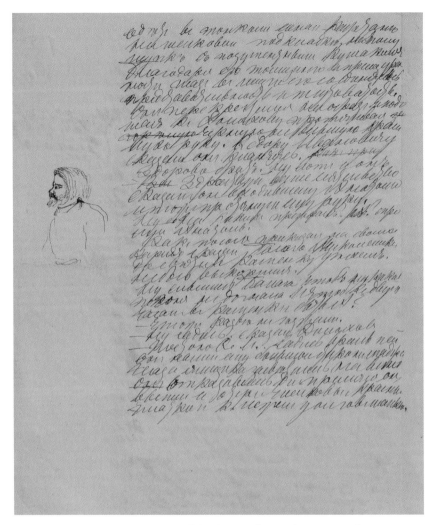

FIGURE 36. Lev Tolstoy, Drawing of the driver Balaga in the margins of a manuscript of *War and Peace* (drawing by L. N. Tolstoy, manuscript copied by S. A. Tolstaya), 1867. Manuscript 127, l. 3. State Tolstoy Museum, Moscow.

description of this person, folding the paper to hide their answers as they passed it around. The resulting descriptions would then be read aloud, with the most convincing receiving praise and the least, good-hearted ridicule. In this case, the profile of a scowling man with a bulbous nose and shoulder-length hair is followed by six descriptions. Although one player considered him a "naturalist" and another a "landscape painter, very witty and very sweet with the ladies," the others seemed to agree that he embodies the notion of a great man. Turgenev writes: "Great man—neither more nor less! [...] He would be a leader of nations if he were not too philosophical." And Pauline

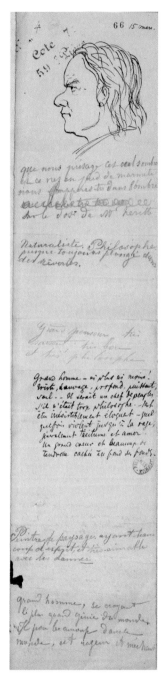

FIGURE 37. Ivan Turgenev, Playing card for the portrait game (drawing by Ivan Turgenev and text by Turgenev, Pauline Viardot, and guests), n.d. Tourguéniev, Manuscrits parisiens VI, Documents biographiques: Le Jeu des portraits, Slave 79, f. 66. Bibliothèque nationale de France, Paris.

Viardot: "Man of genius. Imagination, patience. [...] Great heart—profound thinker, disinterested."[46] Noting the correspondence between such a game and the task of a fiction writer, in a letter to his friend Vasily Botkin, Turgenev even claims that he has saved the playing cards and will use some of the descriptions for his future literary work.[47]

Although there is no evidence that Turgenev ever turned to these scraps of paper in crafting his novelistic characters (despite some seeing a resemblance between the "great man" and Bazarov from *Fathers and Children*), there is nevertheless a compelling case to be made for the echoes between the portraits of the portrait game and the characters of Turgenev's novels, both originating in a sketch of physical attributes and evolving textually into a rounder description of psychological and emotional traits.[48] Recalling conversations with the Russian author about this aspect of his creative process, Henry James explains that, for Turgenev, "the germ of a story [...] was never an affair of plot—that was the last thing he thought of: it was the representation of certain persons. The first form in which a tale appeared to him was as the figure of an individual. [...] They stood before him definite, vivid, and he wished to know, and to show, as much as possible of their nature."[49] To capture this "nature," Turgenev would then, James writes, construct a biography, a complete "dossier" of the character, which would form the foundation for the character's actions within the plot.

This method is evident throughout Turgenev's work, from *Fathers and Children*, which begins with a physical description of Nikolai Kirsanov and moves into an extended narration of his personal and family biography, to a manuscript from the first half of the 1840s for a never completed literary sketch called "Stepan Semyonovich Dubkov and My Conversations with Him" (figure 38).[50] On the first page of this early manuscript, a drawing of Dubkov with his jaunty cap, cane, and striped pants is followed by a précis of his life, which starts with his date of birth, outlines his various occupations and places of residence, and concludes with the notation that he moved to the city where he currently resides in 1840. While not necessarily part of his creative toolbox, therefore, the portrait game illustrates, rather clearly and charmingly, how a particular relation between the visual and the verbal motivated Turgenev's characterization from his earliest literary sketches to his mature realist novels. Furthermore, Turgenev's tendency to move from visual, or visually inscribed, portraiture into a verbal description and narration is a realist method of representation that he shared with Tolstoy, as seen, for example in the case of Balaga. What distinguishes the authors' approaches to this kind of description is more a matter of tone than substance. While Turgenev layers a physical description with the biographical and behavioral, building an image through the accrual of visual and verbal evidence, Tolstoy often takes a polemical orientation, turning away from supposedly inadequate visual impressions toward seemingly fuller narrative realizations. Indeed, this difference is apparent even beyond the matter of portraiture. Whereas Turgenev shifts from visual to verbal categories in his landscape description to highlight aesthetic and social

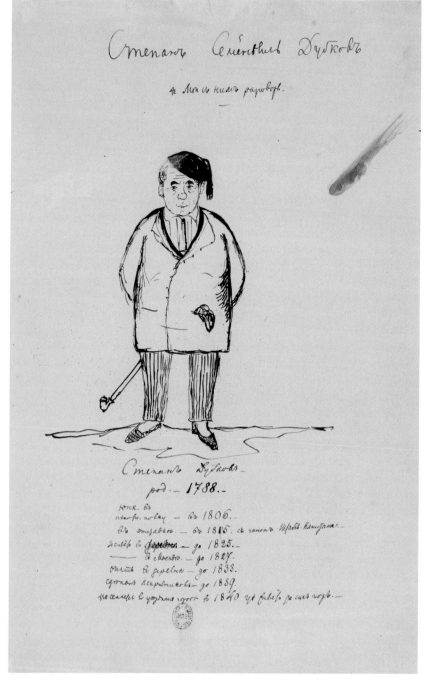

FIGURE 38. Ivan Turgenev, Notes for uncompleted story "Stepan Semyonovich Dub-kov," early 1840s. Tourguéniev, Manuscrits parisiens I, Stepan Doubkov, Slave 79, f. 34. Bibliothèque nationale de France, Paris.

distinctions, Tolstoy in his descriptions of Borodino transforms these relatively benign distinctions into outright collisions, discounting Pierre's initial panoramic views and sending him into the action of narrative.

To clarify why Tolstoy privileges such a polemical approach in *War and Peace* it is instructive to introduce yet another example of portraiture from a different literary genre—the memoir. In fact, Tolstoy himself suggests this comparison in the letter cited earlier in this section, in which he juxtaposes the characterization of the novelist to that of the memoirist. Rather than creating a character of an unknown person, the memoirist must, in his words, "copy a portrait."[51] In its potential to throw in relief the particular aesthetic and ontological demands of the novel, this generic comparison is worth exploring further. Composed roughly at the same time as *War and Peace*, Aleksandr Herzen's *My Past and Thoughts* (1852–1868) is one of the best-known memoirs in the Russian tradition. Although like Tolstoy's novel, it is diffuse in its content, one of its most central aims is, undoubtedly, to represent the intimate circles of the Russian intelligentsia. In the course of remembering his friends and colleagues, Herzen repeatedly evokes visual imagery to build a virtual portrait gallery of the intelligentsia, one that attempts to resurrect Nikolai Ogaryov, Pyotr Chaadaev, and others, while also providing an organized space for future generations to consult for insights into this historical moment and its key players.

Following Tolstoy's judgment on the artificial conventions of visual representation, Herzen's utter lack of concern with these elements seems almost naïve. Early in the memoir Herzen recalls a portrait of his closest friend, Ogaryov:

> In his father's house there long remained a large oil portrait of Ogaryov from that time (1827–28). Later, I would often pause in front of it and gaze at it for a long time. He is represented [*predstavlen*] with the collar of his shirt thrown open; the painter marvelously captured his rich chestnut hair, the youthful, not yet settled beauty of his awkward features, and his somewhat swarthy complexion; the canvas revealed the pensiveness that precedes powerful thought; instinctive sadness and extreme meekness shone from the large gray eyes, hinting at the future growth of a great spirit [*dukh*]; and that is what he became. This portrait, given to me as a gift, was taken by a stranger. Perhaps she will see these lines and send it back to me.[52]

Instead of drawing attention to the picture's shortcomings, Herzen writes that the "painter marvelously captured" all of the salient physical characteristics of his friend, even communicating that which is not visible, Ogaryov's "great spirit." When he praises the artist of Ogaryov's portrait, Herzen also—according to the logic of interart encounters proposed throughout this book—reinforces the supposed accuracy of his own description, its likeness to its subject. In fact, Herzen remembers this painting as so evocative of Ogaryov's person that he even addresses a request to the woman who took it. No single gesture could be more telling of the different interart orientations of Tolstoy's

novel and Herzen's memoir; while Pierre gallops away from the panorama, Herzen hopes to reacquire Ogaryov's portrait and hang it in his gallery.

The theoreticians of classical mnemonics often proposed an imagined architectural structure—a palace, theater, or gallery—in which to organize and store information.[53] A good memory would choose objects of aesthetic appeal, all filtered through the sense of sight, and place these objects in a particular order within this virtual space, which the mind could then later peruse. In a related way, Ogaryov's portrait functions as a mnemonic trigger for Herzen, an aesthetic object that hangs in the gallery of his mind. In its insertion into the memoir, the portrait also becomes a mnemonic device for the reader, one of many (somewhat) visualizable elements with which the reader can populate Herzen's virtual gallery of the intelligentsia. This particular use of ekphrastic description—rhetorically framing and preserving a "picture" of an individual—supports the mnemonic task of the memoir: it secures a spot for figures like Ogaryov, who might otherwise be forgotten, both in the long sweep of Russian history and in the lengthy text of Herzen's multivolume memoir.

And yet, this mnemonic gallery does not remain a purely rhetorical device or metaphorical image in *My Past and Thoughts*. Seemingly prompted by a memory of Nicholas I, Herzen mentions that in December of 1847 he visited the Braccio Nuovo Gallery in the Vatican, established by Pope Pius VII in 1817–1822 to house the many sculptures, newly returned, that Napoleon had taken to Paris. Describing the gallery's collection of statues and busts, Herzen writes that "the entire history of the decline of Rome is there expressed in eyebrows, foreheads, lips."[54] For Herzen, the sculptural objects reach beyond their aesthetic beauty to communicate the history of the Roman Empire. Herzen, in fact, saw much of Rome as a spatial holder for national memory, writing in a letter that "Rome is the greatest cemetery in the world, the greatest anatomical theater; here, it is possible to study past existence and death in all of its phases. The past is easily restored here in a single column, in a few stones."[55] Unlike Borodino's panoramic "amphitheater," whose spectacular forms fail to provide Pierre with useful information, Herzen's Roman "anatomical theater" contains all of its past "in a single column."

Further in *My Past and Thoughts*, buried within an ekphrastic description of Chaadaev, Herzen references a second gallery space, this one much closer to home. Possessing an immobile countenance "as if it were made of wax or marble," Chaadaev seems to morph into one of the stone columns of an architectural mnemonic space:

> The years had not distorted his slender figure; he dressed very meticulously; his gentle face was completely immobile when he was silent, as if it were made of wax or marble, "his forehead like a naked skull"; his gray-blue eyes were melancholy and along with that had something kind in them; his thin lips, on the contrary, smiled ironically. For ten years he stood, his arms folded, somewhere by a column, by a tree on the boulevard, in the halls of theaters, in the club.[56]

Without the inclusion of an intertextual reference to the "forehead" (*chelo*) of Pushkin's 1835 poem "The Commander," Chaadaev's "immobile" face might forever be associated only with the sculptural busts in the long corridor in the Vatican. But Pushkin begins his poem with a different palace interior, that of the Hermitage, and, more specifically, the War Gallery of 1812. Commissioned to celebrate the heroes of the Patriotic War, the gallery formally opened on December 25th, 1826, and contained over three hundred portraits by the British artist George Dawe. It is easy to imagine the 1812 gallery as a mnemonic space, one in which the visitor is called upon to recollect important personages of the past. Sensitive to this reconstitutive function of the gallery, Pushkin writes:

> The painter placed here in close multitude
> The commanders of our native force,
> Wreathed in the glory of the marvelous campaign
> And the eternal memory of the year 1812.[57]

It is precisely this "eternal memory" that Herzen seeks to promote in his memoir, and he does so, in part, along the model offered by the Braccio Nuovo and War of 1812 galleries. Presenting Ogaryov, Chaadaev, and others as framed visual representations, Herzen takes advantage of the virtual power of *enargeia*, in an effort to fulfill the demands of his chosen genre, the memoir—to resurrect history, and close the gap between past and present.

In his 1868 article, "A Few Words about *War and Peace*," Tolstoy makes clear the distinction between such commemorative portraiture and what he hoped to achieve in his novel. Much like in the portrait of Napoleon's power-hungry baby, the typical conventions used to portray historical figures are, according to Tolstoy, anything but natural. "Kutuzov did not always ride a white horse, holding a field glass and pointing at enemies [...] and the empress Maria Fyodorovna did not always stand in an ermine mantle, her hand resting on the code of law; but that is how they are presented to the popular imagination" (16:10). With these words Tolstoy takes issue with the genre of the official imperial portrait, featuring a human being frozen into a timeless image, locked forever and *always* in an idealized, and often exaggerated, pose. As memorial objects, they are quite significantly outside of time and space, petrified for the passive consumption of a future generation. These men and women will never join Pierre as he gallops down the hill toward the battlefield.

And the reason that they never will join Pierre is that, despite his famous protestations concerning the genre of his work, Tolstoy is not writing a memoir or anything else; he is writing a novel.[58] Tolstoy's task is to move beyond the limits of depiction and description, and into a truthful narration of reality that is unavailable to historians or memoirists or portrait painters.[59] It is this mission that sends him to Borodino in 1867, and *not* to the War Gallery of 1812. His nephew, who had assisted the author during this excursion, recalls that Tolstoy had wanted to interview survivors of the battle, but soon discovered that the last eyewitness had died just a few months prior to their arrival.[60]

In the absence of such documentary evidence, Tolstoy then becomes his own eyewitness, rising at dawn to experience the exact moment the battle began. He walks through the fields, examines the landscape from multiple perspectives. He even makes the curious sketch of a hill with two suns—one rising, one setting—discussed in the introduction (figure 6). These two suns introduce time and movement into the drawing, and yet, as with the narrator's map that opened this chapter (figure 2), their dynamism is at best restrained. In the space between the two suns on the sketch, just as in the space between the two sets of rectangles on the map, one may certainly imagine the "ceaseless carving" of time. In both images, however, this series of events is represented synthetically as a static collection of forms. This space, where visual representation reaches its limits, is what the novel hopes to fill with the infinite variety of experiences that buckle an otherwise smooth record of history.

On a page from one of the novel's manuscripts, Tolstoy attempts to resolve this visual stasis by disaggregating the layers of the narrator's map, separating the "proposed" and the "actual" battle positions into two separate and sequential plans (figure 39). In their temporal progression, these two plans represent a narrative, albeit of the most rudimentary kind; and yet in its visuality, it is a narrative that the novel simply cannot absorb. Like the single map that it will become, and like the two suns from which it emerges, this sketch remains insufficient to the temporal task required by the novel. The narrator, therefore, moves on, leaving the map, and the panorama, and the magic lantern, dissolving the stasis of the visual with the ceaseless movement of time,

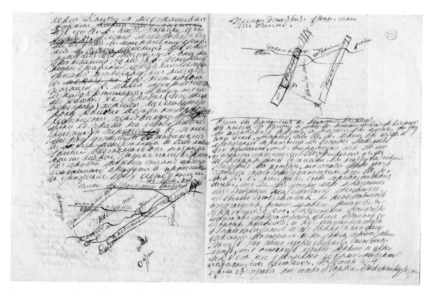

FIGURE 39. Lev Tolstoy, Second draft of the Borodino chapters with the map of "proposed" and "actual" troop positions in a manuscript of *War and Peace* (manuscript copied by S. A. Tolstaya and others), September–October 1867. Manuscript 133, f. 1, no. 9194/336. State Tolstoy Museum, Moscow.

history, and the novel. In doing this, the novel initiates a battle between the sister arts to enhance the realism of its verbal representation *relative* to the visual. But it also initiates this battle for reasons that have less to do with aesthetics than with medium; in resisting that which it considers foreign, the novel asserts its own ontological identity, its novel-ness. The recognition of this formal identity provides the foundation for what *War and Peace* ultimately offers—to Pierre and to the reader—as its unique narrative solution to the problem of description.

The Novelistic Illusion

When last we saw Pierre at Borodino, he had just abandoned his position atop Gorky Hill in favor of a more intimate perspective. Pierre's trajectory, from high to low, from passively watching to actively experiencing, mirrors that of the reader-hero in Tolstoy's "Sevastopol in December" (1855).[61] This early story, one of three describing the events of the Crimean War, begins with the painterly language now familiar to us from Pierre's panorama: "Morning's dawn is just beginning to color [*okrashivat'*] the horizon above Sapun Hill; the dark-blue surface of the sea has already cast off the gloom of night and waits for the first ray of sun to begin sparkling with joyful brilliance" (4:3). The delicate hue of the horizon and the flat surface of the water are visions only available to an observer from afar.[62] Like Pierre, though, this viewer quickly moves into the chaos, the very essence, of war. Tolstoy employs a second-person narrative to propel the reader-hero into the landscape and through a cascading series of impressions and realizations: "Your first impression will definitely be the most unpleasant. [...] But look closer at the faces of these people, moving around you, and you will understand something completely different" (4:5). This engagement of the reader through a series of sensory observations aligns Tolstoy's early realism with that of the Natural School's physiological sketches (especially with Dmitry Grigorovich's "Petersburg Organ Grinders," which also employs second-person narration). However, unlike the Natural School, Tolstoy seeks to move his reader beyond a mimetic representation, and beyond distanced visual impressions, and toward far more proximate images and experiences of war, capable of shocking and startling the reader into higher levels of perception. When Tolstoy's reader is commanded to "look closer at the faces of these people," he is rewarded with an understanding of truth that is far more profound than the writer of the Natural School sought to offer. And it is this truth, inscribed on the faces of ordinary soldiers and comprehensible only through communion with others, that Pierre will also glimpse once he reaches the trenches.

The desire for its hero to shed various illusions in favor of a greater truth, as opposed to remaining trapped within a world of illusion, distinguishes Tolstoy's novel from that of another realist, Gustave Flaubert. In *Madame Bovary* (1856), Flaubert's eponymous heroine looks at the city on her way to

Rouen to visit Léon, and is greeted by a view that recapitulates painterly and panoramic categories of literary visualization.

> Sloping down like an amphitheater, and drowned in the fog, it overflowed unevenly beyond its bridges. Then the open country mounted again in a monotonous sweep until it touched in the distance the elusive line of the pale sky. Seen thus from above, the whole landscape seemed frozen, like a picture.[63]

Roland Barthes calls upon this passage to illustrate how "the aesthetic intention of Flaubertian description is totally interwoven with the imperative of 'realism.'"[64] For Barthes, the seemingly insignificant visual details of the landscape do double duty, highlighting their origins in classical rhetoric (in the device of hypotyposis or *enargeia*, that is, vivid description that allows for reader visualization), while announcing their participation in a more radical project, that of the "referential illusion," which signifies nothing more than "*we are the real*."[65] To compare Tolstoy and Flaubert in these terms is telling. Both authors rely upon visual diction, grounded in the tradition of the sister arts, to produce the effect of presence in their landscape descriptions. However, Tolstoy rejects the loose commingling of the aesthetic and real that results, in the words of Barthes, in a classical aesthetic "impregnated [. . .] with referential constraints." While Flaubert's heroine travels past the panoramic view of the city to rendezvous with her lover in yet another world of artifice, a world in which she appears like one of Jean-Auguste-Dominique Ingres's odalisques, Tolstoy's hero sheds the aesthetic confines of the panorama for a supposedly less mediated version of reality. For Pierre, the realist illusion is not to be found within or in tandem with the visual aesthetic, but in professed opposition to it.

In articulating these different approaches to representation, Georg Lukács distinguishes between Flaubertian description and Tolstoyan narration. Flaubert's penchant for description, according to Lukács, results from and, in turn, reinforces the structures of bourgeois capitalism, producing an aesthetic that is prosaic, passive, and akin to a still life. Tolstoy, on the other hand, embraces an epic narration, which activates struggle and promotes connection between characters.[66] Although Lukács's binary model is rather too rigid to capture the complexities of either author's realism, it nevertheless condenses in broad terms the values ascribed to description and narration, and to the visual and verbal, in *Madame Bovary* and *War and Peace,* respectively. Flaubert's novel offers visually framed descriptions, only then to flow into other visually framed descriptions, from landscape to painting and so on. When Tolstoy offers a visual representation, however, he discredits it as unreliable in its passivity and stasis and, by doing so, suggests a better, more convincing verbal illusion achieved through the temporality and movement of narrative. Taking the Borodino chapters as archetypal of Tolstoy's realism, it follows that the extended polemic between the visual and the verbal on the battlefield not only produces the authenticity of Pierre's historical experience, but also advances the *paragone* of the novel as a whole.

Returning to Pierre galloping down the hill, it becomes clear what Tolstoy had in mind as a novelistic alternative to these optical illusions. At first, Pierre has trouble readjusting his vision. Disoriented, with smoke in his eyes, he cannot see anything, cannot recognize either enemy or friend, living or dead. Bullets race by; dust and dirt obscure the activity around him. In the midst of this disorder, Pierre crouches behind an embankment, and it is there that he discovers the correct perspective for viewing a battle: "Sitting on the side of the trench now, he observed the faces around him" (11:232; 794). Whereas the panoramic distance and the mapped diagram had transformed the individual faces of soldiers into minuscule dots of paint, or masked them beneath white rectangles of absence within the solid black line of an "actual position," the narrative of the novel thrusts Pierre into the middle of this space that up until now had been removed and aestheticized.

Finally, Pierre is able to see and, even more importantly, *experience* the Battle of Borodino. With every passing moment, with every successful shot, he notices the increasing intensity of a "hidden fire" that burns on the faces of the men around him. "Pierre did not look ahead at the battlefield and was not interested in knowing what was going on there: he was entirely absorbed in contemplating this fire flaring up more and more, which (he felt it) was flaring up in his soul" (11:233; 795). In redirecting his gaze from the battlefield to the individual faces, from the general to the specific, Pierre finds a "fire" burning all around him. This "fire" does not appear to him as the secondhand puffs of smoke on the surface of a painting, but is communicated through the spirit of the soldiers. Moreover, with this more truthful perspective, Pierre not only observes that which resides in the soul of each individual on the battle-field, he also senses this excitement and passion ignite in his soul as well. By abandoning distance and the anesthetizing interference of representation for human connection, Pierre for the first time *feels* (*on chuvstvoval*) the historic moment. The dual physical and emotional meaning of "feeling" highlights the resonance between Pierre's experience of the battle and what was discussed in the previous chapter as the phenomenal and affective engagement encouraged by Perov and Turgenev. In other words, in each case, this is a realism that strives for mimetic illusion and empathic connection.[67]

When one steps down from the viewing platform in a panorama building and walks freely, one notices that the painted image is nothing but an illusion. When one pulls back the curtain concealing the machinery of a magic lantern, one sees that there is no such thing as ghosts. In both cases, it is the observer's freedom of movement that allows for the exposure of the magic trick. And this is precisely the process that Pierre models for the reader during the Battle of Borodino. Having learned this lesson, Pierre is able to cast aside his optical illusions, abandoning the lens of his telescope for a truer form of knowledge:

> He had armed himself with a mental spyglass [*umstvennoi zritel'noi truboi*] and gazed into the distance, where the petty and humdrum, disappearing in the dis-tant mist, had seemed to him great and infinite, only because it was not clearly

visible. [...] Now he had learned to see the great, the eternal, and the infinite in everything, and therefore, in order to see it, to enjoy contemplating it, he had naturally abandoned the spyglass he had been looking through until then over people's heads, and joyfully contemplated the ever-changing, ever-great, unfathomable, and infinite life around him. (12:205–6; 1104)

Instead of searching for the meaningful in expansive views, through the lens of an optical device, Pierre discovers that if he can only look closer at that which surrounds him, he will be able to do more than simply "see life"; he will be able to "contemplate" it. And this contemplation gives him access to far more than a petrified and finite image. It reveals an understanding of life that is "ever-changing, ever-great, unfathomable, and infinite."

In a letter dated November 1854, posted to his older brother Sergei from the Crimean front, the young Tolstoy states simply: "The spirit of the troops is beyond any description" (59:281). In the Tolstoyan novel, there are certain complex truths—a person, history, spirit—that are barely, if at all, available to the sense of sight. And in *War and Peace*, while it is certainly challenging to narrate such truth—a fact that the narrator admits in relation to Nikolai's war stories, stating that "to tell the truth is difficult"—it is *impossible* to describe it. Faced with this predicament, the novel transforms what had been for Turgenev more of a distinction between the sister arts into a polemic, a battle for the superior realism. To do so, it aligns the category of description with the visual realm, exposing the perceived inadequacies of both, and positing distinctly verbal solutions to the problem of the realist representation of history. With truthful representation imperceptible in either the portrait or the panorama, the novel seeks it instead in the process of moving from one perspective to another, of seeing the illusion that resides in any fixed view.[68] Although Tolstoy rejects the optical illusion because it is limited and fails to tell the whole story, he does not banish these illusory visions from the novel. These false impressions must be included, for by overcoming them, the subsequent realizations acquire their potency. In and of themselves, Pierre's vantage points from Gorky and his observations from the trench are as devoid of meaning as the dots on the military map that opens Tolstoy's account of Borodino. It is the movement from one point to another, a movement the novel considers visually unrepresentable, which gives the proper perspective to the events of history. This is a movement through space and time, through states of consciousness, and into the psychological and spiritual condition of others. It is a movement that connects the general and the abstract, the internal and the external, reality and the represented, the movement of narrative itself. This is the illusion of the novel, the verbal illusion that takes the place of the optical illusion in Tolstoy's fiction.

4

Repin and the Painting of Reality

> But there in front of [the public] appears its beloved artist,
> *en déshabillé*, so to speak, in a dressing gown.
>
> VLADIMIR CHUIKO[1]

AT THE FIRST MEETING of Tolstoy and Repin in 1880, the very meeting with which this book opens, Tolstoy articulated his displeasure with Repin's preparatory work for a painting of a group of Cossacks. He judged the subject "not a painting but a study, because in it there was no serious, fundamental idea."[2] Although initially discouraged by this assessment, Repin returned to the picture, carefully researching it over the course of a decade. In 1891, at his first solo exhibition, he revealed to the public the finished version of *The Zaporozhian Cossacks Writing a Letter to the Turkish Sultan* (figure 1). As it would happen, the painter's ten years of hard work did not change Tolstoy's mind. In a letter to Repin, Tatyana Tolstaya writes that her father "remained indifferent" to the Cossack painting.[3] Moreover, two years earlier, the writer Nikolai Leskov cited his and Tolstoy's shared distaste for such a "lack of an artistic idea" (*bezideinost'*) in explaining that he far preferred Repin's dramatic religious painting, *Saint Nikolai Saving Three Innocents from Death* (1888), to *Zaporozhian Cossacks* (both of which he had seen in the artist's studio).[4] A similar discontent, albeit in formal terms, would be voiced by the critic Vladimir Chuiko in his review of Repin's 1891 exhibition. Remarking upon the apparent discrepancy between the picture's large format and the "insignificance of its subject," Chuiko writes that it was as if "Turgenev, having taken the subject of one of his stories of a hunter, wrote an entire volume and called it a novel."[5] While Tolstoy's and Leskov's focus on the absence of a strong religious or moral narrative is quite different from Chuiko's formal observation, their criticisms nevertheless bring to light how Repin's picture, in its breeziness, its levity of style and content, disrupts one of the central assumptions underlying realist painting—that medium and the traces of the artistic process are not to be privileged at the expense of clear signification and a serious message.

Chuiko's objection to the Turgenevian "sketchiness" of *Zaporozhian Cos-sacks* was likely influenced by the presence of so many of Repin's own sketches at the exhibition.⁶ Of the approximately 300 works on display, close to 250 were studies and drawings. Although Chuiko concedes the pedagogical value of this preparatory work, he is, for the most part, embarrassed by its indeco-rous exposure of the creative process. Showing such works is the equivalent, according to the critic, of Repin appearing in public "*en déshabillé,* so to speak, in a dressing gown."⁷ While Chuiko considers this aesthetically unseemly— Repin in a robe—some viewers would greet this fresh presentation of an already legendary artist as a long overdue revision of the realist project, high-lighting painterly style and technique over social and moral purpose. It comes as little surprise, then, that the younger generation of artists, who would even-tually form the core of the World of Art group (*Mir iskusstva*), responded with great enthusiasm to Repin's sketches. In fact, among those who purchased these works were none other than Sergei Diaghilev and Alexandre Benois, both in their early twenties, both poised to steer Russian art into its next phase.

At this moment during the turn of the twentieth century, when realism was giving way to alternative artistic philosophies more consistent with what would ultimately become modernism, it is possible to understand Repin's indecent exposure as evidence of a similarly transitional status. After all, cit-ing the association's inflexible adherence to an ideologically inflected realism, Repin had resigned from the Wanderers already in 1887. And in articles and personal correspondence throughout the subsequent decade, he would chal-lenge Tolstoy's and Stasov's rigid views on art, and express increasing support for the doctrine of art for art's sake.⁸ "I think that this is a disease among us, Russian artists, jammed with literature," writes Repin in an 1894 letter. "We do not have that burning, childlike love of *form.* [. . .] Our salvation is in form, in the living beauty of nature, but we crawl to philosophy, to morality. How tiring it is. I am sure that the next generation of Russian artists won't give a toss about tendentiousness, about the search for an idea, about intellectualizing."⁹ In an obituary for his fellow artist Nikolai Ge, written in the same year, Repin identifies the source of this "disease" as the preponderance of literary figures in the field of art criticism, and their tendency to rely on "beautiful analogies" between the plastic and literary arts rather than on informed artistic assess-ment. He continues with a distinctly Lessingian argument for the distinct capacities of artistic media: "The word will never represent form in all of its palpable fullness, just as none of the arts, except the verbal, will ever express plots, stories, dialogues, deductions, and instructions."¹⁰

Given this context, *Zaporozhian Cossacks* appears as an artifact of the pro-found cultural shift from a socially motivated realism toward the supposedly more formally or medium-conscious aesthetic of art for art's sake, and, thus, as straddling two modes of artistic representation and two interart philosophies. On the one hand, it is constructed upon the cornerstones of Stasov's painterly realism, namely, the meticulous and purportedly objective recording of detail and the reliance upon narrative content, in this case, historical. On the other

hand, Repin's picture forgoes a heavy-handed morality and punctures the illusion of objectivity with a loose, ecstatic handling of paint, leading Benois to note that, unlike Repin's generally narrative oeuvre, in this picture the "subject has disappeared behind the painterly task [*siuzhet ischez za zhivopisnoi zadachei*]."[11] So, is this an example of a protomodernist Repin, a Repin that the likes of Benois can tolerate (in small doses, of course)? Can we see in this muddied legibility of narrative in favor of a more aggressive painterly facture the seeds for what would become the formal experimentation of the avant-garde and the relentless self-reflexivity of Greenbergian modernism?

In a limited sense, it would be unreasonable to deny this; even Repin himself mentions in his 1894 letter the generational dimensions of this aesthetic shift. However, rather than situate the formally discordant aspects of Repin's painting at the beginning of a modernist teleology, this chapter flips the timeline. That is, *Zaporozhian Cossacks* represents not so much the start of modernism as the culmination of a debate on form and content that was inherent to painterly realism all along, and that can be discerned in Repin's first major success, the genre painting *Barge Haulers on the Volga* (1870–1873, figure 40), as well as one of his celebrated history paintings, *Ivan the Terrible and His Son Ivan, 16 November 1581* (1885, figure 46). These three pictures, all now firmly established within the Russian realist canon, span the first and most illustrious phase of Repin's long career and bookend the twenty-year period when the Wanderers enjoyed the greatest popularity and produced their most renowned works.[12] What they reveal is that painterly realism is defined by a relationship with content that is far more complex than has typically been presumed.[13] Repin's painting does not, as Stasov would have it, pursue its social message in a vacuum, independent of formal considerations. And it does not, as the modernists would presuppose, approach representation slavishly or content indifferently, oblivious to the mechanisms of artistic convention and ideology. On the contrary, by capitalizing on the tension between the sister arts inherent in

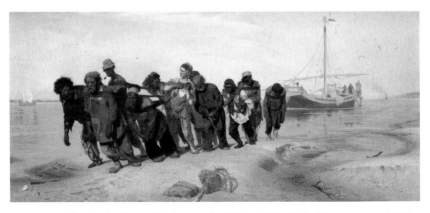

FIGURE 40. Ilya Repin, *Barge Haulers on the Volga*, 1870–1873. Oil on canvas, 131.5 x 281 cm. State Russian Museum, St. Petersburg.

the encounter between painterly form and narrative content, Repin's realism stakes out a far more complex and considered position regarding questions of aesthetics and representation. It is certainly true, therefore, that his pictures foreground their communication of social content, but they also distinguish themselves as manifestations of a painterly medium. Moreover, by recognizing Repin's engagement with matters narrative *and* pictorial, an engagement just as evident in his barge haulers as in his Cossacks twenty years later, it is possible to understand his painting as self-conscious in a way that has often been denied realism.

Writing in 1861, the year when the emancipation of the serfs marked a symbolic start to the era of reform, Stasov anticipated a revolution in the artistic sphere parallel to those underway in the political and social spheres. What he describes is a shift in focus—from technical and formal mastery (*tekhnika*) to socially relevant and useful content (*soderzhanie*)—that will supply much of the momentum behind the rise of painterly realism in the 1860s.

> What is at issue here is not virtuosity, not mastery of execution, not showiness, ability, or brilliance, but the very content of paintings.
>
> This content ceases to be a mere premise for the painter, as it was for the academic painters of the past. There occurs a transference of notions and things: what had been insignificant and secondary—content—assumes prime importance; what had seemed most important, what had exclusively occupied artists and the public—technique—suddenly recedes to second place.[14]

Two years later, in his review of the annual exhibition of the Academy of Arts, Stasov recognized signs of this shift in the growing number of genre paintings on topics of social import.[15] The progressive critic Ivan Dmitriev, however, took a more pessimistic view, publishing a condemnation of contemporary artists, accusing them of pandering to the tastes of the Academy and its elite patrons. "Art has not been of any use to the people," writes Dmitriev. "It has not given them any content because it was itself to the highest degree content-less [*bessoderzhatel'no*]."[16]

A few weeks after the publication of Dmitriev's article, a collective of fourteen artists led by the painter Ivan Kramskoy (in an episode that was discussed in chapter 2) withdrew from the Academy and formed the St. Petersburg Artel, a communal artistic association meant to ensure the economic security and professional autonomy of its members. By the end of the decade, a group of Moscow artists, many teaching at the Moscow School of Painting and Sculpture and on the whole more professionally advanced than the younger Artel members, began to discuss the establishment of a new organization to promote the independent exhibition of art around the empire. Led by Nikolai Ge and Grigory Myasoedov, the Muscovites in late 1869 drafted a proposal for this organization, which they sent to Kramskoy and his Artel. Ultimately, only four Artel members would join the new group, the rest too hesitant to completely sever their ties to the Academy, which had remained an important

if limited source of assistance.[17] In September of 1870, the final statute for the Society of Traveling Art Exhibitions, better known as the Wanderers (*Tovarishchestvo peredvizhnykh khudozhestvennykh vystavok*, or *Peredvizhniki*), was filed with the authorities.[18]

Beyond their shared interest in gaining independence from the official patronage and exhibition structures of the Academy and the state, the founding members of the Wanderers were inspired by, in Elizabeth Valkenier's words, a "mixture of economic, liberationist, and missionary motives."[19] This confluence of practical and much loftier concerns was evident in the original proposal that Myasoedov and his colleagues sent to the Artel, in which the artists' regulatory and economic concerns were expressed through the rhetoric of liberation and cultural appreciation: "We think that there is a possibility to liberate [*vysvobodit'*] art from bureaucratic regulation and to widen the circle of art lovers and, therefore, the circle of buyers."[20] In the final statute, the central goals of the Wanderers were just as mixed, put forward rather vaguely as the intention to expose provincial Russians to contemporary art, to encourage in the public a love of art, and to provide opportunities for their members to exhibit and sell their work.[21] Beyond these principles and a general interest in freeing artists from the control of the state, the Wanderers did not, in any official capacity, articulate a clear set of aesthetic prescriptions. Because of this, the art of the Wanderers was quite varied, ranging from conventional landscapes and portraits of leading thinkers to dramatic revolutionary scenes and expansive historical canvases. It would be in letters, articles, and reviews throughout the 1870s and 1880s that Kramskoy and Stasov, self-appointed spokesmen for the Wanderers, would attempt to better define and guide the group's artistic philosophy.[22]

Although Repin did not join the Wanderers until 1878, his early works, and *Barge Haulers* in particular, were taken up as fodder for these aesthetic debates on the nature of contemporary realism. One of the dominant parameters of this critical discourse is the relation and relative importance of form (*forma*) and content (*soderzhanie*), whereby form is aligned with a network of visual categories—painterliness, technique, and aesthetics (*zhivopisnost', tekhnika, estetika*)—and content with a network of verbal categories—literariness, ideas, and tendentiousness (*literaturnost', ideia/mysl', tendentsioznost'*). As in the preceding chapters of this book, these conceptual clusters are not employed as essential categories of artistic production. Indeed, Repin's painting transformed this critical opposition between form and content into a flexible binary structure within which to consider its own capacities for realist representation relative to those of other artistic modes and media. In this sense, form came to mean all that is somehow inherent to painterly ontology (line, color, the interplay between surface and depth), while content denoted the transformation of that form through semantic or narrative structures of signification. This is not to say that Repin adopted or applied the critical vocabulary of Stasov and others, but rather that his paintings responded to these aesthetic debates in their own terms. Glimpsed in the pictures' interart encounters, Repin's nuanced and

variable relation to form and content ultimately defines his painterly realism in comparison to the realisms of his counterparts.[23]

The critical response to Repin's *Barge Haulers*, which debuted at the Academy of Arts in 1873 as part of a presentation of works bound for the Vienna International Exhibition, reflects just how pressing this question of artistic priorities had become.[24] To take a stand on the relative importance of ideology and aesthetics was also to make a statement about the true path of artistic realism. Stasov, although he pays lip service to Repin's talents as both an "artist and a thinker" (*khudozhnik i myslitel'*), maintains his preference for content by teasing a powerful political message out of the picture. Amid the group of broken men, silently trudging along the banks of the river, Stasov identifies the young boy in a pink shirt as the embodiment of "the protest and opposition of a mighty youth against the meek submissiveness of mature wild Herculeses."[25] The critic Nikolai Mikhailovsky is even more explicit on this point: "Take note of their faces and then look at the steamship speeding in the distance, and you will understand that the task of art is great and sacred, that its role consists not of the tickle of aesthetic ability [*v shchekotanii esteticheskoi sposobnosti*], that it can awaken the conscience, awaken thought [*mysl'*] and feeling."[26] Also noting the dedication of Repin's picture to ideological content, Vasily Avseenko offers a radically different evaluation, arguing that dependence on such a "little idea [*ideika*] borrowed from dubious works of literature" actually empties the painting of any intrinsic artistic value.[27]

Discouraged by these assessments of Repin's critical orientation, Dostoevsky recalled feeling rather wary about seeing the painting that had all of Petersburg abuzz. However, once in the exhibition hall, the writer was pleasantly surprised. "Not one of [the barge haulers] screams at the viewer from the painting," he writes. "It is impossible to imagine that any thought [*mysl'*] of the politico-economic and social debts of the higher classes to the people could have ever entered into the poor, lowered head of this little peasant, beaten down by eternal grief."[28] Dostoevsky considers it simply preposterous that one might ascribe contemporary sociopolitical notions to the profound emotional landscape of the barge hauler. Repin's painting succeeds, in Dostoevsky's opinion, because of its refusal to loudly trumpet a political message, because of its expression of an idea that cannot be put simply into words. Although he speaks here of a quality that goes beyond the ideological provocations championed by progressive critics, Dostoevsky also mentions an artistic specificity to the painting's overall expression, writing that "there is no use telling about a painting; it is too difficult to communicate paintings in words."[29] This otherwise passing comment lays bare the influence of Lessing's insistence on firm artistic borders on Dostoevsky's aesthetic thought, an influence that extends far beyond his perception of Repin (and that will be discussed further in the next chapter). With regard to the barge haulers, however, it is worth emphasizing that Dostoevsky notes a dissonance between political and painterly concerns, between the shouting of a message and the ineffability of a picture.

The question of these competing objectives also preoccupied Repin, and especially from 1873 to 1876, when he was in Paris on a state-funded study trip.[30] His letters and paintings from this period reveal less Stasov's dutiful protégé than a young artist in search of his own voice. It is to Kramskoy that he communicates most clearly his aesthetic concerns.

> May God at least save Russian art from corrosive analysis! When will it fight its way out of this fog?! This misfortune impedes it terribly with the pointless accuracy of socks and ankle bones in its technique, and with rational thoughts drawn from political economy in its ideas.[31]

In a certain sense, these are just the anxious words of an artist who has been celebrated as the great hope of Russian art but who now found himself in a much bigger pond. And yet, Repin was not alone in his worry over the formal inadequacy of Russian painting. Earlier that year, in a letter to Repin, Kramskoy expresses his frustration with the poor quality of the Wanderers' latest exhibition, and wonders whether in time their art will resemble that of older national traditions, which value above all "coloration, effects, and outward appearance, exactly that which painting, and only painting, is."[32] Although Kramskoy argues that it is absolutely necessary for Russian art to move toward greater formal consciousness, he maintains that it must do so without sacrificing ideas. In fact, he writes, the "idea and the idea alone creates technique [*mysl' sozdaet tekhniku*] and elevates it."[33] With these words Kramskoy declares an intermediary position, declaring a commitment to technical perfection and stylistic expression while also remaining loyal to Stasov's privileging of content above all else.

Upon his return from abroad, Repin would be urged by Kramskoy and Stasov to reacquaint himself with national subject matter, and he would do so to great effect, becoming the unofficial figurehead of the Wanderers. His concern with such pressing formal questions, however, continued to be reflected in the best examples of his painting. Repin's aesthetic emerged from the productive tension between form and content, a tension aligned with the interart distinctions emblematic of artistic realism. While it is true, therefore, that his pictures tell compelling "stories," they also invite the viewer to move into, around, and through their fragile narrative structures and toward an experience of painterly materiality that is tactile and timeless in its presence. Unlike Tolstoy, however, Repin does not overturn one artistic mode and then champion another; he does not undermine narrative legibility in an argument for painting's superior realism. Rather, in *Barge Haulers on the Volga*, he sustains a charged tension between visual and verbal that does not deplete, but rather deepens the picture's oppositional content. And in the history painting of his mature period, he develops this fundamental interart binary into an even bolder declaration of painting's unique ability to enhance a narrative foundation for the sake of a fuller representation of reality.

It is worth emphasizing as well the nationalist and professional dimensions of Repin's *paragone* on behalf of realist painting. According to Stasov and his

followers, the perceived dominance of sociopolitical narratives in Russian painting is not only a function of the necessity of art to communicate a message, it is also an assertion of the distinctiveness of Russia's national realism. In opposition to those of Europe, "our literature and art," he writes, "are inseparable twins, unimaginable apart."[34] If for some, this literariness distinguishes Russian painting as a national tradition, then for others it casts Russian painting as underdeveloped. In an 1878 review, Pyotr Boborykin blames the "literary tendency" (*literaturnoe napravlenie*) in painting for what he sees as "explicitly Russian shortcomings" in coloration, draftsmanship, and imagination.[35] It is, he writes, this neglect of the *art* of painting that prevents the Russians from rising above their provincial status. Therefore, while the interart relations discussed throughout this book can be considered part of Western realism writ large, whether in Russia, Europe, or the United States, they gain heightened significance for the visual arts in Russia.[36] To negotiate the line between the verbal and the visual is, on the one hand, to argue for a work's particular realist aesthetic, and on the other, to make a much broader claim for nothing less than the cultural legitimacy of Russian art on the world stage.

And so, when Repin interrupts the Cossacks in their letter-writing to linger over the swampy greens of a glass jug, or the milky creams and taupes of a white fur coat, he also activates larger questions about the place of Russian painting at home and abroad. To be sure, his "stories" ally him with the goals of the Stasovian realists; he seeks authority for painting by proclaiming social messages and drawing analogies with her more mature and valued sibling, literature. But when he disrupts the content and turns his attention to painting itself—when he, to recall Chuiko's colorful image, dons a housecoat— Repin does so in defense of his qualifications as a visual artist, the uniquely expressive potential of his chosen medium, and the identity of the Russian school of painting.

Dissonant Realism on the Volga

As a young student at the Academy of Arts, Repin preferred to work in his studio, venturing only occasionally so far as the foyer to sketch the sculptures that lined the grand staircase. It was here that Repin began studies of a scene he had glimpsed on a rare weekend excursion down the Neva River: barge haulers against a colorful backdrop of picnicking socialites. Repin recalls the reaction of his friend, the promising young landscape painter Fyodor Vasilyev, to these less than subtle early sketches:

> Ahh, the barge haulers! So, they've hit a nerve? [...] But do you know something, I worry that you might fall into tendentiousness. Yes, I see it now, a study in watercolor...Here you've got young ladies, their admirers, a countryhouse setting, something in the manner of a picnic; whereas these grubby ones are rather too artificially "compositioned into" [*prikomponovyvaiutsia*] the picture for the sake of

edification: look, they're saying, what wretched monsters we are, what gorillas. Oh, 135
you'll get into a mess with this picture: it's far too deliberate. A picture should be
broader, simpler, what is known as a picture that stands on its own.[37]

Vasilyev, by all accounts the more outgoing of the two, proposes a summer trip down the Volga River as the appropriate solution to the artificial composition of Repin's sketches, arguing that access to the "real, traditional type of the barge hauler" will temper the subject's didactic heavy-handedness and reveal a greater artistry.[38] In the late spring of 1870, after a year of preparations, Vasilyev and Repin set out for the Volga, accompanied by Repin's younger brother Vasily and fellow artist Evgeny Makarov.[39]

By abandoning the studio for on-site research, Repin and Vasilyev were participating in trends already underway in European and Russian painting, namely, the push toward a greater democratization of subject matter, the rage for ethnography and its presumed scientific objectivity, and the growing enthusiasm for plein air landscape painting (painting created outdoors, in "open air"). More generally, Repin and like-minded artists strove to eliminate the distance, physical and otherwise, between themselves and their subjects. For Stasov, it is precisely this proximity to the "real" that characterizes the ideological power of the new realism. In his 1871 review of the first Wanderers exhibition, he wonders who could have imagined that Russian artists "would suddenly abandon their artistic lairs and wish to plunge into the ocean of real life, to join with its impulses and aspirations, to think about other people, their comrades!"[40] Stasov employs a turn of phrase—*okunut'sia*, to plunge into, to immerse oneself—that would become central to his discussion of Repin during the coming years. In his review of *Barge Haulers*, for example, Stasov announces that Repin has "plunged headfirst into the very depths of the people's lives."[41] This desire for immersion—an elimination of distance between artist and subject, between art and life—is meant to bring an authentic and objective understanding of the world, and, as such is also what drives much of realism, literary and painterly. It is, for example, familiar from the nosy window-peeking of Fedotov, and the galloping of Pierre into the field of battle. In *Barge Haulers on the Volga*, this desire is reflected in the intense physicality that both disrupts and deepens the "tendentiousness" noticed by Vasilyev in Repin's early studies.

Looking at the final painting now, one cannot help but feel grateful to Vasilyev, for even after his intervention, the picture still leans heavily—almost *too* heavily—on exaggerated juxtaposition for its condemnatory message (figure 40). It is easy to locate the content of the picture, stretched taut on a diagonal, in the contrast between the downtrodden men in the foreground and the picturesque landscape in the background (replete with a cheery little sailboat). Repin even painted a bright red shirt on one of the men in the distance, so as to guide the eye of the viewer toward the large boat (marked as imperial by its flag) that the men are towing. Here, he seems to say, are the real and symbolic, physical and political, sources of my heroes' oppression. The composition of Repin's picture operates, then, within a set of relations that produces a narrative, or,

at the very least, a social message. Relative to the riverscape and the political and economic power in the background, the men in the foreground suffer in subjugation. And relative to these suffering older men, lined up in a horizontal chain suggestive of a certain historical linearity, the young boy raises his head, looks into the distance, and imagines a brighter future.

Many viewers of the time accepted Repin's invitation to construct a rudimentary story. And many went still further; assuming that Repin had borrowed his subject from literary works of progressive realism, they set out to find the source. The most frequently mentioned example was Nikolai Nekrasov's poem "Thoughts at a Vestibule" (1858), which features Volga barge haulers as an image of the long-suffering Russian people.[42] Although Repin denied that Nekrasov was an influence, claiming that he had not yet read the poem when he undertook his painting, this association highlights the painting's investment in communicating a message of social injustice.[43] But this is a message, according to Stasov, taken not from "books, but from the very lives of the people."[44] Its sentimentalism aside, Stasov's comment touches on a fundamental difference between the presumed "literariness" of Repin's painting and its commitment to storytelling. Although *Barge Haulers* is certainly invested in its "story," it does not tell it in any straightforward narrative trajectory, despite what the linear compositional structure might suggest. Repin's picture is not, therefore, literary in its messaging, but distinctly painterly, mobilizing the dissonance of form and content—and, by extension, pictorial aesthetics and critical ideology—in the service of an oppositional meaning.

In *Barge Haulers* this tension between aesthetics and ideology manifests in a variety of compositional oppositions, but is perhaps nowhere more evident than in the strict division between foreground and background. The group of hard-working men, painted in a thick impasto of murky browns, blues, and grays, pulls forward out of the calm pastel waters, smoothed over the canvas with barely perceptible brushstrokes. The riverscape, with its periwinkle and gold striations, offers relief for the viewer's weary gaze. In the irresistibility of this landscape, Repin threatens to abandon his social invective for the pleasure of the picturesque. His exclamation from a few years later—"May God [. . .] save Russian art from corrosive analysis!"—resounds across the placid surface of the Volga. This compositional tension reflects the ambivalent status of landscape painting within realism; by far the most popular and marketable genre of the Wanderers, it posed a definite problem for the staunch proponents of critical realism, who were never fully comfortable with the idle, and ideologically negligent, gazing encouraged by such picturesque views.[45] This discomfort is also felt in Repin's painting. Although the tension between background and foreground supports the overall critical narrative, the beauty of the river nonetheless beckons, threatening to derail the viewer's attention. But is this not also part of the painting's proposition, that we as viewers are so fickle and so easily distracted that we may overlook the injustices before our very eyes? In this opposition, then, Repin deftly employs composition, genre,

and paint handling to distract from the social content of the painting, thereby reinforcing its very potency.

Even without looking at Repin's *Barge Haulers*, however, one can discern a note of dissonance in its professed content, for the title itself introduces a challenge to its groundedness in reality. This is because, by the middle of the century, barge hauling was already a dying profession, and, as of 1866, four years before Repin's trip, steamships transported 85 percent of all goods between ports on the Volga.[46] Taking note of this historical inaccuracy, one critic writes that "the contemporary genre painter should take up contemporary subjects [*siuzhety*] and not indulge in anachronism. [...] Repin painted his *Barge Haulers* at a time when steamships already scurried along the Volga and barge hauling was only legend."[47] Repin himself gestures to this discrepancy, introducing a small steamship onto the right side of the canvas, a detail that joins the compositional division between foreground and background in disrupting the narrative cohesion of the painting. Is Repin's picture, therefore, meant to be a critique of social oppression in the empire? Or is it a timeless landscape, a picture straight out of legend? One possible source for these anachronisms lies in the activities of Repin and his traveling companions. Recalling the summer years later, Repin writes that they would spend their evenings reading aloud, at first Turgenev's prose and even an article by one of the leading radical critics, Dmitry Pisarev, until they finally became fully absorbed in *The Iliad* and *The Odyssey*. "Completely unexpectedly, word after word, verse after verse, we didn't even notice that this living fairy tale had pulled us in."[48] Tossing Pisarev aside for epic poetry, therefore, becomes a sign of Repin's investment in aesthetic and cultural matters that extend beyond the critical and the contemporary, a tension that manifests visually in *Barge Haulers* as an occasional strangeness, a sense of nostalgia or epic scope that seems inconsistent with the supposed contemporary relevance of realism.

The strangeness of Repin's "reality" becomes all the more apparent if it is compared to Konstantin Savitsky's *Repair Work on the Railroad*, completed shortly after Repin's *Barge Haulers* (1874, figure 41).[49] Not only does Savitsky represent far more contemporary subject matter, a sight that was likely common during the expansion of the railroad in the 1860s and 1870s, he does so in a manner that retains compositional and spatial coherence. Savitsky's laborers—although slightly odd in the way they soar, arms spread wide, gripping the handles of wheelbarrows—are tightly bound to their environment, sharing its earthy tones and populating a majority of the ground plane. There is little to distract from the visual uniformity of the workers other than the overseer dressed in bright red. And this figure, unlike the man in red aboard the ship in *Barge Haulers* whose coloration is more consistent with the picturesque riverscape than the brutal reality of the foreground, does not detract from but rather supports the picture's message about the backbreaking labor and implicit power structures that build an empire.

Although he communicates a similar social message, Repin does not offer the kind of cohesive, pseudo-photographic image of contemporary life that

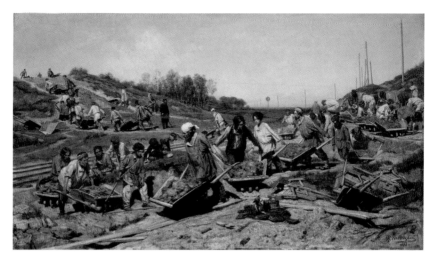

FIGURE 41. Konstantin Savitsky, *Repair Work on the Railroad*, 1874. Oil on canvas, 103 x 180.8 cm. State Tretyakov Gallery, Moscow.

Savitsky does. Instead, he condenses the social and physical tensions of his subject into the very form of the picture. In this, Repin's *Barge Haulers* is reminiscent of another realist classic, Gustave Courbet's *The Stonebreakers* (1849, figure 42).[50] Separated by over two decades, the works nevertheless share a theme, an outsized reputation, and even a discordant approach to the depiction of labor. The stonebreakers, like the barge haulers, possess a physicality that presents itself viscerally and demands to be engaged by the viewer. And yet, also like the barge haulers, the impression that they are affixed to a flat surface makes them seem out of place, and their labor incoherent. In this incongruity, art historian T. J. Clark sees a hallmark of Courbet's realism, the way in which it took up "the social material of rural France, its shifts and ambiguities, its deadly permanence, its total structure."[51] A man of split identity, his peasantry roots never far beneath a bourgeois surface, Courbet, as Clark argues, paints a France that retains these social contradictions, intimate and knowable, yet also distant and foreign.

Although of a necessarily different character than that of Courbet, Repin also possessed an ambiguous, at times precarious, relation to his subjects. Born in 1844 in the small village of Chuguev to a father who was stationed in a Russian military settlement, Repin identified predominantly as a *muzhik* (peasant) of humble origin, a social status that afforded him a privileged view into the life of the people.[52] However, in 1870, as an artist from the capital on a summer trip to the Volga, he also found himself in the position of a distinct "other," observing and painting the downtrodden barge haulers.[53] In this way, *Barge Haulers* reflects the broader social realities of its time—the persistence of class divisions in an empire that was struggling to modernize—while also capturing the peculiar status of the realist artist who was simultaneously close to and hopelessly distant from his subject.

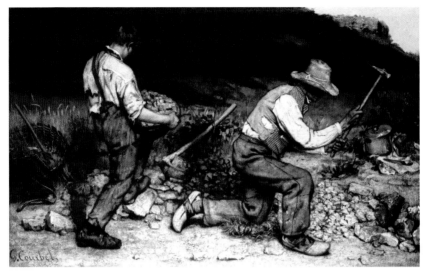

FIGURE 42. Gustave Courbet, *The Stonebreakers*, 1849. Oil on canvas, 160 x 259 cm. De-stroyed (formerly Gemäldegalerie, Dresden). Photo: bpk, Berlin/Art Resource, New York.

This paradox unfolds not only in the compositional dissonances that have been mentioned thus far, but also in the compelling physicality of Repin's subjects. Whereas Stasov chose to focus on the young boy in the pink shirt, another viewer might be drawn first to the man immediately in front of the boy, for he is the only figure who makes direct eye contact, his gaze both attractive and repellant in its intensity. Among the work crew, his body is the one most acutely tilted toward the ground. Because of this awkward suspension, the man urges a consideration of the physics of this scene and, more specifically, the competing forces of weight and gravity. Bodies lean forward, pulled to the ground, yet held in place by the heavy counterweight of the ship on the river. The viewer senses this precariousness all the more because of the utter lack of a stable support plane; the shifting sands of the shore threaten to give way into shallow pools and canyons. A foot sinking backward, a body held aloft by a single loop of material, these elements speak directly to the viewer's sense of physicality, demanding an identification with the solidity of these bodies as well as with their vulnerability.

If we stand in front of the canvas and look down at the shore, we see a tex-tured paint surface that pretends to be sand. Shifting our gaze up and toward the horizon, this texture is replaced by a smooth immateriality, as glossy as a postcard. Confronting the barge haulers, we note a visceral handling of paint and a palette more suitable to volume. Again, look to the shore and feel the ground drop out from underneath you. Look to the men, and feel your body sway out of empathy. Imagine the sensation of tilting forward. The physical sensations that accompany the act of looking at Repin's painting are akin to those described by Michael Fried in Adolph Menzel's painterly realism, what

he calls an "art of embodiment." In the experience of different perspectives—looking down, out, at—and of the real physical demands of viewing, the viewer of such a painting participates in "countless acts of imaginative projection of bodily experience."[54] For Fried, Menzel's viewer makes "a conscious effort at empathic seeing in order to 'enter' and 'activate' a painting that otherwise remains inert."[55] In doing so, the viewer also repeats the very processes of the artist in constructing the painting; looking down and past, sensing the ground and gravity, the viewer embodies the space of both the picture and the painter.[56]

One of Repin's studies—and a rather bizarre one at that—speaks to this corporeal and painterly duality in Repin's picture (figure 43). A man stands strapped into a barge hauler's harness, but behind him, instead of a ship caught in a powerful crosscurrent, is a fenced-in pasture under the fluffy white clouds of a bright afternoon. With its background likely filled in as an afterthought, this study transforms its subject from a barge hauler, engaged in a demanding physical task, into a weightless phantom. This phantom only makes sense within the context of the artist's studio, as an experiment in how to represent a figure constrained and suspended in space. In the final painting, the phantom has been grounded, the barge haulers given a barge to haul. When viewed as part of this labor system, the men are understood as imperial subjects tethered to a difficult and oppressive task and, thus, as the embodiment of the painting's social content. But *Barge Haulers* also retains traces of the uncanny flotation of the man in the study. In particular, the vertiginous rendering of the men's bodies encourages a virtual immersion in the physical space of the picture. The viewer is invited to inhabit a predominantly corporeal consciousness that is not bound to a ship or a narrative or a social reality, but that emerges from the experience of finding a foothold on the Volga or exploring representation in the studio. The last man in the crew underlines the point. With his body pitched forward, he is both a mark of the social dynamics of barge hauling and a trace of the formal challenges of real and pictorial space.

Repin's *Barge Haulers*, therefore, is as much about the barge haulers as it is about Repin's process of representing the barge haulers.[57] In the picture's many formal tensions—the dissonance between foreground and background, the attraction to and repulsion from the men, the intimate physicality and unsettling immateriality of their bodies—are reflected not only the tensions between the lower and subjugating classes, but also the challenges that Repin faced in connecting with his subjects and transferring their reality onto the canvas. Looking back on his summer on the Volga, Repin recalls these creative challenges as inextricably tied to the spatial conditions of the environment and, more specifically, to its sometimes confounding disjunctions between points of view.

> What is most astounding about the Volga is the space. None of our albums had the capacity to hold the unusual horizon.

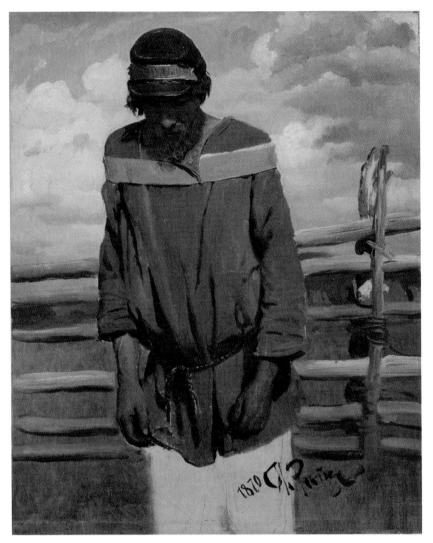

FIGURE 43. Ilya Repin, Study of a barge hauler, 1870. Oil on canvas, 38.5 x 31 cm. State Russian Museum, St. Petersburg.

From the middle of the river or from the steamboat you see mosquitoes of some kind along a luminescent strip on the hilly side of the river. Lord, how they stir and just barely move forward ... And what about this strand of hair pulling toward us? It's the barge haulers pulling the barge with a rope along the shore of the hilly side. We approach: the light strip turns out to be a huge sloping incline up to the forest, completely covered and pitted with boulders of light limestone, sandstone, and granite.[58]

A similar movement between a distant perspective and an extreme close-up comprises the central drama of a curious drawing by Repin (figure 44).[59] It is a composite image, bringing together three different sketches from three different points of view onto a single page. Reading the image from left to right, we are rewarded with a narrative of departure. From what seems to be a relatively generalized sketch of a vessel, we move to a full-body line drawing of Kanin (the lead hauler in the final painting), and then to a landscape, the dark lines of the pencil indicating the abstract gradations of the shore. Reading in the other direction, our departure is reversed into an arrival, moving us toward ever greater proximity and specificity. While the composite nature of the traveler's sketchbook is able to suggest a subtle and linear narrative, in the disjunction between its detailed portraits and hazy horizon, *Barge Haulers* subsumes narrative temporality into a layering of discrete perspectives. By doing so, it suggests a physical closeness to the barge haulers, while also recognizing the impossibility of ever fully immersing oneself, as an artist or a viewer, into the reality it depicts. Through this dissonance, the simultaneous (that is, not consecutive) presentation of spatial incongruities, Repin's painting captures the social conditions of its subject and the aesthetic experience of the artist with that subject. We are always, somehow, both on the ship and on the shore.

Evidence of the realist's desire for an immersion that can overcome this ambivalence can be found in the not infrequent appearance of the artists themselves in the pages of their travel albums. In one instance, Vasilyev lovingly draws two cliffs, with an artist, perhaps Repin, sketchbook in hand, nestled within the lower left corner (figure 45). The hunched-over sketcher, turned from observer to observed, has crawled into the same physical and artistic space as the boatmen. Yet, while a subject, he is certainly not a laboring one. Or if he is, it is a much different kind of labor than that of the barge haulers. While Stasov might have optimistically declared that Repin "plunged headfirst into the very depths of the people's lives," Repin himself seems to recognize the limits of this kind of immersion.

> And yet another great unpleasantness made itself more and more apparent: beginning with our boots, which simply burned from our long strolls among the hills and forests, our clothing suddenly decayed and transformed into the most unacceptable rags: our pants began to split into some kind of ribbons and flopped unceremoniously below like picturesque paws [*zhivopisnymi lapami*] . . . Once with horror I saw myself clearly in such beggarly rags, I was even shocked at how quickly I had arrived at "such a life."[60]

What Repin describes is less travel taking its predictable toll than a process of assimilation. The artists become their subjects; their boots decay, their clothing turns to rags, and their bodies become "picturesque," or, literally, "painterly." It is worth emphasizing, however, that this is not a transformation into a barge hauler but a transformation into a *depicted* barge hauler. Or, to put it

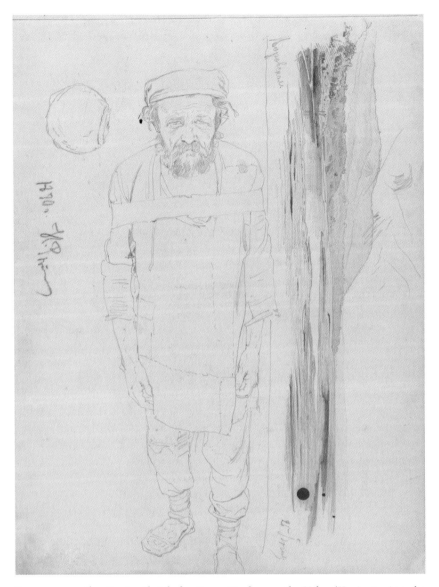

FIGURE 44. Ilya Repin, Sketch for *Barge Haulers on the Volga* (Kanin towing; the Volga near the village of Vorovskaya; clay pot), 1870. Graphite pencil on paper, 37.3 x 28.2 cm. State Tretyakov Gallery, Moscow.

another way still, rather than immersing himself in the reality of the people, Repin approximates their reality and immerses himself in their representation.

This transformation from artist to subject, and the fluidity between art and life that it implies, is one of the boldest conceits of a realist aesthetic famously demonstrated by Nikolai Chernyshevsky's *What Is to Be Done?* (1863), a

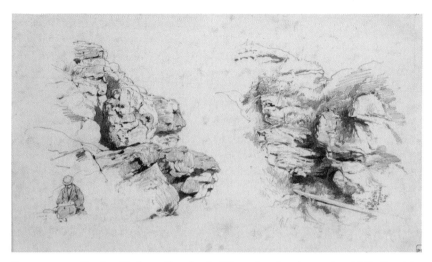

FIGURE 45. Fyodor Vasilyev, Sketch of cliffs and a drawing artist, 1870. Graphite pencil on paper, 21 x 35.4 cm. State Russian Museum, St. Petersburg.

novel intended as a literary model for the lives of new men and women.[61] Rakhmetov, Chernyshevsky's archetypal new man, goes a step further than Repin, working alongside barge haulers in order to reshape his mind and body. Aware that these men would not accept him right away, he begins as a passenger on their boat and gradually insinuates himself into their group. "After a week," explains the narrator, "he had buckled into [a harness], just like an actual barge hauler."[62] Rakhmetov is transformed by his experience, even receiving a new nickname, Nikitushka Lomov, borrowed from a hero of Volga folktales. While his embodiment of a barge hauler may seem more genuine than Repin's, Rakhmetov's adoption of a name out of popular legend exposes the vulnerability of his transformation. He has not become an actual barge hauler, he has become *like* an actual barge hauler, filtered through the cultural imagination, more myth than reality. It is here—in the pressure that artistic representation exerts on the real—that one encounters the limits of the realist promise. Although realism might aspire to a complete immersion in life, it can only ever acquire proximity.

There are even signs of realism's fallibility in Stasov's typically exuberant celebration of Repin's immersive potential. "Whoever looks at Repin's *Barge Haulers*," writes Stasov, "will immediately understand that the artist was deeply affected and shaken by the scenes that passed before his eyes. He has touched these hands made of cast iron, with their sinews, thick and taut like rope."[63] Once again, metaphoric language interrupts a declaration of realism's immersive objective, revealing, in this case, that Repin connected with aesthetically mediated barge haulers—their bodies made of iron and rope—rather than with authentic reality. Highlighting the rhetorical distance between language and its referent, the intrusion of metaphor into a

description of Repin's mimetic acumen mirrors the social and aesthetic tensions in the *Barge Haulers*.

Repin, as a good realist, sought immersion in the lives of his peasant subjects; but because of the uneven power dynamic between painter and subject, he would always remain somehow "other." This conflicted relation of artist (and viewer) to subject is visible in the disjunctions between near and far, the illusion of physical contact and intimacy with the barge haulers, on the one hand, and the pull toward the picturesque and the aesthetic, on the other. And this conflicted relation, which manifests as the simultaneous communication of social content and the assertion of the painterly medium, also touches on the aesthetic paradox at the very core of the realist enterprise.[64] While we might imagine we hold hands with the barge haulers in one instant, in the next we feel not veins and sinews but only the bumps and ridges of dried paint. And it is here, two decades before the exhibition of *Zaporozhian Cossacks*, in the tensions between the painterliness of *Barge Haulers* and its content, that one finds Repin thinking deeply about the social and aesthetic purposes of realism. Rather than a Tolstoyan dismantling of illusion, however, the young painter posits a tensile structure, not unlike the one that binds the barge haulers to the boat, that can accommodate both the message and the medium.

Present Past

If *Barge Haulers* represents an early attempt to work out how a painting is to be socially useful without undermining its ontological capacities, then Repin's limited foray into history painting puts these skills to the test. How can an image from the past capture the proximity and relevance required of realism? And how can a painting so narratively overdetermined assert the power of its medium? These will be the questions that Repin confronts in his turn to history, a turn that coincided with the peak of his early career and that produces perhaps his most forceful pictorial statements on realism and painterly illusion.

During much of the eighteenth and nineteenth centuries, Russian history painting was still closely associated with official academic culture and with an art that privileged the representation of the ideal and the monumental over the particular and the popular. With the rise of realism in the latter half of the nineteenth century came the need to reimagine this most storied of painterly genres, a project that was taken up by some of the Wanderers' most talented members, Nikolai Ge, Viktor Vasnetsov, and, especially, Vasily Surikov. By grounding their historical subjects in ethnographic specificity and imbuing them with psychological complexity, these artists sought to make historical representation more persuasive for their viewers.[65]

In addition to his paintings of Ivan the Terrible and the Cossacks, Repin completed only one other history painting in the course of his long career, *Tsarevna Sofia in the Novodevichy Convent at the Time of the Execution of*

the *Streltsy and the Torture of All Her Servants in 1698* (1879).[66] Stasov would respond unfavorably to Repin's experimentation with the past, writing that Repin "is not a dramaturge, he is not a historian, and in my sincerest estimation, if he were to paint twenty more paintings on historical subjects, he would still not be successful."[67] Indeed, frustrated with his progress on the painting of the Cossacks, Repin parrots Stasov's opinions back to him in an 1881 letter: "I will abandon all these historical resurrections of the dead, all these popular ethnographic scenes; I will move to Petersburg and begin paintings I thought up long ago, paintings from the most vital reality that surrounds us and is understood by us, and moves us more than all past events."[68]

During the 1880s, Repin remained largely true to his word, basing canvas after canvas on contemporary scenes and events, such as the enormous, almost encyclopedic, *Religious Procession in the Kursk Province* (1881–1883) and the intimate picture of a young revolutionary returning home, *They Did Not Expect Him* (1884–1888). Despite the importance of these and other examples of his mature work, his history paintings have become some of his most recognizable pictures, and, given the inextricability of history painting from modes of storytelling, are also particularly rich places to look for the interart encounters that are the subject of this book. As such, they are essential for understanding Repin's particular *paragone*, how he continued to refine his aesthetic philosophy by means of the interart tensions so fundamental to Russian realism. In *Ivan the Terrible and His Son Ivan*, for example, Repin does not reject or even apply pressure to the dominant narrative (figure 46). The painting clearly communicates the story of Ivan and his son, and by drawing historical analogies, also emphasizes its more general critique of abusive political power. However, it achieves this heightened expression of its message not by downplaying form in favor of narrative, but by embracing the specific spatiotemporal capacities of painting. Repin takes the sixteenth-century story and explodes its narrative scope, extending it deep into the past and far into the future, and ultimately into the space of the contemporary moment. In the process, his painting transcends its historical content and strives for a more profound illusion of presence.

Despite his frustrated declaration to Stasov, Repin likely returned to his "historical resurrections of the dead" because the current event of the time that most begged for artistic representation was, in fact, far too risky to paint. On March 1st, 1881, a young member of the People's Will, a left-wing terrorist organization, threw a bomb at Tsar Alexander II, killing him. Repin was in St. Petersburg during the days following the assassination, and a month later witnessed the public execution of several members of the People's Will. It was, for Repin and many other members of the liberal intelligentsia, a moment of reckoning with the violent consequences of a charged political scene. Years later Repin would recall the Moscow evening when, returning from a performance of Nikolai Rimsky-Korsakov's work, he conceived of the idea to paint *Ivan the Terrible*: "Feelings at that time were weighed down by horrible contemporary events. [. . .] These pictures [*kartiny*] stood before our eyes but no one dared paint them. It was natural to search for an escape into an even greater

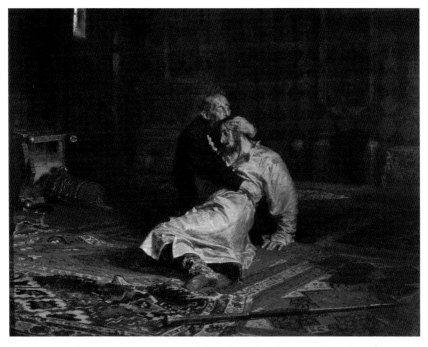

FIGURE 46. Ilya Repin, *Ivan the Terrible and His Son Ivan, 16 November 1581*, 1885. Oil on canvas, 199.5 x 254 cm. State Tretyakov Gallery, Moscow.

tragedy from history."[69] These horrific pictures—a picture of a tsar bleeding on a Petersburg street, a picture of young revolutionaries executed in their prime—could, of course, not be painted. Faced with this impossibility, Repin turned back the clock, exactly three hundred years, to 1581.[70]

Even with this turn to the past, the contemporary moment could not be fully escaped. The year 1881 is apparent in the tenor and morbid mood of the Ivan painting. But it also reverberates in the year visible in the lower right corner of the canvas, 1885. For the contemporary viewer, this date would have been a reminder that he, like Ivan, was standing in the shadow of a brutal historical moment. For a devoted ideological realist, the value of Repin's painting could be found precisely in this covert commentary on the present by analogy with the past.[71] When *Ivan the Terrible* was shown for the first time at the thirteenth annual exhibition of the Wanderers in 1885 in St. Petersburg, this analogy did not go unnoticed. After seeing the picture, Konstantin Pobedonostsev, chief procurator of the Holy Synod and valued adviser to Tsar Alexander III, wrote the tsar a vicious condemnation of the work, accusing it of "naked realism," "critical tendentiousness," and a lack of "ideals."[72] As a result, it was promptly taken down and prohibited from exhibition. Pavel Tretyakov, who had purchased the picture for his collection, was ordered to keep the painting locked up, away from the gaze of the public.[73]

Repin creates this dangerous analogy primarily through thematic rhyming, layering the dominant Ivan narrative with indirect but salient gestures toward the contemporary moment.[74] He also, however, engages the most fundamental tool of painting—color—to expand the Ivan story into a much more protracted and even transnational history of political unrest, a story told across several of Repin's paintings from the 1880s. This is accomplished partly through the strategic deployment of the color red to signify radical revolutionary activity. In, for example, *A Secret Meeting* (1883) and *The Arrest of a Propagandist* (1880–1892), the young populists both wear bright red shirts, rare punches of color in otherwise dark interiors that relate the two men typologically to one another. When applied to a flag, this red symbolizes a comparative moment from European revolutionary history in *The Annual Meeting in Memory of the French Communards at the Père-Lachaise Cemetery in Paris* (1883), based on an event that Repin himself witnessed while abroad. Viewed as part of this chromatically linked group, Repin's *Ivan the Terrible* becomes one possible, albeit anachronistic, culmination of the artist's paintings of nineteenth-century revolutionary themes. If the controlled punches of the color red signal revolutionary activity in the earlier works, the saturation of that red throughout *Ivan the Terrible* signals its unfortunate aftermath. Under the pressure of visual form, the picture's narrative timeline bleeds beyond its frame, crossing centuries and national borders. It is, importantly, the artistic memory of the viewer, noticing connections between Repin's previous pictures, that makes possible this expansive vision. Painting and the experience of painting, it might be said, complete the Ivans' story.

Given the actual drama of November 16th, 1581, it is remarkable that Repin chose to represent such a still and quiet scene. Why not capture the moment when the heated argument stiffened limbs, stopped breath, and turned physical? Or even the instant when the elder Ivan struck his son? Depicting the culmination of the event surely allowed Repin to tap into a more profound and perhaps universal set of emotions; however, his choice of moment also speaks to the picture's awareness of what Lessing considered the temporal limitations of the visual arts. According to Lessing, painting, as a spatial system, "can express only objects whose whole or parts coexist," and therefore must select a single moment (*einzige Augenblick*), "which is most suggestive and from which the preceding and succeeding actions are most easily comprehensible."[75] At its most effective, this pregnant moment "gives free rein to the imagination."[76] Unable to represent a temporal sequence that would tell the story of the Ivans, Repin's picture instead carefully selects a Lessingian moment that encourages the imaginative narrativization of its figures and objects.

The choice of depicting the aftermath of the murder produces a narrative akin to a reconstruction of a crime. Ivan's hand covered in blood leads us to the place where blood pools on the Oriental rug, and to the deadly staff resting ominously nearby. In early studies, Repin had intended for Ivan to still be holding the staff. By wrenching it out of his hands and tossing it onto the floor, Repin produces a series of causal connections that allow the viewer to

imagine the movement of the two central figures through space and time: the son falls back to the floor, the father picks up the weapon, the son rises to his feet, and the father strikes him with the staff. It is a sequence that continues if the viewer follows the other clues. Rugs buckled, cap tossed aside in haste. A chair overturned and a pillow fallen to the floor.

The resulting virtual narrative supplies the verbs that are missing from the otherwise anti-narrative title, *Ivan the Terrible and His Son Ivan*. In doing so, the picture asserts its ability to round out a predominantly verbal historical narrative, approximating its temporality while also bringing it into space. Peter Brooks argues that history painting achieves this fullness of representation by selecting a "perfect moment," a moment that "perfectly illustrates a narrative sequence—and more: which concentrates and condenses in itself, in a way that narrative sequence cannot, the essence of an event, the plastic figuration of its profound meaning."[77] In the case of Repin's picture, the temporal scope can be understood as joining Lessing's imagined narrative with the broader historical implications of Brooks's "moment." Moving from object to object in *Ivan the Terrible*, the viewer also moves in, through, and across the very surface and depth of the picture. Time becomes spatial, and space becomes temporal, vectors woven as tightly together as the warp and woof of the Oriental rugs that cover the ground plane. Perched at a pictorial tipping point, the viewer imagines what preceded *and* what succeeded this day in November, and sees not just a family or historical drama, but a broader vision of the national past and present. This larger temporal scope reaches far back into the history of the Russian Empire, and stretches forward to the moment when the viewer stands before the canvas, in 1885.

This expansion of the past into the present is made possible, in part, by the picture's transcendence of simple analogy, into a space that is more universal than historical. In other words, while Repin's picture certainly proposes that 1581 is like 1881, it also connects to the viewer on the grounds of a shared experience of humanity.[78] After seeing the painting, Kramskoy made much the same point, writing in a letter that he had previously believed the only purpose of history painting to be its capacity for drawing political and social parallels.[79] However, Kramskoy continues, Repin's *Ivan the Terrible* goes beyond a rhetorical device. It possesses emotional and psychological depth. In fact, for Kramskoy, the father and son's humanity even overpowers the extraordinary bloodiness of the painting. In disbelief at this effect, he writes: "Imagine: masses of blood, but you don't think about it; it doesn't affect you, because the picture contains the terrifying, boldly expressed grief of a father and his loud scream, while in his arms lies his son, the son whom he has killed."[80]

Others did not share Kramskoy's view. Shortly after the painting's debut, Anatoly Landtsert, professor of anatomy at the Academy of Arts, criticized the work for its repellant and inaccurate physiological details, arguing that an injury of the kind sustained by the tsarevich would certainly not have produced so much blood.[81] A decade later, the critic V. I. Mikheev offered yet a

third interpretation of the picture's bloodiness, claiming that it was not only unavoidable, it was the key to the painting's affective power.

> "Blood, blood!" they screamed all around. Ladies swooned, nervous people lost their appetites. [...] It is thanks to the blood that this murderer stands before us, like a lost child, covering the wound that he has inflicted, this father awakened within the sovereign, like an exposed psychological apparatus in all of its psychopathic brutality, in all of the humanity of a man and a father.[82]

While it is true that the bloodiness of this painting contributes to the power of its analogy, creating a strong link between the crimson rooms of Ivan the Terrible and the punches of red in Repin's political paintings of the 1880s, the extreme goriness is more than a turn of phrase. It also, as Mikheev suggests, addresses a humanity that is not bound to any one historical moment. When the viewers shriek—"Blood, blood!"—swoon, grow nauseous, and otherwise lose their senses, this is not a reaction to a historical narrative, but rather is a visceral response to what it means to be a human being.

Bathed in light, it is to the two Ivans, locked in a serpentine embrace, that the viewer's gaze first travels. Although his son occupies the true center of the composition, Ivan seems to contain much of the physical energy. He pushes his body to its limit. His eyes bulge. The vein traveling through his sunken left temple is visible, as are the tendons of both hands; they are doing hard work, straining to support his son's body and stave the flow of blood. If Ivan is all strain, his son is more ambiguous. Perched between life and death, he seems to oscillate between a body in control of its weight, holding itself up with one arm, and a body no longer able to counter the laws of gravity. This visceral appeal to humanity extends the empathic goals of Perov's earlier critical realism. However, while the viewer of his tragic genre scenes might have been encouraged to shed a tear and maybe even recognize his role in the social injustices of others, the viewer of Repin's pictures is invited to transcend the status of passerby and connect intimately with his subjects. As with the heaviness and fragility of the laboring men in *Barge Haulers on the Volga*, the corporeal intensity of *Ivan the Terrible* calls upon the viewer to identify with the men, to tap into a shared sense of physicality, and thus verify the illusion of the painting.

It is not only the figures, however, that awaken the viewer's corporeal consciousness. Consider one of Repin's studies of an interior, in which a chair teeters on two legs, supported only by the edge of a table (figure 47). This image of a chair in limbo recalls the human force that would have placed it in such a precarious position. And in the same way, the objects out of place in the final painting urge us to return them to their owners, to humanize the artifacts of history. Repin, in fact, had made several such studies for this painting in the rooms of the Moscow Kremlin, later reconstructing the imperial apartment within his own studio.[83] Therefore, rather than inserting these objects into his picture merely as signs of authenticity, Repin seeks to bring items that might otherwise remain locked in the glass case of a museum into his personal space

and ultimately into the imagined space of the viewer. This desire to make history tangible is a variant of Repin's earlier desire, with *Barge Haulers on the Volga*, to immerse himself in the lives of the people. In both cases, Repin's realism turns on its ability to forge a connection with otherwise distant realities, while also remaining aware that these realities are inevitably mediated by the present.

In recognizing the inherent tension in realism between the indexical trace of reality and its necessary framing, Repin's painting, much like Tolstoy's *War and Peace*, reveals realism to frequently be a historiographic project. This historiographic preoccupation is perhaps nowhere more evident than in Repin's *The Zaporozhian Cossacks Writing a Letter to the Turkish Sultan* (figure 1). While at the Abramtsevo artists' colony during the summer of 1878, Repin first heard the comic anecdote from seventeenth-century history—about the Cossacks responding to the sultan's demand for submission with a rather vulgar letter—that would form the subject of his painting. He then spent over a decade planning the picture. By all accounts, his research was exhaustive, sending the artist on several study trips to Ukraine, where he sketched artifacts held in private and regional collections, and completed portraits of members of the local population so as to capture the Zaporozhian "type." In 1887, in what may have been the turning point in the picture's creative history, Repin met the archaeologist, professor of history, and specialist of Ukraine, Dmitry Yavornitsky.[84] Yavornitsky would supply Repin with historical information (and even some props from his personal collection of artifacts) for the picture, and would be rewarded handsomely with a starring role: the grinning mustachioed scribe at the very center of the canvas is modeled on none other

than the historian himself. In a certain sense, then, *Zaporozhian Cossacks* can be considered a meta-history painting, a painting of a historical episode with a historian who researched that very episode as its main character.

Likely out of gratitude, Repin would contribute nine illustrations to Yavornitsky's two-volume *Zaporozhye in the Remnants of Antiquity and Popular Lore* (1888).[85] A comparison of these illustrations with *Zaporozhian Cossacks* proves particularly enlightening. Take, for example, Repin's approach to weaponry (figure 48). In his historical illustration, Repin draws a saber, a dagger, and a rifle, all lined up vertically, hovering against blank space. Great care is given to the detailing of their decorative adornments, and a neat label—"Rifle, Dagger, Saber"—completes the semantic promise of their rendering (although, amusingly, the label lists the weapons backwards, possibly because of the reversal of the image in the typesetting process). In Repin's painting, these weapons have been distributed rather haphazardly; jutting out of sashes and glimmering in fragments, they certainly lend local color to the picture but are, for the most part, difficult to identify or even locate at all. Rather, it seems that Repin takes advantage of the linear form of various weapons, in order to support his construction of space. The saber and the rifle of the bald man in the foreground provide good examples. Nestled under the man's arm, the saber cuts a sharp diagonal into the picture, while the rifle, leaning as it does against the barrel, rests parallel to the picture plane. Forming a rough cross, the two weapons efficiently create depth, pushing space away from the surface of the barrel (marked as an artistic barrier by Repin's signature) and into the illusion itself. Whereas Repin's illustration had framed and flattened the contents of history, his painting makes sufficient room for the substantial bodies (and spirits) of the Cossacks.

This pictorial transformation of historical information becomes something of a leitmotif in Repin's preparatory work for *Zaporozhian Cossacks*. In one of his many sketches for the painting, three intricately designed pieces of fabric float vertically on a plane parallel to the surface of the paper (figure 49). In its insistence on decoration, the fabric refuses reliable dimension or signification, and becomes instead an almost purely graphic experiment, or, alternatively, a decontextualized historical artifact. In the bottom left quadrant of the study, another piece of fabric, identifiable as a sash, is explored in a different way. One end is tied over the other, creating a pocket in which two daggers are tucked. Stimulating the viewer's spatial imagination with folds and shadows, the drawing summons forth a relatively convincing human body from the flat sheet of paper. In its coaxing of space within which the human body can be placed, this drawing enacts the promise of Repin's realist representation, that an otherwise inert blank surface can, in fact, produce an illusion of the world that has depth and dimension. Repin's painting produces space for the bodies of its subjects, space within which whole worlds can unfold, and thus also makes room for the dynamic interplay between subject and viewer. Encountering this illusion of spatial immersion, the viewer might imagine grabbing the hand of a barge hauler, or rubbing the shiny pate of the Cossack, or moving through Ivan's

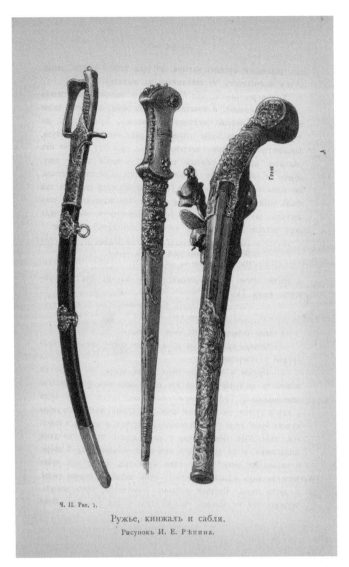

ч. II. Рис. 7.

Ружье, кинжалъ и сабля.

Рисунокъ И. Е. Рѣпина.

FIGURE 48. Ilya Repin, Illustration (rifle, dagger, and saber) for Dmitry Yavornitsky's *Zaporozhye in the Remnants of Antiquity and Popular Lore* (St. Petersburg: Izdanie L. F. Panteleeva, 1888): Part II, Illustration 7. Photo: New York Public Library, New York.

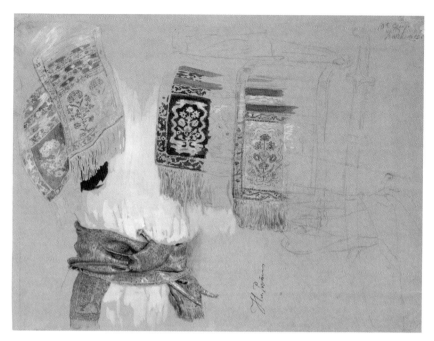

FIGURE 49. Ilya Repin, Study for *The Zaporozhian Cossacks Writing a Letter to the Turkish Sultan* (fragments of sashes; sash tied around the waist with two daggers tucked into it), 1880–1881. Watercolor, gouache, and graphite pencil on gray paper, 24 x 32.8 cm. State Tretyakov Gallery, Moscow.

living quarters. This painterly illusion both enhances and explodes the narrative content of the picture, transforming these stories about others, about the past, into experiences of the self and the present. But this invitation to engage the narrative within the picture is always countered by a reassertion of painting as a medium, a reminder of the impermeable social, historical, and aesthetic boundaries that bar the viewer from total immersion in the world of the painted subjects. In this way, Repin's painting communicates its content not through narrative or literary procedures, but very much in its own terms, and primarily through the pictorial manipulation of space and the dynamic relation between viewer and subject that it presupposes.

A comparison of Repin's approach to realism with that of Tolstoy reveals that they take distinct paths to a not dissimilar end. The previous chapter traced how Tolstoy adopted an antagonistic orientation toward visual modes of representation, leveraging the supposed inadequacies of the visual to enhance his own novelistic illusion. While on occasion Repin also questioned his artistic "other"—in his case, the privileging of ideological or narrative content in realist painting—he did not engage the verbal quite so uncompromisingly as Tolstoy did the visual. Instead of exposing the falsity of verbal structures of meaning, he monopolized the inherent tension between painterly form and

narrative content, in order to reinforce the phenomenological energy and ideological tendentiousness of his pictures. Thus, rather than transforming the relation between the sister arts into a Tolstoyan polemic, Repin intensified interart differentiation (of the kind previously noted in the works of Turgenev and Perov) into a painterly realism that accepts the centrality of content yet announces its medium far more forcefully than had Perov's. By doing so, Repin ultimately arrived at the same place as Tolstoy, at a *paragone* in defense of his own realism. This time, however, it is painting—in its ability to condense and expand narrative in and through space, in its expressive use of the opposition between immersion and its aesthetic limits—that emerges as the superior realist illusion.

Painterly Contraband

The matter of Repin's engagement with painting as a medium returns us to the debates on ideology and aesthetics that accompanied the transition from realism to modernism at the turn of the nineteenth century. Although Benois, the unapologetic modernist and art historian, found Repin's attachment to narrative distasteful and retrograde, he was still able to appreciate the artist's talent, discernible in what he called the "miraculous painterly bits" (*chudnye po zhivopisnym dostoinstvam kuski*) of Repin's canvases. In a sense, these little pockets of painterly self-consciousness represent, for Benois, Repin "in a dressing gown." They strip realist painting of its elaborate ideological costume, and reveal the artistry that lies beneath. Benois's most vivid example is not a dressing gown, though, but yet another article of clothing, a white fur cloak. Draped over the shoulders of a man in *Zaporozhian Cossacks*, this cloak takes up almost a quarter of the already enormous picture. As such, it begs to be looked at, maybe even touched. As Benois writes:

> What a selection of nobly monotonous gray colors in *Zaporozhians*, how beautiful in terms of color even the pathetic white cloak on the Cossack standing with his back turned, which constitutes such an incongruous dissonance for the narrative dimension of this painting. This white cloak is a very characteristic symptom for Repin, and is far from the only example [of its kind] in his work. One can find this "white cloak" in every picture—a concession just like it, made by Repin the storyteller to Repin the painter, and one can only lament that the former did not decide to concede to the latter once and for all. Even in the most unsuccessful works of this master there are these wonderful *bits*, but even in the best of his paintings they are merely bits that creep in like contraband, accidentally, into his conceptual creations [*ideinye sozdaniia*].[86]

In the lower left corner of the canvas, within the swirling brushstrokes of burnt orange and midnight blue, there is another example of such a "white cloak," a moment that seems more invested in color and facture than in signification. It

takes genuine effort to recognize this form as a man, and to match these blocks of color with the hand that has caught the attention of a scowling dog. In the painting of the two Ivans, Benois considers the rich pool of blood on the floor to be the "white cloak," and, indeed, the blood pouring through the tsar's fingers might be still another example. Benois is right that these moments reveal Repin the painter. They tip the balance away from signification and content, communicating little more than the joy of their execution. But while Benois may have thought these examples of painterly "contraband" happy accidents, they are actually fundamental aspects of realism's self-consciousness. They are not gems that point to the inevitability of modernist self-reflexivity, but evidence that Repin was already aesthetically self-aware.

Repin recalls that, when he first caught sight of barge haulers on the Neva River in the summer of 1869, he thought it was "impossible to imagine a more painterly and more tendentious picture."[87] In a conversation with his colleague Savitsky, who had organized this initial trip, Repin distilled this tension between painterliness and tendentiousness into that between two images:

> "What is that moving over there toward us?" I ask Savitsky. "See that dark, greasy, some sort of brown spot [sal'noe kakoe-to, korichnevoe piatno] . . ."
> "Ah! That is the barge haulers pulling a barge with a heavy rope. Bravo! What types!"[88]

What is curious about this snippet of remembered dialogue is how it dramatizes the central tension of Repin's realism. In inscribing globs of oil paint with semantic and narrative structures, Repin posits a realist aesthetic that respects the necessity for narrative communication while maintaining the integrity of painting as a medium. This is not, however, a peaceful interart pair. The oily brown paint never fully transforms into barge haulers; the visual never fully yields to the verbal. Bits of formal excess, Benois's painterly "contraband," are always somehow smuggled into the picture's social content or historical narrative. In this way, Repin's realism retains a perceptible interart friction, prompting a parallel frisson of recognition at the inevitable and unbridgeable gap between reality and its representation. Choosing not to ignore this gap, Repin instead maximizes the energy of this dual interart and mimetic divide, creating paintings that tell meaningful stories but also explore, sometimes cautiously and at other times aggressively, their ontological independence.

The shimmery pool of water in the lower right quadrant of *Barge Haulers* well illustrates this point (figure 50). Sand caving into its watery reflection, it is as much a figure, a promise even, of immersion in the lives of the people, as it is a metaphor for the barge haulers' precarious social position. But it is also, and this impression is undeniable, pure paint, pooling on the artist's palette. Repin writes: "The next day it dried out a little and we took a walk down a roundabout path to the Volga, in which we washed our brushes."[89] With the water turned paint, the twig becomes the brush, plunging itself into the shallow pools of color. As if to render this connection utterly readable, Repin

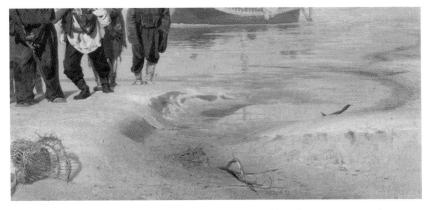

FIGURE 50. Ilya Repin, *Barge Haulers on the Volga* (detail), 1870–1873. Oil on canvas, 131.5 x 281 cm. State Russian Museum, St. Petersburg.

carves his name into the sand with one of these twigs. His painted signature tilts inward, tracing a miniature diagonal trajectory, and so lures us back in, back to the Volga. In this balance is a realism that boldly declares its abilities to capture the "real," while also conceding the illusion of this project.

In other words, although neither *Barge Haulers*, *Ivan the Terrible*, nor *Zaporozhian Cossacks* is about artistic production per se, each engages, in one way or another, the processes and challenges of painting a realist illusion. Look, for example, at the dramatic duo in the center of the Ivan painting (figure 51). The compositional centrality of the hand, perfectly cupped to hold the tsarevich's head, parallels its importance within the historical narrative, as the hand that swings the murder weapon, and the hand that applies pressure to the mortal wound. But if we understand Repin's realism as deeply self-conscious, and always somehow oriented toward the processes of its own production, then we must also recognize this detail as the hand that holds the paintbrush. In engaging the question of representation in this way, *Ivan the Terrible* becomes what Fried calls a "real allegory," a realist painting that is, while not explicitly self-referential, nevertheless "a sustained meditation on the nature of pictorial realism."[90] Seen in this light, Ivan's hand, covered in a viscous, dripping crimson paint, merges with the hand of the artist. And for a moment, blood is no longer blood but red paint, a raw material not yet bound within a semantic system.

This tension between painterly material and historical content takes on an even more explicit interart dimension in the pairing of the two central figures. They are, of course, the two Ivans, father and son, caught in a familial and political struggle. But they are also identifiable as their real-life counterparts. The younger Ivan, for example, was modeled on Repin's close friend, the writer Vsevolod Garshin. Turning from *Ivan the Terrible* to a portrait of Garshin that Repin completed contemporaneously, it is almost as if the tsarevich comes back to life (figure 52). Surrounded by stacks of papers and books—or rather, by the aggressively painterly interpretation of such piles, minimal horizontal

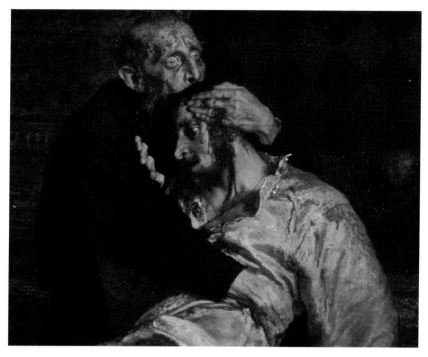

FIGURE 51. Ilya Repin, *Ivan the Terrible and His Son Ivan, 16 November 1581* (detail), 1885. Oil on canvas, 199.5 x 254 cm. State Tretyakov Gallery, Moscow.

swipes of multitoned whites serving as the written word—Garshin's eyes are clear and focused. Moreover, in the months that Repin spent on *Ivan the Terrible*, Garshin himself was preoccupied with matters of history, having returned to work on a short story, called "Nadezhda Nikolaevna," about an artist trying to paint Charlotte Corday on the eve of killing Jean-Paul Marat. It must have been a heady collaboration, two artists thinking deeply about what it means to represent history.[91] Curiously, Repin's three other models were also cultural figures, the composer Pavel Blaramberg and the artists Vladimir Menck and Grigory Myasoedov. Two painters, one composer, and one writer, all locked in an embrace, in a struggle between literature and the nonverbal expression of music and painting. With this in mind, it is possible to see something more sinister in Ivan's bloody hand: the hand of the artist, dripping with paint, overpowering the writer in a vicious bid for power.[92]

This *paragone* is more benign but no less pronounced in *Zaporozhian Cossacks*. Although the white cloak attracted Benois's initial attention, it is the bright white of the quill, resting on the bright white of a blank piece of paper, which contains the bulk of this picture's aesthetic consciousness (figure 53). Repin gives absolute pride of place to the letter and to the story it represents. It is undeniable that verbal content is at the heart of this picture—it is, after all, indicated by the title—and that Repin attempts to communicate an even

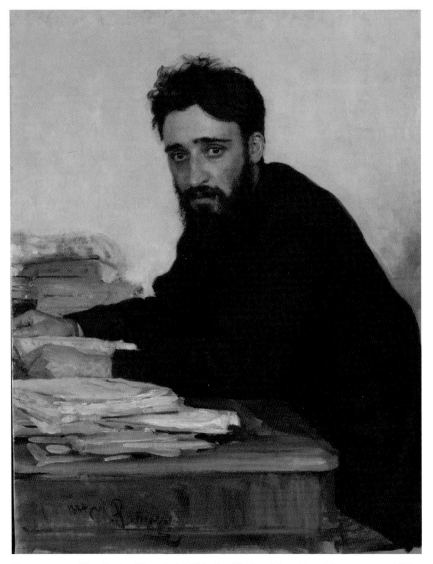

FIGURE 52. Ilya Repin, *Vsevolod Mikhailovich Garshin*, 1884. Oil on canvas, 88.9 x 69.2 cm. The Metropolitan Museum of Art, New York. Gift of Humanities Fund Inc., 1972. www.metmuseum.org.

larger message about the free spirit of a people. But, as discussed at length in the introduction, Repin intercepts this letter. Almost entirely obscured by the glass jug on the table, the letter remains inexpressive, regaling the viewer with neither historical tale nor raunchy joke. With little narrative to unravel, we are invited instead to imagine the oblique surface of the wood table, the bulbous volume of the green vessel, the way in which the light bounces off the surface of the glass just as it does the surface of the man's bald head. In the

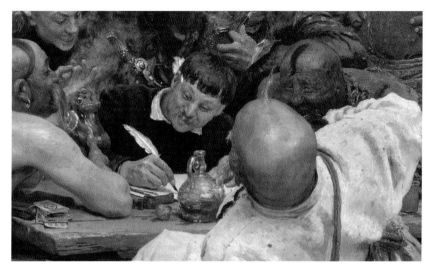

FIGURE 53. Ilya Repin, *The Zaporozhian Cossacks Writing a Letter to the Turkish Sultan* (detail), 1880–1891. Oil on canvas, 203 x 358 cm. State Russian Museum, St. Petersburg.

picture's spatialization of the letter (and the virtual still life that surrounds it), we see its attempt to depict the multidimensionality and tactility of reality. And in the deafening silence of this wordless letter, we hear not only an argument on behalf of realist painting's superior illusion, an argument that posits space and materiality as more expressive than text, we also witness a response to a national culture that tended toward the logocentric and an international context that underestimated the technical competency of Russian painting. The stark contrast between the tiny flash of white letter and the imposing "white cloak," not to mention the overwhelming painterly riot that surrounds it, is a clear statement of Repin's aesthetic priorities and the broader legitimacy of Russian painting.

In the years since his death in 1930, Repin's paintings have become both ubiquitous and somehow completely overlooked. In a rather infamous story told in greater depth in the introduction, the modernist art critic Clement Greenberg effectively made Repin into a scapegoat for a realism that manipulated the masses with its easy messages, holding him up as the example of a "pre-digested" artistic kitsch in opposition to the avant-garde Picasso. Although Greenberg's unfortunate slandering of Repin is not entirely to blame, during the previous century Repin's works were still largely excluded from the Western canon because of their seemingly outmoded realism and the supposed provincialism of imperial Russian painting. Soviet art history, however, more than made up for this exclusion in the extraordinary gusto with which it turned to Repin and his compatriots. With its painterly contraband minimized and its critical ideology emphasized, Repin's painting, along with most of the realist tradition, was appropriated and written into a continuous narrative of socialism, the imperial abuses of Ivan giving rise to the rebellious Cossacks, and then to 1917 and the rise of the Soviet state.[93] Until, finally, in a

poster from 1950, Repin's barge haulers appear on the wall of a cruise ship (figure 54). A young pioneer reads a volume of Nekrasov, while his elder gestures toward a Volga utterly transformed by Soviet industry. The caption declares: "The People's Dreams Have Come True!"

More recently, the barge haulers have been spotted on a poster at an anti-Putin rally, and the Cossacks have appeared in Maidan Square in Kiev; in both cases, they continue the narrative of opposition that Stasov discerned in 1873, becoming the legacy of the spirited young boy in the pink shirt.[94] Of course, Repin's legacy is not always so meaningful. His masterpieces are often found on everyday objects—candy wrappers, tapestries, even on the side of a moving van—and are turned into memes at an alarming rate.[95] To some, aesthetically sparse; to others, clichés or ideological vessels—Repin's paintings are hardly ever really looked at. They are dismissed, or read, but not *seen*. Repin's pictures, however, are most expressive when listened to carefully *and* looked at attentively. And what they communicate are thoughts about what a painting, and a realist painting, can and should be. Ultimately, Repin discovered that painting possessed a store of mimetic potential unique to its medium. If in 1874 Kramskoy declared that the "idea and the idea alone creates technique," then by 1891, in the "white cloaks" and the interart encounters of Repin's mature painting, Repin responded that it is painterly form that creates, enhances, and reinvents narrative content. It is painting, the artist seems to say, that presumed lesser of the sisters in Russian culture, that offers a representation of reality so proximate and so present that it invites us to plunge into its very depths, while also asserting its artistic autonomy.

СБЫЛИСЬ МЕЧТЫ НАРОДНЫЕ!

FIGURE 54. Aleksei Lavrov, *The People's Dreams Have Come True!*, 1950. Poster, 55.5 x 81 cm. Russian State Library, Moscow. Photo: HIP/Art Resource, New York.

5

Dostoevsky's Realist Image

I must put forward an image. But will it develop under my pen?

<div align="right">FYODOR DOSTOEVSKY[1]</div>

IN LATE DECEMBER OF 1867, Fyodor Dostoevsky, then living in Geneva with his new bride, Anna, wrote a New Year's letter to his close friend Apollon Maikov. Among the usual financial concerns and complaints about the cold weather, Dostoevsky includes a few paragraphs on his latest literary project, what would become *The Idiot* (1868–1869), the first two parts of which he had just sent off for publication to the journal the *Russian Messenger*. In this letter, which has attracted much scholarly attention for its explicit commentary on perhaps Dostoevsky's most perplexing novel, the author, a frequent and frequently unlucky gambler, writes of what might be the biggest *artistic* gamble of his career.

> One idea has tormented me for a long time, but I have been afraid to make a novel out of it, because the idea is too difficult and I am not prepared for it, although the idea is absolutely enticing and I love it. This idea is to represent a completely beautiful person [*izobrazit' vpolne preksrasnogo cheloveka*]. In my opinion, there can be nothing more difficult than this, especially in our time. [...] In the past this idea has flickered in a certain artistic image, but really only in a certain one. A more complete image is needed. It is only my desperate situation that has compelled me to take up this undeveloped idea. I have taken a risk, as at roulette. (28.2:240–41)

Resolved to his task yet unsure of its viability, Dostoevsky concludes, "I must put forward an image [*postavit' obraz*]. But will it develop under my pen?" To transform the idea of such a "completely beautiful person" into a "complete image" is, in Dostoevsky's estimation, the greatest of literary challenges; but faced with financial ruin and a baby on the way, he takes a chance. Perhaps influenced by Anna's pregnancy, Dostoevsky even employs the language of fertility to describe this creative process. "Always in my head and in my soul

many conceptions [*zachatii*] of artistic ideas flicker and make themselves felt,"
he writes. "But it really only occurs in flickers, whereas what is needed is a complete embodiment [*voploshchenie*]" (28.2:239).[2]

In a letter written just one day later to his favorite niece, Sofia, to whom he would dedicate *The Idiot*, Dostoevsky repeats many of the same sentiments, but seems to have become somewhat more anxious about his chosen hero. Given the literary models that he considers, it is little wonder. Don Quixote came close to perfection, Dostoevsky writes, but was far too ridiculous. Pickwick suffered the same fate. Hugo's Jean Valjean also fell short of an ideal of beauty that might elicit both awe and compassion. In fact, the only example of such a human ideal is Christ himself and, to quote Dostoevsky, "the appearance of this immeasurably, infinitely beautiful person is of course an infinite miracle" (28.2:251).[3] If the appearance of Christ is a miracle, then according to Dostoevsky's logic, the novelistic image of such an "immeasurably, infinitely beautiful person" must also be nothing short of divine in nature, an idea turned literary incarnation just as Christ is the word made flesh.

This correlation of aesthetic and religious objectives is precisely what distinguishes Dostoevsky's realism so markedly from that of his contemporaries. And a year later, in another letter to Maikov about *The Idiot*, Dostoevsky qualifies the parameters and profundity of this particular kind of realism. Responding to readers who had criticized his characters for being too "fantastic," he states: "I have a completely different understanding of reality and realism than our novelists and critics. My idealism is more real than theirs. Lord! Just to narrate what we all, Russians, have lived through in the last ten years in our spiritual development: wouldn't the realists shout that this is fantasy! Meanwhile, this is genuine, true realism. This is realism, only deeper" (28.2:329).[4] In this sense, Dostoevsky considered his "fantastic realism," what he would later call "realism in a higher sense," a transcendent alternative to a more grounded, objective recording of phenomenal reality, one capable of accessing truths far higher, or deeper, than those of the material world.[5]

Although Dostoevsky aspired to rather distinct theological ends with his "fantastic realism," he sought these ends by interrogating the same interart questions that have been traced throughout this book. Therefore, when Dostoevsky wonders whether an image will come forth from his pen, whether he will be able to fully incarnate an idea, he speaks not only of a desire to represent a Christ-like figure in a novel, but also of a desire to transfigure the materials of pen and page into a rounder, more complete realist image. However, while the writers of the Natural School had pursued a more complete realism in the harmonious and mimetically beneficial mutuality of the sister arts, Dostoevsky adopted a more critical attitude—not unlike Tolstoy's—toward the epistemological capacity of either verbal or visual representation alone. Recognizing Lessingian distinctions between the arts, as well as their respective shortcomings, Dostoevsky thus offers neither an optimistic union of the sister arts nor a narrative disillusionment of the visual, but instead posits his novel as a realist image capable of productively transfiguring both the visual and the verbal.

As such, Dostoevsky's realism, while certainly of its own sort, continues and develops further the interart preoccupations of nineteenth-century realism. Indeed, in aspiring to transcend the interart divide, Dostoevsky even enacts, in the most striking fashion yet, the much broader realist promise to transform the matter of art into reality, and, in the process, to make obsolete the very breach between death and life.

In his study of Dostoevsky's aesthetics, Robert Louis Jackson describes the author's search for this kind of transcendent representation as a "quest for form." Longing to move beyond the chaotic ugliness, or "formlessness" (*bezobrazie*), of life in the modern world, Dostoevsky attempted again and again to attain an image (*obraz*) of Platonic or Christian ideals of beauty.[6] For Jackson, this ideal form is predominantly iconic rather than discursive, and is grounded in the timeless spatiality evident in certain examples of the fine arts, such as Raphael's Sistine Madonna, or a marble sculpture of Diana. Jackson's focus on the plastic image runs counter to Mikhail Bakhtin's theory of the word as the source of truth in Dostoevsky's poetics. Attempting a dialogue between Jackson and Bakhtin, if not a full rapprochement, Caryl Emerson concludes that "how one balances the competing claims of the image and the word in Dostoevsky's text is not, therefore, a trivial exercise."

> The image (*obraz*) promises resolution, but also instant dissolution and all the risks of noncontinuity; the word (*slovo*) refuses to resolve anything, and yet implicit in this refusal is an endlessly hopeful series of second chances. [...] Readers might conclude that neither the image nor the word is especially benevolent in Dostoevsky. Both of these constructs display their darkly pitted as well as their redemptive sides, and in opening up the bad alongside the good, they do constant battle with one another.[7]

It is a version of this "constant battle" that is the topic of this chapter. While this infinite interart war might seem hopeless, *The Idiot* represents Dostoevsky's impassioned attempt at a productive resolution, a resolution that harnesses the powers of both the visual and the verbal for the creation of a realist image. This is not, to be sure, a strictly pictorial or spatial image. Rather, *The Idiot* seeks to bring together, and thus move beyond, the discrete temporal or spatial characteristics of words and pictures. As Emerson asserts, such a balance is not "a trivial exercise," and Dostoevsky certainly did not understand it as such. And although the relative success or failure of this transcendent image remains a matter of debate, Dostoevsky's attempts to achieve such a representation—seemingly unfettered by the limits of any artistic form—reveal the aesthetic and spiritual conditions of his realism.

The drawings in Dostoevsky's notebooks for *The Idiot*, and especially the series of sketches that comprise the visual prehistory of Prince Myshkin, make clear how fundamental this interart metamorphosis was for the author's creative process.[8] In the earlier sketches, completed during the first drafts of the novel, the face of the hero is centered on the page, framed by the notebook's

ruled vertical and horizontal borders, with little to distract from the shifting facial expressions. In one, Myshkin's chin tilts downward in what is either a knowing chuckle or an absent-minded grin (figure 55). In another, the hero looks straight out from the page with an unmistakable frown (figure 56). Still another features a plumper figure, grinning good-naturedly from inside a frame of calligraphic doodles (figure 57). The ambivalence of these portraits reflects Dostoevsky's own uncertainty about his hero at this time, for Myshkin is not yet a "completely beautiful person," but a vengeful character awaiting moral transformation.

It is a later page from Dostoevsky's notebook, however, that suggests a more pointedly aesthetic argument (figure 58). A partial profile of the novel's hero is positioned in the center of the page. But unlike in the previous sketches, the face here is upside down, as if Dostoevsky had grabbed the notebook in haste to record an elusive or even hallucinatory image that had flashed before his mind's eye. Looking down, the hero's eye creases upward in parallel with his broad, close-lipped smile. His forehead wrinkles with thought, joy, maybe stress. Dostoevsky takes care to create the illusion of three-dimensionality

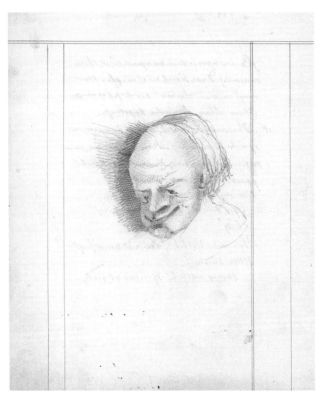

FIGURE 55. Fyodor Dostoevsky, Sketch of Prince Myshkin from *The Idiot*, notebook no. 3, 1867. F. 212, op. 1, ed. khr. 5, l. 7. Russian State Archive of Literature and Art, Moscow.

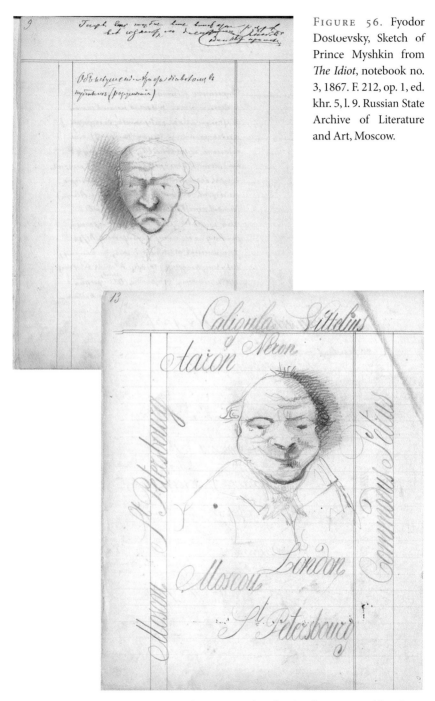

FIGURE 56. Fyodor Dostoevsky, Sketch of Prince Myshkin from *The Idiot*, notebook no. 3, 1867. F. 212, op. 1, ed. khr. 5, l. 9. Russian State Archive of Literature and Art, Moscow.

FIGURE 57. Fyodor Dostoevsky, Sketch of Prince Myshkin from *The Idiot*, notebook no. 3, 1867. F. 212, op. 1, ed. khr. 5, l. 13. Russian State Archive of Literature and Art, Moscow.

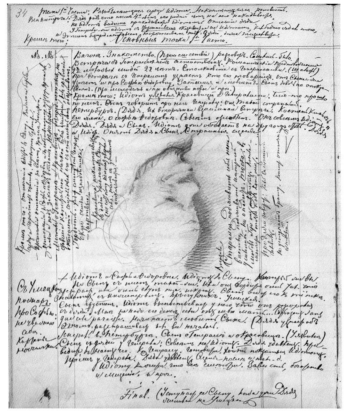

FIGURE 58. Fyodor Dostoevsky, Sketch of Prince Myshkin from *The Idiot*, notebook no. 3, 1867. F. 212, op. 1, ed. khr. 5, l. 34. Russian State Archive of Literature and Art, Moscow.

with shading and cross-hatching, and an almost imperceptible turn of the head toward the surface of the page. With the image recorded, Dostoevsky turns the notebook right side up and begins a different type of sketching, with words rather than visual forms. Under a carefully underlined heading, he jots down key words relating to the first part of the novel, beginning with what are known to be its opening moments. "The railway carriage. Getting acquainted. (The incident.) Conversation" (9:163). Dostoevsky continues to sketch out the relationship between the characters, the main structure of the narrative, and the central themes. He does so in neat lines that honor, rather than violate, the original occupant of this page.

Let us suppose that the verbal and visual sketches, which crowd the rectangle of this sheet of paper, are the graphic answers to Dostoevsky's question, "But will it develop under my pen?" The fragmentary flashes of an incomplete idea, the tracings of a future hero, find their way to paper, first in the form of a visual portrait, then as a series of partially organized words, phrases, and

sentences. These details still await a more complete form, a living incarnation, and one gets a sense of how this will be achieved in a different part of Dostoevsky's notebook, in an entry dated April 10th, 1868.

> The main task: the character of the Idiot. Develop it. [...] For this, *the plot [fabula] of the novel* is needed.
>
> So as to make the character of the Idiot more charming (more sympathetic), it must be imagined in the field of action. (9:252)

While the verbally framed sketch of Myshkin summarizes rather succinctly the first stage of his creative process, in these notes Dostoevsky makes clear that it is the novel that transforms these pictures and words into a more complete image, one capable of eliciting a profound response (sympathetic or otherwise) from the other characters and from the reader. Dostoevsky employs the development of character and plot through time and in a "field of action"—that is to say, narrative—to overcome the limits of visual and verbal modes of representation. But unlike Tolstoy, as was discussed in chapter 3, he does not annihilate the visual sphere for the sake of a novelistic illusion. Instead, he acknowledges and assimilates the extraordinary power of the visual into a wholly transfigured and limitless image.

Because of this, it is still fair to say that *The Idiot*, in some fundamental measure, is a novel about the visual arts.[9] The first part alone is a virtual Grand Tour through Europe's greatest museums, featuring many works that the Dostoevskys saw while traveling and living abroad.[10] Myshkin mentions a Swiss landscape that is likely Alexandre Calame's *Lake of the Four Cantons*, compares Aleksandra Epanchina to Hans Holbein the Younger's Darmstadt Madonna, and describes a rendering of the beheaded John the Baptist as reminiscent of a panel by Hans Fries. And of course, Holbein's *The Body of the Dead Christ in the Tomb*, which had captivated Dostoevsky in Basel, haunts the novel from its first mention until Ippolit's extended analysis in part 3.[11] In its interest in the visual arts, *The Idiot* reveals itself to be a deeply self-conscious text, as concerned with its characters and plot as with how to represent reality, how to produce artistic images, and how to do so in a manner that draws on the specificity of the novel as a verbal form. This consistent engagement with the other arts makes *The Idiot* something of a manifesto, a novel that readily accommodates meta-aesthetic commentary on the possibilities and limits of representation. It is this aesthetic orientation that contributes a certain conceptual density to all moments that reference the arts. Whether in a large-scale ekphrasis of Holbein's *Dead Christ* or a seemingly offhand comment about a sheet of paper, the reader is invited to pause and consider what the novel is *really* saying about the distinct capacities of verbal and visual representation, and the realist novel's particular claims to truth.

Although it might seem that Myshkin is the best place to look for the "complete image" that Dostoevsky mentions in his 1867 letter to Maikov, Nastasya Filippovna is the novel's most coherent emblem of this aesthetic project. At

every turn, she is presented as artistically mediated, operating both as a character and as a vehicle for aesthetic self-consciousness. Our first glimpse of her is in a photograph and our last is as a foot appearing from underneath a sheet, as if it were carved from marble. These two images dramatize the very different realist modes that she introduces into Dostoevsky's novel. On the one hand, as a photograph, she becomes a figure for nineteenth-century visual culture, dominated by a belief in empirical optical technologies, and their impact on the objective imperative of realism as a historical movement. On the other, as a marble sculpture, she represents the desires that underwrite realism as a classical mode, becoming something more like Pygmalion's Galatea, a sculpture so real that it can move beyond the realm of art into life itself. As such, in her movement throughout the text and her interaction with other characters, Nastasya Filippovna tells us a great deal about the realist novel's particular attitude toward its sister art and the problem of mimesis. What is her place in Dostoevsky's novel, the place of the visual in his realist image? Is she a source for reliable representation or for deception? Will she overpower the verbal, or can she be transformed by narrative?

It is Myshkin who is ultimately charged with this narrative transformation of Nastasya Filippovna, proposing a marriage that could turn her from a fallen into an honest woman, saving her eternal soul in the process. Making explicit the link between Myshkin's actions and the Christological resurrection of a soul (and, given Nastasya Filippovna's fate, perhaps even a life), Dostoevsky states in his notebook that "the Prince declares when he marries NF [Nastasya Filippovna] that it is far better to resurrect [*voskresit'*] one woman than to perform the deeds of Alexander the Great" (9:268). The religious diction aligns Myshkin's difficult salvational project with Dostoevsky's likely impossible literary project of representing a completely beautiful man, so fully and so convincingly that it becomes an "infinite miracle" rivaled only by the appearance of Christ himself. This parallel between Myshkin and Dostoevsky is further underscored by the many echoes between the author and his hero throughout the novel; after all, not only did Dostoevsky make Myshkin epileptic, he also made him a writer (although one only capable of copying calligraphy formulae). Through this pairing, Dostoevsky entrusted his hero with the social and moral version of his aesthetic task. In Myshkin's struggle to restore virtue, and life itself, to Nastasya Filippovna, Dostoevsky embedded his own struggle to move beyond the limits of art and into a higher realism.

The relative success of Nastasya Filippovna's social and spiritual transformation is, therefore, closely tied to whether or not Dostoevsky could transform the flickering of ideas, flashing words and pictures, into an unbounded, and thus more truthful, representation of reality.[12] This project is imagined in *The Idiot* as the transfiguration of the imperfect, even sinister, visual realm into an image that, by fusing word and picture, overcomes the limits of both. In recognizing the respective limits of verbal and visual representation, Dostoevsky draws from the same Lessingian distinctions between the sister arts that motivated the subtle spatiotemporal shifts of Turgenev's landscape

descriptions, as well as the more forceful polemic against visual illusion in Tolstoy's *War and Peace*. Rather than monopolizing the dissonance between the arts or discrediting one for the other, however, he attempts a reconciliation of the verbal and the visual. And given the central proposition of this book—that interart encounters operate as emblems of realism in general—it follows that when Dostoevsky attempts to transcend interart divisions, he attempts as well to transcend the very divide between reality and its representation. In the process, he seeks to erase the final barrier to realism, to create an artistic image that ceases to be art, and instead comes to life. This makes *The Idiot* a realist *paragone* with the highest stakes yet, an argument not only in favor of its superior ability to represent reality, and a fantastic one at that, but also an argument for its potential victory over time and space, over death itself.

The Medusa Effect

Moments before the first physical appearance of Nastasya Filippovna in *The Idiot*, a frustrated Ganya throws her photographic portrait, a portrait that has already generated a great deal of buzz, across the room. "The portrait of Nastasya Filippovna lay most conspicuously [literally, "in the most visible place," *na samom vidnom meste*] on Nina Aleksandrovna's worktable, directly in front of her. Ganya saw it, frowned, vexedly took it from the table, and flung it onto his desk [*na svoi pis'mennyi stol*] (8:84; 99).[13] The primary motivation for Ganya's action is most certainly a desire to spare his mother and sister the distracting presence of Nastasya Filippovna. So why does Dostoevsky bother to qualify his choices in home décor? Why, if this episode is merely narrative filler, must the photograph move from a worktable to a writing table? Roland Barthes would likely file these tables under the category of "reality effect," extraneous details that are meant to signify nothing more and nothing less than reality itself. But given the context, within Dostoevsky's most visual novel, this minor domestic drama takes on greater meaning. In flinging the photograph from its "most visible place" to a "writing table," Ganya touches on the novel's preoccupation with matters of representation. In this instance, he attempts to correct, or at least neutralize, the power of Nastasya Filippovna's visuality with the verbal. He tosses the picture out of sight, and toward the word.

By doing so, Ganya signals the much larger problem that Nastasya Filippovna poses for the other characters and for the novel itself. Although she is first introduced into the text as the subject of gossip on the train to Petersburg, it is her photographic portrait, passing from hand to hand, that focalizes her image.[14] Myshkin's first encounter with this image provides the novel's only extended physical description of a character known for her singular beauty.

"So this is Nastasya Filippovna?" he said, gazing at the portrait attentively and curiously. "Remarkably good-looking!" he warmly added at once. In the portrait was represented a woman of highly unusual beauty. She had been photographed in a

black silk dress of a very simple and graceful cut; her hair, apparently dark blond, was done simply, informally; her eyes were dark and deep, her forehead pensive; the expression on her face was passionate and somehow haughty. Her face was somewhat thin, perhaps also pale. (8:27; 31)

In the absence of an original, Nastasya Filippovna's appearance takes on photographic characteristics, constructed out of contrasts between light and dark, positive and negative. Black dress and dark eyes are juxtaposed with typically Dostoevskian pale skin. Even Nastasya Filippovna's hair is two-toned, not just blond, but "dark blond." Notably, however, the hesitant qualifications—"apparently," "somehow," "somewhat," "perhaps"—reveal this passage to be more than an absorption of photographic contrasts. This insecure diction demonstrates the novel's difficulty in deciphering character from Nastasya Filippovna's visual image alone, an impediment to description akin to that discussed in relation to Tolstoy and Turgenev in chapter 3.

The challenge of Nastasya Filippovna's visuality continues when she makes her first appearance. Likely as a result of her introduction into the text as a mediated visual representation, she appears almost like a living incarnation of her photographic image. In her interactions with Myshkin, her status as visual emblem is reinforced by her flashing eyes and penetrating gaze.

The prince lifted the bar, opened the door, and—stepped back in amazement, even shuddered all over: before him stood Nastasya Filippovna. He recognized her at once from her portrait. Her eyes flashed with a burst of vexation when she saw him. [...]

The prince wanted to say something, but he was so much at a loss that nothing came out, and, holding the coat, which he had picked up from the floor, he went toward the drawing room. [...]

The prince came back and stood like a stone idol [*kak istukan*] looking at her; when she laughed, he also smiled, but he was unable to move his tongue. (8:86; 101)

Framed by the door, Nastasya Filippovna is a visual image come to life, shocking Myshkin into silence, and stunning him into a stilled object, a stone idol. But Nastasya Filippovna does not stop there. This time framed by the window behind her, she directs her attention toward Ganya. In response, "he turned terribly pale; his lips twisted convulsively; silently, with a fixed and nasty look, not tearing his eyes away, he stared into the eyes of his visitor" (8:88; 103). Myshkin even thinks that Ganya stands "like a post" (*stolbom*), a figure of speech that is repeated moments later when Nastasya Filippovna asks why the men are so "dumbstruck" (*ostolbeneli*) at the sight of her (8:89; 104–5). By deploying the power of the visual that has been afforded her by her photographic origin, Nastasya Filippovna thus transforms the men around her into immobile, speechless objects for her own visual consumption.[15]

Put simply, Nastasya Filippovna is Dostoevsky's Medusa. And as a Medusa figure, she embodies not only the power of visuality as such, but the particular

ways in which the visual threatens or challenges the verbal. W. J. T. Mitchell has remarked on the meta-aesthetic potential of Medusa, in particular, writing that she is the "prototype for the image as a dangerous female other who threatens to silence the poet's voice and fixate his observing eye."[16] This first physical introduction of Nastasya Filippovna into the novel invites us to imagine her in much the same way, as a visual other that brings everything to a stop, stunning the characters, even the novel itself, into silence. Even more, her impact never seems to diminish in potency, merely being redirected from Myshkin and Ganya to Rogozhin.

> But at that moment, in the drawing room, directly facing him, he suddenly caught sight of Nastasya Filippovna. Obviously, he had never thought to meet her here, because the sight of her made an unusual impression on him; he turned so pale that his lips even became blue. "So it's true!" he said quietly and as if to himself, with a completely lost look. "The end! . . . Well . . . You'll answer to me now!" he suddenly rasped, looking at Ganya with furious spite . . . "Well . . . ah! . . ."
> He even gasped for air, he even had difficulty speaking. (8:95–96; 112)

Entranced by Nastasya Filippovna's Medusan image, Rogozhin spouts and sputters, struggling to express a single thought. While his clipped fragments of speech might seem rather insignificant in and of themselves, their association with higher levels of meaning—"truth," "the end," "answer"—suggest that Nastasya Filippovna not only flusters those around her, but also interferes with the capacity of language to achieve a coherent articulation of truth.

This encounter with Rogozhin represents only a momentary standoff between the visual and the verbal, momentary because Rogozhin turns out to be no match at all for Nastasya Filippovna, moving "as if drawn to her by a magnet" (8:96; 113). Eventually, at the climactic birthday party that closes part 1, Rogozhin yields to her image.

> Timidly and like a lost man he gazed at Nastasya Filippovna for several seconds, not taking his eyes off her. [. . .] Then he stood, not saying a word, his arms hanging down, as if awaiting his sentence. He was dressed exactly as earlier, except for the brand-new silk scarf on his neck, bright green and red, with an enormous diamond pin shaped like a beetle, and the huge diamond ring on the dirty finger of his right hand. (8:135; 159–60)

Rogozhin's prolonged glance at Nastasya Filippovna turns him into a mute aesthetic object, multicolored and encrusted in jewels. He even wears a pin in the shape of a beetle, a work of visual art in the form of a living object.[17] And as if to emphasize the triumph of the visual in this moment, the narrator remarks that "Rogozhin himself had turned into one immobile gaze" (8:146; 173). Rogozhin's searing gaze and his immobility—"he looked like a stone idol," the narrator claims, repeating his earlier description of Myshkin—will disarm Myshkin during their visit in the Rogozhin family home in part 2 (8:170; 205).

Emphasizing the transfer of Nastasya Filippovna's visual power to Rogozhin, this same gaze will also pursue Myshkin during his epileptic fit and reappear at various inopportune moments throughout the rest of the novel.

The impact of this kind of visuality on language—what is called here the Medusa effect—is also apparent in Myshkin's response to the photographic image of Nastasya Filippovna. In this case, it is both Myshkin and the narrator who seem, if not tongue-tied, then most definitely uncertain.

> It was as if he wanted to unriddle something hidden in that face that had also struck him earlier. The earlier impression had scarcely left him, and now it was *as if* he were hastening to verify *something*. That face, unusual for its beauty and for *something* else, now struck him still more. There *seemed* to be a boundless pride and contempt, *almost* hatred, in that face, and at the same time *something* trusting, *something* surprisingly simple-hearted; the contrast even *seemed* to awaken *some sort* of compassion as one looked at those features. That dazzling beauty was even unbearable, the beauty of the pale face, the nearly hollow cheeks and burning eyes—strange beauty! (8:68; 79–80, italics mine)

Robin Feuer Miller draws on what she terms the "tentative quality of this passage," in order to show how Myshkin's confusion exposes Dostoevsky's own hesitation to express his ideas fully and directly through any one particular narrative mode.[18] Rather than representing a failure of expression, she argues, this indeterminate narration allows for the exploration of the potential for words to lie, while ultimately presenting the combination of multiple narrative modes as the only means to approach truth in expression.[19] There is also, however, an interart and self-consciously aesthetic dimension to Miller's paradigm. When Myshkin (and Dostoevsky) gaze at the photograph of Nastasya Filippovna, their ability to give verbal expression to aspects of her character is severely compromised. Definite attributes become alarmingly indefinite. Uncertainties arise. They, like Rogozhin later, are rendered mute, or at least relatively incoherent in their attempt to "unriddle" this picture. Adelaida, a few lines later, will offer the much-repeated explanation for the photograph's pernicious influence. "Such beauty has power," she says. "You can overturn the world with such beauty" (8:69; 80).

This power is visual in nature, and represents the realist novel's concern with the ability of narrative to overcome the dumbfounding stasis of the visual, of the Medusa effect. And so, if we return to Ganya's writing table, we see that his tossing of the photograph onto the desk is a narrative attempt to move the picture away from its blunt visuality and toward the realm of the verbal. Once the photograph is safely on the desk, Dostoevsky finally manages to summon Nastasya Filippovna herself into the novel; however, she retains the power of her visual associations. Not yet a fully integrated image, she terrorizes the text with her capacity to stun and shock and still. Whether Myshkin can recover enough to transfigure her into a transcendent image, whether the world can be righted after experiencing her beauty, is, of course, one of the novel's most

pressing questions. But before attempting an answer, it is important to note that Nastasya Filippovna is not solely a Medusa; in fact, she gains her power as a visual force from a variety of cultural associations beyond the mythological. And to understand why Dostoevsky did not respond to the threat of the visual by discrediting it, it is necessary first to consider these additional sources, sources that are both expected and, especially for the realist novel, perhaps less so.

Spirit Photography

Although it might seem that Nastasya Filippovna emerges fully formed from her photographic image, the narrator of *The Idiot* also offers a brief pre-photographic history of her life. Orphaned at the age of six, young Nastya is taken in by a wealthy local landowner, Afanasy Totsky, who supports her financially yet also initiates the immoral acts that lead to her ruin. It is the rumor of Totsky's impending marriage that eventually buries the victimized girl and gives birth to a new entity, the vengeful fallen woman. While her social disgrace manifests as a haunted quality in her eyes, the subsequent betrayal of Nastasya Filippovna accelerates her physical transformation from a child victim to a beautiful yet frightening social pariah.

> It was difficult to imagine how this new Nastasya Filippovna resembled the former one in looks. Formerly she had been merely a very pretty girl, but now ... [...] However, [Totsky] recalled moments, even before, when strange thoughts had come to him, for instance, while looking into those eyes: it was as if he had sensed some deep and mysterious darkness in them. Those eyes had gazed at him—and seemed to pose a riddle. During the last two years he had often been surprised by the change in Nastasya Filippovna's color; she was growing terribly pale and—strangely—was even becoming prettier because of it. (8:38; 44)

While her strange beauty and unusual paleness cohere with the descriptions of her photographic image, they also cast Nastasya Filippovna as an otherworldly creature. The repeated mention of her strangeness and mysteriousness, in particular, inscribes her within the realm of the supernatural. She is even called an "extraordinary and unexpected being," and "a being who was completely out of the ordinary" (8:36–37; 42–43). In her fall, therefore, Nastasya Filippovna is transformed simultaneously into a photograph, a stilled image of the female subject, and into a creature of the undead, a specter from beyond the grave. In her dual status as photograph and spirit, Nastasya Filippovna condenses the particular visual associations of both, becoming more picture than word. In fact, the narrator even observes that her appearance seems to have silenced any interest in her story, her past or her present: "Everyone knew her beauty, but only that; no one had anything to boast of, no one had anything to tell" (8:39; 46).

The overwhelming threat that Nastasya Filippovna poses to the men around her—staring them into silence and stillness—suggests the *rusalka* as her closest supernatural analogue. According to Russian folk tradition, the *rusalka*, a water nymph akin to the mermaid, emerges from rivers and streams during the springtime to tickle handsome young men into stupors and ultimately to their deaths. Having either died before her time in a violent manner or, more frequently, by her own hand, often by drowning herself in a body of water, the *rusalka* belongs to the category of the "unclean dead," servants of the devil who show themselves to the living so as to render some kind of harm.[20] Although Nastasya Filippovna does not literally commit suicide, she does suffer a moral death and, as Olga Matich observes, even speaks of a "frequent desire to throw herself in the pond."[21] Indeed, Matich convincingly argues that in embodying the *rusalka*, with a touch of the Gothic maiden, Nastasya Filippovna represents "the victory of female magic and demonic power" over the most typical of progressive Chernyshevskian narratives, the redemption of the fallen woman.[22] Given her effect on the narrator and characters of *The Idiot*, Nastasya Filippovna's supernatural associations allow her not only to triumph over particular progressive ideologies, but also to challenge the very possibility of narrative itself with her feminine visuality.

The figure of the *rusalka* was relatively well known throughout the nineteenth century, both from popular lore and high culture, having made her way into the poetry of Pushkin and an opera by Aleksandr Dargomyzhsky (based on Pushkin's unfinished dramatic poem and performed in 1856). For the purposes of the present study, it is perhaps most relevant that she appears in paintings by two of the leading realists, Ivan Kramskoy and Konstantin Makovsky, both members of the Wanderers. Although such a supernatural subject might seem not to cohere with a realism that privileges contemporary relevance and social issues, it does, however, accord with the nationalist tendencies of the Wanderers, especially as articulated in the 1870s and 1880s. In support of advancing a specifically native cultural tradition, the Wanderers, as well as their colleagues in the other arts, increasingly turned to themes from Russian folk culture and the medieval past, often legitimized by adopting a sheen of ethnographic or archaeological veracity. This seems to be the case with Kramskoy's *Rusalkas* (1871), which represents approximately a dozen women lounging by a lake. Although their white gowns and pale faces glow in the moonlight, they nevertheless give the impression more of concrete physical beings than of supernatural entities, as if Kramskoy has made the unreal real.

This intersection of the *rusalka* and realism's aesthetic preoccupation with the border between the immaterial and material, between invisibility and visibility, rises to the level of theme in Makovsky's painting on this subject from 1879 (figure 59). The women in the immediate foreground stretch and turn, their bodies modeled in warm, fleshy tones. But as they float into the night sky, they become more and more transparent, eventually merging with the clouds and rays of moonlight. In Kramskoy's *rusalkas* and the women in the foreground of Makovsky's painting, realism professes on canvas its biggest

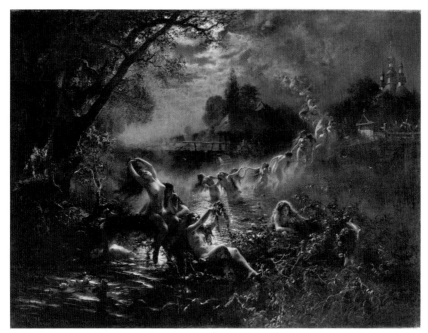

FIGURE 59. Konstantin Makovsky, *Rusalkas*, 1879. Oil on canvas, 261.5 x 347.9 cm. State Russian Museum, St. Petersburg.

promise, that it will summon forth into existence that which it represents. These physically embodied *rusalkas* rely on the conceit of realism to put before the viewer's eyes, in a convincing fashion, that which might not otherwise be visible. But as they spiral up into the moonlit clouds, losing materiality as they go, Makovsky's *rusalkas* expose the doubt that accompanies the realist promise, the suspicion that the images are just illusion, plays of light and color, and not living, breathing beings after all. Whether one sees Makovsky's *rusalkas* as coming into existence or fading into immateriality, as living women or undead spirits, they nevertheless dramatize this tension between illusion and reality, and also between death and life, that haunts the realist project. In her alternative identity as a *rusalka*, Nastasya Filippovna introduces this aesthetic specter into *The Idiot*, representing at once a threat to the novel as well as the possibility of the realist illusion.

It is not solely the *rusalka's* folk origins, however, that haunt the realism of Dostoevsky's novel, for in her emergence from a liquid bath into a dark space, she also conveniently parallels the production of a photographic portrait. And this association between the *rusalka* and photography is not purely rhetorical. Rather, photography, especially in its nineteenth-century context, engages many of the same concerns about art and illusion, objective materialization and supernatural visualization, that energize realism in a broader sense. Indeed, histories of photography often relate the apparent incongruity, from our contemporary perspective, between an early use of the medium for

scientific purposes—Eadweard Muybridge's photographic studies of motion, for example, or the discovery of x-rays at the end of the century—and the simultaneous rise in popularity of spirit photography that claimed to capture the images of ghosts (often by manipulating the medium's technological properties, its capacity for double exposures and its still long exposure times).[23] In both cases, the new invention was deployed in order to make visible the supposedly invisible; in one scholar's words, it "enlarged the dimension of the visual world beyond its seemingly secure boundaries, revealing previously unimaginable realms in which invisible threats might lurk."[24] Photography, therefore, becomes a rather poignant emblem for realism, promising objectivity and material reality, while also recognizing the somewhat magical illusion required for such a mimetic representation.[25] As in her role as a *rusalka*, therefore, Nastasya Filippovna as a photograph—and maybe even as a spirit photograph, a picture of the undead—represents the dual hopes and anxieties of Dostoevsky's realism. In her supernatural capacity, she must be magical enough to summon forth an image but not allowed to enchant the narrative into silence; and as a materialist image, she must be concrete enough to be believable but not allowed to sap Dostoevsky's "fantastic realism" of its fantastic potential.

The relevance of photography to the realist project, both as an ally in its quest for objective truth and as a polemical opponent of its higher artistic aims, became apparent almost immediately after the invention of the daguerreotype, which was officially announced in Russia on January 4th, 1839, in the *Northern Bee*.[26] Although many recognized the potential for the daguerreotype to aid artists in achieving more convincing representations, others quickly perceived the limits of photographic technology. In fact, even as early as 1840, one critic declared that the daguerreotype was "a useless means of making a portrait. Mathematical verisimilitude [...] and lifeless precision do not do justice to a portrait, for which one needs expression and life; these can only be conveyed by the animating strength of talent and the thought of an individual—no machine can do this."[27] Throughout the 1840s, this distinction between the photograph as a truthful record of reality and as deceptive in its excessive verisimilitude persisted as an axis around which writers and critics defined the emerging realist aesthetic. Responding to accusations of "daguerreotypism," the members of the Natural School claimed, in ever more vigorous terms, that their art was far from slavish in its representation. In an 1845 review, for example, Belinsky resorts to a comparison between a daguerreotype and a painting to communicate the difference between a more or less accurate rendering of a person and a more truthful representation of a type. "Indeed, who can copy better than a daguerreotype?" Belinsky asks. "And yet, how much lower is the very best daguerreotype than a proper painter. And therefore, we repeat: it is good if someone is able to be a good daguerreotype in literature, but it is incomparably better and more honorable to be a painter in literature." To be a "painter in literature," therefore, is to possess the "inspiration, creation, talent, and genius" necessary to transform the raw material of reality into a more truthful realism.[28]

For Turgenev, as well, the daguerreotype comes to represent a literary form that is inferior to genuine art. In an 1844 review of a Russian translation of Goethe's *Faust*, Turgenev employs a similar rhetorical gesture to explain his theories on good and bad translation, arguing that the translator must not simply reproduce the language of the original. "What can be more slavishly scrupulous than a daguerreotype? And yet, is not a good portrait a thousand times more beautiful and more truthful than any daguerreotype?" he asks, prefiguring Belinsky's sentiments of a year later. "The good translation," he concludes, "is a complete transformation, a metamorphosis."[29] For some an insufficient copy, for others an adequate starting point, the photograph therefore represents an image that has not yet undergone an artistic transformation, a metamorphosis.

These associations continued well into the period of high realism, even figuring, albeit briefly, in Turgenev's *Fathers and Children*. Early in the novel, the narrator describes the assortment of charmingly domestic objects that adorn the room of the elder Kirsanov's mistress, Fenechka. Of special interest are the pictures on the wall: "fairly bad photographic portraits of Nikolai Petrovich in various positions," as well as one of Fenechka herself, appearing as "some kind of eyeless face smiling tensely in a dark frame."[30] Fenechka's missing eyes, likely a result of an amateur traveling photographer struggling with slow exposure time, gesture to the inadequacies of the new technology (and also, perhaps, its tendency to create ghostly visages). Turgenev also, however, uses the photograph of Fenechka as a foil against which to provide a more significant verbal comment.[31] After the mention of her photograph, Fenechka herself walks in, and the narrator effusively wonders whether "there is anything in the world more captivating than a young, beautiful mother with a healthy baby in her arms."[32] It is this final statement, which generalizes Fenechka into a type and speaks to universal values, that transforms her faulty (and frightening) photograph into a more complete realist image.

While Belinsky and Turgenev focus on the inability of photography to capture the typicality of a more developed literary description, often relying on the polemically useful yet vague opposition between "slavish" representation and true art, in an 1861 review Dostoevsky offers a more pointed critique of photography as a medium. More specifically, in order to critique the short stories of the progressive writer Nikolai Uspensky, he compares Uspensky's approach to what he perceives as the brutal indexicality of photography.

> For the most part Mr. Uspensky does the following: he arrives, for example, at a square and without even choosing a point of view, he sets up his photographic apparatus directly where it lands. Thus, everything that is done in a particular little corner of the square will be transmitted faithfully as is. Naturally, everything perfectly extraneous to this picture (or, better yet, to the idea of the picture) will enter into the picture. Mr. Uspensky cares little about this. For example, let's say that he wants to represent a market in his photograph, and give us an understanding of this market. But if at that moment a hot-air balloon descends into the market (which

could at some point happen), then Mr. Uspensky would capture this appearance, accidental and completely unrelated to the character of the market. If from outside the frame of the picture there peeks in at that moment the end of a cow's tail, he would leave that cow's tail, decidedly not caring about its extraneousness to the picture. (19:180)

The possibility of a stray and unrepresentative object in the picture plainly troubled Dostoevsky. A hot-air balloon. The end of a cow's tail. Although this kind of accidental preservation of fleeting objects would have been impossible given the technological limitations of photography in 1861, Dostoevsky clearly noticed the photographic potential for radical cropping, the same cropping that would be so appealing to the avant-garde, and even to the painters of mature realism and Impressionism in a decade or two (look, for instance, at the men cut off by the frame in Repin's *Zaporozhian Cossacks Writing a Letter to the Turkish Sultan* or, in a more classic example, the man on the right of Gustave Caillebotte's *Paris Street, Rainy Day,* from 1877). For Dostoevsky, however, the randomness of the photographic frame, as opposed to a more considered artistic point of view, failed to ascribe meaning to the objects it happened to capture. It was faithful, yes, but it was not truthful.

And yet, for Dostoevsky, the photograph threatens to chop off more than just a cow's tail. It extracts one moment, a single instant, from a continuous flow of time. This temporal amputation of the photographic image is precisely what was so threatening, for Dostoevsky, about the copy of Holbein's *The Body of the Dead Christ in the Tomb* that hangs in the Rogozhin home (figure 60).[33] It is too photographic, too natural—*super* natural. And because of this excessive naturalism, "a man could even," to quote Myshkin, "lose his faith from that painting!" (8:182; 218). It is young Ippolit, however, who provides the most extended analysis of Holbein's work, describing in detail the despair and doubt it instills in him. What troubles Ippolit so much is the painting's

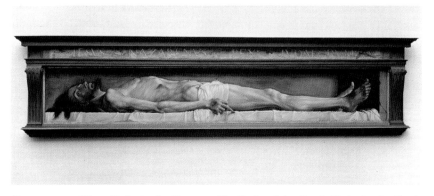

FIGURE 60. Hans Holbein the Younger, *The Body of the Dead Christ in the Tomb,* 1521. Oil on wood, 30.5 x 200 cm. Kunstmuseum Basel. Photo: Erich Lessing/Art Resource, New York.

photographic extraction of a single moment, the moment when Christ is taken down from the cross, and out of the narrative of death and resurrection.[34] Too closely bound with natural time, the painting thus denies a divine narrative.

> In the picture this face is horribly hurt by blows, swollen, with horrible, swollen, and bloody bruises, the eyelids are open, the eyes crossed; the large, open whites have a sort of deathly, glassy shine. But, strangely, when you look at the corpse of this tortured man, a particular and curious question arises: if all his disciples, his chief future apostles, if the women who followed him and stood by the cross, if all those who believed in him and worshipped him had seen a corpse like that (and it was bound to be exactly like that), how could they believe, looking at such a corpse, that this sufferer would be resurrected? Here, the notion involuntarily occurs to you that if death is so terrible and the laws of nature are so powerful, how can they be overcome? (8:339; 408)

Ippolit emphasizes the implacability of the laws of nature by describing the painting with words that evoke stasis and immobility. There are few active verbs in the first sentence of this description, but rather an accumulation of short-form verbal adjectives and participles. The repetition of the words "swollen" and "horrible" suggests a verbal tic produced by the trauma of the image; much like Nastasya Filippovna, this painting seems to interfere with normal verbal expression. In fact, when Myshkin first sees the work, he remarks how strange it is that Rogozhin, who had started speaking of the Holbein painting, suddenly ended the conversation. "'But I like looking at that painting,' Rogozhin muttered after a silence, as if again forgetting his question" (8:182; 218).

By threatening speech and mobility, both Nastasya Filippovna and Holbein's painting contribute to what has been identified here as the Medusa effect in Dostoevsky's novel, a persistent sense that the visual realm has the power to halt narrative, thereby preventing the communication of artistic (and Christian) truth. Indeed, emphasizing vision specifically as a source of such doubt, Ippolit declares that "when you look at the corpse," you will wonder if, having "seen" this corpse, one could still believe in the resurrection. Given the high stakes of this project for Dostoevsky, it is not surprising that this visual menace manifests as a series of almost hallucinatory horrors. Faced with Holbein's Christ, Ippolit declares that "nature appears to the viewer of this painting in the shape of some enormous, implacable, and mute beast," and, recalling his subsequent delirium, Ippolit describes an encounter with a "blank, dark, and mute creature," something like a "huge and repulsive tarantula" (8:339–40; 408–9). Such monstrosities echo Ippolit's earlier account of a nightmare, in which he is visited by a scorpion-like lizard.[35] Although gripped by a "mystical fear," the family dog Norma comes to the rescue.

> All of a sudden, Norma squealed pitifully: the reptile had managed after all to sting her on the tongue. Squealing and howling with pain, she opened her mouth, and I saw the bitten reptile was still stirring as it lay across her mouth, its half-crushed

body oozing a large quantity of white juice onto her tongue, resembling the juice of a crushed black cockroach. (8:324; 390–91)

Grotesque, perhaps excessively so, Ippolit's nightmare makes explicit the horror of the visual image that stuns, stings, and steals speech. Both frightening and frighteningly powerful, these wordless creatures lurk through the text, appearing unexpectedly at birthday parties and in dreams and in the picture galleries of Gothic homes, inspiring metaphysical dread that threatens to stop the novel in its very tracks. And therefore, in Ippolit's question, "If death is so terrible and the laws of nature are so powerful, how can they be overcome?" we might also ask whether Dostoevsky's verbal narrative can transcend a visual force that is extraordinary in its power.

At this juncture, it is worth mentioning that many scholars have remarked upon the conspicuous absence of religious icons in Dostoevsky's novel.[36] Andrew Wachtel has even speculated that it is precisely because of the lack of iconographic models, and the overreliance on Western painting and photography, that Myshkin fails to become a Christ figure capable of saving Nastasya Filippovna.[37] While Wachtel is correct in seeing both the photograph of Nastasya Filippovna and Holbein's painting of Christ as failed attempts to reproduce an image capable of transcending the limits of secular representation, the very absence of an icon is significant for *The Idiot* in a way that does not necessarily connote failure. An icon would, in some fundamental way, short-circuit the process of transfiguration that Dostoevsky's realism seeks to enact. It would shuttle the miracle onto a plane other than that of this world, this novel. Therefore, rather than offering a perfect picture, even one like the icon that purports to be beyond the visual and beyond representation, Dostoevsky aspired to transform the picture *through* the word. To resurrect the undead woman, to breathe life into the photograph. He aspired, to use Turgenev's phrase, to a "metamorphosis" of the visual and the verbal into a hybrid novelistic image.

Pictures at an Exhibition

Dostoevsky discusses the desire to attain such a transcendent image, and the dangers of falling short, in two articles from 1861: "Mr. —bov and the Question of Art" and a review of the 1860–1861 annual exhibition at the St. Petersburg Academy of Arts.[38] In the first, he takes up Afanasy Fet's "Diana," which chronicles the poet's response to a marble statue of the Greek goddess. According to Dostoevsky, the poet, enchanted with this image of Diana, "expects and believes, in prayer and enthusiasm, that the goddess now will step down from the pedestal and come before him," that she will be brought to life through his artistic vision. However, he continues, this does not happen. Diana does not come to life. "The goddess is not resurrected, and she does not need to be resurrected, she does not need to live; she has already

reached the highest moment of life; she is already in eternity; for her, time has stopped; this is the highest moment of life, after which life ceases" (18:97). Already in an ideal form that grafts a Christian resurrection onto a pagan past, Diana does not need to be transfigured, and so, her timelessness, her visual stasis, poses no problem. Nastasya Filippovna, on the other hand, has yet to reach this transcendent place. Still awaiting her "resurrection" by Myshkin, her transformation into a "complete image" by Dostoevsky, she must continue to move through *The Idiot*. If the time of the narrative is somehow cut short, either through the intervention of Nastasya Filippovna's Medusan visuality or by means of another force, then she could remain forever the dead photographic or mute matter of a world with no eternity.

The horrific results of such a temporal interruption are, according to Dostoevsky, plainly visible in two paintings from the 1860–1861 Academy exhibition. The first is *Nymph Surprised,* by Édouard Manet (figure 61).[39] Caught by the viewer in the act of bathing, the nude woman invites associations with a number of Nastasya Filippovna's cultural kin. Not only does she look like a French variant of the Russian *rusalka*, she also—especially when one notices the vague outlines of a (now overpainted) satyr watching her from the tree in the upper right corner—recalls the myth of Diana and Actaeon. This is no ideal, eternal Diana, however, but the Diana who catches her male voyeur, turns him into a deer, and takes away his powers of speech. Fresh from the water, Manet's nymph looks the viewer directly in the eye in overt recognition of this sisterhood. She not only draws attention to the objectifying nature of the gaze, she directs it back at the viewer, stunning him into submission. As a Medusa, *rusalka*, and Diana all at once, Manet's nymph is also, therefore, the double of Nastasya Filippovna, and, even a decade before the publication of *The Idiot*, Dostoevsky was clearly already uncomfortable with this type of female image. "Horror, horror, horror! This last picture is exhibited, of course, with the intention of showing us the extent of the ugliness that can be reached by the imagination of an artist who has painted a completely flat thing and has given the nymph's body the color of a five-day-old corpse" (19:157). Dostoevsky dislikes Manet's picture because the woman appears to be a corpse, and the "flatness," or what an art historian might call planarity, of the painted surface prevents the depiction of an ideal human form. It is not necessarily ugliness, then, that is the true crime (certainly Dostoevsky was no stranger to such imperfections), but the medium used to depict it.[40]

Dostoevsky elaborates upon death's ill-suitedness as a painted subject later in the review, this time in relation to Mikhail Klodt's *The Last Spring*, a picture of a dying girl surrounded by her family (figure 62).

> The entire picture is painted beautifully, impeccably, but on the whole the picture is far from beautiful. Who will want to hang such a pathological picture in their study or living room? Naturally, no one, absolutely no one. It would be a constant memento mori for us and those who are close to us. We are all well aware of this, and can manage quite comfortably without a reminder, which serves no

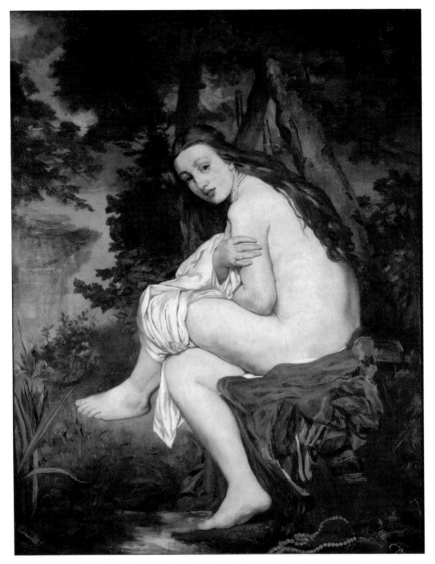

FIGURE 61. Édouard Manet, *Nymph Surprised*, 1861. Oil on canvas, 144.5 x 112.5 cm. Museo Nacional de Bellas Artes, Buenos Aires. Photo: Scala/White Images/Art Resource, New York.

purpose other than the constant, ceaseless poisoning of our lives. [...] Mr. Klodt the Younger represents for us the agony of the dying woman and, with it, almost the agony of the entire family, and this agony will continue not for a day or a month but eternally, for as long as this beautifully executed but ill-fated picture hangs on the wall. No viewer will be able to stand it. Everyone will run away. No, artistic truth is something completely different from natural truth. (19:167)

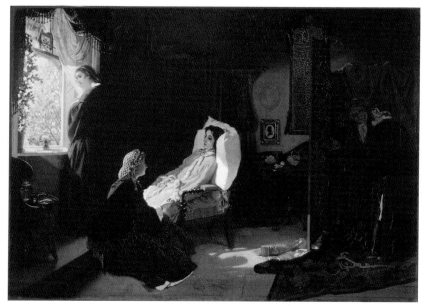

FIGURE 62. Mikhail Klodt, *The Last Spring*, 1859. Oil on canvas, 39 x 51.2 cm. State Tretyakov Gallery, Moscow.

As Jackson observes in his analysis of this passage, Dostoevsky clearly concedes that Klodt's painting is beautifully executed, but takes issue with the subject matter. Like Holbein's painting of Christ in the tomb, Klodt's picture achieves a mimetic, "natural truth," but fails to rise to an "artistic truth" that a more expansive narrative scope might offer. To quote Jackson, "Klodt's painting presented an example of natural truth without transfiguration; aesthetically and religiously—death without transfiguration."[41] And this naturalism has dire consequences. Freezing the poor girl in the moment of her greatest agony, Klodt not only denies her the mercy of death, he also denies her the promise of eternal life. While Jackson finds Dostoevsky's answer to such a stunted painting in classical and Christian ideals of perfect form, the writer's response is also deeply bound up with the aesthetic, and specifically, interart, preoccupations of the time.

Evidence for this view can be found in the resonance between Dostoevsky's critique of such "pathological" paintings and Lessing's *Laocoön, or On the Limits of Painting and Poetry*, which was published in Russian in 1859, less than a decade before *The Idiot*. Theorizing painting as predominantly spatial and poetry as predominantly temporal, Lessing argues that one art must not infringe upon the subject matter appropriate to another. According to Lessing, because of its temporality, poetry is able to rid itself of the horror that accompanies a description of ugliness and, therefore, can represent such subjects as the disgusting and death. "Ugliness of form loses its repulsive effect almost entirely by the change from coexistence to the consecutive," he writes. But

painting, by contrast, "exerts all its force at one time," and thus should depict only the beautiful.[42] Some have even located proof of Dostoevsky's familiarity with Lessing's *Laocoön* in his review of the 1860–1861 Academy exhibition.[43] Referring to paintings based upon literary narratives, Dostoevsky claims that "pieces like these are almost never successful. In a work of literature an entire picture of feelings unfolds, but in painting—just one moment" (19:168). For both Dostoevsky and Lessing, then, the literary arts are particularly, and perhaps singularly, adept at representing the flow of time and of history. Therefore, if Nastasya Filippovna were introduced into the novel as the embodiment of an ideal, akin to Fet's Diana, she would not need literary expression. She could, in this case, remain a transfixing visual entity. But as an imperfect figure awaiting the continuation of a resurrection story, the picture of Nastasya Filippovna must unfold in and through narrative time.

It is his assessment of yet another painting from the Academy exhibition that provides a glimpse into what would become Dostoevsky's narrative resolution to the problem of the visual. He begins his review with what is by now a rather predictable critique, this time applied to Valery Yakobi's gold medal–winning *The Halt of the Convicts* (figure 63).

> In Mr. Yakobi's painting the viewer actually sees real convicts just as he would see them, for example, in a mirror or in a photograph that has been colored by someone with great knowledge of the subject matter. But this is actually the absence of art. [. . .] No, this is not what is required of an artist; not photographic verisimilitude,

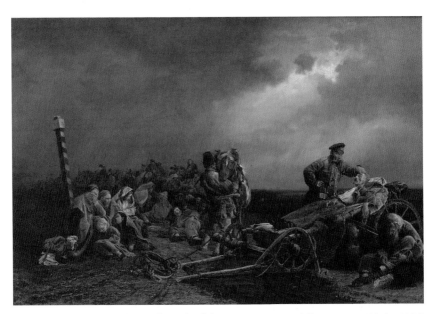

FIGURE 63. Valery Yakobi, *The Halt of the Convicts*, 1861. Oil on canvas, 98.6 x 143.5 cm. State Tretyakov Gallery, Moscow.

not mechanical accuracy, but something else, bigger, wider, deeper. [...] Accuracy and verisimilitude are just the material from which the artistic work is then created; they are the tools of creative work. (19:153)

Dostoevsky then directs a rather condemnatory question to the painter himself: "Do you know, Mr. Yakobi, that in straining for photographic truth you have in this instance painted a lie?" (19:154). Truthful art, by contrast, must strive for "something else."[44] Setting out to improve upon Yakobi's "mechanical" picture, Dostoevsky poses a series of questions about details in the work, providing backstory and explaining how the men, barely out of Moscow, had spotted the giant ring on the hand of their fellow convict. He even speculates about what they might have been thinking: "And when this convict fell ill and was preparing to die, many, very many, had this thought: 'How can I steal it when he dies?'" (19:155). In the process of chronicling the shortcomings of Yakobi's painting, Dostoevsky constructs his own version of the same subject, infusing the "picture" with dialogue and narrative time, making it more than a simple mechanical copy. In other words, he describes the visual representation, correcting a visual lie with an ekphrastic truth. And it will be this particular device of classical rhetoric—ekphrasis—that holds the promise of a transcendent image for Dostoevsky, an image that retains its visual power yet gains the capacity for infinite development.

Speaking Out

Literally translated from the Greek as "speaking out," ekphrasis, in its more limited sense, refers to a verbal description of a visual work of art, either real or imagined.[45] As such, any ekphrasis can be understood as a charged inter-art moment, a moment that activates the desire of the verbal to capture the magic of the visual, but also the desire (albeit born of anxiety) to supplement or correct the visual with sound and narrative.[46] Pockets of heightened aesthetic self-consciousness, ekphrases do more, therefore, than give voice to a work of art; they also give voice to the aesthetic philosophies of the text in which they appear.

Although Ippolit's description of Holbein's painting is the most prominent ekphrasis in *The Idiot*, an early example of the rhetorical device appears in part 1.[47] In response to the amateur painter Adelaida's request for a subject, Prince Myshkin suggests that she "portray the face of a condemned man a minute before the stroke of the guillotine" (8:54; 63). The description of this subject runs several pages and evinces from the very beginning an ekphrastic preoccupation with matters of representation. Recalling his inspiration for this hypothetical painting, an execution that he had himself witnessed, Myshkin says: "I looked at his face and understood everything ... But how can one tell about it! I'd be terribly, terribly glad if you or someone else could draw that!" (8:55; 64). Although this scene presents itself as a visual phenomenon, a

portrait of a man's face, Myshkin is fearful that words cannot capture what he saw with his own eyes. And this doubt manifests in his subsequent turn not to pictorial language, but to one of the most narrative of modes, the simple past tense: "He lived in prison" (8:55; 64). Myshkin then brings the reader back in time, imagining "everything that went before, everything, everything," relating the night before the execution, the morning breakfast, never failing to mention the precise passage of time. Hours and minutes are as meaningful to Myshkin the narrator as they are to his condemned subject.

As the passage continues, Myshkin's description repeatedly encounters the pictorial unfeasibility of his subject. Suspending or even outright negating the possibility of visual representation, he first gives voice to the silent visual object from his memory. "The man sat up, leaned on his elbow—saw a light: 'What's this?' 'The execution's at ten'" (8:55; 64). And then, Myshkin proceeds to give verbal expression to the thoughts that must have been running through the prisoner's head and even turns to his listener with an appeal for empathic engagement. Have we ever felt our throats tingle in a moment of fright, he wonders? In the detail and sheer length of this description, Dostoevsky suggests that narrative is required to produce a proper representation, one that possesses the ability to expand temporally, to give voice to speech and to thoughts, and to forge a physical and emotional link with the reader. Although Myshkin seems confident that such a picture could in fact be painted, his narrative implies otherwise. The meaning of this portrait turns on the almost magical expansion of a single instant—of the flash or flicker of an idea—into hours, and pages.[48]

One can certainly read this episode as an example of the verbal overcoming of the perceived limits (or dangerous powers) of the visual; the utter wordiness of the description implies the lurking of just such a competitive streak. What Myshkin actually creates, however, is a hybrid representation, an ekphrasis that strives to be better than the sum of its parts. In its fusion of verbal and visual, this ekphrasis attempts a transfiguration of both into an ideal form capable of perfect expression. "I looked at his face and understood everything," says Myshkin at the outset of the description. And he concludes by asserting that the man in the picture "*knows everything*" (8:56; 66). This circularity of understanding, of the revelation of life's miracle, is made possible by the two bookended references to the visual portrayal of the man's face, with the verbal expression of his story in between. To be clear, this interpolated narrative is not chattiness for the sake of chattiness. Although silence can be dangerous in a deafening vacuum, when it is coupled with a fullness and unity of form, it can also serve as a profound vehicle for transcendent meaning.[49] The ultimate lesson of Myshkin's ekphrasis is that if there is any truth in representation, it is thanks neither to the visual nor to the verbal alone, but to an almost mystical fusion of the two, one that brings together the silence and plasticity of form with the infinite time of narrative.

It is worth returning to Mitchell's work on word and image relations to better understand the power of ekphrasis both as a rhetorical device and as

a space to consider the social, cultural, and ideological tensions that emerge within interart relations. As a necessary standoff between the verbal and the visual, according to Mitchell, ekphrastic moments confront the dialectic between word and image that always defines cultural production, a dialectic that itself contains a wide array of social, ideological, and aesthetic conditions. "Ekphrasis, even in its classical forms," writes Mitchell, "tends to unravel the conventional suturing of the imagetext and to expose the social structure of representation as an activity and a relationship of power/knowledge/desire—representation as something done to something, with something, by someone, for someone."[50] This is perhaps most obvious in the gendered aspect of Nastasya Filippovna's Medusan visuality, especially since as a visual emblem, she is always somehow ekphrastic in her verbal representation. As a walking embodiment of ekphrastic potential, Nastasya Filippovna glares at and strikes dumb virtually every man she encounters, wielding her visual image as a weapon against a masculine verbal sphere that would otherwise seek to control her.

In addition to these fraught social relations, ekphrasis also exposes the aesthetic unconscious of a text, especially as it pertains to the fears and desires that drive the realist project. On the one hand, Mitchell describes "ekphrastic fear," or the anxiety experienced by the verbal text over the erosion of traditional aesthetic borders. In response to this fear, the text, in our case Dostoevsky's novel, reasserts the difference between itself and its other. And so, Nastasya Filippovna's photograph and Holbein's painting are confirmed as immobile, mute visual objects and quarantined from the surrounding narrative. On the other hand, "ekphrastic hope," which manifests as the text's desire to dissolve the differences between the verbal and the visual, makes the reader "see" what is being described, all in an effort to achieve the proximity of unmediated experience. The hope, then, is that the erosion of aesthetic boundaries will be rewarded with another kind of border-crossing, from art into life, and maybe even from death into life.[51]

Such a desire is rather extraordinary, and yet is also part and parcel of ekphrasis and the realist project, more generally. Calling the fantastic "a displaced mode of ekphrastic representation," François Rigolot relies on the distinction between *energeia* and *enargeia* to explain just how fantastic prose reaches beyond the bounds of ordinary reality.

> Iconic descriptions (i.e. descriptions of which a work of art is the subject) may possess the power—*energeia*—to set before the reader the very object or scene being described. Yet, in the process of producing enthrallment or astonishment, this power may exceed the limits of verisimilitude. As a result, the very energy that achieves lifelike vividness (*enargeia*) may also solicit the reader's disbelief.[52]

What Rigolot describes is fantastic, to be sure, but it is also the central premise of even the most modest versions of realism. To produce a convincing ekphrasis, then, is also to produce a convincing representation of reality. In the hopes and fears of Dostoevsky's ekphrastic interludes, one senses, as well,

the hopes and fears of his realism. When Myshkin describes the painting of a man about to be executed, he exhibits the optimistic hope that by crossing borders between verbal and visual, he will be able not only to summon the image before the eyes of the Epanchin family, but possibly also to bring the man back into the present, into the living moment. For although Myshkin himself had witnessed the execution, he attempts nonetheless to rhetorically resuscitate his subject through the ekphrastic process. This dream to create such a perfect representation that it comes to life—a dream that has its classical origins in the myth of the sculptor Pygmalion and his Galatea—is always, however, haunted by the fear of permanent death, the fear that the sculpture, in refusing to come to life, may also turn us all to stone. It is worth reiterating that, for Dostoevsky, this is a theological project as well as an aesthetic one. With the myths of mimesis overlaid with divine presumptions regarding imagery, the aim of artistic vivification also becomes the hope of religious resurrection.[53]

This fantastic potential of ekphrasis is perhaps best exploited by the genre of Gothic literature, which contains countless examples of men and women brought to life (or taken from life) through art. Dostoevsky, as is well known, was himself an avid reader of Gothic fiction, from the classics of Ann Radcliffe to the more contemporary tales of E. T. A. Hoffmann and Edgar Allan Poe. But there would have been, for him, many models of supernatural art to draw from in the Russian literary tradition, as well: consider, for example, the statue terrorizing the capital city in Pushkin's *The Bronze Horseman* (1837), or the animated painting channeling demonic forces in Gogol's "The Portrait" (1835, 1842).[54] In Myshkin's intense reaction to Holbein's painting and to Nastasya Filippovna's photograph, it is easy to sense the impact of this Gothic mode, and the accompanying fear (or desire) that enchanted portraits will transcend the realm of art and enter into life.[55]

Although such fantastic works of art might seem anathema to Tolstoy's particular brand of realism, a painting with Gothic elements nevertheless makes its way into *Anna Karenina* (1875–1877). A comparison of Mikhailov's portrait of Anna and the visual images of *The Idiot* offers a telling glimpse into the authors' related, yet distinct, approaches to realism. There has been much written on Mikhailov's portrait, completed during Anna and Vronsky's time in Italy, as well as the conversations on art and aesthetics that it and its artist inspire.[56] It is, however, the later appearance of the portrait—which Levin sees hanging in Anna's home before meeting Tolstoy's doomed heroine for the first and only time—that speaks most productively to the question of ekphrasis.

> Another lamp, a reflector, burned on the wall, throwing its light on to a large, full-length portrait of a woman, to which Levin involuntarily turned his attention. This was the portrait painted in Italy by Mikhailov. While Stepan Arkadyich went behind a trellis-work screen and the male voice that had been speaking fell silent, Levin gazed at the portrait, which in the brilliant light had stepped out of its frame [*vystupavshii iz ramy*], and could not tear himself away from it. He even forgot where he was, and, not listening to what was said around him, gazed without taking

his eyes from the astonishing portrait. It was not a painting but a lovely living woman with dark, curly hair, bare shoulders and arms, and a pensive half smile on her lips, covered with tender down, looking at him triumphantly and tenderly with trembling eyes. Only, because she was not alive, she was more beautiful than a living woman can be. (19:273–74; 696–97)

Cast in the generic shadow of supernatural photographs and Gothic paintings, and lit by the flickering of a reflector lamp, this "astonishing portrait" of Anna takes on a far more ominous tone. Levin appears to be possessed by the image; he looks at it "involuntarily," he cannot avert his eyes. Like Myshkin, Ganya, and Rogozhin, he forgets where he is and loses a sense of what surrounds him. Absorbed fully by the visual impact of Anna's portrait, he hears nothing. Indeed, in a comment that gestures toward the presence of a similar Medusa effect in Tolstoy's novel, the narrator even remarks that a "male voice that had been speaking fell silent." Moreover, the painting seems to come to life, or at least to approximate it—it "had stepped out of its frame"—and the narrator responds that "it was not a painting but a lovely living woman," only then to explain that "she was not alive," and more beautiful for it. In this oscillation between art and life, between a painted and a lovely living woman, the portrait of Anna, like Nastasya Filippovna's visual manifestations, gives form to the most profound conceits and anxieties of realism. On the one hand, as images of realist representation, images that approach the limit of realist illusion, they serve as emblems for the realist novel itself. In other words, just as Mikhailov's portrait can completely and fully capture the essence of Anna, so too can Tolstoy's literary portrait.[57]

And yet, these emblems of visual representation also reveal a deep anxiety about the realist project. The portraits of Nastasya Filippovna and Anna emerge as living, breathing entities, threatening to take control of the words and thoughts of Myshkin and Levin, both doubles of their respective authors. Throughout their fateful visit, Anna and Levin exchange meaningful glances, seeming to understand one another through the act of looking. But Levin turns out to be no match for Anna and her powerful visuality: while at the opening of the scene the portrait is "triumphant" (*pobeditel'no*), by the end Levin is described as "defeated" (*pobezhden*) (19:279; 701).[58] Levin's subsequent confession of his visit to Kitty emphasizes how dangerous Anna is for the text, capable of seducing its hero, entrancing him with her image, maybe even derailing the novel altogether. But before she can succeed, she is sent to her death; her power is contained. Our final glimpse of Anna comes in the form of Vronsky's memory of her mutilated body in the railway station, "sprawled shamelessly among strangers" (19:362; 780). To expose her in such a way is perhaps an act of vengeance for her behavior. While her portrait had seemed to come to life, tempting Levin with a triumphant gaze, the horrific description of her dead body turns that gaze back on her, fixing her as an object to be visually consumed. But Anna's ultimate punishment comes in the continuation of the narrative, which leaves her and her portrait behind forever.

There are certainly echoes of this process in *The Idiot*, but there is also a significant difference in the authors' attitudes toward interart boundaries. While Tolstoy responds to the anxiety over the visual by disarming Anna and reinforcing limits between the arts, Dostoevsky adopts a more hopeful stance. It is true that Nastasya Filippovna suffers the same grim fate as Anna, but in the final description of her body, Dostoevsky weaves together visual and verbal modes of description, reconciling the arts for a shared purpose. In doing so, he attempts to repurpose the latent ability of ekphrasis to animate the inanimate, to resurrect his heroine from the dead, and thus transform his realism into something more—a realism without limits, aesthetic or otherwise.

A Fantastic Ekphrasis

On the eve of the ill-fated wedding of Prince Myshkin to Nastasya Filippovna, the narrator relates Myshkin's hope that he will still be able to save her fallen soul, saying, "He sincerely believed that she could still rise [*voskresnut'*]" (8:489; 589). Although the marriage never comes to pass, Nastasya Filippovna's murder at the hands of Rogozhin makes the necessity of her "resurrection" all the more urgent. While neither Myshkin nor Dostoevsky can literally resuscitate Nastasya Filippovna—this is still realism, after all—the novel does allow for the possibility that her image will rise again and that this time, it might even emerge not as the undead, but as a transfigured perfect form. It does so in the novel's closing *tour de force*—the description of Nastasya Filippovna's corpse and Myshkin and Rogozhin's all-night vigil before it—by calling on the potential of ekphrastic representation to blur the lines between life and death. Although this scene does not abide by a strict definition of ekphrasis, the predominance of visual language and the association of Nastasya Filippovna herself with the realm of the visual both encourage, if not outright demand, such a reading.

Of course, even beyond the peculiar characterization of Nastasya Filippovna, the image of the dead woman, as the fixed representation of an object of aesthetic contemplation, has been considered by many to be closely aligned with the realm of art. Responding to Edgar Allan Poe's infamous statement that "the death of a woman is, unquestionably, the most poetical topic in the world," Elisabeth Bronfen explains how the dead woman can become the locus for aesthetic self-consciousness. "Because her dying figures as an analogy of the creation of an art work, and the depicted death serves as a double of its formal condition, the 'death of a beautiful woman' marks the *mise en abyme* of a text, the moment of self-reflexivity, where the text seems to comment on itself and its own process of composition, and so decomposes itself."[59] Bronfen's conclusions ring just as true with the *mise en abyme* that is the encounter between the "not alive" portrait of Anna and Tolstoy's double, Levin, as they do with the final meeting between the deceased Nastasya Filippovna and

Dostoevsky's double, Myshkin. In each case, the description of the woman, dead or near death, serves as a moment of reflection on realist representation, and the interart relations implicit in such a representation.

In fact, after haunting the residents of St. Petersburg for several hundred pages, with her death Nastasya Filippovna becomes an almost wholly aesthetic object. She is immobile, silent, an accumulation of transparent or white objects set against the pitch-black interior of the bedroom. There is little color, other than the unspecified hue of flowers, to suggest any fate for Nastasya Filippovna other than the return to her photographic origin. Dostoevsky even fragments her body into items of clothing, and mentions only the very tip of her foot. The end of her foot, much like the end of the cow's tail, is a random photographic detail, captured as a result of the violent severing of a single moment from the flow of narrative. This scene is a snapshot of her death.

> The prince took one step closer, then another, and stopped. He stood and peered for a minute or two; neither man said anything all the while they were by the bed; the prince's heart was pounding so that it seemed audible in the dead silence of the room. But his eyes were accustomed now, so that he could make out the whole bed; someone was sleeping there, a completely motionless sleep; not the slightest rustle, not the slightest breath could be heard. The sleeper was covered from head to foot with a white sheet, but the limbs were somehow vaguely outlined; one could only see by the raised form that a person lay stretched out there. Scattered in disorder on the bed, at its foot, on the chair next to the bed, even on the floor, were the taken-off clothes, a costly white dress, flowers, ribbons. On the little table by the head of the bed, the taken-off and scattered diamonds sparkled. At the foot of the bed some lace lay crumpled in a heap, and against the white lace, peeping from under the sheet, the tip of a bare foot was outlined; it seemed carved from marble and was terribly still. The prince looked and felt that the more he looked, the more dead and quiet the room became. Suddenly, an awakened fly buzzed, flew over the bed, and alighted by its head. The prince shuddered. (8:503; 606)

There are two opposing forces at work in this passage. As Myshkin looks at Nastasya Filippovna, she becomes "more dead," more of an aestheticized work of visual art, an inanimate object open to the gaze of others. What at first looks like an anonymous sleeper, not making "the slightest breath," becomes a scattered pile of clothes and accessories, and finally hardens into a marble statue. The ekphrasis charts Nastasya Filippovna's transition from sleeping, but still living, woman into a lifeless aesthetic object. But ekphrasis also works in the reverse direction, coaxing the stilled visual object back to life with narrative, time, and speech. As such, the "vaguely outlined" body becomes more defined as the passage progresses, with the dress, the ribbons, the diamonds, and even the "head" and "foot" of the bed all working to create a clearer image of the figure beneath the white sheet, ending finally in the "bare foot outlined" in the fabric. This movement from descriptive imprecision to precision summons Nastasya Filippovna into physical presence.

One scholar has identified Honoré de Balzac's "The Unknown Masterpiece" (1831) as the source for this protruding foot.[60] As a teenager, Dostoevsky had read almost all of Balzac's works and, according to Leonid Grossman, revisited much of Balzac in the 1860s while living abroad and working on *The Idiot*.[61] Like Gogol's "The Portrait" and Edgar Allan Poe's "The Oval Portrait" (1842), "The Unknown Masterpiece" belongs to the family of literary works that thematizes the Pygmalion complex, the desire and fear that the work of art will be animated as a result of perfect representation. Balzac's story tells of the artist Master Frenhofer, who, after years of working in secret on a single painting, finally reveals his work to two young admirers. "You did not expect such perfection," he says. "You are confronted with a woman when you [are] looking for a painting. [. . .] But she breathed, I think! That breast, see? Ah! Who would not want to worship her on his knees? Her flesh palpitates. She is going to rise up, just wait."[62] But instead of a breathing woman about to rise up, the young artists see "a confused mass of color inside a multitude of weird lines, making a wall of paint."[63] Balzac exploits this simultaneous pull of reality and illusion, of palpitating flesh and weird lines, in his ekphrastic description of the painting.

> Drawing closer, they noticed, in one corner of the canvas, part of a naked foot emerging from a chaos of colors and indistinct tones and hues, a sort of formless fog; but a delicious foot, a living foot! They stood petrified with admiration, faced with this fragment that had escaped the extraordinary process of slow but inexorable destruction. The foot emerged, like the torso of some Venus in Parian marble, from amid the rubble of a burnt-out city.
>
> "There is a woman underneath all that!" cried Porbus, showing Poussin the layers of color that the old painter had successively superimposed, believing that he was perfecting the painting.[64]

By alternating between declarations of the picture's verisimilitude and acknowledgment of its materiality, Balzac guides his reader through a series of realizations, from recognizing a living woman to seeing the inanimate paint that makes up her form, and back and forth again. As he does this, Balzac mobilizes painting to expose the tension inherent in realism, the sometimes uncomfortable coexistence of hope that the mimetic illusion will come forth, and fear that it will not.

Dostoevsky enacts a similar confrontation of interart and existential borders in his description of Nastasya Filippovna's corpse. Her bare foot is outlined on the surface of a white sheet, a material that gestures not only to Frenhofer's canvas, but also to a sheet of photographic paper or a blank sheet of writing paper. This white surface, on which both of these female figures materialize, provides a link to Dostoevsky's previous ekphrasis, his description of the painting of a condemned man. Standing on the scaffold awaiting death, the man's face turns "white as paper, absolutely white as a sheet of writing paper" (8:56; 65). In both of these instances—of the condemned man, of Nastasya Filippovna's corpse—Dostoevsky embraces the hope that the bridge of the interart

divide implicit in ekphrasis will bring the subject into presence, into life. But he also, by accepting the inert matter of art, anticipates its failure.

This ekphrastic instability is perhaps most evident in the buzzing fly at the end of the passage. First and foremost, it is a reminder of the natural world and the inevitability of death, the same buzzing fly that torments Ippolit in his rambling confessional monologue, "Necessary Explanation," which also contains the extended ekphrasis of Holbein's *Dead Christ*.[65] But this fly can also be linked to the varied scorpions, lizards, and tarantulas also mentioned by Ippolit, or to an even earlier moment, the "enormous diamond pin shaped like a beetle" that Rogozhin wears at the end of part 1. The diamonds that had turned Rogozhin into a bejeweled aesthetic object (made that way, as previously argued, by Nastasya Filippovna's own Medusan visuality) have now been strewn around the room. And the represented insect has become a living, noise-making fly. This fly contains promise and fear. It promises that Nastasya Filippovna will be transfigured, and that the sounds of life and narrative will triumph over the silence of the visual. However, the fly's association with decomposition, especially when paired with Myshkin's shudder, also serves as a reminder of mortality, a threat of impending paralysis.

The corpse of Nastasya Filippovna, perched here on multiple borders, is far too unstable to represent the ideal transfigured image that Dostoevsky seeks with his "fantastic realism." He alludes to such an image with the marble foot, which thanks to Balzac now carries associations with a sculpture of Venus, but does not yet provide a complete, harmonious representation. This is because so far we have only been looking at a portion of Dostoevsky's final fantastic ekphrasis. Although Nastasya Filippovna was introduced through a photograph of her face, we see in this scene only her foot. It will be Myshkin and Rogozhin, one face pressed to another, who will fill in the missing parts of the final portrait, a collective portrait, which attains fullness through the communion of these three individuals.[66]

> The prince watched and waited; time passed, it began to grow light. Now and then, Rogozhin sometimes suddenly began to mutter, loudly, abruptly, and incoherently; began to exclaim and laugh; then the prince would reach out his trembling hand to him and quietly touch his head, his hair, stroke it and stroke his cheeks . . . There was nothing more he could do! He was beginning to tremble again himself, and again he suddenly lost the use of his legs. Some completely new feeling wrung his heart with infinite anguish. Meanwhile, it had grown quite light; he finally lay down on the pillows, as if quite strengthless now and in despair, and pressed his face to the pale and motionless face of Rogozhin; tears flowed from his eyes onto Rogozhin's cheeks, but perhaps by then he no longer felt his own tears and knew nothing of them. (8:506–7; 610–11)

Paired with Nastasya Filippovna's corpse, Myshkin and Rogozhin absorb its visual characteristics. Rogozhin is "pale and motionless," and, when the police arrive in the morning, they find that the prince too is now "sitting motionless."

Together they constitute a sculptural image of crushing despair. However, as still and silent as they are, Myshkin and Rogozhin also break free of this visual frame. "The prince watched and waited; time passed," says the narrator. Is there any simpler statement of ekphrastic promise, the visual turned verbal through the application of narrative time? And, as if to check off all the boxes, the narrator then gives voice to the silent Rogozhin. Although incoherent, his mumbling joins the buzzing of the fly, and breaks the deadly silence and stillness of the visual realm. It is feeble, to be sure, but there are cracks discernible in this marble edifice, in the permanent death of Nastasya Filippovna's (and Holbein's) visuality.[67]

What Dostoevsky attempts here is a fantastic synthesis of the visual and the verbal, of stillness and movement, of silence and speech. Recalling the multimodal mimesis of the Natural School, the cooperation of visual and verbal modes of representation for the mutual benefit of early realism, it is tempting to interpret this interart synthesis as Dostoevsky, who was after all a member of the Natural School, coming full circle. Indeed, both realisms encourage the bridging of distance between the sister arts: while Fedotov and the writers of the physiological sketches traversed interart borders in much the same way they traversed social ones, opting for an aesthetic of inclusion and collaboration, Dostoevsky fused the visual and the verbal for predominantly aesthetic and spiritual reasons. However, to see in this similarity more than an echo or a reverberation would fail to recognize how very much water there is under the bridge. After the painstaking aesthetic differentiation in the works of Turgenev and Perov, and after the interart feuds of Tolstoy and Repin, the Natural School's coupling of the arts seems rather optimistic, or, less generously, naïve. Dostoevsky is aware of this, as is clear in Nastasya Filippovna's piercing gaze and Ippolit's devastation before Holbein's painting. He has absorbed the lessons of Lessing, internalized the fraught interart distinctions. And so, when he attempts a reconciliation between the sister arts, he does so with eyes open. "I must put forward an image," he writes. "But will it develop under my pen?" In Dostoevsky's statement, we hear his hopeful determination. And in his question, we hear his awareness of the difficulty of his task. To know the limits of the arts, and of realism; and yet, to attempt to transcend them anyway—this is Dostoevsky's contribution to the story of Russian realism that has been told in these pages.

But how does this particular aesthetic philosophy impact a reading of *The Idiot*? Does the image, in fact, develop for Dostoevsky? At the end of the climactic finale, the narrator speculates that if Myshkin's former doctor had seen him, he would have exclaimed, "An idiot!" *The Idiot*. The title of this novel. With this final utterance, Dostoevsky guides us to a perception of the novel as a whole, to a work that is itself a composite of multiple narratives and modes of representation. And if we desire, we might see in the totality of this work something like a complete realist image, a more substantial transformation of the haphazard scribbles and sketches of Dostoevsky's notebook pages. One would also be justified, however, in seeing failure in Myshkin's return to

idiocy, and the oppressive silence of the death vigil, a silence paralleled by the emptiness of the white, white sheet that covers Nastasya Filippovna's body. This blinding whiteness seems to taunt the author, challenging his capacity to produce a suitable redemptive image, erasing everything that has gone before.

A blank white canvas, a blank sheet of writing paper. Images of both promise and failure. To take a position for one or the other, although the literature on *The Idiot* almost demands this of the scholar, seems beside the point. And here let us return to what has been proposed throughout this book, that by considering moments of heightened aesthetic self-consciousness, moments that reflect an overarching realist *paragone*, we can trace the contours of realism itself. In the photograph on the writing table, in the men turned to stone, and in the final composite ekphrasis, Dostoevsky's novel engages the defining characteristic of realism as a literary and painterly aesthetic: its paradoxicality. Realism, and Dostoevsky's realism especially, is audacious in its central conceit—to represent and even resurrect reality, to summon into presence, into life. But this audacity is always, albeit to varying degrees, tempered by doubt, by the awareness of the inevitable futility of the task at hand. It is always, somehow, about the potential fullness but probable emptiness of the blank page.

Conclusion

IN INTRODUCING THE SUBJECT of this book, I called upon one of the most persistent clichés in the study of realism: that it is difficult to pin down, ever shifting, elusive. This elusiveness is largely the result of realism's dual aspect. At once a transhistorical commitment to mimesis and a historical movement that swept through the West during the nineteenth century, realism is anything but a stable category, as variable in subject as it is in method. In limiting the scope of this study to literature and painting between 1840 and 1890, I have sought therefore to ground Russian realism in its historical context. And yet, by locating the outlines of a realist aesthetic within the inter-art encounters of any given work, I acknowledge that these moments, when a particular art form confronts its other, are glimpses into realism's classical past, remnants of a shared concern with representation that unites the distinct manifestations of realism across time and space.

What has arisen, then, is not one Russian realism, but rather multiple, all of them defined in some fundamental way through a sustained engagement with debates on the sister arts. The Natural School and Fedotov, for example, relied upon a mutual collaboration of the verbal and visual arts for an aesthetically and socially inclusive verisimilitude, while Turgenev and Perov foregrounded a differentiation between artistic modes that reflected the growing divisions in society and politics during the age of reform. This cautious aesthetic differentiation then moved even further away from a Horatian *ut pictura poesis* and toward a Lessingian insistence on artistic borders: first, in Tolstoy's polemic against visual illusion in the context of his novelistic representation of history; and second, in Repin's exploration of the tension between painterly form and "literariness" as fundamental for communicating pictorial meaning. And finally, Dostoevsky attempted a reconciliation between the sister arts as part of a project of literary resurrection, a transcendent fusion capable of transfiguring reality into a higher realism. While quite different, taken together the aesthetic approaches and social imperatives of these writers and painters nevertheless create a holistic picture of the Russian realist tradition, in which literature and

painting emerge as formally distinct yet commensurate in their central aims. In each of the works considered here, realism emerges as a self-conscious aesthetic phenomenon, continually engaging the divide between the arts, as well as the divide between reality and illusion. These interart and epistemological questions coalesce into what I have called a realist *paragone*, an argument for the particular mimetic capacities of a given medium. In making such interart comparisons, comparisons that on occasion become impassioned contests, novels and paintings profess their autonomy or superiority, while also declaring the legitimacy of Russian culture in a broader historical and global context.

The very best contests, of course, must feature opponents of equal stature. While it is true that the likes of Tolstoy and Dostoevsky need no test to ensure their cultural dominance, Russian realist painting has not fared nearly as well. Considered secondary by a culture that has tended to privilege literature, and rendered largely invisible to the Western canon, the painting of Repin and his colleagues seems, at first, a rather unmatched opponent to the classic Russian novel. In recalibrating focus on the ideological *and* formal aspects of these paintings—and in giving them the prolonged attention that has typically only been afforded literature—I have not only aspired to an integrated evaluation of Russian realism, but also to the disciplinary rehabilitation of imperial Russian art. In an important sense, therefore, this book is itself a *paragone*, a declaration that Russian painting is just as suitable to realism as its novelistic counterparts, just as formally complex, and just as worthy of extended analysis. As such, this book should be taken on the whole as an argument for the proportionality of Russian literature and painting in the study of nineteenth-century culture, in which both arts are equally engaged in the painstaking and self-aware task of constructing a realist movement, while also furthering a national tradition.

The Deaths and Afterlives of Realism

So what, then, happened to realism in Russia? The historically situated realism that has been the topic of this book does, indeed, come to a close, but it also somehow persists, and often in curious ways. After completing *Anna Karenina* in 1877 and undergoing a religious crisis and conversion, Tolstoy forswore literature in favor of extraliterary writing, often professing increasingly unyielding moral positions. Although he would return to fiction in the 1880s and would write up until his death in 1910, producing a number of great works, this break in his career seems to offer one possible bookend to the realist novel. The other occurred a few years later, in 1881, when Dostoevsky died not long after the publication of what he claimed was the first part of a trilogy on the Karamazov brothers. Perov died a year later, and Turgenev a year after that. The year 1885 saw the controversy, discussed in chapter 4, surrounding Repin's *Ivan the Terrible and His Son Ivan*, concluding with the tsar's order for its removal from exhibition. But in a surprising turn of events, the tsar quickly reversed his order and subsequently committed to serving as a patron

for the Wanderers. Shortly after, Repin would not only accept a commission to paint the tsar, but would also participate in the reform of the Academy of Arts, ultimately becoming one of its most sought-after teachers. Now the figures of authority, no longer the vanguard, as the century drew to a close, Repin and the Wanderers gradually gave way to the younger generation.[1]

Coupled with this generational changing of the guard, starting already in the 1880s and accelerating in the 1890s, broad shifts in the cultural landscape began to take place, marking a movement away from artistic representation invested in objective truth or phenomenal reality, and toward explorations of the subjective, the mystical, and the symbolic. As was evident in Alexandre Benois's praise of Repin's "painterly contraband," his occasional turn away from content in the interest of purely painterly concerns, the World of Art group would reject the narrativity of the Wanderers' painting and adopt a philosophy of art for art's sake. In literature, this aesthetic shift was most dramatic in the orientation away from the novel and toward short prosaic forms and poetry. We hear an awareness of these cultural transitions in an oft-cited letter from Maksim Gorky to Anton Chekhov. "You are killing realism," he writes. "No one can go further along this path than you, no one can write so simply about such simple things as you are able to."[2] Although he declared realism dead at the hands of Chekhov's simple stories, Gorky would, nevertheless, be one of the writers who carried novelistic realism into the new century, eventually supporting it as the privileged template for socialist realism. Indeed, he points to this continued need for grand forms in the very same letter to Chekhov, declaring that the time has come for something "heroic," for an art that is not "like life, [. . .] but higher than it, better, more beautiful."[3] And so, just as realism disappears, the need for a new realism resurfaces, a realism that is more real than reality, in a higher sense, but certainly not of the Dostoevskian sort.

The waning of realism accelerated in the first decades of the twentieth century. And, as it turned out, Benois's acknowledgment of Repin's "painterly contraband" was not an anomaly. Just as it had been for the formulation of high Russian realism, an engagement with the sister arts became an essential tool in the dismantling of nineteenth-century realism as well. While the World of Art and other early modernist groups had rejected realism's negotiation of the sister arts by obliterating artistic differences altogether—seen, for example, in the intermedial aestheticism of synesthetic approaches, Baudelaire's correspondences, and the Wagnerian *Gesamtkunstwerk*—the Russian avant-garde would take a more openly combative approach. In 1912 a group of young soon-to-be Futurists (David Burliuk, Aleksandr Kruchenykh, Vladimir Mayakovsky, and Velimir Khlebnikov) open their founding manifesto, "A Slap in the Face of Public Taste," with a declaration that "the past is too tight." In response to such cramped quarters, they exhort their readers to "throw Pushkin, Dostoevsky, Tolstoy, etc., etc., overboard from the Ship of Modernity."[4] Only by divesting themselves of the bulky narratives of the past could they arrive at the "Self-sufficient Word," the word as such, language itself, freed from the constraints of signification and ideology.[5] Three years later, Kazimir

Malevich would arrive at a similar conclusion. In a brochure that accompanied the first showing of his abstract Suprematist canvases in Petrograd, he declares, in no uncertain terms, that his realism will be nothing short of salvational, liberating art from the tyranny of figuration. As conceived by Malevich, this is an abstraction completely unbound by any external reality, a realism not of objects but of painting's ontological characteristics. "The new realism in painting," he writes, "is very much painterly, for it contains no realism of mountains, sky, water."[6] He even confronts Repin, as a representative of the now outmoded realism, directly: "Repin's picture, *Ivan the Terrible*, could be devoid of color and still give us the same impressions of horror as in color. The subject will always kill color."[7] Malevich, then, considered his task to be the resurrection of that which nineteenth-century realism had murdered—form and color. The international avant-garde's rejection of realist representation, and explicit confrontation of the nineteenth-century heritage, would later be described by art historian Clement Greenberg as a "revolt against the dominance of literature," as a "newer *Laocoön*."[8] "The arts lie safe now, each within its own 'legitimate' boundaries. [...] Pure art exists in the acceptance, willing acceptance, of the limitations of the medium of the specific art."[9] For Russian avant-garde artists like Malevich, who had inherited a modernist interpretation of nineteenth-century realist painting as overly reliant on narrative, this rejection of literature, and literary structures, takes on an almost frantic tone.

What this amounts to is a critical fantasy, a wholesale and willful misunderstanding of realism. In refusing to see the interart complexity of realism, how the works of Tolstoy and Repin maintain a self-consciousness, if not exactly an ontological medium specificity, while pursuing their project of representation, the avant-garde refused to see its ideological and epistemological complexity as well. Nowhere is this more dramatically apparent than in a scandal that took place two years before Malevich's exhibition. In January of 1913, a book dealer and icon painter by the name of Abram Balashov walked into the Tretyakov Gallery and repeatedly stabbed Repin's painting of Ivan the Terrible, screaming, "Enough blood! Down with blood!"[10] The vandalization of Repin's painting rocked the Russian art world, inspiring a range of theories on why this man would commit such a crime. In a published letter, Repin blamed the younger generation of artists, in particular the Symbolists and the Futurists, for their attacks on the "classical and academic monuments of art," even concluding that Balashov's act was "the first signal of a genuine artistic pogrom."[11] In defense of the young artists, the poet and critic Maksimilian Voloshin responded by publishing his own article and organizing, along with Burliuk and the Jack of Diamonds group, a public debate at the Moscow Polytechnical Institute. In this debate, Voloshin argued that Repin (and his painting), not Balashov, were to blame, that Balashov "was deceived by the most naturalistic and most natural representation of a horrible event, and could not endure the position of weak-willed and idle witness. He shattered that protective, invisible glass that separates us from a work of art, and threw himself inside the painting, as if it were reality."[12] To support his argument, Voloshin offered

an alternative history of realism. His realism is the study of surfaces, of the
external characteristics of things, and the laws of representing these things;
it is the Impressionists, and Paul Cézanne, Paul Gauguin, Vincent van Gogh.
The art of Repin, Voloshin asserts, is demonstratively not realism, but rather
naturalism.[13] By stripping Repin's painting of its realism and relegating it to a
brute and even dangerous naturalism, Voloshin salvages the category of the
"real" for the works of the Russian avant-garde.

In other words, by not remaining pure in its commitment to painterly
properties as such, Repin's picture, according to Voloshin, couples its blur-
ring of artistic borders with a criminal blurring of epistemological ones. In
a rather strange echo, exactly one hundred years after the Balashov affair, in
October of 2013, representatives for the Russian Orthodox group Holy Rus
filed a petition with the minister of culture and the director of the Tretyakov
Gallery requesting that Repin's *Ivan the Terrible* be removed from exhibition.
Considering the picture a slanderous depiction of Russian imperial history,
offensive to the "patriotic feelings of the Russian people," they also objected
to what they perceived as the strong psychological impact the picture had on
visitors to the museum, and especially on children.[14] Like Voloshin, Holy Rus
attributed a disproportionate power to Repin's realism, seeing in it the poten-
tial to trick innocent viewers, make them question what is real and what is
not, what to believe in and what not to. While it is obvious that in both cases
the choice of Repin as a target has little to do with serious aesthetic critique
and more to do with furthering larger artistic and political aims, these two
episodes also serve as exaggerated examples of the more widespread misinter-
pretations of Russian realism that this book has set out to correct. By accepting
Repin's picture as unapologetic in its pursuit of both a mimetic illusion and
an ideological message, Voloshin and Holy Rus fail to account for the com-
plexity of its realism. If Voloshin had recognized Repin's interest in facture, if
Holy Rus had seen the aesthetic tensions that disrupt a cohesive narrative, then
perhaps they might have also seen the nuanced negotiation of art and reality
that manifests as a persistent paradoxicality in realism. Maybe they would have
seen that while realism strives for the illusion of proximity and presence, it also
always admits that it is "just" a work of art, that its illusion is compelling but
not exactly dangerous.

Despite their best efforts and likely much to their chagrin, the avant-garde
did not ultimately succeed in dethroning realism for good. In fact, the global
legacy of classic Russian literature was ensured, in part, by Western modern-
ists' enthusiastic reception of Tolstoy's and Dostoevsky's distinctive contribu-
tions to European realism and its novelistic tradition. While the Russians were
noted for their formal innovation, and, especially, their experiments in narra-
tive—perhaps most brilliantly on display in the pseudo-stream-of-conscious-
ness narration of Anna Karenina's final ride to the train station—Virginia
Woolf, writing in 1925, would also touch on the extraordinary intensity of
the Russians' engagement with the human experience. Noting the pronounced
visuality of Tolstoy's prose, Woolf imagines that we, as readers, "have been set

on a mountain-top and had a telescope put in our hands," until, of course, "some detail [...] comes at us in an alarming way, as if extruded by the very intensity of its life."[15] And when confronted with Dostoevsky's chaotic worlds, "against our wills we are drawn in, whirled around, blinded, suffocated, and at the same time filled with a giddy rapture."[16] Although she does not speak explicitly of realism or the sister arts, Woolf echoes what we too have discovered, how Tolstoy counters an initial vision with a more truthful narrative of life, how Dostoevsky aspires to transcend the sights and sounds of the world and move into a higher plane.

Meanwhile in postrevolutionary Russia, with years of upheaval giving way to the increased centralization and conservatism of the Soviet Union under Stalin, realism came back with a vengeance. Throughout the 1920s and up until his death in 1930, Repin would be courted by the members of the Association of Artists of Revolutionary Russia (AKhRR), repeatedly asked, as symbolic forefather, to endorse their politically motivated realist painting. In the years to come, and especially during the Stalinist period, Repin and the Wanderers would be lifted out of their historical context and taken up as an aesthetic and ideological precursor to socialist realism. The appropriation of nineteenth-century realism by official Stalinist culture was on full display in 1936 at the Tretyakov Gallery's massive exhibition of Repin's works; this and similar events confirmed the status of Repin and his colleagues as sources of cultural legitimacy for a new generation of painters, who reinterpreted and, in some cases, reinvented the varied commitments of nineteenth-century realism to better suit their purposes.[17] A parallel process occurred within the literary sphere, as well, as was strikingly evident in the one-hundredth anniversary celebration of Tolstoy's birth in 1928. With public events and articles, including the publication of the jubilee edition of Tolstoy's collected works, the Soviet establishment spearheaded a reevaluation of Tolstoy from an eccentric and zealous personality to a reflection of the social contradictions of bourgeois society and a gifted writer of heroic novels.[18]

And indeed, as proof that each new epoch must either grapple with or stake its own unique claims to the realist heritage, for the past decade or two, there has been yet another return to realism in Russian culture. Not only has a "new realism" in literature, marked by a move away from postmodernist conventions and a return to the novel form, been declared since the early years of the twenty-first century (evident, for example, in the works of Zakhar Prilepin, Roman Senchin, and others), a similar faction has emerged in contemporary Russian art as well, and also with a distinctly nationalist predisposition.[19] This is perhaps best illustrated by the mission of the Russian Academy of Painting, Sculpture, and Architecture, founded in Moscow in 1987 by the realist painter Ilya Glazunov. On the Academy's website, Glazunov justifies his retrospective turn to the nineteenth-century realist tradition as the foundation for his school's artistic philosophy in terms that are anything but measured. Exhorting his students to forgo the avant-garde trends of the art world for the "principles of mastery, realism, and spirituality," Glazunov proclaims that the

true artist will harness the supreme powers of realism to "reflect the battle of good and evil in the world," and express the "national self-consciousness of his people."[20]

Of course, what makes these appropriations and reinventions of realism possible, and indeed inevitable, is not only the bedeviling mutability of the broad category of the "real," but also the status of the nineteenth-century realist tradition as a source for cultural legitimacy. In other words, it turns out that the realist *paragone* that I have discussed throughout this book—the many ways in which the works of Russian realism argued for their particular capacities to represent reality, but also defended their respective media and professional competencies within the Russian and Western European cultural spheres—was, for the most part, successful. Why else would artists and writers throughout the twentieth century, whether in positive or negative ways, position themselves in relation to the nineteenth-century tradition? And yet, while this consistent orientation toward the past has established the credentials of nineteenth-century Russian realism, it has also resulted in an occasionally pernicious relativizing of its achievements and even its perceived failures. In this way, Tolstoy's narrative experimentation can be understood as protomodernist, or Dostoevsky's spiritual preoccupations as protoexistentialist. The narrativity of Repin's paintings can be read as consistent with the ideological messaging of monumental socialist realism, or the nationalist turn in conservative culture during the Putin era. Interpreting nineteenth-century realism solely through such retrospective lenses distorts how related aesthetic and ideological complexities are inherent and discernible within the historical movement itself. Its achievements are not the achievements of modernism, and its failures are not the failures of Soviet culture. Rather, realism's bold proclamations and persistent doubts are contained within the very works of art, visible and audible in moments of heightened aesthetic self-reflection. For these reasons, I offer now an alternative conclusion to Russian realism, not as the precursor to subsequent realisms and the birth of modernism, but as a self-contained movement that persistently engages its own limits.

Last Songs

I opened this book with two sheets of paper, Tolstoy's map of the Battle of Borodino and Repin's letter to a Turkish sultan from the Zaporozhian Cossacks, and suggested that on the surface of these texts, in their negotiation between visual and verbal modes of representation, we might discern the outlines of an aesthetic philosophy of realism. As a final gesture, with many such interart encounters already behind us, allow me to offer still two more sheets of paper. These two white rectangles, both blinding white, represent the paradoxical ends of realism itself—realism as the ultimate illusion, and realism as pure art.

For the first, let us turn to one of Ivan Turgenev's final works, the novella "Klara Milich (After Death)," written in late 1882, just a year before his death. On the face of it, "Klara Milich" is a fairly standard ghost story; borrowing tropes from the Gothic tradition, it tells the tale of a young scientist, Yakov Aratov, who becomes obsessed with the singer Klara after seeing her perform, engages in a brief and failed romantic rendezvous with her, and then reads in a newspaper of her eventual suicide. Determined to find out as much as he can about this woman with whom he has become so infatuated, he travels to her family home, is given a photograph, and steals a page from her diary. With these fragments, and sounding a lot like Dostoevsky in his letter to Maikov, Aratov exclaims, "I am obliged to reconstruct her image [*vosstanovit' ee obraz*]!" (13:116). Back in Moscow, Aratov applies himself to this mission. Using a stereoscope to enlarge her photograph into a projection, he finds that Klara's eyes remain immobile and lifeless, making her appear more like "some kind of a doll" than a living woman. Turning to the page of her diary for inspiration, Aratov sits down to write what he hopes will be a kind of psychological analysis or biography, perhaps something akin to the Natural School's sketches of social types or Turgenev's portrait game. But he quickly becomes discouraged; it all seems "so false, so rhetorical" (13:119–20). And so Aratov goes to bed, only to awaken in a room glowing with an eerie light. "He looked around, and noticed that the weak light, which had filled the room, emanated from a bedside lamp, half obscured by a sheet of paper" (13:128). Either the page from the diary, or one of Aratov's drafts, or a stray blank piece of paper, the white rectangle casts a filtered light onto the room. Aratov's eyes adjust to the surroundings, eventually landing on a woman, dressed in black, sitting on the chair next to him—Klara. She is in the same position as she is in the photograph, a shimmery ghost as if emerged from the flickering projection of the stereoscope. Or maybe even from the page of her diary.

This ghostly vision of Klara, I propose, steps out of the illuminated sheet of paper that rests against Aratov's bedside lamp, a combination of Aratov's visual and verbal pursuits producing her lifelike (or living?) form. Photograph, and stereoscope, and page full of writing all merge, filling each others' gaps, completing each others' sentences, joining to become an image that actualizes realism's rhetorical *enargeia*, summoning a supernatural form from the dead so convincing that it literally scares Aratov to death. The next morning Aratov's aunt finds his body, a lock of dark hair clutched in his hand. What Turgenev offers in this curious story—and as one of his last stories, it begs to be read with the weighty sense of retrospection, of looking back at a career, at a movement—is a literary fulfillment of realism's ultimate fantasy. What else is this, after all, than a Pygmalion myth for the modern age? While poor Aratov is most definitely haunted by ghosts, he also succeeds in bringing forth an image from the familiar raw material of realism: the snapshots, the documents, the evidence of reality. Is the lock of hair not proof that Aratov's Klara is real, that the material and analytical conventions of realism have delivered on its bold claims? Is this not the representation come to life, mimesis at its desired end? Of course, it is

also just a ghost story. And so, just as Klara is real, she is also kin to Nastasya Filippovna as a spirit photograph or Andrei Bolkonsky's magic lantern visions, a visual reminder that she, and Turgenev's story, are artistic constructions.

We find the second sheet of paper—in fact, there is *much* paper—in Ivan Kramskoy's *Nekrasov in the Period of the "Last Songs"* (figure 64). Commissioned in 1877 by Pavel Tretyakov for his collection of portraits of the Russian cultural elite, Kramskoy's painting captures a critical moment in the history of realism, at the pinnacle of its achievements but already, in some important sense, nearing an end. On his deathbed, writing his final collection of lyric poems, is one of the founding members of Russian realism, Nikolai Nekrasov, who would be dead in less than a year. Acknowledging the gravity of this

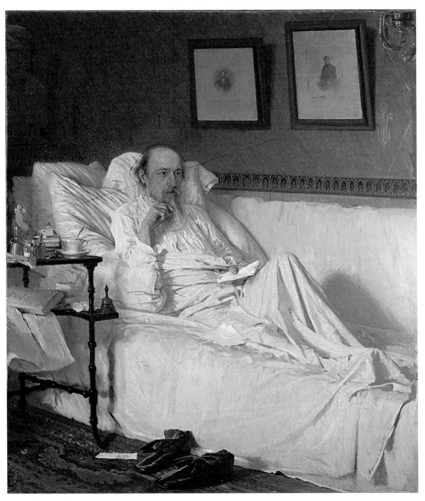

FIGURE 64. Ivan Kramskoy, *Nikolai Nekrasov in the Period of the "Last Songs,"* 1877–1878. Oil on canvas, 105 x 89 cm. State Tretyakov Gallery, Moscow.

moment, Kramskoy's painting both looks back on thirty years of artistic development and prefigures its final propositions. A bust of Belinsky watches over the dying poet from the shadows of the background. Portraits of the Polish poet Adam Mickiewicz and the 1860s critic Nikolai Dobroliubov adorn the wall beside Nekrasov's bed.

Not only does this painting chronicle the achievements of an age, it does so by employing the very interart strategies that I have posited as essential to the realist aesthetic. Kramskoy paints a poet, one writing his "Last Songs"; and the potential for this to become one last painterly *paragone* is not, it seems, lost on Kramskoy. On the one hand, this is most definitely a painting that demands an iconological reading. In the materiality of the environment—the house shoes on the floor; the teacup, medicine bottles, and bell on the side table—we are transported back to the quotidian things and places that Nekrasov introduced to the Russian reading public with the physiological sketches, and that Fedotov so lovingly detailed in his genre paintings. These objects, and the pictures on the wall, tell a story about death that is anything but romantic, pared down to its most basic biological realities and everyday banalities. And the portraits behind Nekrasov create a lineage of these materialist ideas in Russian philosophical and artistic life, showing the path of realism from its beginnings to the present moment, from the fathers to the sons. It is fitting, therefore, to read this painting as the death of one man, but also as a family portrait, a paean to an age, the rise and fall of an artistic movement.

But just as the story of the suffering children in Perov's *Troika* is balanced by a tooth that is simply a dab of paint on canvas, and just as the blood on the hand of Repin's Ivan is also sticky red paint, so too does Kramskoy counter the narrative of his painting with an assertion of the painterly medium. This is most apparent in the picture's obsession with color, or the absence of it; while the walls and the floor are dark shades of orange, red, and brown, the central field of the composition is a study in white. In the tradition of so many other painters, Kramskoy displays his craft with the subtle variations of cream, gray, yellow, and blue, which conjure monochromatic bedclothes, pillows, and sheets of writing paper. Such details recall Benois's location of "painterly contraband" in the virtuosic white cloak of Repin's *Zaporozhian Cossacks*. But the parallel with Dostoevsky's ekphrastic description of Nastasya Filippovna's corpse is even more striking. Sheets. Paper. Bodies formed out of the contours of white fabric.

Kramskoy's white sheet, fabric that mirrors a blank white canvas, becomes a white leaf of paper. The painter even signs his name along the edge of the sheet, turning this fabric into a surface for writing. This, however, is not a stable transformation of the visual into the verbal. One need only focus on the stray sheet of paper that has fallen to the floor for evidence of this instability. It is painterly illusion at its most minimal, a single stroke of a wide brush, executed at an angle to give the impression of dimension, yet devoid of any other distinguishing marks. Once we see it, we cannot forget it. And in this instant, we sense realism coming up against its limits, becoming art and art alone. But

then again, it sheds painterly materiality and floats across the floor, a piece of paper light as air. Moving between pure white paint and a blank sheet of writing paper, this image enacts the very processes of its own representation, the way in which realism brings forth magnificent, sometimes frighteningly lifelike, illusions from the most basic matter. Women step out of frames. An emaciated leg, or the tip of a foot, emerges from flat white fabric. A final poem, the whole history of an artistic movement, appears on a blank page, which is really just a streak of paint.

Michel Foucault, analyzing a realist masterpiece from another period, Diego Velázquez's *Las Meninas* (1656), describes the painting as picturing pure representation. It traces, in his words, "how representation came into being, reached completion, only to dissolve once more into the light."[21] This is precisely what Turgenev and Kramskoy do with their sheets of paper. While they engage both sides of realism's paradox, Turgenev and Kramskoy also tend to tip the balance, each in his own way. In oscillating between a page from a diary and a photograph, in absorbing both word and picture, Aratov's paper night-light merges and transcends both, leaving behind the distinctions between verbal and visual, as well as those between art and reality, and becoming instead the matter of life itself. Instead of with the mirages and forms of artistic illusion, Turgenev concludes his story in a relatable, everyday key, with the touch of a lock of hair on one's fingertips. Kramskoy's picture, by comparison, while pivoting between the verbal material of reality and the visuality of the painterly illusion, tends slightly more toward a self-conscious recognition of the processes of painterly representation. These moments are each fantastic in their illusion and self-conscious in their construction, yet to varying degrees. In a lock of hair, we see the audacity of the realist proposition that representation can be so realistic it becomes real. And in the brushstroke, we see realism's awareness that this is all just the stuff of illusion. If we linger for too long on either, the fragile balance is destroyed; life gives way to art, or art to life. And the realism of the image fades away, until, of course, it emerges again.

Notes

Notes to Introduction

1. I. E. Repin to V. V. Stasov, Moscow, 8 October 1880, in *I. E. Repin i L. N. Tolstoi, II: Materialy*, by I. E. Repin, ed. S. A. Tolstaia-Esenina and T. V. Rozanova (Moscow: Iskusstvo, 1949), 25.

2. I. E. Repin to V. V. Stasov, Moscow, 17 October 1880, ibid., 26.

3. S. A. Tolstaia, *Moia zhizn'*, ed. V. B. Remizov et al., 2 vols. (Moscow: Kuchkovo pole, 2011), 1:323.

4. I. E. Repin to L. N. Tolstoi, Moscow, 14 October 1880, in *I. E. Repin i L. N. Tolstoi, I: Perepiska s L. N. Tolstym i ego sem'ei*, by I. E. Repin, ed. V. A. Zhdanov and E. E. Zaidenshnur (Moscow: Iskusstvo, 1949), 9.

5. Ibid.

6. Dostoevsky makes this famous statement in the notebooks for *Diary of a Writer* (1881). F. M. Dostoevskii, *Polnoe sobranie sochinenii*, ed. V. G. Bazanov et al., 30 vols. (Leningrad: Nauka, 1972–1990), 27:65. Hereafter, unless otherwise noted, all references to Dostoevsky's literary and extraliterary works come from this edition and will be cited in the text or notes as volume and page number.

7. René Wellek, "The Concept of Realism in Literary Scholarship," in *Concepts of Criticism*, ed. Stephen G. Nichols, Jr. (New Haven, CT: Yale University Press, 1963), 252–53.

8. Ibid., 226–32.

9. Wellek briefly discusses the philosophical origins of the term "realism," including its relation to nominalism and its use in German romantic philosophy. Ibid., 225–26.

10. L. N. Tolstoi, *Polnoe sobranie sochinenii*, ed. V. G. Chertkov et al., 90 vols. (Moscow: Khudozhestvennaia literatura, 1928–1958), 11:186. Hereafter, unless otherwise noted, all references to Tolstoy's literary and extraliterary works come from this edition and will be cited in the text or notes as volume and page number. Translations are from Leo Tolstoy, *War and Peace*, trans. Richard Pevear and Larissa Volokhonsky (New York: Vintage, 2007), and will follow the *Polnoe sobranie sochinenii* (*PSS*) citation (757).

11. For Leonardo and others in the fifteenth and sixteenth centuries, to make the case for painting as equal to poetry in the mimetic representation of life was also to make the case for painting as a reputable profession and a liberal, rather than a manual, art. This professional aspect of the interart question is, as I explain later in the introduction, especially important for Russian culture, which tended to privilege literature over painting well into the nineteenth century. For more on Leonardo's engagement with these matters and the Renaissance context, see Claire J. Farago, *Leonardo da Vinci's "Paragone": A Critical Interpretation with a New Edition of the Text in the "Codex Urbinas"* (Leiden: E. J. Brill, 1992), 32–117; Larry Silver, "Step-Sister of the Muses: Painting as Liberal Art and Sister Art," in *Articulate Images: The Sister Arts from Hogarth to Tennyson*, ed. Richard Wendorf (Minneapolis: University of Minnesota Press, 1983), 36–69; and James V. Mirollo, "Sibling Rivalry in the Arts Family: The Case of Poetry vs. Painting in the Italian Renaissance," in *So Rich a Tapestry: The Sister Arts and Cultural Studies*, ed. Ann Hurley and Kate Greenspan (Lewisburg, PA: Bucknell University Press, 1995), 29–71.

12. Leonardo da Vinci, *Paragone: A Comparison of the Arts*, trans. Irma A. Richter (London: Oxford University Press, 1949), 49.

13. Ibid., 50.

14. Although much Soviet-era scholarship assumed the genetic link between nineteenth-century realism and Soviet socialist realism, there have also been more careful considerations of the aesthetic, institutional, and ideological underpinnings of this connection. See, for example, Elizabeth Kridl Valkenier, *Russian Realist Art: The State and Society; The Peredvizhniki and Their Tradition* (Ann Arbor, MI: Ardis, 1977), 165–93; and Régine Robin, *Socialist Realism: An Impossible Aesthetic*, trans. Catherine Porter (Stanford, CA: Stanford University Press, 1992), 75–164.

15. Virginia Woolf, "Modern Fiction," in *The Essays of Virginia Woolf*, vol. 4, *1925 to 1928*, ed. Andrew McNeille (London: Hogarth Press, 1986), 163.

16. In addition to Valkenier, Rosalind P. Blakesley and David Jackson are also notable for advancing the study of Russian realist art in Western art historical scholarship. See, among their other works mentioned throughout this book and in the bibliography: Valkenier, *Russian Realist Art*; Blakesley, *Russian Genre Painting in the Nineteenth Century* (Oxford: Clarendon Press, 2000), 125–51; and Jackson, *The Wanderers and Critical Realism in Nineteenth-Century Russian Painting* (Manchester: Manchester University Press, 2006).

17. Clement Greenberg, "Avant-Garde and Kitsch," in *Pollock and After: The Critical Debate*, ed. Francis Frascina (New York: Harper & Row, 1985), 27. Greenberg takes this example of a Russian peasant looking at a Picasso and a Repin from an article by Dwight MacDonald on Soviet cinema, in which MacDonald discusses a well-attended exhibition at the Tretyakov Gallery featuring "Repin, Surikov, Kramskoy, Perov, and other equally celebrated painters of battle scenes and sunsets." MacDonald, "Soviet Society and Its Cinema," *Partisan Review* 6, no. 2 (Winter 1939), 87.

18. Greenberg, "Avant-Garde and Kitsch," 27–28.

19. Ibid., 28.

20. Ibid., 33.

21. I agree with Rachel Bowlby when she attributes the scholarly oversight of realism to its perception as simplistic and self-evident, and to its subsequent relegation to the status of precursor or straw man to a presumably more sophisticated modernism. Bowlby, foreword to *Adventures in Realism*, ed. Matthew Beaumont (Malden, MA: Blackwell, 2007), xi–xii.

22. Such exceptions include: D. V. Sarab'ianov, *Russkaia zhivopis' XIX veka sredi evropeiskikh shkol* (Moscow: Sovetskii khudozhnik, 1980); Rosalind P. Blakesley and Susan Reid, eds., *Russian Art and the West: A Century of Dialogue in Painting, Architecture, and the Decorative Arts* (DeKalb: Northern Illinois University Press, 2007); and Rosalind P. Blakesley, "'There Is Something There . . .': The Peredvizhniki and West European Art," *Experiment/Eksperiment: A Journal of Russian Culture* 14 (2008): 18–58.

23. Terry Eagleton, for example, opens his review of Erich Auerbach's *Mimesis* thusly: "Realism is one of the most elusive of artistic terms." Eagleton, "Pork Chops and Pineapples," review of *Mimesis: The Representation of Reality in Western Literature*, by Erich Auerbach, trans. Willard R. Trask, *London Review of Books* 25, no. 20 (October 23, 2003), http://www.lrb.co.uk/v25/n20/terry-eagleton/pork-chops-and-pineapples (accessed 18 August 2013).

24. Lidiia Ginzburg, *Literatura v poiskakh real'nosti* (Leningrad: Sovetskii pisatel', 1987), 7.

25. Wellek, "The Concept of Realism," 238.

26. For the history of the term "realism" in European literature and criticism, see ibid.; and, for greater detail on the Russian context, see Iu. S. Sorokin, "K istorii termina *realizm* (40–60-e gody XIX v.)," *Uchenye zapiski leningradskogo gosudarstvennogo universiteta: Seriia filologicheskikh nauk* 17, no. 158 (1952): 231–65.

27. Kazimir Malevich, "From Cubism and Futurism to Suprematism: The New Painterly Realism" (1915, rev. 1916), in *Art in Theory, 1900–2000: An Anthology of Changing Ideas*, ed. Charles Harrison and Paul Wood (Malden, MA: Blackwell, 2003), 173–83.

28. Roman Jakobson, "On Realism in Art" (1921), in *Readings in Russian Poetics*, ed. Ladislav Matejka and Krystyna Pomorska (Ann Arbor: Michigan Slavic Publications, 1978), 42.

29. Stendhal, *The Red and the Black: A Chronicle of 1830*, trans. Burton Raffel (New York: Modern Library, 2004), 342.

30. E. H. Gombrich, *Art and Illusion: A Study in the Psychology of Pictorial Representation* (Princeton, NJ: Princeton University Press, 1969).

31. I refer here to Viktor Shklovsky's concept of *ostranenie* (estrangement or defamiliarization). Shklovsky, "Art as Technique" (1917), in *Russian Formalist Criticism: Four Essays*, trans. and ed. Lee T. Lemon and Marion J. Reis (Lincoln: University of Nebraska Press, 1965), 3–24. Shklovsky discusses Tolstoy's "deformation" of material in the construction of *War and Peace* in his *Mater'ial i stil' v romane L'va Tolstogo* Voina i mir (Moscow: Federatsiia, 1928).

32. Roland Barthes, *S/Z*, trans. Richard Miller (New York: Hill and Wang, 1974), 55. Linda Nochlin makes a similar point, rejecting "the commonplace notion that Realism is a 'styleless' or transparent style." Nochlin, *Realism* (Harmondsworth: Penguin, 1971), 14.

33. Erich Auerbach, *Mimesis: The Representation of Reality in Western Literature*, trans. Willard R. Trask (Princeton, NJ: Princeton University Press, 2003), 463.

34. Ibid., 523.

35. Irina Paperno argues this point in *Chernyshevsky and the Age of Realism: A Study in the Semiotics of Behavior* (Stanford, CA: Stanford University Press, 1988), 12.

36. This is not to say that such hybridity is not a relevant aesthetic category for the consideration of genuinely transitional aesthetics. Viktor Vinogradov's "sentimental naturalism" and Donald Fanger's "romantic realism," to offer two examples, both highlight in productive ways the aesthetic, generic, and stylistic echoes between Dostoevsky's realism and its precursors: V. V. Vinogradov, *Evoliutsiia russkogo naturalizma: Gogol' i Dostoevskii* (Leningrad: Akademiia, 1929), 291–389; and Fanger, *Dostoevsky and Romantic Realism: A Study of Dostoevsky in Relation to Balzac, Dickens, and Gogol* (Cambridge, MA: Harvard University Press, 1965).

37. V. G. Belinskii, "Vzgliad na russkuiu literaturu 1847 g." (1848), in Belinskii, *Polnoe sobranie sochinenii* [hereafter *PSS*], 13 vols. (Moscow: Akademiia nauk SSSR, 1953–1959), 10:291.

38. George Levine posits a similar understanding of realism in his study of the English novel. Levine, *The Realistic Imagination: English Fiction from* Frankenstein *to* Lady Chatterley (Chicago: University of Chicago Press, 1981), esp. 19–20.

39. V. G. Belinskii, "Literaturnye mechtaniia (Elegiia v proze)" (1834), in Belinskii, *PSS*, 1:22.

40. In fact, as late as 1848, Belinsky remarks on the "pathetic state of the painting of our time," referring to the medium's continued allegiance to academic modes and methods. Belinskii, "Vzgliad na russkuiu literaturu 1847 g.," *PSS*, 10:311.

41. Valkenier, *Russian Realist Art*, 10–17.

42. The history of the Wanderers and the realist painters that preceded them is discussed in greater depth in chapters 2 and 4.

43. V. V. Stasov, "Nashi itogi na vsemirnoi vystavke" (1878–1879), in Stasov, *Izbrannye sochineniia*, ed. E. D. Stasova et al., 3 vols. (Moscow: Iskusstvo, 1952), 1:375.

44. Ibid.

45. A. N. Benua [Benois], *Istoriia russkoi zhivopisi v XIX veke* (1902) (Moscow: Respublika, 1995), 17.

46. Ibid., 21.

47. P. Ia. Chaadaev, *Polnoe sobranie sochinenii i izbrannye pis'ma*, ed. Z. A. Kamenskii, 2 vols. (Moscow: Izdatel'stvo Nauka, 1991), 1:89.

48. Ibid., 1:92.

49. Belinskii, *PSS*, 1:103.

50. In fact, both French and Russian realism can be said to have arisen ad hoc (on this point, see Wellek, "The Concept of Realism," 227–28). Although realism is noted far earlier in France, it is not until the debates on Courbet and Flaubert, prompted by the publication of Champfleury's *Le Réalisme* in 1857 and the trial of *Madame Bovary* in the same year, that realism as an artistic movement was declared and applied retroactively to Balzac, Victor Hugo, and others. The Natural School also retroactively constructed its own history, reaching back to anoint Gogol the first realist and Dostoevsky his direct heir. Stasov enacted a similar process for realist painting and music.

51. D. S. Likhachev, *Russkoe iskusstvo ot drevnosti do avangarda* (Moscow: Iskusstvo, 1992), 45–64. See also: N. A. Dmitrieva, *Izobrazhenie i slovo* (Moscow: Iskusstvo, 1962), 11–102; and V. G. Bazanov and A. N. Iezuitov et al., eds., *Literatura i zhivopis'* (Leningrad: Nauka, 1982). Marcus Levitt challenges this presumption of Russian culture's logocentrism in *The Visual Dominant in Eighteenth-Century Russia* (DeKalb: Northern Illinois University Press, 2011).

52. In considering Russia's realism as colored by its peripheral status, I engage recent scholarship on marginal artistic traditions. See, for example, Partha Mitter, "Decentering Modernism: Art History and Avant-Garde Art from the Periphery," *Art Bulletin* 90, no. 4 (December 2008): 531–48. In a special issue of *Modern Language Quarterly* on "Peripheral Realisms," Jed Esty and Colleen Lye see the possibility for a "new realist turn" in this shift to the margins. Esty and Lye, "Peripheral Realisms Now," *Modern Language Quarterly* 73, no. 3 (September 2012): 276. See also the two-volume special issue of *Journal of Narrative Theory*, "Realism in Retrospect," edited by Abby Coykendall and Audrey Jaffe, and published in fall 2006 (vol. 36, no. 3) and winter 2008 (vol. 38, no. 1).

53. Translations are from Leo Tolstoy, *Anna Karenina*, trans. Richard Pevear and Larissa Volokhonsky (New York: Penguin, 2001).

54. In a diary entry dated 13 March 1870, Tolstoy mentions Lessing's *Laocoön* in relation to the painting of Nikolai Ge (48:118). For a theological interpretation of Tolstoy's engagement

with Lessing, see Amy Mandelker, *Framing "Anna Karenina": Tolstoy, the Woman Question, and the Victorian Novel* (Columbus: Ohio State University Press, 1993), 104–21.

55. Gotthold Ephraim Lessing, *Laocoön: An Essay on the Limits of Painting and Poetry*, trans. Edward Allen McCormick (Baltimore: Johns Hopkins University Press, 1984), 17.

56. Ibid., 91.

57. Ibid., 95.

58. For a thorough study of Lessing in Russia, see R. Iu. Danilevskii, *G. E. Lessing i Rossiia: Iz istorii russko-evropeiskoi kul'turnoi obshchnosti* (St. Petersburg: Dmitrii Bulanin, 2006), esp. 69–106.

59. Chernyshevsky even exaggerates Horace's phrase *ut pictura poesis*, turning it into the far more partisan, "let poetry transform into painting, let poetry imitate painting." N. G. Chernyshevskii, "Lessing i ego vremia," in *Polnoe sobranie sochinenii* [hereafter *PSS*], ed. V. Ia. Kirpotin et al., 15 vols. (Moscow: Khudozhestvennaia literatura, 1939–1953), 4:151.

60. Ibid., 4:152.

61. [N. A. Dobroliubov], "Laokoon, ili o granitsakh zhivopisi i poezii: Soch. Lessinga; Perevod E. Edel'sona; Moskva 1859 g.," *Sovremennik* 75 (1859), 352.

62. Jean Hagstrum, *The Sister Arts: The Tradition of Literary Pictorialism and English Poetry from Dryden to Gray* (Chicago: University of Chicago Press, 1958), 4.

63. Ibid., 6.

64. Ibid., 9. Leonard Barkan, *Mute Poetry, Speaking Pictures* (Princeton, NJ: Princeton University Press, 2013), 30. Rensselaer W. Lee's long article remains a classic on this subject: "*Ut Pictura Poesis*: The Humanistic Theory of Painting," *Art Bulletin* 22, no. 4 (December 1940): 197–269. See also: Henryk Markiewicz, "Ut Pictura Poesis . . . A History of the Topos and the Problem," *New Literary History* 18, no. 3 (Spring 1987): 535–58; Christopher Braider, "The Paradoxical Sisterhood: 'Ut Pictura Poesis,'" in *The Cambridge History of Literary Criticism*, vol. 3, *The Renaissance*, ed. Glyn P. Norton (Cambridge: Cambridge University Press, 1999), 168–75; and, for a discussion of the legacy of these debates in the nineteenth century, Roy Park, "'Ut Pictura Poesis': The Nineteenth-Century Aftermath," *Journal of Aesthetics and Art Criticism* 28, no. 2 (Winter 1969): 155–64.

65. Leonardo, *Paragone*, 59.

66. Barkan, *Mute Poetry*, 29.

67. Fredric Jameson forgoes the visual-verbal opposition made available by the sister arts in his recent discussion of realism, calling it not "very productive" and opting instead for a dialectic comprised of "narrative impulse" and "the realm of affect" (8). While I agree that realism reaches its expressive apex when engaged with the tension between temporal scope and the present moment, in this book I hold that these tensions (and many others) can be productively interrogated along the fissures between verbal and visual representation. Jameson, *The Antinomies of Realism* (London: Verso, 2013).

68. The scholarship on the relation between the visual arts and literature in the nineteenth century, especially in France and Britain, is vast. There is nothing to compare to this subdiscipline in Russian studies, perhaps due to the persistent assumption that Russian culture is predominantly logocentric. For a few representative examples from comparative traditions, see Hugh Witemeyer, *George Eliot and the Visual Arts* (New Haven, CT: Yale University Press, 1979); Marianna Torgovnick, *The Visual Arts, Pictorialism, and the Novel: James, Lawrence, and Woolf* (Princeton, NJ: Princeton University Press, 1985); Adrianne Tooke, *Flaubert and the Pictorial Arts: From Image to Text* (Oxford: Oxford University Press, 2000); Arden Reed, *Manet, Flaubert, and the Emergence of Modernism: Blurring Genre Boundaries* (New York: Cambridge University Press, 2003); and Kendall Johnson, *Henry James and the Visual* (Cambridge: Cambridge University Press, 2007). Additional sources are cited throughout this book and in the bibliography.

69. Peter Brooks, *Realist Vision* (New Haven, CT: Yale University Press, 2005), 3.

70. Photography will be discussed at greater length in chapter 5. For studies that address the intersection of vision and nineteenth-century literature more specifically, see Carol T. Christ and John O. Jordan, eds., *Victorian Literature and the Victorian Visual Imagination* (Berkeley: University of California Press, 1995); and Kate Flint, *The Victorians and the Visual Imagination* (Cambridge: Cambridge University Press, 2008).

71. Alison Byerly makes a similar argument about the relationship of English literature to the fine and performing arts in *Realism, Representation, and the Arts in Nineteenth-Century Literature* (Cambridge: Cambridge University Press, 1997), 2. For a related perspective, see Julie Thomas, *Pictorial Victorians: The Inscription of Values in Word and Image* (Athens: Ohio University Press, 2004), esp. 1–19.

72. Michael Fried, *Courbet's Realism* (Chicago: University of Chicago Press, 1990), 3.

73. W. J. T. Mitchell, "Beyond Comparison: Picture, Text, and Method," in *Picture Theory: Essays on Verbal and Visual Representation* (Chicago: University of Chicago Press, 1994), 83–107.

74. Ibid., 94–95.

75. W. J. T. Mitchell, *Iconology: Image, Text, Ideology* (Chicago: University of Chicago Press, 1986), 43.

76. W. J. T. Mitchell, "Going Too Far with the Sister Arts," in *Space, Time, Image, Sign: Essays on Literature and the Visual Arts*, ed. James A. W. Heffernan (New York: Peter Lang, 1987), 1–11.

77. The complicated history of interart studies in the second half of the twentieth century begins with René Wellek's appeal for caution in the study of literature and the other arts in a 1941 lecture. While some scholars will ground their comparisons in historical or biographical correspondences, elaborate typologies, or explicit relations of one work of art to another, others will reach for more ambitious models based on formal confluence (Frank), Weltanschauung (Praz), and semiotics (Bal; Bryson; Steiner). Beginning in the 1970s, there is a discernible pushback, mainly on the part of art historians, who see these efforts as flimsy, at best, and colonizing, at worst (Alpers and Alpers; Seznec; Kuspit; Elkins; Gilman). The following sources represent the foundational contributions to this debate: René Wellek, "The Parallelism between Literature and the Visual Arts," in *English Institute Annual* (New York: Columbia University Press, 1941), 29–63; Joseph Frank, "Spatial Form in Modern Literature" (1945), in *The Widening Gyre: Crisis and Mastery in Modern Literature* (New Brunswick, NJ: Rutgers University Press, 1963), 3–62; Mario Praz, *Mnemosyne: The Parallel between Literature and the Visual Arts* (Princeton, NJ: Princeton University Press, 1970); Mieke Bal and Norman Bryson, "Semiotics and Art History," *Art Bulletin* 73, no. 2 (June 1991): 174–208; Wendy Steiner, *The Colors of Rhetoric: Problems in the Relation between Modern Literature and Painting* (Chicago: University of Chicago Press, 1982); Svetlana Alpers and Paul Alpers, "Ut Pictura Noesis? Criticism in Literary Studies and Art History," *New Literary History* 3, no. 3 (Spring 1972): 437–58; Jean Seznec, "Art and Literature: A Plea for Humility," *New Literary History* 3, no. 3 (Spring 1972): 569–74; Donald Kuspit, "Traditional Art History's Complaint against the Linguistic Analysis of Visual Art," *Journal of Aesthetics and Art Criticism* 45, no. 4 (Summer 1987): 345–49; James Elkins, "Marks, Traces, 'Traits,' Contours, 'Orli,' and 'Splendores': Nonsemiotic Elements in Pictures," in *On Pictures and the Words That Fail Them* (New York: Cambridge University Press, 1998), 3–46; and Ernest B. Gilman, "Interart Studies and the 'Imperialism' of Language," *Poetics Today* 10, no. 1 (Spring 1989): 5–30. Additional sources are cited in the bibliography.

78. The best known of such writer-artist pairings are summarized in Mikhail Gorlin, "The Interrelation of Painting and Literature in Russia," trans. Nina Brodiansky, *Slavonic and East European Review* 25, no. 64 (November 1946): 134–48. For examples of biographical considerations of interart relations, see S. N. Durylin, *Repin i Garshin: Iz istorii russkoi zhivopisi i literatury* (Moscow: Gosudarstvennaia akademiia khudozhestvennykh nauk, 1926); and I. S. Zil'bershtein, *Repin i Turgenev* (Moscow: Izdatel'stvo akademii nauk, 1945). On Tolstoy and visual artists, see chapter 3, note 7.

79. The personal and artistic connection between Chekhov and Levitan is expored in: Iu. A. Koroleva, *Soprikosnovenie sudeb: A. P. Chekhov, I. I. Levitan* (Moscow: Gelios ARV, 2011); and Galina Churak, "Sud'by skreshchen'e . . . Chekhov i Levitan," *Tretyakov Gallery Magazine/Tret'iakovskaia galereia*, special issues: Isaak Levitan (2013): 16–29.

80. Of the few nonbiographical considerations of the relation between literature and the other arts in Slavic studies, most are centered around modernism; two excellent examples are Roger Anderson and Paul Debreczeny, eds., *Russian Narrative and Visual Arts: Varieties of Seeing* (Gainesville: University of Florida Press, 1994); and Catriona Kelly and Stephen Lovell, eds., *Russian Literature, Modernism, and the Visual Arts* (Cambridge: Cambridge University Press, 2000). For scholarship that addresses the nineteenth century more specifically, see K. V. Pigarev, *Russkaia literatura i izobrazitel'noe iskusstvo (XVIII–pervaia chetvert' XIX veka): Ocherki* (Moscow: Nauka, 1966), esp. 7–21; K. V. Pigarev, *Russkaia literatura i izobrazitel'noe iskusstvo: Ocherki o russkom natsional'nom peizazhe serediny XIX v.* (Moscow: Nauka, 1972); K. A. Barsht, "O tipologicheskikh vzaimosviaziakh literatury i zhivopisi (na materiale russkogo iskusstva XIX veka)," in *Russkaia literatura i izobrazitel'noe iskusstvo XVIII–nachala XX veka: Sbornik nauchnykh trudov*, ed. Iu. K. Gerasimov (Leningrad: Nauka, 1988), 5–34; and Douglas Greenfield, ed., *Depictions: Slavic Studies in the Narrative and Visual Arts in Honor of William E. Harkins* (Dana Point, CA: Ardis, 2000).

Notes to Chapter One

1. N. A. Nekrasov, "O pogode (Ulichnye vpechatleniia)" (1858–1865), in *Polnoe sobranie sochinenii i pisem* [hereafter *PSS*], ed. M. P. Khrapchenko et al., 15 vols. (Leningrad: Nauka, 1981–2000), 2:181.

2. N. A. Nekrasov, *Zhizn' i pokhozhdeniia Tikhona Trostnikova*, ibid., 8:89.

3. N. A. Nekrasov, "Neobyknovennyi zavtrak" (1843), ibid., 7:322.

4. N. A. Nekrasov, ed., *Fiziologiia Peterburga*, ed. V. I. Kuleshov (Moscow: Nauka, 1991), 77. In some, but not all, cases, full or amended translations are borrowed from Nikolai Nekrasov, ed., *Petersburg: The Physiology of a City*, trans. Thomas Gaiton Marullo (Evanston, IL: Northwestern University Press, 2009), 111. Hereafter, all references from *The Physiology of Petersburg* will be taken from these editions and will be cited within the text, with the Russian preceding the translation.

5. F. M. Dostoevskii, "Peterburgskaia letopis'" (1847), in Dostoevskii, *PSS*, 18:35.

6. A. V. Druzhinin, *Vospominanie o russkom khudozhnike Pavle Andreiche Fedotove* (St. Petersburg: Tip. Eduarda Pratsa, 1853), 8.

7. For a more detailed discussion of the formation of the Natural School and the *Physiology*, see V. I. Kuleshov, *Natural'naia shkola v russkoi literature XIX veka*, 2nd ed. (Moscow: Prosveshchenie, 1982), 5–76; and V. I. Kuleshov, "Znamenityi al'manakh Nekrasova," in Nekrasov, *Fiziologiia Peterburga*, 216–43.

8. In addition to the *Physiology*, Nekrasov edited two other illustrated almanacs. *Petersburg Collection* (1846) brought together works by Nekrasov, Belinsky, Herzen, Turgenev, Panaev, and Vladimir Sollogub. Most notably, Dostoevsky's *Poor Folk* was published in this collection. *Illustrated Almanac* was completed in 1848, but never published due to censorship. See facsimile reprints of these almanacs: N. A. Nekrasov, ed., *Peterburgskii sbornik* (Leipzig: Zentralantiquariat der Deutschen Demokratischen Republik, 1976); and N. A. Nekrasov and I. I. Panaev, eds., *Illiustrirovannyi al'manakh: Izdanie I. I. Panaeva i N. A. Nekrasova 1848 g.* (Moscow: Kniga, 1990).

9. Kuleshov, *Natural'naia shkola*, 47.

10. Faddey Bulgarin makes these comments in an 1846 feuilleton in the *Northern Bee*. Cited in A. G. Tseitlin, *Stanovlenie realizma v russkoi literature: Russkii fiziologicheskii ocherk* (Moscow: Nauka, 1965), 93.

11. V. G. Belinskii, "Vzgliad na russkuiu literaturu 1846 goda" (1847), in Belinskii, *PSS*, 10:16.

12. Viktor Vinogradov offers a now classic Formalist interpretation of Gogol's influence on the Natural School in *Evoliutsiia russkogo naturalizma*.

13. In his famously scathing "Letter to Gogol," Belinsky writes that Gogol had produced masterworks that had "contributed to Russia's awareness of herself, allowing her to take a look at herself as if in a mirror." Belinskii, "Pis'mo k Gogoliu" (1847), in Belinskii, *PSS*, 10:213.

14. V. G. Belinskii, "Russkaia literatura v 1845 godu" (1846), ibid., 9:378.

15. Belinskii, "Vzgliad na russkuiu literaturu 1846 goda," ibid., 10:16.

16. For a thorough review of the French *physiologies*, with an emphasis on their ideological implications as a genre tied to a petit bourgeois mentality, see Richard Sieburth, "Same Difference: The French *Physiologies*, 1840–1842," in *Notebooks in Cultural Analysis: An Annual Review*, ed. Norman F. Cantor (Durham, NC: Duke University Press, 1984), 163–200.

17. Tseitlin, *Stanovlenie realizma*, 69–70.

18. A facsimile reprint of *Russians, Painted from Nature by Themselves* has been published as Aleksandr Bashutskii, ed., *Nashi, spisannye s natury russkimi* (Moscow: Kniga, 1986).

19. For a comparison of Belinsky's views on the *physiologies* (published in *Notes of the Fatherland*) to the more critical opinions expressed in the *Northern Bee* and *Library for Reading*, see Tseitlin, *Stanovlenie realizma*, 79–89.

20. Tseitlin considers the physiological sketch central not only to the Natural School and to realist prose more generally, but also to realist painting. Tseitlin, *Stanovlenie realizma*, 91–92.

21. V. G. Belinskii, "Fiziologiia Peterburga (retsenziia na vtoruiu chast')" (1845), in Belinskii, *PSS*, 9:216.

22. On Belinsky's relation to the visual arts, see V. Bakushinskii, "Vstrecha Belinskogo s Sikstinskoi Madonnoi," in *Venok Belinskomu: Novye stranitsy Belinskogo; Rechi, issledovaniia, materialy*, ed. N. K. Piksanov (Moscow: Novaia Moskva, 1924), 109–19; D. Chaushanskii, "Belinskii i russkaia realisticheskaia illiustratsiia 1840-kh godov," in *V. G. Belinskii III*, vol. 57 of *Literaturnoe nasledstvo*, ed. A. M. Egolin et al. (Moscow: Akademiia nauk SSSR, 1951), 327–56; M. S. Kagan, "V. G. Belinskii i izobrazitel'noe iskusstvo" and "V. G. Belinskii o russkoi zhivopisi," both in Kagan, *Iskusstvoznanie i khudozhestvennaia kritika: Izbrannye stat'i* (St. Petersburg: Petropolis, 2001), 66–76, 77–92.

23. The relation between Dostoevsky's "Polzunkov" and Fedotov's illustrations, as well as broader resonances between the writer and the painter, are discussed in the introductory essay by V. S. Nechaeva in F. M. Dostoevskii, *Polzunkov* (Moscow: Gosudarstvennoe izdatel'stvo, 1928), esp. 14–32.

24. In her valuable study of Russian genre painting, Rosalind Blakesley draws connections between Fedotov, the genre painting of Aleksei Venetsianov and his students, and the illustrators of the Natural School, seeing Fedotov as a crucial link between earlier romantic and protorealist traditions and the overtly critical realism of the 1860s. Blakesley, *Russian Genre Painting*, 125–51.

25. In this chapter, the juxtaposition of Fedotov and the Natural School writers does not mean to suggest a relation of influence or analogy, but rather a common engagement with the sister arts in

the development of an early realist aesthetic. For two studies that more deeply engage the historical and stylistic connections between Fedotov and his literary counterparts (the first focusing on the Natural School and the second on Gogol), see G. K. Leont'eva, *Pavel Andreevich Fedotov: Osnovnye problemy tvorchestva* (Leningrad: Iskusstvo, 1962), 77–83; and D. V. Sarab'ianov, *P. A. Fedotov i russkaia khudozhestvennaia kul'tura 40-kh godov XIX veka* (Moscow: Iskusstvo, 1973), 81–109.

26. Iu. V. Mann, "Filosofiia i poetika 'Natural'noi shkoly,'" in *Problemy tipologii russkogo realizma*, ed. N. L. Stepanov and U. R. Focht (Moscow: Nauka, 1969), 242–45.

27. Nekrasov's comments are recounted by Viktor Panaev in V. A. Panaev, "Vospominaniia V. A. Panaeva," *Russkaia starina* 79 (1893): 501.

28. For more on Nekrasov's unfinished novel and, in particular, a discussion of its autobiographical sources, see K. I. Chukovskii, "Trosnikov—Nekrasov (cherty avtobiografii v naidennykh proizvedeniiakh Nekrasova," in *Zhizn' i pokhozhdeniia Tikhona Trosnikova: Novonaidennaia rukopis' Nekrasova*, by N. A. Nekrasov, ed. V. E. Evgen'ev-Maksimov and K. I. Chukovskii (Moscow: Khudozhestvennaia literatura, 1931), 29–47; and A. G. Kroshkin, "Roman N. A. Nekrasova *Zhizn' i pokhozhdeniia Tikhona Trostnikova*," in *Nekrasovskii sbornik*, ed. V. G. Bazanov, N. F. Bel'chikov, and A. M. Egolin (Moscow: Akademiia nauk SSSR, 1960), 3:36–58.

29. In the use of second-person narration to engage the reader, Grigorovich relies on a well-worn device of the French *physiologie*. See, for example, the opening lines of Balzac's "The Parisian Lady" (published initially as "La Femme comme il faut" in *Les Français peints par eux-mêmes*): "Passing along, in certain quarters of Paris, some fine morning between the hours of two and five, you observe a Lady approaching." Jules Janin et al., *Pictures of the French: A Series of Literary and Graphic Delineations of French Character* (London: W. S. Orr, 1840), 1.

30. V. G. Belinskii, "Rech' o kritike" (1842), in Belinskii, *PSS*, 6:267.

31. Nancy Armstrong discusses Locke's philosophy in relation to the invention and popularization of photography and questions of realism in the nineteenth century. Armstrong, "Realism before and after Photography: 'The Fantastical Form of a Relation Among Things,'" in Beaumont, *Adventures in Realism*, 84–102, esp. 85–89.

32. Belinskii, "Rech' o kritike," 6:268.

33. V. G. Belinskii, "Fiziologiia Peterburga," 9:55.

34. Ruth Webb, *Ekphrasis, Imagination, and Persuasion in Ancient Rhetorical Theory and Practice* (Burlington, VT: Ashgate, 2009), 105. See also: François Rigolot, "The Rhetoric of Presence: Art, Literature, and Illusion," in *The Cambridge History of Literary Criticism*, vol. 3, *The Renaissance*, ed. Glyn P. Norton (Cambridge: Cambridge University Press, 1999), 161–67.

35. I. S. Turgenev, "Povesti, skazki i rasskazy kazaka Luganskogo (retsenziia)" (1847), in *Polnoe sobranie sochinenii i pisem* [hereafter *PSS*], ed. M. P. Alekseev et al., 28 vols. (Moscow: Akademiia nauk, 1960–1968), 1:300. Hereafter, unless otherwise noted, all references to Turgenev's literary and extraliterary works come from this edition and will be cited in the text or notes as volume and page number.

36. Conversations with Galina Mardilovich helped to clarify the importance of polytype techniques in nineteenth-century engraving and print technology.

37. Chaushanskii, "Belinskii," 327. For more on nineteenth-century book illustration, see K. S. Kuz'minskii, *Russkaia realisticheskaia illiustratsiia XVIII i XIX vv.* (Moscow: Gosudarstvennoe izdatel'stvo izobrazitel'nykh iskusstv, 1937); and G. E. Lebedev, *Russkaia knizhnaia illiustratsiia XIX v.* (Moscow: Iskusstvo, 1952).

38. In an 1843 issue of *Notes of the Fatherland*, an unnamed journalist (often considered to be Belinsky himself) writes that polytype illustrations "make everything equally accessible to each and every one, to the rich and the poor [...] [they] explain the text, giving a lively, vivid understanding, now of the painting of a great master, now of the multifaceted subjects of the natural sciences and history." Cited in Chaushanskii, "Belinskii," 329–30.

39. V. G. Belinskii, "'Fiziologiia teatrov v Parizhe i v provintsiiakh' i 'Fiziologiia vivera (liubitelia naslazhdeniia)' (retsenziia)" (1843), in Belinskii, *PSS*, 7:80.

40. It is tempting to note the double meaning of *cherta* (as both "line" and "trait") in Russian, as well as the related words, *chertit'* ("to draw") and *chertezh* ("sketch" or "drawing"). In a way, then, Kovrigin's "lines" and Belinsky's "traits" unite the physiology and its illustration in a shared fusion of the verbal and visual meanings of "sketch."

41. J. Hillis Miller, "The Fiction of Realism: *Sketches by Boz*, *Oliver Twist*, and Cruikshank's Illustrations," in *Dickens Centennial Essays*, ed. Ada Nisbet and Blake Nevius (Berkeley: University of California Press, 1971), 129–30.

42. Ibid., 153.

43. Priscilla Parkhurst Ferguson, *Paris as Revolution: Writing the Nineteenth-Century City* (Berkeley: University of California Press, 1994), 91. Ferguson discusses the historical transformation

of the flâneur on pp. 80–114. Regarding the Russian context, Julie Buckler describes the 1840s feuilletonist as a reimagined 1830s Parisian flâneur in *Mapping St. Petersburg: Imperial Text and Cityshape* (Princeton, NJ: Princeton University Press, 2005), 96–108, esp. 99. The massive corpus of scholarship on the flâneur is mostly indebted to Walter Benjamin's work on Baudelaire, especially in *Charles Baudelaire: A Lyric Poet in the Era of High Capitalism*, trans. Harry Zohn (London: Verso, 1973).

44. Tseitlin outlines the similarities and differences between the physiological sketch and the novella, the travel narrative, and the feuilleton. Tseitlin, *Stanovlenie realizma*, 107–10. On the importance of the feuilleton at a later moment, see Katia Dianina, "The Feuilleton: An Everyday Guide to Public Culture in the Age of the Great Reforms," *Slavic and East European Journal* 47, no. 2 (Summer 2003): 187–210.

45. Michel de Certeau, *The Practice of Everyday Life*, trans. Steven Rendall (Berkeley: University of California Press, 1984), 93.

46. Ibid., 106.

47. D. V. Grigorovich, *Literaturnye vospominaniia* (1892–1893) (Moscow: Khudozhestvennaia literatura, 1987), 77.

48. Ibid., 78.

49. Ibid.

50. Ibid. The whole statement reads as follows: "To write haphazardly, to give in to my fantasy, to say to myself, 'And so it will be!'—seemed tantamount to an untold action; besides, the tendency toward realism had already awakened in me the wish to represent reality as it actually presents itself, like Gogol describes it in 'The Overcoat.'"

51. Alison Byerly discusses Dickens's and Thackeray's appropriation of the visual sketch—primarily as a concept—as a means to bolster the realism of their literary "sketches." Byerly, "Effortless Art: The Sketch in Nineteenth-Century Painting and Literature," *Criticism* 41, no. 3 (1999): 349–64.

52. Druzhinin, *Vospominanie*, 26.

53. Ibid., 27–28.

54. Vsevolod Dmitriev summarizes the trends in Fedotov scholarship from Druzhinin through the first decade of the twentieth century in "P. A. Fedotov," *Apollon* 9–10 (November–December 1916): 1–36.

55. N. N. Punin, "P. A. Fedotov," in *Russkoe i sovetskoe iskusstvo* (Moscow: Sovetskii khudozhnik, 1976), 115. Sarabianov offers an alternative reading of Fedotov's supposed dilettantism, claiming that such amateur credentials would have been an advantage for an emerging realism that sought to distance itself from official art institutions and artistic conventions. D. V. Sarab'ianov, *Pavel Andreevich Fedotov* (Leningrad: Khudozhnik RSFSR, 1985), 15.

56. Many have remarked upon the theatricality of Fedotov's painting. See, for example, Sarab'ianov, *Pavel Andreevich Fedotov*, 56; and E. N. Atsarkina, "Novatorstvo Fedotova-zhanrista," in *Gosudarstvennaia tret'iakovskaia galereia: Materialy i issledovaniia*, ed. E. Butorina, 2 vols. (Moscow: Sovetskii khudozhnik, 1956–1958), 2:78.

57. For a related point, see G. K. Leont'eva, *Kartina P. A. Fedotova "Svatovstvo maiora"* (Leningrad: Khudozhnik RSFSR, 1985), 24–26.

58. Such a narrative series would not have been new for Fedotov. See, for example, his 1844 sepia prints depicting the death and memorialization of the dog Fidelka. Reproduced in Sarab'ianov, *Pavel Andreevich Fedotov*, plates 6, 7.

59. By all accounts, Fedotov considered himself as much a writer as a painter. Opinions of his poetry ranged from the dismissive to the hyperbolic. Apollon Maikov, for example, writes that "his verses can in no way compete with his brush; they are incomparably lower than his brush." Ivan Mozhaisky, on the other hand, writes that "many of his poems are entirely successful," and confirms this artistic ambidexterity with the ultimate compliment: "His verses were liked by the greatest of our painters, Briullov, and his paintings were liked by the famous writer Gogol." Maikov, "Retsenziia na stat'iu Tol'bina o P. A. Fedotove" (1853), in *Pavel Andreevich Fedotov: Khudozhnik i poet*, ed. Ia. D. Leshchinskii (Leningrad: Iskusstvo, 1946), 229. Mozhaiskii, "Neskol'ko slov o pokoinom akademike P. A. Fedotove" (1859), in Leshchinskii, *Pavel Andreevich Fedotov*, 202.

60. P. A. Fedotov, "Popravka obstoiatel'stva, ili zhenit'ba maiora," in Leshchinskii, *Pavel Andreevich Fedotov*, 146–57. This poem was first published only in 1872 in the journal *Russian Antiquity*.

61. Although she admits that there is little material evidence linking Fedotov specifically with the group of revolutionary democrats known as the Petrashevsky Circle, Marina Shumova makes a compelling argument for the echoes of a sociocritical position in Fedotov's poetic works and suggests that these texts, which bypassed the censors by circulating in oral form, made the ideological content of Fedotov's painted works more understandable. M. N. Shumova, "'Slovo' i 'izobrazhenie' v

tvorchestve P. A. Fedotova," in *Russkaia literatura i izobraziteľnoe iskusstvo XVIII–nachala XX veka: Sbornik nauchnykh trudov*, ed. Iu. K. Gerasimov (Leningrad: Nauka, 1988), 119–42.

62. P. A. Fedotov, "Ratseia," in Leshchinskii, *Pavel Andreevich Fedotov*, 183–84. Sarabianov has suggested that this mixed-media performance has associations with Russian folk traditions and, more specifically, with the *lubok*, a popular woodcut print that combined text and picture. Sarabianov even sees in Fedotov's impulse to verbalize his paintings the influence of street performances, with the painter himself cast as a sort of carnival barker. Sarab'ianov, *Pavel Andreevich Fedotov*, 54.

63. Leshchinskii, *Pavel Andreevich Fedotov*, 88.

64. P. A. Fedotov, "Zhenit'ba maiora (opisanie kartiny)," in ibid., 176.

65. Ibid.

66. Druzhinin, *Vospominanie*, 36. Remarking on another moment that dramatizes the correlation between talking and drawing (words and images) in Fedotov's creative process, Druzhinin writes that Fedotov would frequent the homes of friends where "it was possible to, without ceremony, sit down amid the guests with pencil and paper, sketch and draw, and at the same time chat." Ibid., 34.

67. Mozhaiskii, "Neskoľ ko slov," 201.

68. Highlighting the dual status of the painting's objects as signs of reality and artistic "props," Nikolai Ramazanov tells of the dismay of one of Fedotov's friends at seeing the artist sitting at his table with an opened bottle of Clicquot. "'I am destroying my models,' Fedotov answered, pointing at the skeletons of a pair of herring and pouring his friend a glass of champagne." N. A. Ramazanov, *Materialy dlia istorii khudozhestv v Rossii* (Moscow: Gubernskaia tip., 1863), 234.

69. For a fascinating and detailed analysis of the objects in Fedotov's paintings, see Raisa Kirsanova, *Pavel Andreevich Fedotov (1815–1852): Kommentarii k zhivopisnomu tekstu* (Moscow: Novoe literaturnoe obozrenie, 2006).

70. Druzhinin, *Vospominanie*, 28.

71. Druzhinin writes: "The artist noticed through the window of the main room a chandelier with sooty glass baubles, which 'all by itself climbed into his painting.'" Ibid., 35.

72. Sarab'ianov, *P. A. Fedotov*, 48.

73. M. M. Allenov, "Evoliutsiia inter'era v zhivopisnykh proizvedeniiakh P. A. Fedotova," in *Russkoe iskusstvo XVIII–pervoi poloviny XIX veka: Materialy i issledovaniia*, ed. T. V. Alekseeva (Moscow: Iskusstvo, 1971), 121.

74. For more on the Western influences on Fedotov's art, see Blakesley, *Russian Genre Painting*, 125–52; Leshchinskii, *Pavel Andreevich Fedotov*, 52–93; and Sarab'ianov, *P. A. Fedotov*, 12–18. In considering the influence of Dutch painting on the non-narrative aspects of Fedotov's painting, I have been guided by Svetlana Alpers's *The Art of Describing: Dutch Art in the Seventeenth Century* (Chicago: University of Chicago Press, 1983).

75. Ronald D. Leblanc discusses the importance of Dutch painting on the formation of the Natural School in "Teniers, Flemish Art, and the Natural School Debate," *Slavic Review* 50, no. 3 (Autumn 1991): 576–89. For a comparative example that shows Russia to be participating in a much broader phenomenon, see Ruth Bernard Yeazell's study of Dutch painting as a flexible concept through which to understand realism in the novels of Balzac, George Eliot, Thomas Hardy, and Marcel Proust. Yeazell, *Art of the Everyday: Dutch Painting and the Realist Novel* (Princeton, NJ: Princeton University Press, 2008).

76. In an 1850 article, the critic P. M. Leonev remarks dismissively that Fedotov "transmits reality with the precision of the daguerreotype." P. M. Leonev, "Esteticheskoe koe-chto po povodu kartin i eskizov gospodina Fedotova," *Moskvitianin* 3, no. 10 (May 1850): 26.

77. Druzhinin, *Vospominanie*, 9.

78. James Elkins, *The Poetics of Perspective* (Ithaca, NY: Cornell University Press, 1994), 46–52.

79. Anne Friedberg, *The Virtual Window: From Alberti to Microsoft* (Cambridge, MA: MIT Press, 2006), 26.

80. Hubert Damisch, *The Origin of Perspective*, trans. John Goodman (Cambridge, MA: MIT Press, 2000), 389.

81. A. O., "Neskoľ ko slov o Fedotove" (1858), in Leshchinskii, *Pavel Andreevich Fedotov*, 211. Leshchinskii thinks that the author's acronym refers either to Grigory Ozhe, editor of the journal *Light-Writing*, in which the article appeared, or Amply Ochkin, censor and journalist.

82. Druzhinin, *Vospominanie*, 25.

83. A. I. Somov, *Pavel Andreevich Fedotov* (St. Petersburg: Tip. A. M. Kotoshina, 1878), 17. According to fellow artist and friend Aleksandr Beideman, the wedding might not have been completely fabricated. Apparently, Fedotov made a surprise proposal to Beideman's sister Liza (after

reciting his poem "Major," no less), but never returned to the house as promised. A. E. Beideman and E. F. Beideman, "Iz vospominanii," in Leshchinskii, *Pavel Andreevich Fedotov*, 213.

 84. Nekrasov, *PSS*, 2:181.

Notes to Chapter Two

 1. Viktor Shklovskii, *O teorii prozy* (Moscow: Federatsiia, 1929), 24.

 2. Translations are from Ivan Turgenev, *Fathers and Sons*, trans. Rosemary Edmonds (New York: Penguin, 1975).

 3. Michael Holquist attributes this shift in language to the novel's final critique of Bazarov, forcing him to recognize "the inescapability of metaphor, even in science." Holquist, "Bazarov and Sečenov: The Role of Scientific Metaphor in *Fathers and Sons*," *Russian Literature* 16, no. 4 (1984), 372.

 4. Although this chapter focuses on the modal shifts implicit in these narrative possibilities, in many cases these shifts coincide with generic ones (between social invective and pastoral, for example). For discussions of genre more specifically, see Gary Saul Morson, "*Fathers and Sons*: Inter-Generic Dialogues, Generic Refugees, and the Hidden Prosaic," in *Literature, Culture, and Society in the Modern Age: In Honor of Joseph Frank*, ed. Edward J. Brown et al., *Stanford Slavic Studies* 4, no. 1 (Stanford, CA: Stanford University Press, 1991): 336–81; and Russell S. Valentino, "A Wolf in Arkadia: Generic Fields, Generic Counterstatement, and the Resources of Pastoral in *Fathers and Sons*," *Russian Review* 55, no. 3 (July 1996): 475–93.

 5. Stendhal, *The Red and the Black*, 342. For an analysis of Stendhal's statement, see Hans Ulrich Gumbrecht, "The Roads of the Novel," in *The Novel*, vol. 2, *Forms and Themes*, ed. Franco Moretti (Princeton, NJ: Princeton University Press, 2006), 611–12. Donald Fanger calls Stendhal's comment a "notoriously unproductive notion" and argues that Gogol's *Dead Souls*, "alone among the major novels of European literature, might be said to fit and validate it." Fanger, *The Creation of Nikolai Gogol* (Cambridge, MA: Belknap Press of Harvard University Press, 1979), 169.

 6. M. M. Bakhtin, "Forms of Time and of the Chronotope in the Novel" (1937–1938), in *The Dialogic Imagination*, ed. Michael Holquist, trans. Caryl Emerson and Michael Holquist (Austin: University of Texas Press, 1981), 244.

 7. Ibid., 84–85.

 8. For evidence of the omnipresence of the road in Russian realist art, see the catalogue for the 2004 exhibition *Roads in Russian Art* at the State Russian Museum: E. N. Petrova, ed., *Doroga v russkom iskusstve* (St. Petersburg: Palace Editions, 2004). In the opening pages, Vladimir Leniashin even writes that "the road was the child of realism." V. A. Leniashin, "Doroga i put' v zhivopisi XIX–XX veka," ibid., 10.

 9. For a more detailed discussion of these philosophical and aesthetic shifts, see Andrzej Walicki, *A History of Russian Thought: From the Enlightenment to Marxism*, trans. Hilda Andrews-Rusiecka (Stanford, CA: Stanford University Press, 1979), esp. 135–51 and 183–221.

 10. N. G. Chernyshevskii, "Esteticheskie otnosheniia iskusstva k deistvitel'nosti" (1855), in Chernyshevskii, *PSS*, 2:92.

 11. The journal polemics surrounding *Fathers and Children* are discussed in P. S. Reifman, "Bor'ba v 1862–1863 godakh vokrug romana I. S. Turgeneva 'Ottsy i deti'," *Trudy po russkoi i slavianskoi filologii: Uchenye zapiski tartuskogo gosudarstvennogo universiteta* 6 (1963): 82–94.

 12. Valkenier, *Russian Realist Art*, 32 and 32–37. For more on the history of Russian painting during this period, see Jackson, *The Wanderers*, 21–33. The petition to the Academy requesting a free choice in gold medal subject (8 October 1863) and Kramskoy's account of the secession (13 and 21 November 1863), among other documents about the Artel and its activities, have been translated and collected in "Russian Realist Painting: The Peredvizhniki; An Anthology," ed. Elizabeth Kridl Valkenier and Wendy Salmond, *Experiment/Eksperiment: A Journal of Russian Culture* 14 (2008): 59–81.

 13. The history of Russian art criticism is discussed in the following sources: N. I. Bespalova and A. G. Vereshchagina, *Russkaia progressivnaia khudozhestvennaia kritika vtoroi poloviny XIX veka: Ocherki*, ed. M. M. Rakova (Moscow: Izobrazitel'noe iskusstvo, 1979), 11–82; Alexey Makhrov, "The Pioneers of Russian Art Criticism: Between State and Public Opinion, 1804–1855," *Slavonic and East European Review* 81, no. 4 (October 2003): 614–33; and Carol Adlam, "Realist Aesthetics in Nineteenth-Century Russian Art Writing," *Slavonic and East European Review* 84, no. 4 (October 2005): 638–63.

 14. For more on Tretyakov and his artistic patronage, see John O. Norman, "Pavel Tretiakov and Merchant Art Patronage, 1850–1900," in *Between Tsar and People: Educated Society and the Quest for Public Identity in Late Imperial Russia*, ed. Edith W. Clowes, Samuel D. Kassow, and James L. West (Princeton, NJ: Princeton University Press, 1991), 93–107; and I. S. Nenarokomova, *Pavel Mikhailovich Tret'iakov i ego galereia* (Moscow: Galart, 1994).

15. Shklovskii, *O teorii prozy*, 24.

16. N. V. Gogol', *Polnoe sobranie sochinenii*, ed. N. L. Meshcheriakov, 14 vols. (Moscow: Akademiia nauk SSSR, 1937–1952), 6:221. Translation is from Nikolai Gogol, *Dead Souls*, trans. Richard Pevear and Larissa Volokhonsky (New York: Vintage Classics, 1997), 226–27.

17. Fanger, *The Creation of Nikolai Gogol*, 169–70.

18. Iu. M. Lotman, "Problema khudozhestvennogo prostranstva v proze Gogolia," in *Izbrannye stat'i v trekh tomakh* (Tallinn: Aleksandra, 1992), 1:445. Lotman makes an additional distinction that is curious (especially in relation to the discussion in the next chapter of Pierre's movement through Borodino) between a "hero of the path" who moves in a fixed, linear way (Tolstoy's Pierre Bezukhov), and a "hero of the steppe" who moves unpredictably (Tolstoy's Hadji Murat). Ibid., 417.

19. Translations are from Ivan Turgenev, *Sketches from a Hunter's Album*, trans. Richard Freeborn (New York: Penguin, 1990). This text is translated as *Notes of a Hunter* throughout this chapter.

20. Christopher Ely argues that Turgenev's discussion of poor road conditions and lengthy landscape descriptions contribute to the creation of a shared discourse of Russian national identity. Ely, *This Meager Nature: Landscape and National Identity in Imperial Russia* (DeKalb: Northern Illinois University Press, 2002), 129–33. Ely discusses road conditions, in particular, on pp. 140–45.

21. Victor Ripp makes a similar point, albeit briefly, writing that the road is "a simplistic device to get the narrative in motion." Ripp, *Turgenev's Russia from* Notes of a Hunter *to* Fathers and Sons (Ithaca, NY: Cornell University Press, 1980), 43.

22. Bakhtin, "Forms of Time and of the Chronotope," 245.

23. Ibid., 9.

24. Referring to concepts like "plot" and "plane," David Summers writes that "all of these terms preserve real spatial metaphors characterizing how things are made evident, as true as they can be made or seen to be." Summers, *Real Spaces: World Art History and the Rise of Western Modernism* (London: Phaidon, 2003), 350.

25. Kirill Pigarev makes a related observation with regard to "Bezhin Meadow." Pigarev, *Russkaia literatura* (1972), 85.

26. Bogoliubov is quoted in the 1 October 1883 edition of *Gatsuk's Newspaper*, cited in L. R. Lanskoi, "Poslednii put': Otkliki russkoi i zarubezhnoi pechati na smert' i pokhorony Turgeneva," in *I. S. Turgenev: Novye materialy i issledovaniia*, vol. 76 of *Literaturnoe nasledstvo*, ed. A. N. Dubovikov and I. S. Zil'bershtein et al. (Moscow: Nauka, 1967), 663.

27. Belinskii, "Vzgliad na russkuiu literaturu 1847 goda," 10:347.

28. Vladimir Nabokov, *Lectures on Russian Literature*, ed. Fredson Bowers (New York: Harcourt, Brace, 1981), 65.

29. D. S. Mirsky, *A History of Russian Literature from Its Beginnings to 1900*, ed. Francis J. Whitfield (1881; repr., Evanston, IL: Northwestern University Press, 1999), 195.

30. Ibid., 205.

31. For a recent survey of this dual Turgenev, see Robert Reid's introductory article in Reid and Joe Andrew, eds., *Turgenev: Art, Ideology, and Legacy* (Amsterdam: Rodopi, 2010), 1–20. Victor Terras considers this contradiction between "Turgenev-the-aesthete" and "Turgenev-the-realist" a conscious and productive aspect of Turgenev's realism. Terras, "Turgenev's Aesthetics and Western Realism," *Comparative Literature* 22, no. 1 (Winter 1970): 19–35, esp. 27. Elizabeth Cheresh Allen also attempts to reconcile this division, articulating Turgenev's realism as both aesthetic and ethical. Allen, *Beyond Realism: Turgenev's Poetics of Secular Salvation* (Stanford, CA: Stanford University Press, 1992).

32. In her study of landscape descriptions in the English and French novel, Doris Y. Kadish argues for a similar approach that does not distinguish between pictorial analysis and sociohistorical context. Kadish, *The Literature of Images: Narrative Landscape from* Julie *to* Jane Eyre (New Brunswick, NJ: Rutgers University Press, 1987), 5–9.

33. For more on the biographical and aesthetic connections between Turgenev and the landscape painters of his time (both Russian and European), see Pigarev, *Russkaia literatura* (1972), 82–109. Iu. P. Pishchulin offers a more wide-ranging study of Turgenev, his relationships with artists, and his own artistic preoccupations in *Ivan Sergeevich Turgenev: Zhizn', iskusstvo, vremia* (Moscow: Sovetskaia Rossiia, 1988).

34. Pigarev, *Russkaia literatura* (1972), 94–95. Turgenev's collection is surveyed in a catalogue published to accompany an 1878 auction at Hôtel Drouot in Paris, *Collection de M. Ivan Tourguéneff et collection de M. X.* For a Russian transcription, see *Opisanie rukopisei i izobrazitel'nykh materialov pushkinskogo doma*, vol. 4, *I. S. Turgenev*, ed. Institut russkoi literatury (Moscow: Izdatel'stvo akademii nauk SSSR, 1958), 217–24.

35. I. E. Tsvetkov, "Vstrecha s I. S. Turgenevym," in Dubovikov and Zil'bershtein, *I. S. Turgenev*, 422.

36. Grigorovich, *Literaturnye vospominaniia*, 89.

37. For a similar point, see Gumbrecht, "The Roads of the Novel," 613.

38. I. S. Turgenev to I. A. Goncharov, Spasskoe, 7 April 1859. Rimvydas Silbajoris notices a similar disconnectedness in *Notes of a Hunter*, unsurprising given its serial character; he calls the collection a "picture gallery with a humane and sophisticated country squire, the narrator, guiding us around from one framed vignette to another." Silbajoris, "Images and Structures in Turgenev's *Sportman's Notebook*," *Slavic and East European Journal* 28, no. 2 (Summer 1984), 181.

39. Translation is from Ivan Turgenev, *Home of the Gentry*, trans. Richard Freeborn (Baltimore, MD: Penguin, 1970).

40. Making a larger argument about the inscription of a lyrical world within the novel's temporal and historical narrative, Jane Costlow calls Lavretsky's journey a "journey from the historical into the intimate, a realm freed of the constraints of the larger world beyond." Costlow, *Worlds within Worlds: The Novels of Ivan Turgenev* (Princeton, NJ: Princeton University Press, 1990), 68.

41. In his juxtaposition of a ravaged landscape with one that it is either "picturesque" or pastoral (as is suggested by Kirsanov's subsequent recitation of Pushkin), Turgenev may be gesturing to Fyodor Tiutchev's 1855 poem "These Poor Villages," in which the profound essence that shines beneath the devastated villages of the Russian countryside is visible only to the native gaze. I am grateful to Michael Kunichika for this point.

42. M. E. Saltykov-Shchedrin, "V derevne (letnii fel'eton)" (1863), in Saltykov-Shchedrin, *Sobranie sochinenii*, ed. S. A. Makashin et al., 20 vols. (Moscow: Khudozhestvennaia literatura, 1965–1977), 6:461. Cathy A. Frierson understands this passage as indicative of the broader disillusionment of romantic images of the peasant that took place after the emancipation. Frierson, *Peasant Icons: Representations of Rural People in Late Nineteenth-Century Russia* (New York: Oxford University Press, 1993), 24.

43. V. G. Perov to the Council of the Academy of Arts, 8 July 1864, in A. A. Fedorov-Davydov, *V. G. Perov: Dokumenty, pis'ma i rasskazy; Katalog proizvedenii; Bibliografiia* (Moscow: Gosudarstvennoe izdatel'stvo izobrazitel'nykh iskusstv, 1934), 94–95.

44. In a letter to the minister of the Imperial Court dated 11 July 1884, Academy Rector Konstantin Ton writes that "during a two-year placement in foreign places [Perov] managed through constant study to develop the technical side of painting" (ibid., 95). In relation to the Western influences on Perov's work, Blakesley argues that he likely was not that familiar with the Salon des Refusés of 1863 or predisposed to the works of Courbet and Édouard Manet. Rather, he was more sympathetic to Jean-Louis-Ernest Meissonier, Honoré Daumier, Octave Tassaert, and Philippe-Auguste Jeanron. Blakesley concludes that while Perov might have been drawn to the subject matter of the Parisian artists (poor and destitute workers), he learned more about technique (specifically a more restrained color palette) from Bartolomé Esteban Murillo, Rembrandt van Rijn, and Diego Velázquez. See Blakesley, *Russian Genre Painting*, 152–77.

45. The characterization of these two modes of representation is informed by Svetlana Alpers's article, "Interpretation without Representation, or, The Viewing of *Las Meninas*," *Representations* 1, no. 1 (February 1983): 30–42.

46. On the two diagonals, see V. A. Leniashin, *Vasilii Grigor'evich Perov* (Leningrad: Khudozhnik RSFSR, 1987), 72.

47. V. M. Obukhov, *V. G. Perov* (Moscow: Izobrazitel'noe iskusstvo, 1983), 15.

48. A. Z. Ledakov's comments are quoted in N. A. Aleksandrov, "Biografiia: Vasilii Grigor'evich Perov," *Khudozhestvennyi zhurnal* 11 (November 1882): 282.

49. Benua, *Istoriia russkoi zhivopisi*, 241. Many scholars have made connections between Perov and the literature of his time, namely the poetry of Nikolai Nekrasov and the early prose of Dostoevsky. Vladimir Leniashin even links Perov's hunting paintings to Turgenev's *Notes of a Hunter*. Leniashin, *Vasilii Grigor'evich Perov*, 94, 98. However, in an earlier article, Leniashin writes in a more measured fashion that Perov's paintings "do not become literary novellas translated into the language of the visual arts," concluding that they operate on painterly principles and only contain a kernel of literariness to shore up the depiction of reality. Leniashin, "Narodnyi khudozhnik," *Khudozhnik* 12 (1983): 5.

50. Cited in N. P. Sobko, *Vasilii Grigor'evich Perov: Ego zhizn' i proizvedeniia* (St. Petersburg: Izdatel'stvo D. A. Rovinskago, 1892), 63.

51. L. Dintses makes a similar observation, claiming that the paired lines of the mother's and horse's sloped backs draw the viewer into a physical and emotional engagement with the painting. L. A. Dintses, *V. Perov: Zhizn' i tvorchestvo* (Leningrad: Gosudarstvennyi russkii muzei, 1935), 44.

52. For a convincing argument about Perov's critical realism that foregrounds a Bakhtinian distance between author and hero, see A. T. Iagodovskaia, "Avtor i geroi v iskusstve V. G. Perova," *Sovetskoe iskusstvoznanie* 20 (1986): 232–53.

53. I. I. Dmitriev, "Rassharkivaiushcheesia iskustvo (po povodu godichnoi vystavki v akademii khudozhestv)" (1863), *Iskra* 5, nos. 37–38 (September 27–October 4, 1863): 527.

54. I. E. Repin, *Dalekoe blizkoe*, ed. K. I. Chukovskii (Moscow: Iskusstvo, 1964), 178.

55. For a thought-provoking account of whether and how pictures compel viewers to cry, see James Elkins, *Pictures and Tears: A History of People Who Have Cried in Front of Paintings* (New York: Routledge, 2001).

56. Jameson, *The Antinomies of Realism*, 8–11. Jane F. Thrailkill argues for the fundamental importance of feelings, based on the connection between the physiological and the emotional, to American literary realism in *Affecting Fictions: Mind, Body, and Emotion in American Literary Realism* (Cambridge, MA: Harvard University Press, 2007).

57. Victoria Frede, "Radicals and Feelings: The 1860s," in *Interpreting Emotions in Russia and Eastern Europe*, ed. Mark D. Steinberg and Valeria Sobol (DeKalb: Northern Illinois University Press, 2011), 63.

58. Although my point is influenced by Michael Fried's phenomenological conceptualization of the embodied and empathic viewer of Adolph Menzel's realism, I depart from him in emphasizing the specifically affective character of this engagement. Fried, *Menzel's Realism: Art and Embodiment in Nineteenth-Century Berlin* (New Haven, CT: Yale University Press, 2002).

59. V. V. Stasov, "Perov i Musorgskii" (1883), in Stasov, *Izbrannye sochineniia*, 2:140.

60. V. G. Perov, "Tetushka Mar'ia," in *Rasskazy khudozhnika*, ed. A. I. Leonov (Moscow: Akademiia khudozhestv SSSR, 1960), 17. For more on Perov's stories, see Leonov's introductory essay in the aforementioned volume, "V. G. Perov i ego rasskazy."

61. Roland Barthes, "The Reality Effect" (1968), in *French Literary Theory Today: A Reader*, ed. Tzvetan Todorov, trans. R. Carter (Cambridge: Cambridge University Press, 1982), 11–17.

62. Many art historians have considered such marks or forms. See, for example, Hans Sedlmayr, "Bruegel's *Macchia*" (1934), in *The Vienna School Reader: Politics and Art Historical Method in the 1930s*, ed. Christopher S. Wood (New York: Zone, 2003), 323–78; Elkins, "Marks, Traces," 3–46; and Reed, *Manet, Flaubert*, 56–91.

63. Gombrich's discussion of the duck-rabbit puzzle goes as follows: "True, we can switch from one reading to another with increasing rapidity; we will also 'remember' the rabbit while we see the duck, but the more closely we watch ourselves, the more certainly we discover that we cannot experience alternative readings at the same time." Gombrich, *Art and Illusion*, 5.

64. Richard Wollheim, *Painting as an Art* (London: Thames and Hudson, 1987), 46.

65. For a similar argument with regard to the composition of *Accompanying the Deceased*, see V. B. Rozenvasser, "Peizazh v kartinakh Perova," *Khudozhnik* 12 (1983): 20.

66. Fried argues that figures seen from the back are meant to double and absorb the painter-beholder into the painting, ultimately resisting any closure of the painterly space. See, in particular, his discussion of Courbet's *After Dinner at Ornans* and *The Stonebreakers*. Fried, *Courbet's Realism*, 85–110.

67. Blakesley suggests a comparative source for Perov's composition in Philippe-Auguste Jeanron's *Scene in Paris* (1833). Blakesley, *Russian Genre Painting*, 171. For a consideration of the passerby as a tool to create depth, both in *Troika* and in *Savoyard*, see O. A. Liaskovskaia, *V. G. Perov: Osobennosti tvorcheskogo puti khudozhnika* (Moscow: Iskusstvo, 1979), 45, 163.

68. In his review of the 1863 Academy exhibition, Stasov comments upon the similarly large format of Vasily Pukirev's *An Unequal Marriage,* celebrating it as proof of the improved stature of genre painting. V. V. Stasov, "Akademicheskaia vystavka 1863 g." (1863), in Stasov, *Izbrannye sochineniia*, 1:117.

69. Leniashin, *Vasilii Grigor'evich Perov*, 83.

70. In a coincidental rhetorical echo of Perov's wall, yet one that speaks to ontological correspondences among realist paintings, Fried writes that the facture of Courbet's *A Burial at Ornans* "walls" the viewer both in *and* out of the painting. Fried, *Courbet's Realism*, 266.

71. For an example of such a reading, see David Jackson, "The Motherland: Tradition and Innovation in Russian Landscape Painting," in *Russian Landscape*, ed. David Jackson and Patty Wageman (Schoten, Belgium: BAI, 2003), 57.

72. M. E. Saltykov-Shchedrin, "Pervaia russkaia peredvizhnaia khudozhestvenaia vystavka" (1871), in Saltykov-Shchedrin, *Sobranie sochinenii*, 9:232.

Notes to Chapter Three

1. L. N. Tolstoi to S. N. Tolstoi, Orda, 20 November 1854, 59:281.

2. L. N. Tolstoi to S. A. Tolstaia, Moscow, 27 September 1867.

3. The map was first published as part of the six-volume edition of *War and Peace* (1868–1869). It is inserted into the text after the following brief introduction by the narrator: "In crude form the plan of the proposed battle and the battle that occurred is as follows." L. N. Tolstoi, *Voina i mir* (Moscow: Tip. Ris, 1868–1869), 4:239.

4. While Donna Tussing Orwin interprets the map as "confer[ring] legitimacy on Tolstoy's fictional narrative," this chapter argues that Tolstoy's broader critique of graphic and visual representations far outweighs any legitimizing function the map might advance. Orwin, "The Awful Poetry of War: Tolstoy's Borodino," in *Tolstoy on War: Narrative and Historical Truth in "War and Peace,"* ed. Rick McPeak and Donna Tussing Orwin (Ithaca, NY: Cornell University Press, 2012), 132. For a related argument about Tolstoy's use of the visual to engage reader visualization, see Sarah Beth Mohler, "The Prosaics of the Mind's Eye: Reader Visualization, Perspectival Engagement, and the Visual Ethics of Tolstoy's *War and Peace*" (PhD diss., Princeton University, 2006).

5. On the matter of narrative inadequacy for Tolstoy, see Gary Saul Morson's discussion of the Borodino chapters as "an extended example of counternarration." Morson even directly addresses the inserted map, calling it "dialogic." Morson, *Hidden in Plain View: Narrative and Creative Potentials in "War and Peace"* (Stanford, CA: Stanford University Press, 1987), 136, 138.

6. Tolstoy's polemic with the visual is related to what Justin Weir calls Tolstoy's technique of "narrative diversion" when confronting the boundaries between fiction and other art forms. Weir, *Leo Tolstoy and the Alibi of Narrative* (New Haven, CT: Yale University Press, 2011), 58–60.

7. For more on Tolstoy's relation to the arts in a broader sense, see M. Fabrikant, "Tolstoi i izobrazitel'nye iskusstva (kontury problemy)," in *Estetika L'va Tolstogo: Sbornik statei*, ed. P. N. Sakulin (Moscow: Akademiia khudozhestvennykh nauk, 1929), 309–24; L. N. Kuzina, "Tolstoi o probleme 'sinteza' iskusstv," in *Tolstoi i nashe vremia*, ed. K. N. Lomunov (Moscow: Nauka, 1978), 106–21; V. S. Kemenov, "Tolstoi i izobrazitel'noe iskusstvo," in *L. N. Tolstoi i izobrazitel'noe iskusstvo: Sbornik statei*, ed. M. M. Rakova (Moscow: Izobrazitel'noe iskusstvo, 1981), 7–12; and A. N. Kuz'min, "Lev Tolstoi i russkie khudozhniki," in Bazanov and Iezuitov, *Literatura i zhivopis'*, 167–87. Primary sources have been collected in: *L. N. Tolstoi i khudozhniki: Tolstoi ob iskusstve; Pis'ma, dnevniki, vospominaniia o L. N. Tolstom*, ed. I. A. Brodskii (Moscow: Iskusstvo, 1978).

8. V. N. Fedorov, "Poezdka Tolstogo v Borodino," in Rakova, *L. N. Tolstoi*, 130.

9. Drawing on portraits, cartoons, *lubki*, battle paintings, and other primary sources, Nikolai Manaev posits that the visual often had a "negative influence" on Tolstoy's creative process, providing a contrast to the novelistic narrative. In contrast to Manaev's study, this chapter does not address Tolstoy's *actual* sources so much as the way Tolstoy engages the visual and verbal as conceptual categories within the narrative itself. Manaev, *Za gran'iu nevidimogo: V tvorcheskoi laboratorii L. N. Tolstogo; Ot izobrazitel'nogo istochnika—k istoricheskomu povestvovaniiu* (Kaluga: Eidos, 2002).

10. Brooks, *Realist Vision*, 3.

11. Describing what he calls the author's "visual absolutism," a belief in the dominance of sight influenced by European philosophical thought, Thomas Seifrid posits an argument more closely aligned with that of Brooks, stating that "Tolstoy tends to write as though a thing can be known only if it is seen and seen clearly, at times even as though seeing were constitutive of truth." While it is true that Enlightenment theories of sight underwrite Tolstoy's engagement with vision, the nature of that engagement is fraught and often openly polemical. Seifrid, "Gazing on Life's Page: Perspectival Vision in Tolstoy," *PMLA* 113, no. 3 (May 1998): 436. Similar themes of physiological and metaphysical vision are explored in E. V. Petrovskaia, "Zrenie i videnie v 'Voine i mire,'" *Iasnopolianskii sbornik* (2006): 30–56.

12. D. S. Merezhkovskii, "L. Tolstoi i Dostoevskii: Zhizn', tvorchestvo i religiia" (1900–1901), in *Polnoe sobranie sochinenii*, 17 vols. (St. Petersburg and Moscow: M. O. Vol'f, 1912), 7:157. Merezhkovsky writes that character-specific epithets in Tolstoy's prose (the irrepressible sparkle of Anna's eyes, her uncontrollable dark curl) are "united in the mind of the reader into one whole—living, singular, special, personal, unforgettable—so that when we finish the book, it seems to us that we have seen Anna Karenina with our own eyes." Ibid., 7:155.

13. Ibid.

14. Mandelker, *Framing "Anna Karenina,"* 11–12. In defining Tolstoy's "iconic aesthetics," Mandelker extends Richard Gustafson's conception of Tolstoy's "emblematic realism," a realism that is iconic, allegorical, and in opposition to the dominant social and historical realisms of the nineteenth century. Gustafson, *Leo Tolstoy: Resident and Stranger; A Study in Fiction and Theology* (Princeton, NJ: Princeton University Press, 1986), esp. 202–13. Here, as elsewhere in the book, realism is understood as flexible enough to allow for such dissonance, and need not be reimagined as protomodern, symbolic, or otherwise.

15. Martin Jay, *Downcast Eyes: The Denigration of Vision in Twentieth-Century French Thought* (Berkeley: University of California Press, 1993), 146.

16. Ibid., 128.

17. Walter Benjamin mentions a curious coincidence in the history of visual culture: "In 1839 Daguerre's panorama burns down. In the same year, he announces the invention of the daguerreotype." Benjamin, *The Arcades Project*, ed. Rolf Tiedemann, trans. Howard Eiland and Kevin McLaughlin (Cambridge, MA: Belknap Press of Harvard University Press, 1999), 6.

18. Jonathan Crary, *Techniques of the Observer: On Vision and Modernity in the Nineteenth Century* (Cambridge, MA: MIT Press, 1990), 69.

19. There has been much written on the vividness of Tolstoy's prose. For one example that deals explicitly with the "effect of presence," see V. D. Dneprov, "Izobrazitel'naia sila tolstovskoi prozy," in *V mire Tolstogo: Sbornik statei*, ed. S. I. Mashinskii (Moscow: Sovetskii pisatel', 1978), 53–103.

20. The historiographic and topographic perspectives, although considered part of a broader interart analysis in this chapter, also relate to what Andrew Wachtel describes as an intergeneric dialogue between three distinct voices (historical, fictional, and metahistorical). Wachtel, *An Obsession with History: Russian Writers Confront the Past* (Stanford, CA: Stanford University Press, 1994), esp. 112. As Wachtel himself is, I am indebted to Morson's reading of Tolstoy's novel as resisting any fixed narrative position in an effort to simulate the freedom of possibilities in real life. Morson, *Hidden in Plain View*.

21. Commenting similarly on the ethical dangers of vision in *Sevastopol Stories*, Morson briefly mentions the example of Pierre at Borodino as evidence of Tolstoy's strategy of turning the "reader into just such a tourist of death." Morson, "The Reader as Voyeur: Tolstoi and the Poetics of Didactic Fiction," *Canadian-American Slavic Studies* 12, no. 4 (Winter 1978): 469.

22. Viktor Shklovsky includes Glinka's text in his list of Tolstoy's sources. Shklovskii, *Mater'ial i stil'*, 248.

23. F. N. Glinka, *Ocherki Borodinskogo srazheniia: Vospominaniia o 1812 gode*, 2 vols. (Moscow: Tip. N. Stepanova, 1839), 1:49.

24. Ibid., 1:69.

25. Stephan Oetterman, *The Panorama: History of a Mass Medium*, trans. Deborah Lucas Schneider (New York: Zone, 1997), 7.

26. Although not about panoramas proper, Manaev offers an extended discussion of what he calls "panorama-ness" (*panoramnost'*) in *War and Peace*. Manaev, *Za gran'iu nevidimogo*, 99–112.

27. For more on the history of the panorama, see Oetterman, *The Panorama*; Heinz Buddemeier, *Panorama Diorama Photographie: Entstehung und Wirkung neuer Medien im 19. Jahrhundert* (Munich: Wilhelm Fink Verlag, 1970); Éric de Kuyper and Émile Poppe, "Voir et regarder," *Communications* 34, no. 1 (1981): 85–96; and Dolf Sternberger, *Panorama of the Nineteenth Century*, trans. Joachim Neugroschel (New York: Urizen, 1977), 7–16. Benjamin also collected a significant amount of material on the panorama for *The Arcades Project*. Benjamin, *The Arcades Project*, 527–36.

28. Honoré de Balzac, *Père Goriot*, ed. Peter Brooks, trans. Burton Raffel (New York: W. W. Norton, 1994), 40.

29. Ibid., 40–41.

30. Vanessa R. Schwartz, *Spectacular Realities: Early Mass Culture in Fin-de-Siècle Paris* (Berkeley: University of California Press, 1998), 150.

31. Oetterman, *The Panorama*, 21.

32. In addition to the aesthetic and material interpretation offered here, this episode can (and should) accommodate both philosophical and theological readings. Orwin, for example, associates it with Tolstoy's critique of Plato's allegory of the cave. Orwin, *Tolstoy's Art and Thought, 1847–1880* (Princeton, NJ: Princeton University Press, 1993), 128–29. And in a much different sense, Mandelker contrasts the "transcendent quality" of Andrei's vision with the flashing images Anna Karenina sees before her suicide. Mandelker, *Framing "Anna Karenina,"* 137.

33. Terry Castle, *The Female Thermometer: Eighteenth-Century Culture and the Invention of the Uncanny* (New York: Oxford University Press, 1995), 160.

34. Wellek, "The Concept of Realism," 241.

35. Maurice Samuels, *The Spectacular Past: Popular History and the Novel in Nineteenth-Century France* (Ithaca, NY: Cornell University Press, 2004), 262.

36. Although the fragile nature of Andrei's transcendent realizations are emphasized in this chapter, Seifrid is also correct in arguing that Andrei is able to recognize the falsity of the magic lantern images by acquiring an absolute "perspectival position." Seifrid, "Gazing on Life's Page," 441.

37. In relation to French realism, Harry Levin makes a similar argument, claiming that the novel acquires its claims to truth by imitating and exposing the falsity of preceding literary conventions: "Fiction approximates truth, not by concealing art, but by exposing artifice." With

Tolstoy, this process of disillusionment is inscribed into a polemic with specifically visual modes of representation. Levin, *The Gates of Horn: A Study of Five French Realists* (New York: Oxford University Press, 1963), 51.

38. Shklovsky, "Art as Technique," 15–17. Regarding Hélène, Tolstoy writes that she had "always looked like marble" to Pierre (9:251; 206).

39. This episode is juxtaposed with Kutuzov's later more genuine and touching moment with the Smolensk icon of the Mother of God (11:194–95; 763–64). Although it is tempting to read this contrast as the pairing of a "false" Western painting with a "truthful" religious icon, neither represents a particularly compelling visual alternative to Pierre's narrative experience of war.

40. L. N. Tolstoi to L. I. Volkonskaia, Iasnaia Poliana, 3 May 1865.

41. L. N. Tolstoi to M. S. Bashilov, Iasnaia Poliana, 8 December 1866.

42. Boris Eikhenbaum, *Molodoi Tolstoi* (St. Petersburg: Izdatel'stvo Z. I. Grzhebina, 1922), 34. The diary entry is dated 3 July 1851. Irina Paperno interprets Tolstoy's diary entries differently, less as a creative laboratory and more as an attempt to represent the self. Paperno, *"Who, What Am I?" Tolstoy Struggles to Narrate the Self* (Ithaca, NY: Cornell University Press, 2014), esp. 9–29.

43. Eikhenbaum, *Molodoi Tolstoi*, 41–42. The diary entry is dated 4 July 1851.

44. In a similar vein, N. N. Naumova writes that Tolstoy's descriptions "enter the story without notice, in the course of the action itself." Naumova, "Iskusstvo portreta v romane 'Voine i mire,'" in *Tolstoi-khudozhnik: Sbornik statei*, ed. D. D. Blagoi et al. (Moscow: Akademiia nauk SSSR, 1961), 135.

45. The portrait game has been discussed (and many of its playing cards reproduced) in *Iz parizhskogo arkhiva I. S. Turgeneva*, vol. 73.1 of *Literaturnoe nasledstvo*, ed. I. I. Anisimov et al. (Moscow: Nauka, 1964), 427–576. See also: A. Mazon, *Parizhskie rukopisi I. S. Turgeneva*, trans. Iu. Gan (Moscow: Akademiia, 1931), 203–31. For English translations of the surviving playing cards, see Marion Mainwaring, ed., *The Portrait Game* (New York: Horizon, 1973).

46. Mainwaring identifies the players as Marianne Viardot, Jeanne Fawtier, Turgenev, Claudie Viardot, Juliette (Marcel?), and Pauline Viardot. Mainwaring, *The Portrait Game*, 90–91. Mainwaring dates the card to 15 March 1864, although *Literaturnoe nasledstvo* includes it among the undated cards. A. N. Dubovikov considers it most likely that the card belongs to an earlier date, possibly March 1857. Dubovikov, "Eshche ob 'igre v portrety,'" in Anisimov, *Iz parizhskogo arkhiva*, 448.

47. I. N. Turgenev to V. P. Botkin, Paris, 25 October 1856. Turgenev, *PSS*, 3:24–25.

48. While Dubovikov considers it unlikely that the "great man" is a direct progenitor of Bazarov, he thinks that they may both have emerged from a common character type. He concludes that such similarities between the portraits of the portrait game and Turgenev's novelistic characters merit further investigation. Dubovikov, "Eshche ob 'igre v portrety,'" 448–49.

49. Henry James, "Ivan Turgenieff," in *The Novels and Stories of Ivan Turgenieff*, vol. 1, *Memoirs of a Sportsman I*, trans. Isabel F. Hapgood (New York: Charles Scribner's Sons, 1903), xxx.

50. For the beginning of *Fathers and Children*, see Turgenev, *PSS*, 8:195–98. The text of "Stepan Semyonovich Dubkov and My Conversations with Him" has been published in Turgenev, *PSS*, 13:315–17.

51. L. N. Tolstoi to L. I. Volkonskaia, Iasnaia Poliana, 3 May 1865, in Tolstoi, *PSS*, 61:80.

52. A. I. Gertsen [Herzen], *Sobranie sochinenii v tridtsati tomakh* [hereafter *SS*], 30 vols. (Moscow: Akademiia nauk SSSR, 1954–1965), 8:82.

53. For more on mnemonics, see Frances A. Yates's *The Art of Memory* (Chicago: University of Chicago Press, 1966); and Patrick H. Hutton, "The Art of Memory Reconceived: From Rhetoric to Psychoanalysis," *Journal of the History of Ideas* 48, no. 3 (1987): 371–92.

54. Gertsen, *SS*, 8:62.

55. Ibid., 5:81.

56. Ibid., 9:141–42.

57. A. S. Pushkin, *Polnoe sobranie sochinenii* [hereafter *PSS*], ed. A. M. Gor'kii et al., 17 vols. (Moscow: Akademiia nauk SSSR, 1937–1959), 3:378.

58. Tolstoy writes: "What exactly is *War and Peace*? It is not a novel, still less an epic [*poema*], and even less a historical chronicle" (16:7).

59. Making a different yet not unrelated point, Vladimir Nabokov locates the power of Tolstoy's realism not in his "vivid description," but in his ability to manipulate time so that "his characters seem to move with the same swing as the people passing under our window while we sit reading his book." Nabokov, *Lectures on Russian Literature*, 141–42. I am grateful to Marijeta Bozovic for suggesting this reference.

60. S. A. Bers, *Vospominaniia o Grafe L. N. Tolstom* (Smolensk: Tipo-Litografiia F. V. Zel'dovicha, 1893), 49–50. For a discussion of this trip, see E. E. Zaidenshnur, *"Voina i mir" L. N. Tolstogo: Sozdanie velikoi knigi* (Moscow: Izdatel'stvo Kniga, 1966), 121–22.

61. On descent as a "governing metaphor of Pierre's involvement at Borodino," see Jeff Love, *The Overcoming of History in "War and Peace"* (Amsterdam: Rodopi, 2004), 59.

62. Although photography is discussed at greater length in chapter 5, it is worth noting that the Crimean War was the first to be documented with a camera, most notably by the British photographer Roger Fenton. Given the limitations of the new technology and the photographers' desire to remain safely removed from the battles themselves, images like Fenton's can be considered just as "distant" as the landscape descriptions in "Sevastopol in December" and the diagrams and panoramas in *War and Peace*. For more on photography and the Crimean War, see John Hannavy, *The Camera Goes to War: Photographs from the Crimean War, 1854–56* (Edinburgh: Scottish Arts Council, 1974); Lawrence James, *Crimea 1854–56: The War with Russia from Contemporary Photographs* (Thame, England: Hayes Kennedy, 1981); and Ulrich Keller, *The Ultimate Spectacle: A Visual History of the Crimean War* (Amsterdam: Gordon and Breach, 2001).

63. Gustave Flaubert, *Madame Bovary: Contexts, Critical Reception*, 2nd ed., ed. Margaret Cohen, trans. Eleanor Marx Aveling and Paul de Man (New York: W. W. Norton, 2005), 207.

64. Barthes, "The Reality Effect," 14.

65. Ibid., 16.

66. Georg Lukács, "Narrate or Describe?" (1936), in *Writer and Critic and Other Essays*, ed. and trans. Arthur Kahn (London: Merlin, 1970), 110–48.

67. Alyson Tapp identifies a correlation between narrative movement and emotion in *Anna Karenina*. Tapp's argument provides further evidence for my claim that narrative is what delivers Pierre to (and from) this revelatory "feeling." Tapp, "Moving Stories: (E)motion and Narrative in *Anna Karenina*," *Russian Literature* 61, no. 3 (April 2007): 341–61.

68. Although I consider this multiperspectival aspect of Tolstoy's fiction to be an essential part of his realist aesthetic, some scholars have called him protomodernist or cinematic in his storytelling. See, for example, I. L. Andronikov, "Ob istoricheskikh kartinakh, o proze L'va Tolstogo i o kino," in *Izbrannye proizvedeniia*, 2 vols. (Moscow: Khudozhestvennaia literatura, 1975), 2:152–58.

Notes to Chapter Four

1. V. V. Chuiko, "Khudozhestvennye vystavki gg. Repina i Shishkina," *Nabliudatel'* 11, no. 2 (February 1892): 53.

2. Tolstaia, *Moia zhizn'*, 1:323.

3. T. L. Tolstaia to I. E. Repin, n.d., in Repin, *I. E. Repin i L. N. Tolstoi, I*, 123.

4. N. S. Leskov to I. E. Repin, 18 February 1889, cited in I. S. Zil'bershtein, "Kak sozdavalas' kartina 'Zaporozhtsy,'" in *Khudozhestvennoe nasledstvo: Repin*, ed. I. E. Grabar' and I. S. Zil'bershtein, 2 vols. (Moscow: Akademiia nauk SSSR, 1949), 2:68. Repin responds to Leskov's criticism by explaining that the "idea" of *Zaporozhian Cossacks* is the freedom and "noble spirit" of the Cossacks. I. E. Repin to N. S. Leskov, 19 February 1889. Ibid., 2:69.

5. Chuiko, "Khudozhestvennye vystavki," 60.

6. For more on the critical responses to this exhibition, see Galina Churak, "The Contemporary Reception of Ilia Repin's Solo Exhibition of 1891," in *From Realism to the Silver Age: New Studies in Russian Artistic Culture*, ed. Rosalind P. Blakesley and Margaret Samu (DeKalb: Northern Illinois University Press, 2014), 111–22.

7. Chuiko, "Khudozhestvennye vystavki," 53.

8. For an account of the 1880s as a transitional period for Repin and for realism, see Elizabeth Kridl Valkenier, *Ilya Repin and the World of Russian Art* (New York: Columbia University Press, 1990), 127–56.

9. I. E. Repin to E. P. Antokol'skii, Zdravnevo, 7 August 1894, in Repin, *Izbrannye pis'ma, 1867–1930*, ed. I. A. Brodskii, 2 vols. (Moscow: Iskusstvo, 1969), 2:74.

10. I. E. Repin, "Nikolai Nikolaevich Ge i nashi pretenzii iskusstvu" (1894), in Repin, *Dalekoe blizkoe*, 325. Grigory Sternin offers a brief review of realism's "literariness" in G. Iu. Sternin, *Dva veka, XIX–XX: Ocherki russkoi khudozhestvennoi kul'tury* (Moscow: Galart, 2007), 180–85.

11. A. N. Benua [Benois], *Russkaia shkola zhivopisi* (1904; repr., Moscow: Art-rodnik, 1997), 80.

12. Given that the Wanderers, in their over fifty years of existence (dissolving only in 1923), counted among their members a wide variety of artists with many different styles, it would be reductive to claim that Repin can stand in for the group as a whole. In this book, therefore, Repin is explored as just one example of an approach to realist painting during the 1870s and 1880s, in the hope that such a targeted analysis will inspire future and varied considerations of the realist aesthetics of the Wanderers. For a suitably cautious consideration of Repin as representative of the dominant themes and styles of the Wanderers, see D. V. Sarab'ianov, "Repin i russkaia zhivopis'

vtoroi poloviny XIX veka," in *Iz istorii russkogo iskusstva vtoroi poloviny XIX–nachala XX veka: Sbornik issledovanii i publikatsii,* ed. E. A. Borisova, G. G. Pospelov, and G. Iu. Sternin (Moscow: Iskusstvo, 1978), 7–17.

13. Nina Dmitrieva makes a passing, yet forceful, appeal for scholars to reconsider the supposed "literariness" of the Wanderers' painting (using Repin's *They Did Not Expect Him* as an example), writing that such paintings might be narrative, but that "in them plot is resolved in complete accordance with the laws of visual art." Dmitrieva, *Izobrazhenie i slovo,* 102.

14. V. V. Stasov, "O znachenii Briullova i Ivanova v russkom iskusstve" (1861), in Stasov, *Izbrannye sochineniia,* 1:45.

15. V. V. Stasov, "Akademicheskaia vystavka 1863 goda," 1:117–8.

16. I. I. Dmitriev, "Rassharkivaiushcheesia iskustvo," 510.

17. Evgeny Steiner even challenges the long presumed independence of the Wanderers from the Academy in "Pursuing Independence: Kramskoi and the Peredvizhniki vs. the Academy of Arts," *Russian Review* 70 (April 2011): 252–71.

18. The definitive institutional history of the Wanderers remains Valkenier's *Russian Realist Art.* On the formation of the Wanderers, especially in relation to developments in the 1860s, see pp. 37–43; and Elizabeth Kridl Valkenier, "The Peredvizhniki and the Spirit of the 1860s," *Russian Review* 34, no. 3 (July 1975): 247–65. See also: F. S. Roginskaia, *Tovarishchestvo peredvizhnykh khudozhestvennykh vystavok: Istoricheskie ocherki* (Moscow: Iskusstvo, 1989), esp. 5–27; and Jackson, *The Wanderers,* 21–33. Primary sources have been translated and collected in Elizabeth Kridl Valkenier and Wendy Salmond, "Russian Realist Painting: The Peredvizhniki; An Anthology," *Experiment/Eksperiment: A Journal of Russian Culture* 14, no. 1 (2008): ix–xii.

19. Valkenier, *Russian Realist Art,* 39.

20. A group of Moscow artists to the St. Petersburg Artel of artists, Moscow, 23 November 1869, in *Tovarishchestvo peredvizhnykh khudozhestvennykh vystavok, 1869–1899: Pis'ma, dokumenty,* ed. S. N. Gol'dshtein (Moscow: Iskusstvo, 1987), 1:53.

21. "Proekt ustava Tovarishchestva peredvizhnykh khudozhestvennykh vystavok" (1870), ibid., 1:55.

22. For more on the influence of Stasov and Kramskoy on one another, and their collective impact on Russian art criticism, see R. S. Kaufman, *Ocherki istorii russkoi khudozhestvennoi kritiki XIX veka* (Moscow: Iskusstvo, 1985), 112–56.

23. Such a consideration of the intersection of critical discourse and Repin's realist aesthetic has been influenced by the work of Richard Taruskin. See, for example, his "Realism as Practiced and Preached: The Russian Opera Dialogue," *Music Quarterly* 56, no. 3 (July 1970): 431–54; and *Opera and Drama in Russia as Preached and Practiced in the 1860s* (Ann Arbor, MI: UMI Research Press, 1981).

24. A brief survey of the critical reception to *Barge Haulers* can be found in Bespalova and Vereshchagina, *Russkaia progressivnaia khudozhestvennaia kritika,* 95–107.

25. V. V. Stasov, "Kartina Repina 'Burlaki na Volge'" (1873), in Stasov, *Izbrannye sochineniia,* 1:241.

26. N. K. Mikhailovskii, "Na venskoi vsemirnoi vystavke" (1873), in Mikhailovskii, *Polnoe sobranie sochinenii,* 8 vols. (St. Petersburg: Tip. N. K. Klobukova, 1906–1914), 2:518.

27. Avseenko calls this the "anti-artistic tendency" (*antikhudozhestvennoe napravlenie*) in painting. V. G. Avseenko, "Nuzhna li nam literatura?," in *Russkii vestnik* 5 (May 1873), 394.

28. F. M. Dostoevskii, "Po povodu vystavki" (1873), in Dostoevskii, *PSS,* 21:74.

29. Ibid.

30. Valkenier and Jackson both discuss the Parisian period as critical for Repin's aesthetic formation. See Valkenier, *Ilya Repin,* 45–68; Jackson, "Western Art and Russian Ethics: Repin in Paris, 1873–76," *Russian Review* 57, no. 3 (July 1998): 394–409; and Jackson, *The Russian Vision: The Art of Ilya Repin* (Schoten, Belgium: BAI, 2006), 42–74.

31. I. E. Repin to I. N. Kramskoi, Paris, 16 October 1874, in Repin, *Izbrannye pis'ma,* 1:143.

32. I. N. Kramskoi to I. E. Repin, St. Petersburg, 23 February 1874, in I. N. Kramskoi, *Pis'ma,* 2 vols. (Moscow: OGIZ-IZOGIZ, 1937), 1:239.

33. Ibid., 2:240.

34. V. V. Stasov, "Nashi itogi," 1:374.

35. P. D. Boborykin, "Literaturnoe napravlenie v zhivopisi (Progulka po shestoi peredvizhnoi vystavke)," *Slovo* (July 1878), 56. Stasov polemicizes with this and a second article by Boborykin from the same volume of *Slovo,* "Likuiushchii gorod," in his "Drug russkogo iskusstva (Pis'mo k redaktoru 'Novogo vremeni')" (1878), in *Izbrannye sochineniia,* 1:311–12.

36. Michael Fried traces a similar interart tension between painting and writing in the work of Thomas Eakins, for example, but without the larger professional and national implications that

accompany Repin's realist painting. Fried, *Realism, Writing, Disfiguration: On Thomas Eakins and Stephen Crane* (Chicago: University of Chicago Press, 1987), esp. 42–89.

37. Repin, *Dalekoe blizkoe*, 225. Repin's reminiscences of the barge haulers and his research for the painting were originally published as "Iz vremen vozniknoveniia moei kartiny 'Burlaki na Volge'" in *Golos minuvshego*, nos. 1, 3, and 6 (1915).

38. Repin, *Dalekoe blizkoe*, 225.

39. A. I. Leonov reconstructs several key dates and places of Repin's 1870 itinerary in *Burlaki na Volge: Kartina I. E. Repina* (Moscow: Iskusstvo, 1945), 9–23.

40. V. V. Stasov, "Peredvizhnaia vystavka 1871 goda" (1871), in Stasov, *Izbrannye sochineniia*, 1:204.

41. Stasov, "Kartina Repina," 1:139. Two years later, Stasov wrote that Repin "was drawn to plunge into the very middle of people's lives." Stasov, "Il'ia Efimovich Repin" (1875), *Izbrannye sochineniia*, 1:265.

42. Avseenko mentions Nekrasov's poetry and Fyodor Reshetnikov's prose as possible sources in "Nuzhna li nam literatura?," 395. In a helpful survey of the barge hauler in Russian painting, Elena Nesterova places Repin in a broader artistic context that also includes Orest Kiprensky, Vasily Vereshchagin, and Aleksei Savrasov. Nesterova, "Tema burlakov v russkoi zhivopisi 1860–1870 godov," in *Il'ia Efimovich Repin: K 150-letiiu so dnia rozhdeniia; Sbornik statei*, ed. E. N. Petrova et al. (St. Petersburg: Palace Editions, 1995), 57–65.

43. Repin, *Dalekoe blizkoe*, 274.

44. Stasov, "Nyneshnee iskusstvo v Evrope: Khudozhestvennye zametki o vsemirnoi vystavke (1873 goda) v Vene" (1874), in Stasov, *Izbrannye sochineniia*, 1:91–92.

45. For an overview of the landscape painting of the Wanderers, see Jackson, *The Wanderers*, 119–32. Christopher Ely offers a more detailed interpretation of the ideological challenges of landscape painting in *This Meager Nature*, esp. 167–73. Ely has also discussed the search for picturesque Russian landscapes, especially in connection with the tourism industry, in "The Origins of Russian Scenery: Volga River Tourism and Russian Landscape Aesthetics," *Slavic Review* 62, no. 4 (Winter 2003): 666–82.

46. F. N. Rodin, *Burlachestvo v Rossii: Istoriko-sotsiologicheskii ocherk* (Moscow: Mysl', 1975), 174.

47. A. Ledakov, *Sankt-Peterburgskie vedomosti*, no. 59 (1880), cited in V. V. Stasov, "Tormozy novogo russkogo iskusstva" (1885), in Stasov, *Izbrannye sochineniia*, 2:615.

48. Repin, *Dalekoe blizkoe*, 276. Repin and Vasilyev would act out miniature epic battles for fun; drawing out these classical associations, Repin even calls *Barge Haulers* a "barge hauler epic" (*burlatskaia epopeia*), and variously associates Kanin, the leader of the work crew, with a Roman philosopher, a saint, a Scythian statue, and Leo Tolstoy plowing his fields. Ibid., 277, 273–74. Perhaps picking up on these historical layers, art historian Aleksei Fyodorov-Davydov notes an "epic breath" in the picture. A. A. Fedorov-Davydov, *Il'ia Efimovich Repin* (Moscow: Iskusstvo, 1961), 21.

49. Sarabianov considers these works by Repin and Savitsky an essential intermediary stage in the development in Russian painting of the theme of the people as a progressive force. Sarab'ianov, *Narodno-osvoboditel'nye idei russkoi zhivopisi vtoroi poloviny XIX veka* (Moscow: Iskusstvo, 1955), 134.

50. Reporting on the Russian contribution to the 1878 World's Fair in Paris, Stasov quotes the French critic Paul Manz as saying that Pierre-Joseph Proudhon himself, who had been moved by Courbet's *The Stonebreakers*, would have been even more taken with Repin's *Barge Haulers*. Stasov, "Nashi itogi," 1:344. In what can only amount to an amusing overstatement, Igor Grabar claims that he was impressed by Repin's technical mastery compared with the "backwardness" of Courbet's *The Stonebreakers*. I. E. Grabar', *Repin: Monografiia*, 2 vols. (Moscow: Akademiia nauk SSSR, 1963), 1:108–9.

51. T. J. Clark, *Image of the People: Gustave Courbet and the 1848 Revolution* (1973; repr., Berkeley: University of California Press, 1999), 116. For his analysis of *The Stonebreakers*, see 79–80.

52. Repin remarks on his identity as a *muzhik* in a letter to Stasov. I. E. Repin to V. V. Stasov, 3 June 1872, in Repin, *Izbrannye pis'ma*, 1:41.

53. Discussing the social distance between the artists and their subjects, Repin recalls hearing the locals say that the artists were messengers of the Antichrist. He adds that mothers would not allow their children to sit for the artists and that only the bravest of locals would do so themselves, even when promised payment. I. E. Repin to P. V. Alabin, 26 January 1895, ibid., 2:90–94.

54. Fried, *Menzel's Realism*, 13.

55. Ibid., 139.

56. Sarabianov also makes use of the productive triangulation of Repin with Courbet and Menzel in what amounts to one of the few serious comparisons of Repin with parallel realist

traditions in Western Europe in Soviet-era scholarship. Sarab'ianov, *Russkaia zhivopis' XIX veka*, esp. 125–40.

57. The relation between the painting's formal peculiarities and its unique creative history is discussed in greater detail in Molly Brunson, "Wandering Greeks: How Repin Discovers the People," *Ab Imperio: Studies of New Imperial History and Nationalism in the Post-Soviet Space* 2 (2012): 83–111.

58. Repin, *Dalekoe blizkoe*, 241.

59. For a review of the contents of this sketchbook, see O. A. Liaskovskaia and F. S. Mal'tseva, "Al'bom I. E. Repin i F. A. Vasil'eva v gosudarstvennoi tret'iakovskoi galeree," in Butorina, *Gosudarstvennaia tret'iakovskaia galereia*, 1:176.

60. Repin, *Dalekoe blizkoe*, 263.

61. Irina Paperno outlines this dimension of Chernyshevsky's realist aesthetics in *Chernyshevsky*.

62. Chernyshevskii, *PSS*, 11:200.

63. Stasov, "Il'ia Efimovich Repin," 1:265.

64. Nina Lübbren uses similar terminology, identifying "landscapes of immersion, in which "two principles—multi-sensual immersion and visual formalism—were held in productive tension." Such a tension is also evident in Repin's painting, although, its "visual formalism" is not a harbinger of modernism. Lübbren, *Rural Artists' Colonies in Europe, 1870–1910* (Manchester: Manchester University Press, 2001), 111.

65. Sarabianov compares European history painting with that of the Wanderers (namely, of Surikov) in *Russkaia zhivopis' XIX veka*, 141–65. For general background on history painting in Russia, see A. G. Vereshchagina, *Khudozhnik, vremia, istoriia: Ocherki russkoi istoricheskoi zhivopisi XVIII–nachala XX veka* (Moscow: Iskusstvo, 1973); M. Rakova, *Russkaia istoricheskaia zhivopis' serediny deviatnadtsatogo veka* (Moscow: Iskusstvo, 1979); and A. G. Vereshchagina, *Istoricheskaia kartina v russkom iskusstve: Shestidesiatye gody XIX veka* (Moscow: Iskusstvo, 1990).

66. For more on Repin's history painting, see Valkenier, *Ilya Repin*, 87–89; and Jackson, *The Russian Vision*, 75–101.

67. V. V. Stasov, "Khudozhestvennye vystavki 1879 goda" (1879), in Stasov, *Izbrannye sochineniia*, 2:24.

68. I. E. Repin to V. V. Stasov, Moscow, 2 January 1881, in *I. E. Repin i V. V. Stasov: Perepiska*, ed. A. K. Lebedev and G. K. Burovaia, 3 vols. (Moscow: Iskusstvo, 1948–1950), 2:58–59.

69. Repin's comments come from an undated document in the Nauchno-bibliograficheskii arkhiv akademii khudozhestv (the Scientific-Bibliographic Archive of the Academy of Arts), and are cited in Repin, *Il'ia Repin: Zhivopis', Grafika*, ed. N. E. Vatenina et al. (Leningrad: Avrora, 1985), 238.

70. Repin was not the only nineteenth-century artist to take up the subject of Ivan the Terrible; Vyacheslav Shvarts's *Ivan the Terrible beside the Body of His Son* (1864), Mark Antokolsky's sculpture of Ivan (1870), and Viktor Vasnetsov's painting *Tsar Ivan the Terrible* (1897) are also important to note. With the twentieth century came a renewed interest in the tsar, the most discussed example of which is Sergei Eisenstein's uncompleted film trilogy *Ivan the Terrible* (1944, 1958). For more on the image of Ivan the Terrible in Russian and Soviet culture, see Maureen Perrie, *The Image of Ivan the Terrible in Russian Folklore* (Cambridge: Cambridge University Press, 1987); Maureen Perrie, *The Cult of Ivan the Terrible in Stalin's Russia* (Houndmills, England: Palgrave, 2001), esp. 5–21; David Brandenberger and Kevin M. F. Platt, "Terribly Pragmatic: Rewriting the History of Ivan IV's Reign, 1937–1956," in *Epic Revisionism: Russian History and Literature as Stalinist Propaganda*, ed. Kevin M. F. Platt and David Brandenberger (Madison: University of Wisconsin Press, 2006), 157–78; Kevin M. F. Platt, *Terror and Greatness: Ivan and Peter as Myths* (Ithaca, NY: Cornell University Press, 2011); and N. N. Mut'ia, *Ivan Groznyi: Istorizm i lichnost' pravitelia v otechestvennom iskusstve XIX–XX vv.* (St. Petersburg: Aleteiia, 2010).

71. In her study of the many artistic transformations of the Boris Godunov story, Caryl Emerson has shown this tendency to "transpose" a historical episode into the contemporary moment to be a standard reflex in Russian cultural history. Emerson, *Boris Godunov: Transpositions of a Russian Theme* (Bloomington: Indiana University Press, 1986).

72. Konstantin Pobedonostsev to Alexander III, 15 February 1885, in Pobedonostsev, *K. P. Pobedonostsev i ego korrespondenty: Pis'ma i zapiski*, 2 vols. (Moscow: Gosudarstvennoe izdatel'stvo, 1923), 1:498.

73. After the removal of *Ivan the Terrible and His Son Ivan*, the censor released a document requesting that no positive reviews be written about the painting. The ban on exhibiting *Ivan the Terrible* was lifted in July 1885. Valkenier, *Ilya Repin*, 122, 217.

74. Perrie identifies a similar tendency toward "historical analogy" in twentieth-century references to Ivan the Terrible. Perrie, *The Cult of Ivan the Terrible*, 3.

75. Lessing, *Laocoön*, 78.

76. Ibid., 19.

77. Peter Brooks, *History Painting and Narrative: Delacroix's "Moments"* (Oxford: Legenda, 1998), 30.

78. This dual focus on the historical and the human is apparent even in the choice of title; Repin had planned to name the painting *Filicide*, only later switching to the longer and more historically grounded version. Repin was also likely influenced by Nikolai Karamzin's *History of the Russian State* (1814–1824), in which Karamzin describes Ivan at his son's burial as "stripped of all signs of the imperial mantle, in a mourning robe, in the guise of a simple, despairing sinner." N. M. Karamzin, *Istoriia gosudarstva rossiiskogo*, 3rd ed., 12 vols. (St. Petersburg: Tip. Aleksandra Smirdina, 1830–1831), 9:386–87. The embrace of the father and son also brings to mind Michelangelo's *Pietà*, as well as Rembrandt's *David and Jonathan* and *The Return of the Prodigal Son*, both housed at the Hermitage in St. Petersburg. These connections are discussed in: Valkenier, *Ilya Repin*, 121–23; and Platt, *Terror and Greatness*, 115–19.

79. I. N. Kramskoi to A. S. Suvorin, 21 January 1885, in Kramskoi, *Pis'ma*, 2:323.

80. Ibid., 2:324.

81. A. Landtsert, "Ioann Groznyi i ego syn 16 noiabria 1581 g.," excerpted in Maksimilian Voloshin, *O Repine* (1914), in Voloshin, *Sobranie sochinenii*, ed. V. P. Kupchenko and A. V. Lavrov, 13 vols. (Moscow: Ellis Lak, 2003–2013), 3:356–62.

82. V. I. Mikheev, "I. E. Repin" (1893), cited in O. A. Liaskovskaia, *Il'ia Efimovich Repin* (Moscow: Iskusstvo, 1962), 180.

83. Repin's daughter Vera writes of her father's preparatory research for *Ivan the Terrible* in the unpublished manuscript of her memoir, which is cited in O. A. Liaskovskaia, "K istorii sozdaniia kartiny I. E. Repina 'Ivan Groznyi i syn ego Ivan 16 noiabria 1581 goda,'" in Butorina, *Gosudarstvennaia tret'iakovskaia galereia*, 1:191.

84. For more on Repin's research for *The Zaporozhian Cossacks*, including Yavornitsky's reminiscences of Repin, see Zil'bershtein, "Kak sozdavalas' kartina 'Zaporozhtsy,'" 2:57–106.

85. D. I. Iavornitskii, *Zaporozh'e v ostatkakh stariny i predaniiakh naroda*, 2 vols. (St. Petersburg: Izdanie L. F. Panteleeva, 1888). Repin's illustrations all appear in the second volume.

86. Benua, *Istoriia russkoi zhivopisi*, 73.

87. Repin, *Dalekoe blizkoe*, 223.

88. Ibid., 222.

89. Ibid., 263.

90. Fried, *Courbet's Realism*, 148. My subsequent interpretation of Ivan the Terrible's hand as the paint-covered hand of the artist has been influenced not only by Fried's concept of a "real allegory" generally, but also by his analysis of Eakins's *The Gross Clinic*, in which he claims that the bloody hand at the center of the composition epitomizes, in his words, realism's "tactics of shock." Fried, *Realism, Writing*, 64–65.

91. The personal and creative aspects of Repin and Garshin's relationship have been discussed in: Durylin, *Repin i Garshin*; Leland Fetzer, "Art and Assassination: Garshin's 'Nadezhda Nikolaevna,'" *Russian Review* 34, no. 1 (January 1975): 55–65; and Elizabeth Kridl Valkenier, "The Writer as Artist's Model: Repin's Portrait of Garshin," *Metropolitan Museum Journal* 28 (1993): 207–16.

92. This argument is further discussed in Molly Brunson, "Painting History, Realistically: Murder at the Tretiakov," in Blakesley and Samu, *From Realism to the Silver Age*, 94–110.

93. The political appropriation of Repin's art has been discussed by Valkenier in her article, "Politics in Russian Art: The Case of Repin," *Russian Review* 37, no. 1 (January 1978): 14–29.

94. Documented in photographs, courtesy of Aglaya Glebova and Max de la Bruyère.

95. In this case, the barge haulers haul a wardrobe on the side of a furniture store truck. Documented in a photograph, courtesy of Vladimir Alexandrov.

Notes to Chapter Five

1. F. M. Dostoevskii to A. N. Maikov, Geneva, 31 December 1867, in Dostoevskii, *PSS*, 28.2:240–41.

2. Not long after making these comments, Dostoevsky's infant daughter Sonya died of pneumonia, prompting the author to cry out in grief that he "would accept crucifixion if only she were alive." One cannot help but think that some of the desperation to "save" or "resurrect" Nastasya Filippovna stems from this personal tragedy. F. M. Dostoevskii to A. N. Maikov, Geneva, 18 May 1868 (28.2:297).

3. F. M. Dostoevskii to S. A. Ivanova, Geneva, 1 January 1868.

4. F. M. Dostoevskii to A. N. Maikov, Florence, 11 December 1868.

5. In the notebooks for *Diary of a Writer* (1881), Dostoevsky writes: "They call me a psychologist. This is not true. I am a realist in a higher sense, that is, I represent the entire depth of the human soul" (27:65). Joseph Frank discusses the formation of Dostoevsky's conception of "fantastic realism" in relation to *The Idiot* in *Dostoevsky: The Miraculous Years, 1865–1871* (Princeton, NJ: Princeton University Press, 1995), 301–2 and 308–9. On the "fantastic realism" of Dostoevsky's earlier works, see Frank's article, "Dostoevsky's Discovery of 'Fantastic Realism,'" *Russian Review* 27, no. 3 (July 1968): 286–95.

6. Robert Louis Jackson, *Dostoevsky's Quest for Form: A Study of His Philosophy of Art* (New Haven, CT: Yale University Press, 1966), 3–4. On *obraz* and *bezobrazie*, in particular, see pp. 40–70.

7. Caryl Emerson, "Word and Image in Dostoevsky's Worlds: Robert Louis Jackson on Readings That Bakhtin Could Not Do," in *Freedom and Responsibility in Russian Literature: Essays in Honor of Robert Louis Jackson*, ed. Elizabeth Cheresh Allen and Gary Saul Morson (Evanston, IL: Northwestern University Press, 1995), 264–65.

8. Relatedly, Konstantin Barsht argues that Dostoevsky's drawings serve as a medium through which the author transformed and purified his initial ideas. Barsht, "Defining the Face: Observations on Dostoevskii's Creative Processes," in Kelly and Lovell, *Russian Literature*, 53. For more on Dostoevsky's drawings for *The Idiot* as well as for his other novels, see Barsht, *Risunki v rukopisiakh Dostoevskogo* (St. Petersburg: Formika, 1996).

9. See, for example, Tatiana Goerner, "The Theme of Art and Aesthetics in Dostoevsky's *The Idiot*," *Ulbandus Review* 2, no. 2 (Fall 1982): 79–85. On Dostoevsky and the visual arts, more generally, see Jackson, *Dostoevsky's Quest for Form*, 213–30; and Robert Belknap, "On Dostoevsky and the Visual Arts," in Greenfield, *Depictions*, 58–60.

10. An illuminating discussion of the Grand Tour and *The Idiot* can be found in: Stiliana Vladimirova Milkova, "*Sightseeing: Writing Vision in Slavic Travel Narratives*" (PhD diss., University of California, Berkeley, 2007), 82–149.

11. In her diary from 1867, Anna Dostoevskaya describes at length their visit to the Basel art museum, writing that she did not even want to remain in the same room with Holbein's *Dead Christ*, because it "looked like an actual corpse." She describes Dostoevsky, on the other hand, as enthralled, even crawling onto a chair to get a closer look. A. G. Dostoevskaia, *Dnevnik 1867 goda* (Moscow: Nauka, 1993), 234. For a later account of the episode, in which Anna recalls fearing that the painting would provoke an epileptic fit in her husband, see Dostoevskaia, *Vospominaniia A. G. Dostoevskoi*, ed. L. P. Grossman (Moscow: Gosudarstvennoe izdatel'stvo, 1925), 112.

12. On Dostoevsky's spiritual "vision" (distinct from the aspects of visual culture and the visual arts discussed in this chapter), see A. B. Krinitsyn, "O spetsifike vizual'nogo mira u Dostoevskogo i semantike 'videnii' v romane 'Idiot,'" in *Roman F. M. Dostoevskogo "Idiot": Sovremennoe sostoianie izucheniia*, ed. T. A. Kasatkina (Moscow: Nasledie, 2001), 170–205.

13. Translations are from Fyodor Dostoevsky, *The Idiot*, trans. Richard Pevear and Larissa Volokhonsky (New York: Vintage, 2001).

14. The gradual introduction of Nastasya Filippovna into the novel is discussed in Zinaida Malenko and James J. Gebhard, "The Artistic Use of Portraits in Dostoevskij's *Idiot*," *Slavic and East European Journal* 5, no. 3 (Autumn 1961): 243.

15. This discussion of Nastasya Filippovna as a visual object subject to the male gaze, yet also turning her gaze onto men, has been informed by feminist film criticism and theories of the gaze. See, for example, Laura Mulvey's classic essay, "Visual Pleasure and Narrative Cinema," in *The Sexual Subject: A "Screen" Reader in Sexuality*, ed. Mandy Merck (New York: Routledge, 1992), 22–34; as well as, Mary Ann Doane, "Film and the Masquerade: Theorising the Female Spectator," *Screen* 23, nos. 3–4 (September–October 1982): 74–87; and Linda Williams, "When the Woman Looks," in *Re-Vision: Essays in Feminist Film Criticism*, ed. Mary Ann Doane, Patricia Mellencamp, and Linda Williams (Frederick, MD: University Publications of America, 1984), 83–99.

16. Mitchell, *Picture Theory*, 172. For additional perspectives on the relation between the Medusa myth and ekphrasis, see Grant F. Scott, "Shelley, Medusa, and the Perils of Ekphrasis," in *The Romantic Imagination: Literature and Art in England and Germany*, ed. Frederick Burwick and Jürgen Klein (Amsterdam: Rodopi, 1996), 315–32; and Sophie Thomas, "Ekphrasis and Terror: Shelley, Medusa, and the Phantasmagoria," in *Illustrations, Optics, and Objects in Nineteenth-Century Literary and Visual Culture*, ed. Luisa Calè and Patrizia di Bello (New York: Palgrave Macmillan, 2010), 25–43.

17. Tat'iana Kasatkina offers an alternative reading of the pin as a symbol of power over women. Kasatkina, "Rol' khudozhestvennoi detali i osobennosti funktsionirovaniia slova v romane Dostoevskogo 'Idiot,'" in Kasatkina, *Roman F. M. Dostoevskogo*, 63.

18. Robin Feuer Miller, *Dostoevsky and "The Idiot": Author, Narrator, and Reader* (Cambridge, MA: Harvard University Press, 1981), 104–5.

19. Ibid., 230.

20. D. K. Zelenin, *Izbrannye trudy: Ocherki russkoi mifologii; Umershie neestestvennoiu smert'iu i rusalki* (Moscow: Indrik, 1995), 39–40.

21. Olga Matich, "What's to Be Done about Poor Nastja: Nastas'ja Filippovna's Literary Prototypes," *Wiener slawistischer Almanach* 19 (1987): 55. Matich refers to the moment toward the end of part 1, when Nastasya Filippovna explains the suicidal impact Totsky's behavior has had upon her (8:144; 171).

22. Ibid., 59.

23. See, for example, Tom Gunning's discussion of these two functions of early photography, and its related visual technologies, in his article, "Invisible Worlds, Visible Media," in *Brought to Light: Photography and the Invisible, 1840–1900,* ed. Corey Keller (San Francisco, CA: San Francisco Museum of Art in association with Yale University Press, 2008), 51–63. Clément Chéroux considers a version of this dialectic—between, in his case, mystification and demystification—as it relates to spirit photography in the 1860s, in "Ghost Dialectics: Spirit Photography in Entertainment and Belief," in *The Perfect Medium: Photography and the Occult,* ed. Clément Chéroux et al. (New Haven, CT: Yale University Press, 2005), 45–55.

24. Gunning, "Invisible Worlds, Visible Media," 53.

25. The impact of photography on nineteenth-century literature, and realism especially, has garnered quite a bit of scholarly attention. See, for example, Jennifer Green-Lewis, *Framing the Victorians: Photography and the Culture of Realism* (Ithaca, NY: Cornell University Press, 1996); Nancy Armstrong, *Fiction in the Age of Photography: The Legacy of British Realism* (Cambridge, MA: Harvard University Press, 1999); Daniel A. Novak, *Realism, Photography, and Nineteenth-Century Fiction* (Cambridge: Cambridge University Press, 2008). The Russian case, specifically, is addressed in Stephen Hutchings, *Russian Literary Culture in the Camera Age: The Word as Image* (London: RoutledgeCurzon, 2004).

26. For a useful history of Russian photography, see David Elliott, ed., *Photography in Russia, 1840–1940* (London: Thames and Hudson, 1992).

27. "Otkrytie Dagera," *Khudozhestvennaia gazeta,* no. 2 (15 January 1840). Cited in Elena Barkhatova, "The First Photographs in Russia," in Elliott, *Photography in Russia,* 26.

28. V. G. Belinskii, "Tipy sovremennykh nravov (retsenziia)" (1845), in Belinskii, *PSS,* 9:56. Belinsky continues to use the daguerreotype as an image that represents substandard description. Writing a year later, in 1846, Belinsky concludes that "Butkov does not have the talent for a novel or a novella," and would do well to stick with "daguerreotypical stories and sketches." Belinskii, "Vzgliad na russkuiu literaturu 1846 goda," 10:39.

29. I. S. Turgenev, "*Faust* (retsenziia)" (1845), in Turgenev, *PSS,* 1:249.

30. Turgenev, *PSS,* 8:229.

31. In a passing reference to Fenechka's photograph, Russell S. Valentino rightly argues that "the artificiality of the medium clearly does not accord with the unsophisticated purity of the subject." Valentino, "A Wolf in Arcadia," 480.

32. Turgenev, *PSS,* 8:230.

33. Before seeing it in Basel, Dostoevsky likely knew of Holbein's painting from Nikolai Karamzin's *Letters of a Russian Traveler* (1791–1792), in which Karamzin writes, "In Christ [. . .] nothing sacred is visible. Rather, the dead man is portrayed completely naturally." See N. M. Karamzin, *Izbrannye sochineniia v dvukh tomakh,* 2 vols. (Moscow: Khudozhestvennaia literatura, 1964), 1:208–9. The scholarship on Holbein's painting in *The Idiot* is vast. In addition to the works cited elsewhere in this chapter, see, for example: Jeffrey Meyers, *Painting and the Novel* (Manchester: Manchester University Press, 1975), 136–47; István Molnár, "'One's Faith Could Be Smashed by Such a Picture': Interrelation of Word and Image (Icon) in Dostoevsky's Fiction; Holbein's 'Christ in the Tomb' in the Ideological and Compositional Structure of 'The Idiot,'" *Acta Litteraria Academiae Scientiarum Hungaricae* 32, nos. 3–4 (1990): 245–58; Olga Meerson, "Ivolgin and Holbein: Non-Christ Risen vs. Christ Non-Risen," *Slavic and East European Journal* 39, no. 2 (Summer 1995): 200–213; Sarah J. Young, "Holbein's Christ in the Tomb in the Structure of *The Idiot,*" *Russian Studies in Literature* 44, no. 1 (Winter 2007): 90–102; B. N. Tikhomirov, "Dostoevskii i 'Mertvyi Khristos' Gansa Gol'beina Mladshego," in *Sub specie tolerantiae: Pamiati V. A. Tunimanova,* ed. A. G. Grodetskaia (St. Petersburg: Nauka, 2008), 207–17; Tat'iana Kasatkina, "After Seeing the Original: Hans Holbein the Younger's *Body of the Dead Christ in the Tomb* in the Structure of Dostoevsky's *Idiot,*" *Russian Studies in Literature* 47, no. 3 (Summer 2011): 73–97.

34. Jefferson Gatrall makes a similar argument in "Between Iconoclasm and Silence: Representing the Divine in Holbein and Dostoevskii," *Comparative Literature* 53, no. 3 (Summer 2001): 218–19. Relatedly, Cristina Farronato argues that this "broken narrative" is not just a Dostoevskian invention, but is an essential part of Holbein's picture. Farronato, "Holbein's 'Dead Christ' and the Horror of the Broken Narrative," *Interdisciplinary Journal for Germanic Linguistics and Semiotic Analysis* 3, no. 1 (Spring 1998): 121–40.

35. In his article "The Exhibition at the Academy of Arts, 1860–1861," Dostoevsky likens Valery Yakobi's painting *The Halt of the Convicts*, in its impression on the viewer, to that of a "disgusting reptile" or something "dangerous and scorpion-like" (19:152). Not only does this imagery, repeated later in *The Idiot*, provide further evidence that Dostoevsky is, in fact, the author of this review (see note 38), but it also strengthens the network of images that link painting, insects and creatures, and the trauma of excessive or photographic realism in Dostoevsky's poetics.

36. Thomas Barran argues this point in "'The Window Closes: The Disappearance of Icons from Dostoevsky's 'Idiot,'" in Greenfield, *Depictions*, 32–43. For the role of iconography in Dostoevsky's work more generally, see V. Lepakhin, "Ikona v tvorchestve Dostoevskogo ('Brat'ia Karamazovy,' 'Krotkaia,' 'Besy,' 'Podrostok,' 'Idiot')," in *Dostoevskii: Materialy i issledovaniia* (St. Petersburg: Nauka, 2000), 15:237–63; and Jefferson J. A. Gatrall, "The Icon in the Picture: Reframing the Question of Dostoevsky's Modernist Iconography," *Slavic and East European Journal* 48, no. 1 (2004): 1–25.

37. Andrew Wachtel, "Dostoevsky's *The Idiot*: The Novel as Photograph," *History of Photography* 26, no. 3 (Autumn 2002): 213. Unlike Wachtel, Hutchings makes an argument closer to the one presented in this chapter, writing that "Dostoevsky's ambiguity toward the photographic image reflects its dual status as a mechanistic copy, and yet as a magical imprint of the real, which places it in the same paradigm as the icon and as Christ himself." Hutchings, *Russian Literary Culture*, 26.

38. Because it was published anonymously, the authorship of the second text has been disputed. In accepting Dostoevsky as author, I follow the reasoning offered by Jackson and others. See, for example, Jackson, *Dostoevsky's Quest for Form*, 231–32.

39. Manet's painting was exhibited in Russia with the title *Nymph and Satyr*, presumably because there was once the face of a voyeuristic satyr in the upper right corner of the canvas. Rosalind Blakesley discusses the Russian critical response to this work in "Emile Zola's Art Criticism in Russia," in *Critical Exchange: Art Criticism of the Eighteenth and Nineteenth Centuries in Russia and Western Europe*, ed. Carol Adlam and Juliet Simpson (Oxford: Peter Lang, 2009), 273–74.

40. As part of his argument that Dostoevsky's artistic truth is inextricably tied to the creation of form, Jackson points out that Dostoevsky uses the word *bezobrazie*, "ugliness" or literally "formlessness," to critique Manet's nymph. Jackson, *Dostoevsky's Quest for Form*, 46.

41. Ibid., 65–66. Here and elsewhere, this chapter's argument concerning the interart and historical dimensions of Dostoevsky's aesthetics is meant to complement what Jackson describes as Dostoevsky's Platonic and Christian approach to form.

42. Lessing, *Laocoön*, 128.

43. Danilevskii, *G. E. Lessing*, 84–85.

44. Dostoevsky suggests that this "something else" might be related to the mediation of artistic subjectivity; unlike in a mirror, in a painting or an equivalent work of art, the artist himself will inevitably be visible in some way (19:153). For a discussion of this point, see Jackson, *Dostoevsky's Quest for Form*, 73.

45. James Heffernan elaborates upon three specific advantages of a more conservative definition of *ekphrasis*: first, such a definition engages the rhetorical tradition of *prosopopoeia*, or the envoicing of a silent object; second, it dramatizes the literary urge to narrate and, thus, to critique; and finally, it highlights the self-consciousness of ekphrasis as a reflection on the nature of representation itself. Heffernan, "Ekphrasis and Representation," *New Literary History* 22, no. 2 (Spring 1991): 302–4. See also his book, *Museum of Words: The Poetics of Ekphrasis from Homer to Ashbery* (Chicago: University of Chicago Press, 1993).

46. In twentieth-century interart theory (see introduction, note 77), the term ekphrasis has frequently been expanded to refer to all manner of spatial, pictorial, or aesthetic aspects of verbal representation. Murray Krieger, for example, has written of an "ekphrastic principle" that motivates aspects of aesthetic formalism in language. He first published "*Ekphrasis* and the Still Movement of Poetry; or, Laokoön Revisited," in *The Poet as Critic*, ed. Frederick P. W. McDowell (Evanston, IL: Northwestern University Press, 1967), 3–26. See also his book on the subject, *Ekphrasis: The Illusion of the Natural Sign* (Baltimore: Johns Hopkins University Press, 1992). Although not explicitly about ekphrasis, Joseph Frank's "spatial form" represents another well-known attempt to describe literature's assimilation of visual principles. Frank's essay was first published in 1945 as "Spatial Form in Modern Literature" in *Sewanee Review*, and subsequently in *The Widening Gyre*, 3–62.

47. For more on ekphrasis in Dostoevsky, see Dmitrii Tokarev, "Deskriptivnye i narrativnye aspekty ekfrasisa ('Mertvyi khristos Gol'beina—Dostoevskogo i 'Sikstinskaia madonna' Rafaelia—Zhukovskogo)" and Konstantin Barsht, "Ideografiia v tvorcheskoi rukopisi F. M. Dostoevskogo: O narratologicheskom aspekte ekfrasisa," both in *"Nevyrazimo vyrazimoe": Ekfrasis i problemy reprezentatsii vizual'nogo v khudozhestvennom tekste*, ed. D. V. Tokarev (Moscow: Novoe literaturnoe obozrenie, 2013), 61–104 and 182–209. More general treatments of ekphrasis in Russian literature can be found in the aforementioned volume, as well as, Maria Rubins, *Crossroads of Arts, Crossroads of Cultures: Ecphrasis in Russian and French Poetry* (Basingstoke, England: Palgrave, 2000); and N. G. Morozova, *Ekfrazis v russkoi proze* (Novosibirsk: NGUEU, 2008).

48. This expansion and contraction of time is available to Myshkin during his epileptic fits as well, which in their status as deeply visual events, are also connected to the novel's ekphrastic moments. In developing the theme of temporal expansion in the moment before death, Dostoevsky was influenced by Victor Hugo's *Le Dernier jour d'un condamné* (1829). Not only does he adopt Hugo's narrative strategies in Myshkin's description of the picture of an execution, he also, as is well known, cites Hugo's story in a letter to his brother in which he relates his 1849 mock execution. Frank discusses the execution and this letter in *Dostoevsky: The Years of Ordeal, 1850–1859* (Princeton, NJ: Princeton University Press, 1983), 58. For the literary relationship between Hugo and Dostoevsky, see Larry R. Andrews, "Dostoevskij and Hugo's 'Le Dernier jour d'un condamné,'" *Comparative Literature* 29, no. 1 (1977): 1–16; and Vinogradov, *Evoliutsiia russkogo naturalizma*, 127–52.

49. On silence in *The Idiot*, see Gatrall, "Between Iconoclasm and Silence"; Nariman Skakov, "Dostoevsky's Christ and Silence at the Margins of *The Idiot*," *Dostoevsky Studies*, new series 13 (2009): 121–40; and Alexander Spektor, "From Violence to Silence: Vicissitudes of Reading (in) *The Idiot*," *Slavic Review* 72, no. 3 (Fall 2013): 552–72.

50. Mitchell, *Picture Theory*, 180. In a discussion of Lessing's *Laocoön*, Mitchell applies this interart approach to consider the ways in which Lessing's text is informed by geopolitical, religious, and gender categories. See Mitchell, *Iconology*, 95–115.

51. Mitchell, *Picture Theory*, 152–56.

52. François Rigolot, "Ekphrasis and the Fantastic: Genesis of an Aberration," *Comparative Literature* 49, no. 2 (Spring 1997): 110.

53. Thomas Epstein, also by appealing (albeit briefly) to ekphrasis, argues that there is a dissonance between apophasis and mimesis, the invisible and the visible, in *The Idiot*. Epstein, "Seeing and Believing in Dostoevsky's *The Idiot*," *Paroles, textes et images: Formes et pouvoirs de l'imaginaire* 19, no. 2 (2008): 109–21.

54. As works that both confront the central questions of art and aesthetics, *The Bronze Horseman* and "The Portrait" have, not surprisingly, inspired scholarship on similar questions. For the classic study of statues in Pushkin, see Roman Jakobson, "The Statue in Pushkin's Poetic Mythology," in *Language in Literature*, ed. Krystyna Pomorska and Stephen Rudy (Cambridge, MA: Harvard University Press, 1987), 308–67. And for a compelling interpretation of vision and mimesis in the two versions of Gogol's story, see Robert A. Maguire, *Exploring Gogol* (Stanford, CA: Stanford University Press, 1994), 135–78.

55. For a detailed analysis of the Gothic mode in *The Idiot* (and engagement with relevant scholarship), see Miller, *Dostoevsky and "The Idiot*," 108–23; and for a comparison of *The Brothers Karamazov* and *Melmoth the Wanderer* that touches on related issues, see Miller, *Dostoevsky's Unfinished Journey* (New Haven, CT: Yale University Press, 2007), 128–47.

56. The portrait's function as a trigger for aesthetic self-consciousness seems to have been reinforced by the author's own "interart encounter"; while Tolstoy was writing the chapters about Mikhailov, he himself was having his portrait painted for the first time by the leading realist artist Ivan Kramskoy. Tolstaia, *Moia zhizn'*, 1:224. On Mikhailov, his portrait, and aesthetics, see Joan Delaney Grossman, "Tolstoy's Portrait of Anna: Keystone in the Arch," *Criticism* 18, no. 1 (Winter 1976): 1–14; Svetlana Evdokimova, "The Drawing and the Grease Spot: Creativity and Interpretation in *Anna Karenina*," *Tolstoy Studies Journal* 8 (1995–1996): 33–45; and David Herman, "Stricken by Infection: Art and Adultery in *Anna Karenina* and *Kreutzer Sonata*," *Slavic Review* 56, no. 1 (Spring 1997): 15–36.

57. Amy Mandelker also considers the portrait, as an ekphrasis, a privileged locus for Tolstoy's aesthetic philosophy. However, given what is described as the ambivalence of the portrait in this chapter, it is impossible to accept Mandelker's conclusion that it is an unequivocally positive example of Christian art. Mandelker, *Framing "Anna Karenina*," 101–21. For an alternative interpretation (which is closer to my own), see Mack Smith, *Literary Realism and the Ekphrastic Tradition* (University Park: Pennsylvania State University Press, 1995), 115–55.

58. Mandelker remarks on the prominence of Anna's vision, and her identity as a spectacle in the novel in "Illustrate and Condemn: The Phenomenology of Vision in *Anna Karenina*," *Tolstoy Studies Journal* 8 (1995–1996): 46–60.

59. Elisabeth Bronfen, *Over Her Dead Body: Death, Femininity, and the Aesthetic* (New York: Routledge, 1992), 71.

60. R. G. Nazirov, "Dikkens, Bodler, Dostoevskii (K istorii odnogo literaturnogo motiva)," in *Russkaia klassicheskaia literatura: Sravnitel'no-istoricheskii podkhod; Issledovaniia raznykh let; Sbornik statei*, ed. R. Kh. Iakubova (Ufa, Russia: RIO BashGU, 2005), 7–20.

61. L. P. Grossman, *Bal'zak i Dostoevskii* (Letchworth, England: Prideaux, 1975), 23–24.

62. Honoré de Balzac, *The Girl with the Golden Eyes and Other Stories*, trans. Peter Collier (Oxford: Oxford University Press, 2012), 62.

63. Ibid.

64. Ibid., 62–63.

65. For additional readings of the fly, see, in particular, David Bethea, "*The Idiot*: Historicism Arrives at the Station," in *Dostoevsky's "The Idiot": A Critical Companion*, ed. Liza Knapp (Evanston, IL: Northwestern University Press, 1998), 173; and Allen Tate, "Dostoevsky's Hovering Fly: A Causerie on the Imagination and the Actual World," *Sewanee Review* 51, no. 3 (July–September 1943): 353–69.

66. For the ethical significance of portraiture and faces in Dostoevsky's novel, see Leslie A. Johnson, "The Face of the Other in *Idiot*," *Slavic Review* 50, no. 4 (Winter 1991): 867–78.

67. The phrase "permanent death" is borrowed from Julia Kristeva, who uses it to reference the impression of Holbein's painting that "this corpse shall never rise again." Kristeva, *Black Sun: Depression and Melancholia*, trans. Leon S. Rudiez (New York: Columbia University Press, 1989), 110.

Notes to Conclusion

1. This period of Repin's career is discussed in detail in Valkenier, *Ilya Repin*, 125–56.

2. A. M. Gor'kii to A. P. Chekhov, 5 January 1900, Nizhnii Novgorod, in Chekhov, *Perepiska A. P. Chekhova v dvukh tomakh*, ed. G. G. Elizavetina, 2 vols. (Moscow: Khudozhestvennaia literatura, 1984), 2:326. For a compelling deconstruction of Gorky's accusation that Chekhov is "killing realism," see Andrey Shcherbenok, "'Killing Realism': Insight and Meaning in Anton Chekhov," *Slavic and East European Journal* 54, no. 2 (Summer 2010): 297–316.

3. Ibid.

4. David Burliuk et al., "Slap in the Face of Public Taste" (1912), in *Russian Futurism through Its Manifestoes, 1912–1928*, ed. Anna Lawton, trans. Anna Lawton and Herbert Eagle (Ithaca, NY: Cornell University Press, 1988), 51.

5. Ibid., 52.

6. Kazimir Malevich, "From Cubism and Futurism," 181.

7. Ibid., 179.

8. Clement Greenberg, "Towards a Newer Laocoon" (1940), in Frascina, *Pollock and After*, 39.

9. Ibid., 41–42.

10. Reminiscences of N. A. Mudrogel', cited in Voloshin, *O Repine,* 3:538–39. Voloshin published the text of his article, "O smysle katastrofy, postigshei kartinu Repina," and his lecture, "O khudozhestvennoi tsennosti postradavshei kartiny Repina," along with other supporting documents, a year after the Balashov event, as *O Repine.*

11. Repin, letter to editor of *Rech'*, cited ibid., 3:315.

12. Voloshin, *O Repine*, 3:333–34.

13. Ibid., 3:320.

14. Russkaia narodnaia liniia, "Eta kartina oskorbliaet patrioticheskie chuvstva russkikh liudei," 2 October 2013, http://ruskline.ru/news_rl/2013/10/02/eta_kartina_oskorblyaet_patrioticheskie_chuvstva_russkih_lyudej/ (accessed 2 October 2013).

15. Virginia Woolf, "The Russian Point of View" (1925), in McNeille, *The Essays of Virginia Woolf,* 188.

16. Ibid., 186.

17. Valkenier, *Ilya Repin*, 195–203.

18. For an excellent account of the Soviet rehabilitation of Tolstoy in 1928, see William Nickell, "Tolstoi in 1928: In the Mirror of the Revolution," in Platt and Brandenberger, *Epic Revisionism*, 17–38.

19. A declaration of this new realism in literature is offered by Sergei Shargunov in "Otritsanie traura," *Novyi mir*, no. 12 (2001): 214–18.

20. Il'ia Glazunov, "Osnovanie akademii," *Rossiiskaia akademiia zhivopisi, vaianiia i zodchestva Il'i Glazunova*, http://www.glazunov-academy.ru/main.html (accessed 18 October 2015).

21. Michel Foucault, *The Order of Things: An Archaeology of the Human Sciences* (New York: Vintage, 1994), 15.

Bibliography

Adlam, Carol. "Realist Aesthetics in Nineteenth-Century Russian Art Writing." *The Slavonic and East European Review* 84, no. 4 (October 2005): 638–63.

Aleksandrov, N. A. "Biografiia: Vasilii Grigor'evich Perov." *Khudozhestvennyi zhurnal* 11 (November 1882): 279–92.

Allen, Elizabeth Cheresh. *Beyond Realism: Turgenev's Poetics of Secular Salvation.* Stanford, CA: Stanford University Press, 1992.

Allenov, M. M. "Evoliutsiia inter'era v zhivopisnykh proizvedeniiakh P. A. Fedotova." In *Russkoe iskusstvo XVIII–pervoi poloviny XIX veka: Materialy i issledovaniia,* edited by T. V. Alekseeva, 116–32. Moscow: Iskusstvo, 1971.

Alpers, Svetlana. *The Art of Describing: Dutch Art in the Seventeenth Century.* Chicago: University of Chicago Press, 1983.

———. "Interpretation without Representation, or, The Viewing of *Las Meninas.*" *Representations* 1, no. 1 (February 1983): 30–42.

Alpers, Svetlana, and Paul Alpers. "*Ut Pictura Noesis?* Criticism in Literary Studies and Art History." *New Literary History* 3, no. 3 (Spring 1972): 437–58.

Anderson, Roger, and Paul Debreczeny, eds. *Russian Narrative and Visual Arts: Varieties of Seeing.* Gainesville: University of Florida Press, 1994.

Andres, Sophia. *The Pre-Raphaelite Art of the Victorian Novel: Narrative Challenges to Visual Gendered Boundaries.* Columbus: Ohio State University Press, 2005.

Andrews, Larry R. "Dostoevskij and Hugo's 'Le Dernier jour d'un condamné.'" *Comparative Literature* 29, no. 1 (1977): 1–16.

Andronikov, I. L. "Ob istoricheskikh kartinkakh, o proze L'va Tolstogo i o kino." In *Izbrannye proizvedeniia,* 2:152–58. Moscow: Khudozhestvennaia literatura, 1975.

Anisimov, I. I. et al., eds. *Iz parizhskogo arkhiva I. S. Turgeneva.* Vol. 73.1 of *Literaturnoe nasledstvo.* Moscow: Akademiia, 1931.

Armstrong, Nancy. *Fiction in the Age of Photography: The Legacy of British Realism.* Cambridge, MA: Harvard University Press, 1999.

———. "Realism before and after Photography: 'The Fantastical Form of a Relation Among Things.'" In Beaumont, *Adventures in Realism,* 84–102.

Atsarkina, E. "Novatorstvo Fedotova-zhanrista." In Butorina, *Gosudarstvennaia tret'iakovskaia galereia,* 2:68–84.

Auerbach, Erich. *Mimesis: The Representation of Reality in Western Literature.* Translated by Willard R. Trask. Princeton, NJ: Princeton University Press, 2003.

Avseenko, V. G. "Nuzhna li nam literatura?" *Russkii vestnik* 5 (May 1873): 390–422.

Bakhtin, M. M. "Forms of Time and of the Chronotope in the Novel" (1937–1938). In *The Dialogic Imagination: Four Essays,* edited by Michael Holquist, translated by Caryl Emerson and Michael Holquist, 84–242. Austin: University of Texas Press, 1981.

Bakushinskii, V. "Vstrecha Belinskogo s Sikstinskoi Madonnoi." In *Venok Belinskomu: Novye stranitsy Belinskogo; Rechi, issledovaniia, materialy,* edited by N. K. Piksanov, 109–19. Moscow: Novaia Moskva, 1924.

Bal, Mieke. *The Mottled Screen: Reading Proust Visually*. Translated by Anna-Louise Milne. Stanford, CA: Stanford University Press, 1997.

———. *Reading "Rembrandt": Beyond the Word-Image Opposition*. Cambridge: Cambridge University Press, 1991.

Bal, Mieke, and Norman Bryson. "Semiotics and Art History." *Art Bulletin* 73, no. 2 (June 1991): 174–208.

Balzac, Honoré de. *Père Goriot*. Edited by Peter Brooks, translated by Burton Raffel. New York: W. W. Norton, 1994.

———. "The Unknown Masterpiece." In *The Girl with the Golden Eyes and Other Stories*, translated by Peter Collier, 39–65. Oxford: Oxford University Press, 2012.

Barkan, Leonard. *Mute Poetry, Speaking Pictures*. Princeton, NJ: Princeton University Press, 2013.

Barkhatova, Elena. "The First Photographs in Russia." In *Photography in Russia, 1840–1940*, edited by David Elliott, 24–29. London: Thames and Hudson, 1992.

Barran, Thomas. "The Window Closes: The Disappearance of Icons from Dostoevsky's 'Idiot.'" In Greenfield, *Depictions*, 32–43.

Barsht, K. A. "Defining the Face: Observations on Dostoevskii's Creative Processes." In *Russian Literature, Modernism, and the Visual Arts*, edited by Catriona Kelly and Stephen Lovell, 23–57. Cambridge: Cambridge University Press, 2000.

———. "Ideografiia v tvorcheskoi rukopisi F. M. Dostoevskogo: O narratologicheskom aspekte ekfrasisa." In Tokarev, *"Nevyrazimo vyrazimoe,"* 182–209.

———. "O tipologicheskikh vzaimosviaziakh literatury i zhivopisi (na materiale russkogo iskusstva XIX veka)." In Gerasimov, *Russkaia literatura*, 5–34.

———. *Risunki v rukopisiakh Dostoevskogo*. St. Petersburg: Formika, 1996.

Barthes, Roland. "The Reality Effect" (1968), in *French Literary Theory Today: A Reader*, edited by Tzvetan Todorov, translated by R. Carter, 11–17. Cambridge: Cambridge University Press, 1982.

———. *S/Z*. Translated by Richard Miller. New York: Hill and Wang, 1974.

Bashutskii, Aleksandr, ed. *Nashi, spisannye s natury russkimi*. 1841. Facsimile reprint. Moscow: Kniga, 1986.

Bazanov, V. G., and A. N. Iezuitov et al., eds. *Literatura i zhivopis'*. Leningrad: Nauka, 1982.

Beaumont, Matthew, ed. *Adventures in Realism*. Malden, MA: Blackwell, 2007.

Beideman, A. E., and E. F. Beideman. "Iz vospominanii." In *Pavel Andreevich Fedotov*, edited by Ia. D. Leshchinskii, 212–15. Leningrad: Iskusstvo, 1946.

Belinskii, V. G. *Polnoe sobranie sochinenii*. 13 vols. Moscow: Akademiia nauk SSSR, 1953–1959.

Belknap, Robert L. "On Dostoevsky and the Visual Arts." In Greenfield, *Depictions*, 58–60.

Benjamin, Walter. *The Arcades Project*. Edited by Rolf Tiedemann, translated by Howard Eiland and Kevin McLaughlin. Cambridge, MA: Belknap Press, 1999.

———. *Charles Baudelaire: A Lyric Poet in the Era of High Capitalism*. London: Verso, 1973.

Benua, A. N. [Benois]. *Istoriia russkoi zhivopisi v XIX veke*. Moscow: Respublika, 1995.

———. *Russkaia shkola zhivopisi*. 1904. Reprint, Moscow: Art-rodnik, 1997.

Berg, William J. *The Visual Novel: Emile Zola and the Art of His Times*. University Park, PA: Pennsylvania State University Press, 1992.

Bers, S. A. *Vospominaniia o Grafe L. N. Tolstom*. Smolensk: Tipo-Litografiia F. V. Zel'dovich, 1893.

Bespalova, N. I., and A. G. Vereshchagina. *Russkaia progressivnaia khudozhestvennaia kritika vtoroi poloviny XIX veka: Ocherki*. Edited by M. M. Rakova. Moscow: Izobrazitel'noe iskusstvo, 1979.

Bethea, David. "*The Idiot*: Historicism Arrives at the Station." In *Dostoevsky's "The Idiot": A Critical Companion*, edited by Liza Knapp, 130–90. Evanston, IL: Northwestern University Press, 1998.

Blakesley, Rosalind P. "Emile Zola's Art Criticism in Russia." In *Critical Exchange: Art Criticism of the Eighteenth and Nineteenth Centuries in Russia and Western Europe*, edited by Carol Adlam and Juliet Simpson, 263–84. Oxford: Peter Lang, 2009.

——— [Rosalind P. Gray, pseud.]. *Russian Genre Painting in the Nineteenth Century*. Oxford: Clarendon Press, 2000.

———. "'There Is Something There . . .': The Peredvizhniki and West European Art." *Experiment/Eksperiment: A Journal of Russian Culture* 14 (2008): 18–58.

Blakesley, Rosalind P., and Margaret Samu, eds. *From Realism to the Silver Age: New Studies in Russian Artistic Culture*. DeKalb: Northern Illinois University Press, 2014.

Blakesley, Rosalind P., and Susan Reid, eds. *Russian Art and the West: A Century of Dialogue in Painting, Architecture, and the Decorative Arts*. DeKalb: Northern Illinois University Press, 2007.

Boborykin, P. D. "Literaturnoe napravlenie v zhivopisi (Progulka po shestoi peredvizhnoi vystavke)." *Slovo* 7 (July 1878): 55–69.

Bowlby, Rachel. Foreword to Beaumont, *Adventures in Realism*, xi–xviii.

Braider, Christopher. "The Paradoxical Sisterhood: 'Ut Pictura Poesis.'" In *The Cambridge History of Literary Criticism*. Vol. 3, *The Renaissance*, edited by Glyn P. Norton, 168–75. Cambridge: Cambridge University Press, 1999.

Brandenberger, David, and Kevin M. F. Platt. "Terribly Pragmatic: Rewriting the History of Ivan IV's Reign, 1937–1956." In Platt and Brandenberger, *Epic Revisionism*, 157–78.

Brodskii, I. A., ed. *L. N. Tolstoi i khudozhniki: Tolstoi ob iskusstve; Pis'ma, dnevniki, vospominaniia o L. N. Tolstom*. Moscow: Iskusstvo, 1978.

Bronfen, Elisabeth. *Over Her Dead Body: Death, Femininity, and the Aesthetic*. New York: Routledge, 1992.

Brooks, Peter. *History Painting and Narrative: Delacroix's "Moments."* Oxford: Legenda, 1998.

———. *Realist Vision*. New Haven, CT: Yale University Press, 2005.

Brunson, Molly. "Painting History, Realistically: Murder at the Tretiakov." In Blakesley and Samu, *From Realism to the Silver Age*, 94–110.

———. "Wandering Greeks: How Repin Discovers the People." *Ab Imperio: Studies of New Imperial History and Nationalism in the Post-Soviet Space* 2 (2012): 83–111.

Bryson, Norman. *Word and Image: French Paintings of the Ancien Régime*. Cambridge: Cambridge University Press, 1981.

Buckler, Julie. *Mapping St. Petersburg: Imperial Text and Cityshape*. Princeton, NJ: Princeton University Press, 2005.

Buddemeier, Heinz. *Panorama, Diorama, Photographie: Entstehung und Wirkung neuer Medien im 19. Jahrhundert*. Munich: Wilhelm Fink Verlag, 1970.

Burliuk, David, et al. "Slap in the Face of Public Taste" (1912). In *Russian Futurism through Its Manifestoes, 1912–1928*, edited by Anna Lawton, translated by Anna Lawton and Herbert Eagle, 51–52. Ithaca, NY: Cornell University Press, 1988.

Butorina, E., ed. *Gosudarstvennaia tret'iakovskaia galereia: Materialy i issledovaniia*. 2 vols. Moscow: Sovetskii khudozhnik, 1956–1958.

Byerly, Alison. "Effortless Art: The Sketch in Nineteenth-Century Painting and Literature." *Criticism* 41, no. 3 (1999): 349–64.

———. *Realism, Representation, and the Arts in Nineteenth-Century Literature*. Cambridge: Cambridge University Press, 1997.

Carlisle, Janice. *Picturing Reform in Victorian Britain*. Cambridge: Cambridge University Press, 2012.

Castle, Terry. *The Female Thermometer: Eighteenth-Century Culture and the Invention of the Uncanny*. New York: Oxford University Press, 1995.

Certeau, Michael de. *The Practice of Everyday Life*. Translated by Steven Rendall. Berkeley: University of California Press, 1984.

Chaadaev, P. Ia. *Polnoe sobranie sochinenii i izbrannye pis'ma*. Edited by Z. A. Kamenskii. 2 vols. Moscow: Izdatel'stvo Nauka, 1991.

Chaushanskii, D. "Belinskii i russkaia realisticheskaia illiustratsiia 1840-kh godov." In *V. G. Belinskii III*. Vol. 57 of *Literaturnoe nasledstvo*, edited by A. M. Egolin et al., 327–56. Moscow: Akademiia nauk SSSR, 1951.

Chekhov, A. P. *Perepiska A. P. Chekhova v dvukh tomakh*. Edited by G. G. Elizavetina. 2 vols. Moscow: Khudozhestvennaia literatura, 1984.

Chernyshevskii, N. G. *Polnoe sobranie sochinenii*. Edited by V. Ia. Kirpotin et al. 15 vols. Moscow: Khudozhestvennaia literatura, 1939–1953.

Chéroux, Clément. "Ghost Dialectics: Spirit Photography in Entertainment and Belief." In *The Perfect Medium: Photography and the Occult*, edited by Clément Chéroux et al., 45–55. New Haven, CT: Yale University Press, 2005.

Christ, Carol T., and John O. Jordan, eds. *Victorian Literature and the Victorian Visual Imagination*. Berkeley: University of California Press, 1995.

Chuiko, V. V. "Khudozhestvennye vystavki gg. Repina i Shishkina." *Nabliudatel'* 11, no. 2 (February 1892): 52–63.

Chukovskii, K. I. "Trosnikov—Nekrasov (cherty avtobiografii v naidennykh proizvedeniiakh Nekrasova)." In *Zhizn' i pokhozhdeniia Tikhona Trosnikova: Novonaidennaia rukopis' Nekrasova*, edited by V. E. Evgen'ev-Maksimov and K. I. Chukovskii, 29–47. Moscow: Khudozhestvennaia literatura, 1931.

Churak, Galina. "The Contemporary Reception of Ilia Repin's Solo Exhibition of 1891." In Blakesley and Samu, *From Realism to the Silver Age*, 111–22.

———. "Sud'by skreshchen'e … Chekhov i Levitan." *Tretyakov Gallery Magazine/Tret'iakovskaia galereia*, Special Edition: Isaak Levitan (2013): 16–29.

Clark, T. J. *Image of the People: Gustave Courbet and the 1848 Revolution*. 1973. Reprint, Berkeley: University of California Press, 1999.

Collier, Peter, and Robert Lethridge, eds. *Artistic Relations: Literature and the Visual Arts in Nineteenth-Century France*. New Haven, CT: Yale University Press, 1994.

Costlow, Jane. *Worlds within Worlds: The Novels of Ivan Turgenev*. Princeton, NJ: Princeton University Press, 1990.

Coykendall, Abby. "Introduction: Realism in Retrospect." *Journal of Narrative Theory* 38, no. 1 (Winter 2008): 1–12.

Crary, Jonathan. *Techniques of the Observer: On Vision and Modernity in the Nineteenth Century*. Cambridge, MA: MIT Press, 1990.

Damisch, Hubert. *The Origin of Perspective*. Translated by John Goodman. Cambridge, MA: MIT Press, 2000.

Danilevskii, R. Iu. *G. E. Lessing i Rossiia: Iz istorii russko-evropeiskoi kul'turnoi obshchnosti*. St. Petersburg: Dmitrii Bulanin, 2006.

Dianina, Katia. "The Feuilleton: An Everyday Guide to Public Culture in the Age of the Great Reforms." *Slavic and East European Journal* 47, no. 2 (Summer 2003): 187–210.

Dintses, L. A. *V. G. Perov: Zhizn' i tvorchestvo*. Leningrad: Gosudarstvennyi russkii muzei, 1935.

Dmitriev, I. I. "Rassharkivaiushcheesia iskustvo (po povodu godichnoi vystavki v akademii khudozhestv)." *Iskra* 5, nos. 37–38 (September 27–October 14, 1863): 505–11, 521–30.

Dmitriev, Vsevolod. "P. A. Fedotov." *Apollon* 9–10 (November–December 1916): 1–36.

Dmitrieva, N. A. *Izobrazhenie i slovo*. Moscow: Iskusstvo, 1962.

Dneprov, V. D. "Izobrazitel'naia sila tolstovskoi prozy." In *V mire Tolstogo: Sbornik statei*, edited by S. I. Mashinskii, 53–103. Moscow: Sovetskii pisatel', 1978.

Doane, Mary Ann. "Film and the Masquerade: Theorising the Female Spectator." *Screen* 23, nos. 3–4 (September–October 1982): 74–87.

[Dobroliubov, N. A.] "Laokoon, ili o granitsakh zhivopisi i poezii: Soch. Lessinga; Perevod E. Edel'sona; Moskva 1859 g." *Sovremennik* 75 (1859): 352.

Dostoevskaia, A. G. *Dnevnik 1867 goda*. Moscow: Nauka, 1993.

———. *Vospominaniia A. G. Dostoevskoi*. Edited by L. P. Grossman. Moscow: Gosudarstvennoe izdatel'stvo, 1925.

Dostoevskii [Dostoevsky], F. M. *Polnoe sobranie sochinenii*. Edited by V. G. Bazanov et al. 30 vols. Leningrad: Nauka, 1972–1990.

———. *Polzunkov*. Edited by V. S. Nechaeva. Moscow: Gosudarstvennoe izdatel'stvo, 1928.

Dostoevsky, Fyodor. *The Idiot*. Translated by Richard Pevear and Larissa Volokhonsky. New York: Vintage, 2001.

———. *The Notebooks for "The Idiot."* Edited by Edward Wasiolek, translated by Katharine Strelsky. Chicago: University of Chicago Press, 1967.

Druzhinin, A. V. *Vospominanie o russkom khudozhnike Pavle Andreiche Fedotove*. St. Petersburg: Tip. Eduarda Pratsa, 1853.

Dubovikov, A. N. "Eshche ob 'igre v portrety.'" In Anisimov, *Iz parizhskogo arkhiva*, 435–54.

Durylin, S. N. *Repin i Garshin: Iz istorii russkoi zhivopisi i literatury*. Moscow: Gosudarstvennaia akademiia khudozhestvennykh nauk, 1926.

Eagleton, Terry. "Pork Chops and Pineapples." Review of *Mimesis: The Representation of Reality in Western Literature*, by Erich Auerbach, translated by Willard R. Trask. *London Review of Books* 25, no. 20, October 23, 2003, accessed May 10, 2013, http://www.lrb.co.uk/v25/n20/terry-eagleton/pork-chops-and-pineapples.

Eikhenbaum, Boris. *Molodoi Tolstoi*. St. Petersburg: Izdatel'stvo Z. I. Grzhebina, 1922.

Elkins, James. *On Pictures and the Words That Fail Them*. New York: Cambridge University Press, 1998.

———. *Pictures and Tears: A History of People Who Have Cried in Front of Paintings*. New York: Routledge, 2001.

———. *The Poetics of Perspective*. Ithaca, NY: Cornell University Press, 1994.

Elliott, David, ed. *Photography in Russia, 1840–1940*. London: Thames and Hudson, 1992.

Ely, Christopher. "The Origins of Russian Scenery: Volga River Tourism and Russian Landscape Aesthetics." *Slavic Review* 62, no. 4 (Winter 2003): 666–82.

———. *This Meager Nature: Landscape and National Identity in Imperial Russia*. DeKalb: Northern Illinois University Press, 2002.

Emerson, Caryl. *Boris Godunov: Transpositions of a Russian Theme*. Bloomington: Indiana University Press, 1986.

———. "Word and Image in Dostoevsky's Worlds: Robert Louis Jackson on Readings That Bakhtin Could Not Do." In *Freedom and Responsibility in Russian Literature: Essays in Honor of Robert Louis Jackson*, edited by Elizabeth Cheresh Allen and Gary Saul Morson, 245–65. Evanston, IL: Northwestern University Press, 1995.

Epstein, Thomas. "Seeing and Believing in Dostoevsky's *The Idiot*." *Paroles, textes et images: Formes et pouvoirs de l'imaginaire* 19, no. 2 (2008): 109–21.

Esty, Jed, and Colleen Lye. "Peripheral Realisms Now." *Modern Language Quarterly* 73, no. 3 (September 2012): 269–88.

Evdokimova, Svetlana. "The Drawing and the Grease Spot: Creativity and Interpretation in *Anna Karenina*." *Tolstoy Studies Journal* 8 (1995–1996): 33–45.

Fabrikant, M. "Tolstoi i izobrazitel'nye iskusstva (kontury problemy)." In *Estetika L'va Tolstogo: Sbornik statei*, edited by P. N. Sakulin, 309–24. Moscow: Akademiia khudozhestvennykh nauk, 1929.

Fanger, Donald. *The Creation of Nikolai Gogol*. Cambridge, MA: Belknap Press of Harvard University Press, 1979.

———. *Dostoevsky and Romantic Realism: A Study of Dostoevsky in Relation to Balzac, Dickens, and Gogol*. Cambridge, MA: Harvard University Press, 1965.

Farago, Claire J., ed. *Leonardo da Vinci's "Paragone": A Critical Interpretation with a New Edition of the Text in the "Codex Urbinas."* Leiden: E. J. Brill, 1992.

Farronato, Cristina. "Holbein's 'Dead Christ' and the Horror of the Broken Narrative." *Interdisciplinary Journal for Germanic Linguistics and Semiotic Analysis* 3, no. 1 (Spring 1998): 121–40.

Fedorov, V. N. "Poezdka Tolstogo v Borodino." In Rakova, *L. N. Tolstoi*, 128–38.

Fedorov-Davydov, A. A. *Il'ia Efimovich Repin*. Moscow: Iskusstvo, 1961.

———. *V. G. Perov: Dokumenty, pis'ma i rasskazy; Katalog proizvedenii; Bibliografiia*. Moscow: Gosudarstvennoe izdatel'stvo izobrazitel'nykh iskusstv, 1934.

Fedotov, P. A. "Popravka obstoiatel'stva, ili zhenit'ba maiora." In Leshchinskii, *Pavel Andreevich Fedotov*, 146–57.

———. "Ratseia." In Leshchinskii, *Pavel Andreevich Fedotov*, 183–84.

———. "Zhenit'ba maiora (opisanie kartiny)." In Leshchinskii, *Pavel Andreevich Fedotov*, 176.

Ferguson, Priscilla Parkhurst. *Paris as Revolution: Writing the Nineteenth-Century City*. Berkeley: University of California Press, 1994.

Fetzer, Leland. "Art and Assassination: Garshin's 'Nadezhda Nikolaevna.'" *Russian Review* 34, no. 1 (January 1975): 55–65.

Flaubert, Gustave. "*Madame Bovary*": *Contexts, Critical Reception*. 2nd ed. Edited by Margaret Cohen, translated by Eleanor Marx Aveling and Paul de Man. New York: W. W. Norton, 2005.

Flint, Kate. *The Victorians and the Visual Imagination*. Cambridge: Cambridge University Press, 2008.

Foucault, Michel. *The Order of Things: An Archaeology of the Human Sciences*. New York: Vintage, 1994.

Fowler, Alastair. "Periodization and Interart Analogies." *New Literary History* 3, no. 3 (Spring 1972): 487–509.

Frank, Joseph. *Dostoevsky: The Miraculous Years, 1865–1871*. Princeton, NJ: Princeton University Press, 1995.

———. *Dostoevsky: The Years of Ordeal, 1850–1859*. Princeton, NJ: Princeton University Press, 1983.

———. "Dostoevsky's Discovery of 'Fantastic Realism.'" *Russian Review* 27, no. 3 (July 1968): 286–95.

———. "Spatial Form in Modern Literature." In *The Widening Gyre: Crisis and Mastery in Modern Literature*. 3–62. New Brunswick, NJ: Rutgers University Press, 1963. First published 1945.

Frede, Victoria. "Radicals and Feelings: The 1860s." In *Interpreting Emotions in Russia and Eastern Europe*, edited by Mark D. Steinberg and Valeria Sobol, 62–81. DeKalb: Northern Illinois University Press, 2011.

Fried, Michael. *Courbet's Realism*. Chicago: University of Chicago Press, 1990.

———. *Menzel's Realism: Art and Embodiment in Nineteenth-Century Berlin*. New Haven, CT: Yale University Press, 2002.

———. *Realism, Writing, Disfiguration: On Thomas Eakins and Stephen Crane*. Chicago: University of Chicago Press, 1987.

Friedberg, Anne. *The Virtual Window: From Alberti to Microsoft*. Cambridge, MA: MIT Press, 2006.

Frierson, Cathy A. *Peasant Icons: Representations of Rural People in Late Nineteenth-Century Russia*. New York: Oxford University Press, 1993.

Gatrall, Jefferson. "Between Iconoclasm and Silence: Representing the Divine in Holbein and Dostoevskii." *Comparative Literature* 53, no. 3 (Summer 2001): 214–32.

———. "The Icon in the Picture: Reframing the Question of Dostoevsky's Modernist Iconography." *Slavic and East European Journal* 48, no. 1 (2004): 1–25.

Gerasimov, Iu. K., ed. *Russkaia literatura i izobraziteľnoe iskusstvo XVIII–nachala XX veka: Sbornik nauchnykh trudov*. Leningrad: Nauka, 1988.

Gertsen [Herzen], A. I. *Sobranie sochinenii v tridtsati tomakh*. 30 vols. Moscow: Akademiia nauk SSSR, 1954–1966.

Gilman, Ernest B. "Interart Studies and the 'Imperialism' of Language." *Poetics Today* 10, no. 1 (Spring 1989): 5–30.

Gilmore, Dehn. *The Victorian Novel and the Space of Art: Fictional Form on Display*. Cambridge: Cambridge University Press, 2013.

Ginzburg, Lidiia. *Literatura v poiskakh reaľnosti*. Leningrad: Sovetskii pisateľ, 1987.

Giovannini, G. "Method in the Study of Literature in Its Relation to the Other Fine Arts." *Journal of Aesthetics and Art Criticism* 8, no. 3 (March 1950): 185–95.

Glazunov, Iľia. "Osnovanie akademii." *Rossiiskaia akademiia zhivopisi, vaianiia i zodchestva Iľi Glazunova*. Accessed 18 October 2015. http://www.glazunov-academy.ru/main.html.

Glinka, F. N. *Ocherki Borodinskogo srazheniia: Vospominaniia o 1812 gode*. 2 vols. Moscow: Tip. N. Stepanova, 1839.

Goerner, Tatiana. "The Theme of Art and Aesthetics in Dostoevsky's *The Idiot*." *Ulbandus Review* 2, no. 2 (Fall 1982): 79–85.

Gogol [Gogoľ], Nikolai. *Dead Souls*. Translated by Richard Pevear and Larissa Volokhonsky. New York: Vintage Classics, 1997.

———. *Polnoe sobranie sochinenii*. Edited by N. L. Meshcheriakov. 14 vols. Moscow: Akademiia nauk SSSR, 1937–1952.

Goľdshtein, S. N., ed. *Tovarishchestvo peredvizhnykh khudozhestvennykh vystavok, 1869–1899: Pis'ma, dokumenty*. 2 vols. Moscow: Iskusstvo, 1987.

Gombrich, E. H. *Art and Illusion: A Study in the Psychology of Pictorial Representation*. Princeton, NJ: Princeton University Press, 1969.

Gorlin, Mikhail. "The Interrelation of Painting and Literature in Russia." Translated by Nina Brodiansky. *Slavonic and East European Review* 25, no. 64 (November 1946): 134–48.

Grabar', I. E. *Repin: Monografiia*. 2 vols. Moscow: Akademiia nauk SSSR, 1963.

Gray, Rosalind P. *See* Blakesley, Rosalind P.

Greenberg, Clement. "Avant-Garde and Kitsch." In *Pollock and After: The Critical Debate*, edited by Francis Frascina, 21–33. New York: Harper and Row, 1985. First published 1939.

———. "Towards a Newer Laocoon" (1940). In *Pollock and After: The Critical Debate*, edited by Francis Frascina, 35–46. New York: Harper and Row, 1985.

Greenfield, Douglas, ed. *Depictions: Slavic Studies in the Narrative and Visual Arts in Honor of William E. Harkins*. Dana Point, CA: Ardis, 2000.

Green-Lewis, Jennifer. *Framing the Victorians: Photography and the Culture of Realism*. Ithaca, NY: Cornell University Press, 1996.

Grigorovich, D. V. *Literaturnye vospominaniia*. Moscow: Khudozhestvennaia literatura, 1987.

Grossman, Joan Delaney. "Tolstoy's Portrait of Anna: Keystone in the Arch." *Criticism* 18, no. 1 (Winter 1976): 1–14.

Grossman, L. P. *Baľzak i Dostoevskii*. Letchworth, England: Prideaux, 1975.

Gumbrecht, Hans Ulrich. "The Roads of the Novel." In *The Novel*. Vol. 2, *Forms and Themes*, edited by Franco Moretti, 611–46. Princeton, NJ: Princeton University Press, 2006.

Gunning, Tom. "Invisible Worlds, Visible Media." In *Brought to Light: Photography and the Invisible, 1840–1900*, edited by Corey Keller, 51–63. San Francisco: San Francisco Museum of Art in association with Yale University Press, 2008.

Gustafson, Richard F. *Leo Tolstoy: Resident and Stranger; A Study in Fiction and Theology*. Princeton, NJ: Princeton University Press, 1986.

Hagstrum, Jean. *The Sister Arts: The Tradition of Literary Pictorialism and English Poetry from Dryden to Gray*. Chicago: University of Chicago Press, 1958.

Hannavy, John. *The Camera Goes to War: Photographs from the Crimean War, 1854–56*. Edinburgh: Scottish Arts Council, 1974.

Hatzfeld, Helmut A. "Literary Criticism through Art and Art Criticism through Literature." *Journal of Aesthetics and Art Criticism* 6, no. 1 (September 1947): 1–21.

Heffernan, James A. W. "Ekphrasis and Representation." *New Literary History* 22, no. 2 (Spring 1991): 297–316.

———. *Museum of Words: The Poetics of Ekphrasis from Homer to Ashbery*. Chicago: University of Chicago Press, 1993.

———. *Space, Time, Image, Sign: Essays on Literature and the Visual Arts*. New York: Peter Lang, 1987.

Herman, David. "Stricken by Infection: Art and Adultery in *Anna Karenina* and *Kreutzer Sonata*." *Slavic Review* 56, no. 1 (Spring 1997): 15–36.

Holquist, Michael. "Bazarov and Sečenov: The Role of Scientific Metaphor in *Fathers and Sons*." *Russian Literature* 16, no. 4 (1984): 359–74.

Hurley, Ann, and Kate Greenspan, eds. *So Rich a Tapestry: The Sister Arts and Cultural Studies*. Lewisburg, PA: Bucknell University Press, 1995.

Hutchings, Stephen. *Russian Literary Culture in the Camera Age: The Word as Image*. London: RoutledgeCurzon, 2004.

Hutton, Patrick H. "The Art of Memory Reconceived: From Rhetoric to Psychoanalysis." *Journal of the History of Ideas* 48, no. 3 (1987): 371–92.

Iagodovskaia, A. T. "Avtor i geroi v iskusstve V. G. Perova." *Sovetskoe iskusstvoznanie* 20 (1986): 232–53.

Iavornitskii, D. I. *Zaporozh'e v ostatkakh stariny i predaniiakh naroda*. 2 vols. St. Petersburg: Izdanie L. F. Panteleeva, 1888.

Institut russkoi literatury, ed. *Opisanie rukopisei i izobraziteľnykh materialov pushkinskogo doma*. Vol. 4, *I. S. Turgenev*. Moscow: Izdateľstvo akademii nauk SSSR, 1958.

Jackson, David. "The Motherland: Tradition and Innovation in Russian Landscape Painting." In Jackson and Wageman, *Russian Landscape*, 52–78.

———. *The Russian Vision: The Art of Ilya Repin*. Schoten, Belgium: BAI, 2006.

———. *The Wanderers and Critical Realism in Nineteenth-Century Russian Painting*. Manchester: Manchester University Press, 2006.

———. "Western Art and Russian Ethics: Repin in Paris, 1873–76." *Russian Review* 57, no. 3 (July 1998): 394–409.

Jackson, David, and Patty Wageman, eds. *Russian Landscape*. Schoten, Belgium: BAI, 2003.

Jackson, Robert Louis. *Dostoevsky's Quest for Form: A Study of His Philosophy of Art*. New Haven, CT: Yale University Press, 1966.

Jakobson, Roman. "On Realism in Art." In *Readings in Russian Poetics: Formalist and Structuralist Views*, edited by Ladislav Matejka and Krystyna Pomorska, 38–46. Ann Arbor: Michigan Slavic Publications, 1978. First published 1921.

———. "The Statue in Pushkin's Poetic Mythology." In *Language in Literature*, edited by Krystyna Pomorska and Stephen Rudy, 308–67. Cambridge, MA: Harvard University Press, 1987.

James, Henry. "Ivan Turgenieff." In *The Novels and Stories of Ivan Turgenieff*. Vol. 1, *Memoirs of a Sportsman I*, translated by Isabel F. Hapgood, v–xlv. New York: Charles Scribner's Sons, 1903.

James, Lawrence. *Crimea, 1854–56: The War with Russia from Contemporary Photographs*. Thame, Oxfordshire, England: Hayes Kennedy, 1981.

Jameson, Fredric. *The Antinomies of Realism*. London: Verso, 2013.

Janin, Jules, Honoré de Balzac, Louis-Marie de Lahaye Cormenin, and Jacques Adrien Lavieille. *Pictures of the French: A Series of Literary and Graphic Delineations of French Character*. London: W. S. Orr, 1840.

Jay, Martin. *Downcast Eyes: The Denigration of Vision in Twentieth-Century French Thought*. Berkeley: University of California Press, 1993.

Johnson, Kendall. *Henry James and the Visual*. Cambridge: Cambridge University Press, 2007.

Johnson, Leslie A. "The Face of the Other in *Idiot*." *Slavic Review* 50, no. 4 (Winter 1991): 867–78.

Kadish, Doris Y. *The Literature of Images: Narrative Landscape from "Julie" to "Jane Eyre"*. New Brunswick, NJ: Rutgers University Press, 1987.

Kagan, M. S. "V. G. Belinskii i izobraziteľnoe iskusstvo." In *Iskusstvoznanie i khudozhestvennaia kritika: Izbrannye staťi*, 66–76. St. Petersburg: Petropolis, 2001.

———. "V. G. Belinskii o russkoi zhivopisi." In *Iskusstvoznanie i khudozhestvennaia kritika*, 77–92.

Karamzin, N. M. *Istoriia gosudarstva rossiiskogo*, 3rd ed. St. Petersburg: Tip. Aleksandra Smirdina, 1830–1831.

———. *Izbrannye sochineniia v dvukh tomakh*. 2 vols. Moscow: Khudozhestvennaia literatura, 1964.

Kasatkina, Tat'iana. "After Seeing the Original: Hans Holbein the Younger's *Body of the Dead Christ in the Tomb* in the Structure of Dostoevsky's *Idiot*." *Russian Studies in Literature* 47, no. 3 (Summer 2011): 73–97.

———. "Rol' khudozhestvennoi detali i osobennosti funktsionirovaniia slova v romane Dostoevskogo 'Idiot.'" In *Roman F. M. Dostoevskogo "Idiot": Sovremennoe sostoianie izucheniia*, edited by T. A. Kasatkina, 63–65. Moscow: Nasledie, 2001.

Kaufman, R. S. *Ocherki istorii russkoi khudozhestvennoi kritiki XIX veka*. Moscow: Iskusstvo, 1985.

Keller, Ulrich. *The Ultimate Spectacle: A Visual History of the Crimean War*. Amsterdam: Gordon and Breach, 2001.

Kelly, Catriona, and Stephen Lovell, eds. *Russian Literature, Modernism, and the Visual Arts.* Cambridge: Cambridge University Press, 2000.

Kemenov, V. S. "Tolstoi i izobrazitel'noe iskusstvo." In Rakova, *L. N. Tolstoi,* 7–12.

Kirsanova, Raisa. *Pavel Andreevich Fedotov (1815–1852): Kommentarii k zhivopisnomu tekstu.* Moscow: Novoe literaturnoe obozrenie, 2006.

Knight, Diana. *Balzac and the Model of Painting: Artist Stories in "La Comédie humaine."* London: Legenda, 2007.

Koroleva, Iu. A. *Soprikosnovenie sudeb: A. P. Chekhov, I. I. Levitan.* Moscow: Gelios ARV, 2011.

Kramskoi, I. N. *Pis'ma.* 2 vols. Moscow: OGIZ-IZOGIZ, 1937.

Krieger, Murray. "*Ekphrasis* and the Still Movement of Poetry; or, *Laokoön Revisited.*" In *The Poet as Critic,* edited by Frederick P. W. McDowell, 3–26. Evanston, IL: Northwestern University Press, 1967.

———. *Ekphrasis: The Illusion of the Natural Sign.* Baltimore: Johns Hopkins University Press, 1992.

Krinitsyn, A. B. "O spetsifike vizual'nogo mira u Dostoevskogo i semantike 'videnii' v romane 'Idiot.'" In *Roman F. M. Dostoevskogo "Idiot": Sovremennoe sostoianie izucheniia,* edited by T. A. Kasatkina, 170–205. Moscow: Nasledie, 2001.

Kristeva, Julia. *Black Sun: Depression and Melancholia.* Translated by Leon S. Roudiez. New York: Columbia University Press, 1989.

Kroshkin, A. F. "Roman N. A. Nekrasova *Zhizn' i pokhozhdeniia Tikhona Trostnikova.*" In *Nekrasovskii sbornik,* edited by V. G. Bazanov, N. F. Bel'chikov, and A. M. Egolin, 3:36–58. Moscow: Akademiia nauk SSSR, 1960.

Kuleshov, V. I. *Natural'naia shkola v russkoi literature XIX veka.* 2nd ed. Moscow: Prosveshchenie, 1982.

———. "Znamenityi al'manakh Nekrasova." In Nekrasov, *Fiziologiia Peterburga* (1991), 216–43.

Kuspit, Donald. "Traditional Art History's Complaint against the Linguistic Analysis of Visual Art." *Journal of Aesthetics and Art Criticism* 45, no. 4 (Summer 1987): 345–49.

Kuyper, Éric de, and Émile Poppe. "Voir et regarder." *Communications* 34, no. 1 (1981): 85–96.

Kuzina, L. N. "Tolstoi o probleme 'sinteza' iskusstv." In *Tolstoi i nashe vremia,* edited by K. N. Lomunov, 106–21. Moscow: Nauka, 1978.

Kuz'min, A. N. "Lev Tolstoi i russkie khudozhniki." In Bazanov and Iezuitov, *Literatura i zhivopis',* 167–87.

Kuz'minskii, K. S. *Russkaia realisticheskaia illiustratsiia XVIII i XIX vv.* Moscow: Gosudarstvennoe izdatel'stvo izobrazitel'nykh iskusstv, 1937.

Lagerroth, Ulla-Britta, Hans Lund, and Erik Hedling, eds. *Interart Poetics: Essays on the Interrelations of the Arts and Media.* Amsterdam: Rodopi, 1997.

Lanskoi, L. P. "Poslednyi put': Otkliki russkoi i zarubezhnoi pechati na smert' i pokhorony Turgeneva." In *I. S. Turgenev: Novye materialy i issledovaniia.* Vol. 76 of *Literaturnoe nasledstvo,* edited by A. N. Dubovikov, I. S. Zil'bershtein et al., 633–701. Moscow: Nauka, 1967.

Lebedev, G. E. *Russkaia knizhnaia illiustratsiia XIX v.* Moscow: Iskusstvo, 1952.

Leblanc, Ronald D. "Teniers, Flemish Art, and the Natural School Debate." *Slavic Review* 50, no. 3 (Autumn 1991): 576–89.

Lee, Rensselaer W. "*Ut Pictura Poesis*: The Humanistic Theory of Painting." *Art Bulletin* 22, no. 4 (December 1940): 197–269.

Leniashin, V. A. "Doroga i put' v zhivopisi XIX–XX veka." In *Doroga v russkom iskusstve,* edited by E. N. Petrova, 7–11. St. Petersburg: Palace Editions, 2004.

———. "Narodnyi khudozhnik." *Khudozhnik* 12 (1983): 1–6.

———. *Vasily Grigor'evich Perov.* Leningrad: Khudozhnik RSFSR, 1987.

Leonardo da Vinci. *Paragone: A Comparison of the Arts.* Translated by Irma A. Richter. London: Oxford University Press, 1949.

Leonev, P. M. "Esteticheskoe koe-chto po povodu kartin i eskizov gospodina Fedotova." *Moskvitianin* 3, no. 10 (May 1850): 26.

Leonov, A. I. *Burlaki na Volge: Kartina I. E. Repina.* Moscow: Iskusstvo, 1945.

Leont'eva, G. A. *Kartina P. A. Fedotova "Svatovstvo maiora."* Leningrad: Khudozhnik RSFSR, 1985.

———. *Pavel Andreevich Fedotov: Osnovnye problemy tvorchestva.* Leningrad: Iskusstvo, 1962.

Lepakhin, V. "Ikona v tvorchestve Dostoevskogo: 'Brat'ia Karamazovy,' 'Krotkaia,' 'Besy,' 'Podrostok,' 'Idiot.'" In *Dostoevskii: Materialy i issledovaniia,* 15:237–63. St. Petersburg: Nauka, 2000.

Leshchinskii, Ia. D., ed. *Pavel Andreevich Fedotov: Khudozhnik i poet.* Leningrad: Iskusstvo, 1946.

Lessing, Gotthold Ephraim. *Laocoön: An Essay on the Limits of Painting and Poetry.* Translated by Edward Allen McCormick. Baltimore: Johns Hopkins University Press, 1984.

Levin, Harry. *The Gates of Horn: A Study of Five French Realists.* New York: Oxford University Press, 1963.

Levine, George. *The Realistic Imagination: English Fiction from "Frankenstein" to "Lady Chatterley."* Chicago: University of Chicago Press, 1981.

Levitt, Marcus. *The Visual Dominant in Eighteenth-Century Russia.* DeKalb: Northern Illinois University Press, 2011.

Liaskovskaia, O. A. *Il'ia Efimovich Repin.* Moscow: Iskusstvo, 1962.

———. "K istorii sozdaniia kartiny I. E. Repina 'Ivan Groznyi i syn ego Ivan 16 noiabria 1581 goda.'" In Butorina, *Gosudarstvennaia tret'iakovskaia galereia,* 1:187–97.

———. *V. G. Perov: Osobennosti tvorcheskogo puti khudozhnika.* Moscow: Iskusstvo, 1979.

Liaskovskaia, O. A., and F. S. Mal'tseva. "Al'bom I. E. Repin i F. A. Vasil'eva v gosudarstvennoi tret'iakovskoi galeree." In Butorina, *Gosudarstvennaia tret'iakovskaia galereia,* 1:176–87.

Likhachev, D. S. *Russkoe iskusstvo ot drevnosti do avangarda.* Moscow: Iskusstvo, 1992.

Lotman, Iu. M. "Problema khudozhestvennogo prostranstva v proze Gogolia." In *Izbrannye stat'i v trekh tomakh,* 1:413–47. Tallinn: Aleksandra, 1992.

Louvel, Liliane. *Poetics of the Iconotext.* Edited by Karen Jacobs, translated by Laurence Petit. Burlington, VT: Ashgate, 2011.

Love, Jeff. *The Overcoming of History in "War and Peace."* Amsterdam: Rodopi, 2004.

Lübbren, Nina. *Rural Artists' Colonies in Europe, 1870–1910.* Manchester: Manchester University Press, 2001.

Lukács, Georg. "Narrate or Describe?" (1936). In *Writer and Critic and Other Essays,* edited and translated by Arthur Kahn, 110–48. London: Merlin, 1970.

MacDonald, Dwight. "Soviet Society and Its Cinema." *Partisan Review* 6, no. 2 (Winter 1939): 80–94.

Maguire, Robert A. *Exploring Gogol.* Stanford, CA: Stanford University Press, 1994.

Maikov, A. N. "Retsenziia na stat'iu Tol'bina o P. A. Fedotove" (1853). In Leshchinskii, *Pavel Andreevich Fedotov,* 229–30.

Makhrov, Alexey. "The Pioneers of Russian Art Criticism: Between State and Public Opinion, 1804–1855." *Slavonic and East European Review* 81, no. 4 (October 2003): 614–33.

Malenko, Zinaida, and James J. Gebhard. "The Artistic Use of Portraits in Dostoevskij's *Idiot.*" *Slavic and East European Journal* 5, no. 3 (Autumn 1961): 243–54.

Malevich, Kazimir. "From Cubism and Futurism to Suprematism: The New Painterly Realism." In *Art in Theory, 1900–2000: An Anthology of Changing Ideas,* edited by Charles Harrison and Paul Wood, 173–83. Malden, MA: Blackwell, 2003. First published 1915. Revised 1916.

Manaev, Nikolai. *Za gran'iu nevidimogo: V tvorcheskoi laboratorii L. N. Tolstogo; Ot izobrazitel'nogo istochnika—k istoricheskomu povestvovaniiu.* Kaluga, Russia: Eidos, 2002.

Mandelker, Amy. *Framing "Anna Karenina": Tolstoy, the Woman Question, and the Victorian Novel.* Columbus: Ohio State University Press, 1993.

———. "Illustrate and Condemn: The Phenomenology of Vision in *Anna Karenina.*" *Tolstoy Studies Journal* 8 (1995–1996): 46–60.

Mann, Iu. V. "Filosofiia i poetika 'Natural'noi shkoly.'" In *Problemy tipologii russkogo realizma,* edited by N. L. Stepanov and U. R. Fokht, 241–305. Moscow: Nauka, 1969.

Markiewicz, Henryk. "Ut Pictura Poesis . . . A History of the Topos and the Problem." *New Literary History* 18, no. 3 (Spring 1987): 535–58.

Matich, Olga. "What's to Be Done about Poor Nastja: Nastas'ja Filippovna's Literary Prototypes." *Wiener slawistischer Almanach* 19 (1987): 47–64.

Mazon, A. *Parizhskie rukopisi I. S. Turgeneva,* translated by Iu. Gan. Moscow and Leningrad: Akademiia, 1931.

Meerson, Olga. "Ivolgin and Holbein: Non-Christ Risen vs. Christ Non-Risen." *Slavic and East European Journal* 39, no. 2 (Summer 1995): 200–213.

Meisel, Martin. *Realizations: Narrative, Pictorial, and Theatrical Arts in Nineteenth-Century England.* Princeton, NJ: Princeton University Press, 1983.

Merezhkovskii, D. S. "L. Tolstoi i Dostoevskii: Zhizn', tvorchestvo i religiia" (1900–1901). In *Polnoe sobranie sochinenii.* 17 vols. Moscow: M. O. Vol'f, 1912.

Merriman, James D. "The Parallel of the Arts: Some Misgivings and a Faint Affirmation: Part 1." *Journal of Aesthetics and Art Criticism* 31, no. 2 (Winter 1972): 153–64.

———. "The Parallel of the Arts: Some Misgivings and a Faint Affirmation: Part 2." *Journal of Aesthetics and Art Criticism* 31, no. 3 (Spring 1973): 309–21.

Meyers, Jeffrey. *Painting and the Novel.* Manchester: Manchester University Press, 1975.

Mikhailovskii, N. K. "Na venskoi vsemirnoi vystavke." In *Polnoe sobranie sochinenii.* 4th ed. 8 vols. St. Petersburg: Tip. N. K. Klobukova, 1906–1914. First published 1873.

Milkova, Stiliana Vladimirova. "Sightseeing: Writing Vision in Slavic Travel Narratives." PhD diss., University of California, Berkeley, 2007.

Miller, J. Hillis. "The Fiction of Realism: *Sketches by Boz, Oliver Twist*, and Cruikshank's Illustrations." In *Dickens Centennial Essays*, edited by Ada Nisbet and Blake Nevius, 85–153. Berkeley: University of California Press, 1971.

Miller, Robin Feuer. *Dostoevsky and "The Idiot": Author, Narrator, and Reader*. Cambridge, MA: Harvard University Press, 1981.

———. *Dostoevsky's Unfinished Journey*. New Haven, CT: Yale University Press, 2007.

Mirollo, James V. "Sibling Rivalry in the Arts Family: The Case of Poetry vs. Painting in the Italian Renaissance." In Hurley and Greenspan, *So Rich a Tapestry*, 29–71.

Mirsky, D. S. *A History of Russian Literature from Its Beginnings to 1900*. Edited by Francis J. Whitfield. 1881. Reprint, Evanston, IL: Northwestern University Press, 1999.

Mitchell, W. J. T. "Going Too Far with the Sister Arts." In *Space, Time, Image, Sign: Essays on Literature and the Visual Arts*, edited by James A. W. Heffernan, 1–11. New York: Peter Lang, 1987.

———. *Iconology: Image, Text, Ideology*. Chicago: University of Chicago Press, 1986.

———. *Picture Theory: Essays on Verbal and Visual Representation*. Chicago: University of Chicago Press, 1994.

Mitter, Partha. "Decentering Modernism: Art History and Avant-Garde Art from the Periphery." *Art Bulletin* 90, no. 4 (December 2008): 531–48.

Mohler, Sarah Beth. "The Prosaics of the Mind's Eye: Reader Visualization, Perspectival Engagement, and the Visual Ethics of Tolstoy's *War and Peace*." PhD diss., Princeton University, 2006.

Molnár, István. "'One's Faith Could Be Smashed by Such a Picture': Interrelation of Word and Image (Icon) in Dostoevsky's Fiction; Holbein's 'Christ in the Tomb' in the Ideological and Compositional Structure of 'The Idiot.'" *Acta Litteraria Academiae Scientiarum Hungaricae* 32, nos. 3–4 (1990): 245–58.

Morozova, N. G. *Ekfrazis v russkoi proze*. Novosibirsk, Russia: NGUEU, 2008.

Morson, Gary Saul. "*Fathers and Sons*: Inter-Generic Dialogues, Generic Refugees, and the Hidden Prosaic." In *Literature, Culture, and Society in the Modern Age: In Honor of Joseph Frank*, edited by Edward J. Brown et al., 336–81. Stanford, CA: Stanford University Press, 1991.

———. *Hidden in Plain View: Narrative and Creative Potentials in "War and Peace."* Stanford, CA: Stanford University Press, 1987.

———. "The Reader as Voyeur: Tolstoi and the Poetics of Didactic Fiction." *Canadian-American Slavic Studies* 12, no. 4 (Winter 1978): 465–80.

Mozhaiskii, I. P. "Neskol'ko slov o pokoinom akademike P. A. Fedotove" (1859). In Leshchinskii, *Pavel Andreevich Fedotov*, 201–3.

Mulvey, Laura. "Visual Pleasure and Narrative Cinema." In *The Sexual Subject: A "Screen" Reader in Sexuality*, edited by Mandy Merck, 22–34. New York: Routledge, 1992.

Mut'ia, N. N. *Ivan Groznyi: Istorizm i lichnost' pravitelia v otechestvennom iskusstve XIX–XX vv.* St. Petersburg: Aleteiia, 2010.

Nabokov, Vladimir. *Lectures on Russian Literature*. Edited by Fredson Bowers. New York: Harcourt, Brace, 1981.

Naumova, N. N. "Iskusstvo portreta v romane 'Voine i mire.'" In *Tolstoi-khudozhnik: Sbornik statei*, edited by D. D. Blagoi et al., 135–49. Moscow: Akademiia nauk SSSR, 1961.

Nazirov, R. G. "Dikkens, Bodler, Dostoevskii (K istorii odnogo literaturnogo motiva)." In *Russkaia klassicheskaia literatura: Sravnitel'no-istoricheskii podkhod; Issledovaniia raznykh let; Sbornik statei*, edited by R. Kh. Iakubova, 7–20. Ufa, Russia: RIO BashGU, 2005.

Nekrasov, N. A., ed. *Fiziologiia Peterburga*. Edited by V. I. Kuleshov. Moscow: Nauka, 1991.

———, ed. *Fiziologiia Peterburga: Sostavlennaia iz trudov russkikh literatorov*. 2 vols. St. Petersburg: Izdanie knigoprodavtsa A. Ivanova, 1845.

———, ed. *Peterburgskii sbornik*. Facsimile reprint. Leipzig: Zentralantiquariat der Deutschen Demokratischen Republik, 1976.

———, ed. *Petersburg: The Physiology of a City*. Translated by Thomas Gaiton Marullo. Evanston, IL: Northwestern University Press, 2009.

———. *Polnoe sobranie sochinenii i pisem*. Edited by M. P. Khrapchenko. 15 vols. Leningrad: Nauka, 1981–2000.

Nekrasov, N. A., and I. I. Panaev, eds. *Illiustrirovannyi al'manakh: Izdanie I. I. Panaeva i N. A. Nekrasova 1848 g.* Facsimile reprint. Moscow: Kniga, 1990.

Nenarokomova, I. S. *Pavel Mikhailovich Tret'iakov i ego galereia*. Moscow: Galart, 1994.

Nesterova, E. V. "Tema burlakov v russkoi zhivopisi 1860–1870 godov." In *Il'ia Efimovich Repin: K 150-letiiu so dnia rozhdeniia; Sbornik statei*, edited by E. N. Petrova et al., 57–65. St. Petersburg: Palace Editions, 1995.

Nickell, William. "Tolstoi in 1928: In the Mirror of the Revolution." In Platt and Brandenberger, *Epic Revisionism*, 17–38.

Nochlin, Linda. *Realism.* Harmondsworth, England: Penguin, 1971.

Norman, John O. "Pavel Tretiakov and Merchant Art Patronage, 1850–1900." In *Between Tsar and People: Educated Society and the Quest for Public Identity in Late Imperial Russia,* edited by Edith W. Clowes, Samuel D. Kassow, and James L. West, 93–107. Princeton, NJ: Princeton University Press, 1991.

Novak, Daniel A. *Realism, Photography, and Nineteenth-Century Fiction.* Cambridge: Cambridge University Press, 2008.

O., A. "Neskol'ko slov o Fedotove" (1858). In Leshchinskii, *Pavel Andreevich Fedotov,* 210–12.

Obukhov, V. M. *V. G. Perov.* Moscow: Izobrazitel'noe iskusstvo, 1983.

Oetterman, Stephen. *The Panorama: History of a Mass Medium.* Translated by Deborah Lucas Schneider. New York: Zone, 1997.

Orwin, Donna Tussing. "The Awful Poetry of War: Tolstoy's Borodino." In *Tolstoy on War: Narrative and Historical Truth in "War and Peace,"* edited by Rick McPeak and Donna Tussing Orwin, 123–39. Ithaca, NY: Cornell University Press, 2012.

———. *Tolstoy's Art and Thought, 1847–1880.* Princeton, NJ: Princeton University Press, 1993.

Panaev, V. A. "Vospominaniia V. A. Panaeva." *Russkaia starina* 79 (1893): 461–502.

Paperno, Irina. *Chernyshevsky and the Age of Realism: A Study in the Semiotics of Behavior.* Stanford, CA: Stanford University Press, 1988.

———. *"Who, What Am I?" Tolstoy Struggles to Narrate the Self.* Ithaca, NY: Cornell University Press, 2014.

Park, Roy. "'Ut Pictura Poesis': The Nineteenth-Century Aftermath." *Journal of Aesthetics and Art Criticism* 28, no. 2 (Winter 1969): 155–64.

Perov, V. G. *Rasskazy khudozhnika.* Edited by A. I. Leonov. Moscow: Akademiia khudozhestv SSSR, 1960.

Perrie, Maureen. *The Cult of Ivan the Terrible in Stalin's Russia.* Houndmills: Palgrave, 2001.

———. *The Image of Ivan the Terrible in Russian Folklore.* Cambridge: Cambridge University Press, 1987.

Petrova, E. N., ed. *Doroga v russkom iskusstve.* St. Petersburg: Palace Editions, 2004.

Petrovskaia, E. V. "Zrenie i videnie v 'Voine i mire.'" *Iasnopolianskii sbornik* (2006): 30–56.

Pigarev, K. V. *Russkaia literatura i izobrazitel'noe iskusstvo: Ocherki o russkom natsional'nom peizazhe serediny XIX v.* Moscow: Nauka, 1972.

———. *Russkaia literatura i izobrazitel'noe iskusstvo (XVIII–pervaia chetvert' XIX veka): Ocherki.* Moscow: Nauka, 1966.

Pishchulin, Iu. P. *Ivan Sergeevich Turgenev: Zhizn', iskusstvo, vremia.* Moscow: Sovetskaia Rossiia, 1988.

Platt, Kevin M. F. *Terror and Greatness: Ivan and Peter as Myths.* Ithaca, NY: Cornell University Press, 2011.

Platt, Kevin M. F., and David Brandenburger, eds. *Epic Revisionism: Russian History and Literature as Stalinist Propaganda.* Madison: University of Wisconsin Press, 2006.

Pobedonostsev, K. P. *K. P. Pobedonostsev i ego korrespondenty: Pis'ma i zapiski.* 2 vols. Moscow: Gosudarstvennoe izdatel'stvo, 1923.

Pope, Richard. "Two Key Visual Representations in 'The Idiot.'" In Greenfield, *Depictions,* 44–57.

Praz, Mario. *Mnemosyne: The Parallel between Literature and the Visual Arts.* Princeton, NJ: Princeton University Press, 1970.

Punin, N. N. "P. A. Fedotov." In *Russkoe i sovetskoe iskusstvo.* Moscow: Sovetskii khudozhnik, 1976.

Pushkin, A. S. *Polnoe sobranie sochinenii.* Edited by A. M. Gor'kii et al. 17 vols. Moscow: Akademiia nauk SSSR, 1937–1959.

Rakova, M. M., ed. *L. N. Tolstoi i izobrazitel'noe iskusstvo: Sbornik statei.* Moscow: Izobrazitel'noe iskusstvo, 1981.

———. *Russkaia istoricheskaia zhivopis' serediny deviatnadtsatogo veka.* Moscow: Iskusstvo, 1979.

Ramazanov, N. A. *Materialy dlia istorii khudozhestv v Rossii.* Moscow: Gubernskaia tip., 1863.

Reed, Arden. *Manet, Flaubert, and the Emergence of Modernism: Blurring Genre Boundaries.* New York: Cambridge University Press, 2003.

Reid, Robert, and Joe Andrew, eds. *Turgenev: Art, Ideology, and Legacy.* Amsterdam: Rodopi, 2010.

Reifman, P. S. "Bor'ba v 1862–1863 godakh vokrug romana I. S. Turgeneva 'Ottsy i deti.'" *Trudy po russkoi i slavianskoi filologii, Uchenye zapiski tartuskogo gosudarstvennogo universiteta* 6 (1963): 92–94.

Repin, I. E. *Dalekoe blizkoe.* Edited by K. I. Chukovskii. Moscow: Iskusstvo, 1964.

———. *I. E. Repin i L. N. Tolstoi, I: Perepiska s L. N. Tolstym i ego sem'ei.* Edited by V. A. Zhdanov and E. E. Zaidenshnur. Moscow: Iskusstvo, 1949.

———. *I. E. Repin i L. N. Tolstoi, II: Materialy.* Edited by S. A. Tolstaia-Esenina and T. V. Rozanova. Moscow: Iskusstvo, 1949.

———. *I. E. Repin i V. V. Stasov: Perepiska.* Edited by A. K. Lebedev and G. K. Burovaia. 3 vols. Moscow: Iskusstvo, 1948–1950.

———. *Il'ia Repin: Zhivopis', grafika.* Edited by N. E. Vatenina et al. Leningrad: Avrora, 1985.

———. *Izbrannye pis'ma, 1867–1930.* Edited by I. A. Brodskii. 2 vols. Moscow: Iskusstvo, 1969.

———. "Iz vremen vozniknoveniia moei kartiny 'Burlaki na Volge.'" *Golos minuvshego,* nos. 1, 3, and 6 (1915).

Rigolot, François. "Ekphrasis and the Fantastic: Genesis of an Aberration." *Comparative Literature* 49, no. 2 (Spring 1997): 97–112.

———. "The Rhetoric of Presence: Art, Literature, and Illusion." In *The Cambridge History of Literary Criticism.* Vol. 3, *The Renaissance,* edited by Glyn P. Norton, 161–67. Cambridge: Cambridge University Press, 1999.

Ripp, Victor. *Turgenev's Russia from "Notes of a Hunter" to "Fathers and Sons."* Ithaca, NY: Cornell University Press, 1980.

Robin, Régine. *Socialist Realism: An Impossible Aesthetic.* Translated by Catherine Porter. Stanford, CA: Stanford University Press, 1992.

Rodin, F. N. *Burlachestvo v Rossii: Istoriko-sotsiologicheskii ocherk.* Moscow: Mysl', 1975.

Rozenvasser, V. B. "Peizazh v kartinakh Perova." *Khudozhnik* 12 (1983): 17–23.

Rubins, Maria. *Crossroads of Arts, Crossroads of Cultures: Ecphrasis in Russian and French Poetry.* Basingstoke, England: Palgrave, 2000.

Russkaia narodnaia liniia. "Eta kartina oskorbliaet patrioticheskie chuvstva russkikh liudei." October 2, 2013. Accessed 2 October 2013. http://ruskline.ru/news_rl/2013/10/02/eta_kartina_oskorblyaet_patrioticheskie_chuvstva_russkih_lyudej/

Saltykov-Shchedrin, M. E. *Sobranie sochinenii.* Edited by S. A. Makashin et al. 20 vols. Moscow: Khudozhestvennaia literatura, 1965–1977.

Samuels, Maurice. *The Spectacular Past: Popular History and the Novel in Nineteenth-Century France.* Ithaca, NY: Cornell University Press, 2004.

Sarab'ianov, D. V. *Istoriia russkogo iskusstva vtoroi poloviny XIX veka.* Moscow: Izdatel'stvo moskovskogo universiteta, 1989.

———. *Narodno-osvoboditel'nye idei russkoi zhivopisi vtoroi poloviny XIX veka.* Moscow: Iskusstvo, 1955.

———. *P. A. Fedotov i russkaia khudozhestvennaia kul'tura 40-kh godov XIX veka.* Moscow: Iskusstvo, 1973.

———. *Pavel Andreevich Fedotov.* Leningrad: Khudozhnik RSFSR, 1985.

———. "Repin i russkaia zhivopis' vtoroi poloviny XIX veka." In *Iz istorii russkogo iskusstva vtoroi poloviny XIX–nachala XX veka: Sbornik issledovanii i publikatsii,* edited by E. A. Borisova, G. G. Pospelov, and G. Iu. Sternin, 7–17. Moscow: Iskusstvo, 1978.

———. *Russkaia zhivopis' XIX veka sredi evropeiskikh shkol.* Moscow: Sovetskii khudozhnik, 1980.

Schwartz, Vanessa R. *Spectacular Realities: Early Mass Culture in Fin-de-Siècle Paris.* Berkeley: University of California Press, 1998.

Scott, Grant F. "The Rhetoric of Dilation: Ekphrasis and Ideology." *Word & Image* 7, no. 4 (October–December 1991): 301–10.

———. "Shelley, Medusa, and the Perils of Ekphrasis." In *The Romantic Imagination: Literature and Art in England and Germany,* edited by Frederick Burwick and Jürgen Klein, 315–32. Amsterdam: Rodopi, 1996.

Sedlmayr, Hans. "Bruegel's *Macchia.*" In *The Vienna School Reader: Politics and Art Historical Method in the 1930s,* edited by Christopher S. Wood, 323–78. New York: Zone, 2003. First published 1934.

Seifrid, Thomas. "Gazing on Life's Page: Perspectival Vision in Tolstoy." *PMLA* 113, no. 3 (May 1998): 436–48.

Seznec, Jean. "Art and Literature: A Plea for Humility." *New Literary History* 3, no. 3 (Spring 1972): 569–74.

Shargunov, S. A. "Otritsanie traura." *Novyi mir,* no. 12 (2001): 214–18.

Shcherbenok, Andrey. "'Killing Realism': Insight and Meaning in Anton Chekhov." *Slavic and East European Journal* 54, no. 2 (Summer 2010): 297–316.

Shklovskii, Viktor. *Material' i stil' v romane L'va Tolstogo "Voina i mir."* Moscow: Federatsiia, 1928.

———. *O teorii prozy.* Moscow: Federatsiia, 1929.

Shklovsky, Viktor. "Art as Technique." In *Russian Formalist Criticism: Four Essays,* edited and translated by Lee T. Lemon and Marion J. Reis, 3–24. Lincoln: University of Nebraska Press, 1965. First published 1917.

Shumova, M. N. "'Slovo' i 'izobrazhenie' v tvorchestve P. A. Fedotova." In Gerasimov, *Russkaia literatura,* 119–42.

Sieburth, Richard. "Same Difference: The French *Physiologies*, 1840–1842." In *Notebooks in Cultural Analysis: An Annual Review*, edited by Norman F. Cantor, 163–200. Durham, NC: Duke University Press, 1984.

Silbajoris, Rimvydas. "Images and Structures in Turgenev's *Sportman's Notebook*." *Slavic and East European Journal* 28, no. 2 (Summer 1984): 180–91.

Silver, Larry. "Step-Sister of the Muses: Painting as Liberal Art and Sister Art." In *Articulate Images: The Sister Arts from Hogarth to Tennyson*, edited by Richard Wendorf, 36–69. Minneapolis: University of Minnesota Press, 1983.

Skakov, Nariman. "Dostoevsky's Christ and Silence at the Margins of *The Idiot*." *Dostoevsky Studies*, new series 13 (2009): 121–40.

Slivkin, Evgenii. "'Tanets smerti' Gansa Gol'beina v romane 'Idiot.'" *Dostoevskii i mirovaia kul'tura* 17 (2003): 80–109.

Smith, Mack. *Literary Realism and the Ekphrastic Tradition*. University Park, PA: Pennsylvania State University Press, 1995.

Sobko, N. P. *Vasilii Grigor'evich Perov: Ego zhizn' i proizvedeniia*. St. Petersburg: Izdatel'stvo D. A. Rovinskago, 1892.

Somov, A. I. *Pavel Andreevich Fedotov*. St. Petersburg: Tip. A. M. Kotoshina, 1878.

Sorokin, Iu. S. "K istorii termina *realizm* (40–60-e gody XIX v.)." *Uchenye zapiski leningradskogo gosudarstvennogo universiteta, seriia filologicheskikh nauk* 17, no. 158 (1952): 231–65.

Spektor, Alexander. "From Violence to Silence: Vicissitudes of Reading (in) *The Idiot*." *Slavic Review* 72, no. 3 (Fall 2013): 552–72.

Stasov, V. V. *Izbrannye sochineniia: Zhivopis', skul'ptura, muzyka*. Edited by E. D. Stasov et al. 3 vols. Moscow: Iskusstvo, 1952.

Steiner, Evgeny. "Pursuing Independence: Kramskoi and the Peredvizhniki vs. the Academy of Arts." *Russian Review* 70, no. 2 (April 2011): 252–71.

Steiner, Wendy. *The Colors of Rhetoric: Problems in the Relation between Modern Literature and Painting*. Chicago: University of Chicago Press, 1982.

Stendhal. *The Red and the Black: A Chronicle of 1830*. Translated by Burton Raffel. New York: The Modern Library, 2004.

Sternberger, Dolf. *Panorama of the Nineteenth Century*. Translated by Joachim Neugroschel. New York: Urizen, 1977.

Sternin, G. Iu. *Dva veka, XIX–XX: Ocherki russkoi khudozhestvennoi kul'tury*. Moscow: Galart, 2007.

———. *Il'ia Efimovich Repin*. Leningrad: Khudozhnik RSFSR, 1985.

Summers, David. *Real Spaces: World Art History and the Rise of Western Modernism*. London: Phaidon, 2003.

Tapp, Alyson. "Moving Stories: (E)motion and Narrative in *Anna Karenina*." *Russian Literature* 61, no. 3 (April 2007): 341–61.

Taruskin, Richard. *Opera and Drama in Russia as Preached and Practiced in the 1860s*. Ann Arbor, MI: UMI Research Press, 1981.

———. "Realism as Practiced and Preached: The Russian Opera Dialogue." *Music Quarterly* 56, no. 3 (July 1970): 431–54.

Tate, Allen. "Dostoevsky's Hovering Fly: A Causerie on the Imagination and the Actual World." *Sewanee Review* 51, no. 3 (July–September 1943): 353–69.

Terras, Victor. "Turgenev's Aesthetic and Western Realism." *Comparative Literature* 22, no. 1 (Winter 1970): 19–35.

Thomas, Julie. *Pictorial Victorians: The Inscription of Values in Word and Image*. Athens: Ohio University Press, 2004.

Thomas, Sophie. "Ekphrasis and Terror: Shelley, Medusa, and the Phantasmagoria." In *Illustrations, Optics, and Objects in Nineteenth-Century Literary and Visual Culture*, edited by Luisa Calè and Patrizia di Bello, 25–43. New York: Palgrave Macmillan, 2010.

Thomas, Troy. "Interart Analogy: Practice and Theory in Comparing the Arts." *Journal of Aesthetic Education* 25, no. 2 (Summer 1991): 17–36.

Thrailkill, Jane F. *Affecting Fictions: Mind, Body, and Emotion in American Literary Realism*. Cambridge, MA: Harvard University Press, 2007.

Tikhomirov, B. N. "Dostoevskii i 'Mertvyi Khristos' Gansa Gol'beina Mladshego." In *Sub specie tolerantiae: Pamiati V. A. Tunimanova*, edited by A. G. Grodetskaia, 207–17. St. Petersburg: Nauka, 2008.

Tokarev, Dmitrii. "Deskriptivnyi i narrativnyi aspekty ekfrasisa ('Mertvyi khristos' Gol'beina—Dostoevskogo i 'Sikstinskaia madonna' Rafaelia—Zhukovskogo)." In Tokarev, *"Nevyrazimo vyrazimoe,"* 61–104.

———, ed. *"Nevyrazimo vyrazimoe": Ekfrasis i problemy reprezentatsii vizual'nogo v khudozhestvennom tekste*. Moscow: Novoe literaturnoe obozrenie, 2013.

Tolstaia, S. A. *Moia zhizn'*. Edited by V. B. Remizov et al. 2 vols. Moscow: Kuchkovo pole, 2011.

Tolstoi, L. N. *Polnoe sobranie sochinenii*. Edited by V. G. Chertkov et al. 90 vols. Moscow: Khudozhestvennaia literatura, 1928–1958.

———. *Voina i mir*. Moscow: Tip. Ris, 1868–1869.

Tolstoy, Leo. *Anna Karenina*. Translated by Richard Pevear and Larissa Volokhonsky. New York: Penguin, 2001.

———. *War and Peace*. Translated by Richard Pevear and Larissa Volokhonsky. New York: Vintage, 2007.

Tooke, Adrianne. *Flaubert and the Pictorial Arts: From Image to Text*. Oxford: Oxford University Press, 2000.

Torgovnick, Marianna. *The Visual Arts, Pictorialism, and the Novel: James, Lawrence, and Woolf*. Princeton, NJ: Princeton University Press, 1985.

Tseitlin, A. G. *Stanovlenie realizma v russkoi literature: Russkii fiziologicheskii ocherk*. Moscow: Nauka, 1965.

Tsvetkov, I. E. "Vstrecha s I. S. Turgenevym." In *I. S. Turgenev: Novye materialy i issledovaniia*. Vol. 76 of *Literaturnoe nasledstvo*, edited by A. N. Dubovikov, I. S. Zil'bershtein et al., 415–22. Moscow: Nauka, 1967.

Turgenev, I. S. *Fathers and Sons*. Translated by Rosemary Edmonds. New York: Penguin, 1975.

———. *Home of the Gentry*. Translated by Richard Freeborn. Baltimore: Penguin, 1970.

———. *Parizhskie rukopisi I. S. Turgeneva*, edited by André Mazon, translated by Iu. Gan. Moscow: Akademiia, 1931.

———. *Polnoe sobranie sochinenii i pisem*. Edited by M. P. Alekseev et al. 28 vols. Moscow: Akademiia nauk, 1960–1968.

———. *The Portrait Game*. Edited by Marion Mainwaring. New York: Horizon, 1973.

———. *Sketches from a Hunter's Album*. Translated by Richard Freeborn. New York: Penguin, 1990.

Valentino, Russell S. "A Wolf in Arkadia: Generic Fields, Generic Counterstatement, and the Resources of Pastoral in *Fathers and Sons*." *Russian Review* 55, no. 3 (July 1996): 475–93.

Valkenier, Elizabeth Kridl. *Ilya Repin and the World of Russian Art*. New York: Columbia University Press, 1990.

———. "The Peredvizhniki and the Spirit of the 1860s." *Russian Review* 34, no. 3 (July 1975): 247–65.

———. "Politics in Russian Art: The Case of Repin." *Russian Review* 37, no. 1 (January 1978): 14–29.

———. *Russian Realist Art: The State and Society; The Peredvizhniki and Their Tradition*. Ann Arbor, MI: Ardis, 1977.

———. "The Writer as Artist's Model: Repin's Portrait of Garshin." *Metropolitan Museum Journal* 28 (1993): 207–16.

Valkenier, Elizabeth Kridl, and Wendy Salmond, eds. "Russian Realist Painting: The Peredvizhniki; An Anthology." Special Issue. *Experiment/Eksperiment: A Journal of Russian Culture* 14, no. 1 (2008): ix–xii.

Vanslov, V. V., ed. *Russkaia progressivnaia khudozhestvennaia kritika vtoroi poloviny XIX veka–nachala XX veka: Khrestomatiia*. Moscow: Izobrazitel'noe iskusstvo, 1977.

Vereshchagina, A. G. *Istoricheskaia kartina v russkom iskusstve: Shestidesiatye gody XIX veka*. Moscow: Iskusstvo, 1990.

———. *Khudozhnik, vremia, istoriia: Ocherki russkoi istoricheskoi zhivopisi XVIII–nachala XX veka*. Moscow: Iskusstvo, 1973.

Vinogradov, V. V. *Evoliutsiia russkogo naturalizma: Gogol' i Dostoevskii*. Leningrad: Akademiia, 1929.

Voloshin, Maksimillian. *O Repine*. In *Sobranie sochinenii*, edited by V. P. Kupchenko and A. V. Lavrov, 3:305–62. Moscow: Ellis Lak, 2005. First published 1913.

Wachtel, Andrew Baruch. "Dostoevsky's *The Idiot*: The Novel as Photograph." *History of Photography* 26, no. 3 (Autumn 2002): 205–15.

———. *An Obsession with History: Russian Writers Confront the Past*. Stanford, CA: Stanford University Press, 1994.

Wagner, Peter, ed. *Icons—Texts—Iconotexts: Essays on Ekphrasis and Intermediality*. Berlin: Walter de Gruyter, 1996.

Walicki, Andrzej. *A History of Russian Thought: From the Enlightenment to Marxism*. Translated by Hilda Andrews-Rusiecka. Stanford, CA: Stanford University Press, 1979.

Webb, Ruth. *Ekphrasis, Imagination, and Persuasion in Ancient Rhetorical Theory and Practice*. Burlington, VT: Ashgate, 2009.

Weir, Justin. *Leo Tolstoy and the Alibi of Narrative*. New Haven, CT: Yale University Press, 2011.

Weisstein, Ulrich. "Literature and the Visual Arts." In *Interrelations of Literature*, edited by Jean-Pierre Barricelli and Joseph Gibaldi, 251–77. New York: Modern Language Association, 1982.

Wellek, René. "The Concept of Realism in Literary Scholarship." In *Concepts of Criticism*, edited by Stephen G. Nichols, Jr., 222–55. New Haven, CT: Yale University Press, 1963.

———. "The Parallelism between Literature and the Visual Arts." In *English Institute Annual*, 29–63. New York: Columbia University Press, 1941.

Williams, Linda. "When the Woman Looks." In *Re-Vision: Essays in Feminist Film Criticism*, edited by Mary Ann Doane, Patricia Mellencamp, and Linda Williams, 83–99. Frederick, MD: University Publications of America, 1984.

Witemeyer, Hugh. *George Eliot and the Visual Arts*. New Haven, CT: Yale University Press, 1979.

Wollheim, Richard. *Painting as an Art*. London: Thames and Hudson, 1987.

Woolf, Virginia. "Modern Fiction." In *The Essays of Virginia Woolf*. Vol. 4, *1925 to 1928*, edited by Andrew McNeille, 157–65. London: Hogarth Press, 1986. First published 1919 as "Modern Novels" by the *Times Literary Supplement*. Revised 1925 as "Modern Fiction."

———. "The Russian Point of View." In *The Essays of Virginia Woolf*. Vol. 4, *1925 to 1928*, edited by Andrew McNeille, 181–89. London: Hogarth Press, 1986. First published 1925 by the *Common Reader*.

Yates, Francis A. *The Art of Memory*. Chicago: University of Chicago Press, 1966.

Yeazell, Ruth Bernard. *The Art of the Everyday: Dutch Painting and the Realist Novel*. Princeton, NJ: Princeton University Press, 2008.

Young, Sarah J. "Holbein's Christ in the Tomb in the Structure of *The Idiot*." *Russian Studies in Literature* 44, no. 1 (Winter 2007): 90–102.

Zaidenshnur, E. E. *"Voina i mir" L. N. Tolstogo: Sozdanie velikoi knigi*. Moscow: Izdatel'stvo Kniga, 1966.

Zelenin, D. K. *Izbrannye trudy: Ocherki russkoi mifologii; Umershie neestestvennoiu smert'iu i rusalki*. Moscow: Indrik, 1995.

Zhdanov, V. A., E. E. Zaidenshnur, and E. S. Serebrovskaia, eds. *Opisanie rukopisei khudozhestvennykh proizvedenii L. N. Tolstogo*. Moscow: Izdatel'stvo akademii nauk SSSR, 1955.

Zil'bershtein, I. S. "Kak sozdavalas' kartina 'Zaporozhtsy.'" In *Khudozhestvennoe nasledstvo, Repin*, edited by I. E. Grabar' and I. S. Zil'bershtein, 2:57–72. Moscow: Akademiia nauk SSSR, 1949.

———. *Repin i Turgenev*. Moscow: Izdatel'stvo akademii nauk, 1945.

Index

Page numbers in italics indicate illustrations.